Longman

Visual

ARTS

FOR SECONDARY SCHOOLS

Orders: please contact Bookpoint Ltd, 130 Park Drive, Milton Park, Abingdon, Oxon OX14 4SE.
Telephone: (44) 01235 827720. Fax: (44) 01235 400454. Email education@bookpoint.co.uk
Lines are open from 9 a.m. to 5 p.m., Monday to Saturday, with a 24-hour message answering service. You can also order through our website: www.hoddereducation.com

First published by Pearson Education Limited
Published from 2015 by Hodder Education,
An Hachette UK Company
Carmelite House
50 Victoria Embankment
London EC4Y 0DZ
www.hoddereducation.com

ISBN: 978-1-4082-0853-3

20 19 18 17 16 15
IMP 10 9 8 7

Acknowledgements
The author and publisher would like to thank the following individuals and organisations for their contributions to this publication:

- Reviewers of the text: Irene Banfield (Barbados) and Michelle Chin-See (Jamaica)
- Various Ministries of Education and their Visual Arts Curriculum Officers and Supervisors throughout the Caribbean
- Colleagues in Visual Arts Education in the Caribbean
- Contributing Artists from the Caribbean and beyond
- The School of Education and the Centre for the Creative and Festival Arts, The University of the West Indies, St Augustine
- Colleagues at the Division of Educational Research & Evaluation and the Curriculum Planning & Development Division, Ministry of Education, Trinidad & Tobago
- Educators Shirley P. Ramkissoon and Lochan Harrichan
- Alec, Andrew and Indira.

Dedication from the author
This book is dedicated to my father and educator, R. G. Sieupersad, who gave me my first crayons, and to all students who have felt the magic of using them.

Picture research by Alison Prior

Cover designed by Juice

Prepared for publication by Scout Design Associates

Index compiled by Indexing Specialists (UK) Ltd

Printed in Italy by Printer Trento S.r.l.

Longman Visual Arts for Secondary Schools

Introduction

Longman Visual Arts for Secondary Schools comprehensively covers Visual Arts education at lower secondary in the Caribbean, written to meet the requirements of syllabi across the region. Broad content coverage means this textbook will also be useful for students in all secondary years.

The textbook is divided into 3 parts: Part 1 introduces the Visual Arts, World Art and Caribbean Art; Part 2 contains 11 chapters, each providing in-depth detail of one major area of visual art-making. Part 3 includes considerations for integrating the subject of the visual arts, research and writing and ideas to create a portfolio.

Features of the book

Each chapter is constructed with user-friendly features to help introduce, explain and summarise theory-based and practical content.

Note to Students

As students of the Visual Arts, there is so much that you can learn. This book will help you to learn about and make art, talk and write about your art, find out more about art and artists to understand and appreciate what others do in the wonderful process of practicing art.

Give yourself time to absorb all that is around you, but do it with the aim to improve. What you learn in one chapter of this book, or on the CD-ROM, will only help you to improve what you are about to do next. At times you will have to visit a school or local library, make a field trip or research online to support what you are doing. This may help you on your way to uncovering hidden talent. So get ready to draw and to paint and to build. Let your imagination free!

Outcomes outline what the chapter's main learning objectives are.

Helpful hints throughout provide practical advice on materials and safety tips.

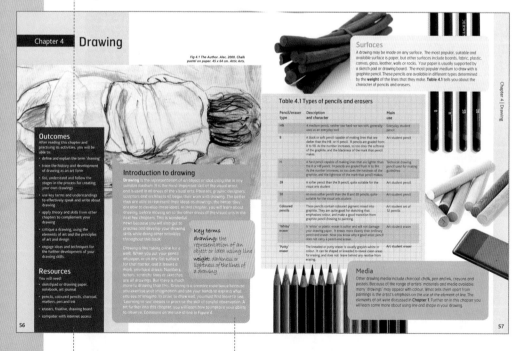

A list of resources helps identify what will be needed when practicing particular mediums of art.

Each chapter contains an introduction, providing a concise opening to what the chapter will cover.

Did you know? boxes provide fun and interesting additional facts.

Features of the CD-ROM

A fun and engaging CD-ROM can be found at the back of this book. It helps to reinforce crucial concepts and promotes independent learning.

The CD ROM provides support for the text and contains:

- easy-to-follow advice for practicing art in the classroom, at home and in the field
- a Visual Arts assessment overview and scoring guide
- over 250 multiple-choice and 170 open-response assessment items
- fun interactive crosswords and word search activities.

Key terms highlight important terminology used in the text and provide easy-to-understand definitions.

Chapter summaries help wrap-up the key concepts that should have been learnt in the chapter.

Each chapter closes with individual, group and integrated questions that help test key concepts covered as well as offering extension activities for further classroom or home-based work.

Helpful references to the accompanying CD-ROM are made throughout so that additional activities and material can be used to expand on the text's content.

The World of Visual Arts

Outcomes

After reading this chapter and practising its activities, you will be able to:

- define and explain the terms 'art', 'craft' and 'visual arts'

- list the major areas of practice in the visual arts

- explore human development through the visual arts

- define and interpret the elements of art in the visual art-making process

- define and interpret the principles of art and design in the visual art-making process

- understand how teaching and learning take place in the visual arts

- apply theory and skills from other chapters to complement your understanding of the visual arts.

Resources

You will need:

- art journal, notebook, sketchpad

- pencils, coloured pencils, scissors, glue

- computer with internet access, digital camera

- access to school and public libraries.

Key term
visual arts: human creativity that appeals to our sense of sight

Introduction to the visual arts

Welcome to the world of the **visual arts**. It is a world where your imagination takes centre stage and your ideas come alive – a world where there is both black and white and an explosion of colour. It is a world where all the materials and supplies you have begin to make magic and where you learn to make things happen.

The visual arts have been practised for thousands of years, beginning with prehistoric people expressing what they saw in their environment and what they thought and felt within themselves. Although most of these artwork have been lost with time, there are many pieces of evidence that prove the impact of the visual arts on early clothing and shelter, hunting and food-gathering, rituals and religion, tools and weapons, settlement and civilisation, and writing. These expressions arose first out of basic need, then later to make life easier as man adapted to the changing environment around him. Humankind's artistic efforts today may be placed into ten areas of study, creativity and practice.

Fig 1.1 Palaeolithic, Gravettian Culture. Venus of Willendorf. c.24000 years ago. Coloured limestone. 11 cm tall. Naturhistorsches Museum, Austria.

6

Ten areas of creativity

There are ten areas of creativity that we shall explore in this book. They are drawing, painting, printmaking, graphic design, textile design, three-dimensional art, leathercraft, ceramics, fibre arts and decorative craft. Sometimes they are referred to as the arts and crafts. You will be introduced to these areas from Chapters 4 to 13. Each of these ten areas of creativity forms its own field of study because it requires you to learn, practise and develop techniques and skills using different materials and media. But these areas also share many skills and together help you to develop your complete artistic ability.

As you learn and practise in these areas, your understanding will change. In many instances, your materials and media, your ideas and skills, will be shared by more than one of the ten areas of creativity covered in this book. An example of this is the use of pieces of fabric, leather, styrofoam or even sand to make a painting. This is called **mixed media**.

Another example is the development of coloured pencil work, which combines drawing techniques with colour. The use of coloured pencils causes new ideas about art to emerge: for instance, is the result a drawing in colour, or a painting made from pencil?

> **Key term**
> **mixed media:** the combination of various materials and media to create an artwork

> **Key term**
> **process:** a sequence of steps or stages for achieving an outcome

Each of the ten areas also requires the art student to be able to know, understand and practise a series of steps that follow one another. Throughout this book, you will use these steps to develop your understanding, skill and appreciation for each area as a **process**.

In the visual arts this process begins, as does everything else, with an idea. To create an artwork, you must be able to think of an idea; decide on media and materials to use; apply a skill, which is often made up of numerous sub-skills; present the completed artwork; be able to speak and write about the artwork; and learn from the experience so that you improve when you repeat the process to create another artwork.

As a student of the visual arts, you may be required to repeat the final artwork as the outcome, such as in printmaking or ceramics. But in other areas such as painting or sculpture, where the final outcome is a single unique piece of artwork, this may not be possible. Each of the ten areas of the visual arts, however, allows you to develop your art-making skills through the use and improvement of an art-making process.

What is art and what is craft?

Art

The word 'art' comes from the Latin *ars*, which means 'arranging'. It is the putting together of various parts to create an artwork. Works of art display creativity, and have meaning, apart from physical description. But art also requires an interpretation as a response.

A good response says what you see, feel and understand about the artwork. It describes the message of the artwork. A piece of art can often evoke an emotional response or mood from the viewer, which gives art its value.

Art therefore has value in itself, and not because it has some other use: for example, a painting is enjoyed because of the skill of the artist and the message it sends. **Figure 1.2 is an example of art. Discuss your reaction to it.**

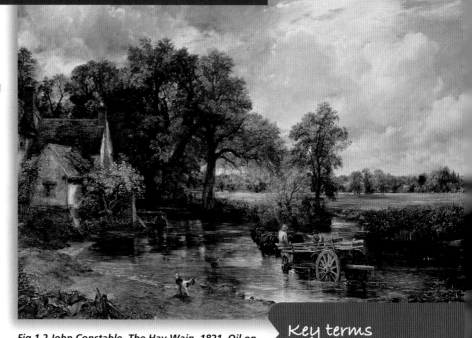

Fig 1.2 John Constable. The Hay Wain. 1821. Oil on canvas. 130 x 185 cm. National Gallery, London.

Craft

Craft produces objects that have utility or **functional value**. The value is more in the object's use than in the object itself. In craft-making, there is **creativity** in the making of the object, but the object serves some purpose: for instance, a tea cup may be beautifully designed, but is replicated to complete a useful set.

Our response to craft includes appreciation of the skill of the craftsman, the description of the object, its purpose, and how well it serves that purpose. Interestingly, a piece of craft, such as a pottery object made long ago for keeping water in, may over time become a piece of art displayed in a museum simply because its purpose has changed. We no longer use it for holding water. Rather, we now marvel at the object itself, how well it was crafted and what it tells us about peoples of a past age. **Figure 1.3** is an example of a craft item.

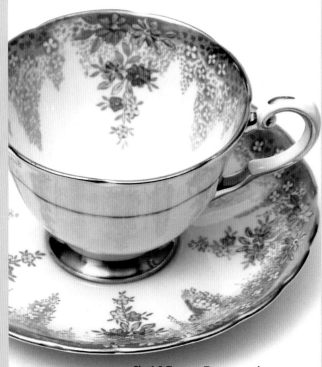

Fig 1.3 Tuscan. Tea cup and saucer. English bone china.

Key terms

creativity: our mental ability to combine, connect or develop new ideas

functional value: serving some practical purpose

Did you know?

Today, many artists use craft techniques to create unique artworks. Others may apply art techniques to craftworks. This may make it a bit more difficult to distinguish between an artwork and a craftwork at times but enhances the creativity of artists, and the value of the work themselves. Can you identify some examples of such works?

Rationale for the visual arts

A rationale provides good reasons for doing something. The rationale for the visual arts demonstrates the value of the visual arts to you as a student and to all individuals as human beings You will begin to understand why the visual arts are created, and why visual arts education is taught. For the complete rationale for the visual arts, please refer to the CD-ROM that accompanies this book.

Read and discuss this rationale in class and add ideas of your own to it. A year from now, do this exercise again.

Elements of art

Elements of art help the art student to express ideas, and therefore communicate a message. Understanding the elements of art also helps us to see how other artists use them in their artworks, and interpret the messages they wish to communicate.

The elements of art are line, shape or form, space, value, texture and colour. **Examine Figure 1.4 for the artist's use of these elements**.

Each element of art is discussed separately below, but you will soon recognise that they work together to produce a successful artwork.

> **Key terms**
> **elements of art:** basic tools artists use to create an artwork
> **line:** a point in motion

Fig 1.5 Various lines.

Line

A point is made when your pencil (or pen, marker, charcoal, pastel, crayon, paintbrush or any other instrument) comes into contact with a suitable art-making surface. A **line** is formed when this point is drawn over that surface. The line is the basic element of the visual arts process and may be manipulated in several ways. Lines may be straight or curved, light or dark, separated or joined, thin or thick, parallel or at various angles to one another, criss-crossed in either regular or irregular patterns. We will learn a bit more about lines in **Chapter 4**.

Discuss the use of line in Figure 1.4. Are all the lines similar or do they differ, and how?

During your observation, look for lines that vary in: length, thickness, direction or weight, lines that are parallel, lines that criss-cross, lines that show solidity, lines that are softer or darker. Consider whether the artist drew quickly or slowly. Why are there some areas without any line? Can you suggest reasons for what you have observed?

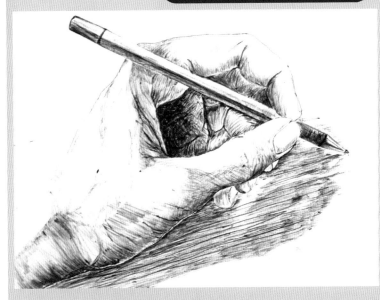

Fig 1.4 The Author. My left hand. 1996.
Ballpoint pen on paper. 18 x 24 cm. Attic Arts.

Shape or form

A **shape** is created when a line returns to its point of origin. Shapes may vary just as much as the lines that create them. Shapes are classified by their thickness. Shapes without thickness are called two-dimensional or flat shapes. Shapes with thickness or form are called three-dimensional or solid shapes. In **Chapter 4**, you will learn more about the use of shapes in the visual arts and **Chapter 9** teaches you how to build solid shapes from flat ones.

Shapes may also be classified by how frequently they are found in everyday life, as regular or irregular. Regular shapes are common and have names. Irregular shapes are not as common and may not have names.

Any three-dimensional artwork, such as a sculpture, has **form**. A sculpture is intended to represent a form such as your hand. It includes the ideas of both shape (the outline) and structure (all that is within the outline). Any solid object or artwork has form. This is discussed further in **Chapter 9**.

Key term
illusion of depth: suggestion of depth or distance on a flat surface

Key terms
shape: an outline
form: space occupied by a three-dimensional artwork

Fig 1.6 Illustration of various shapes.

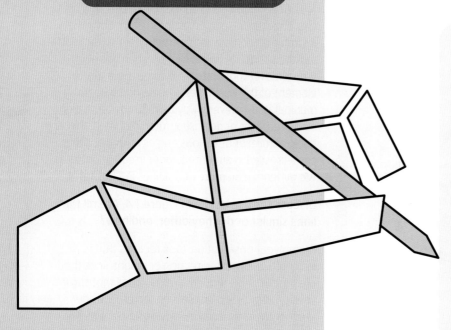

Fig 1.7 Basic shapes that make up the 'My Left Hand'.

Observe how the more complex form of the hand in Figure 1.4 is actually made up of some of the simpler shapes illustrated in Figure 1.7.

However, the artist may create the **illusion of depth** in a two-dimensional artwork such as a drawing or painting. An illusion of **form** is the suggestion of depth or distance on a flat surface. The drawing of a hand on paper will therefore appear similar to the solid and rounded form of an actual human hand.

Examine Figure 1.4 (page 9) again. How are lines used to convey the roundness of the hand and pen? How are lines used to show the depth of the cavity made by the posture of the hand?

Space

Space is the area that a shape or form occupies. Two-dimensional or flat shapes occupy space on a flat surface. For example, the area of a circle is equal to the space that it occupies on the surface on which it is drawn. Three-dimensional or solid shapes, such as sculptures, occupy a space that may be measured by their length, width and height.

In reality, any object occupies space. Your body, a drawing table or even a pencil all occupy space.

Space also exists around all these objects: for example, the space between you and someone else. In a composition for a drawing or any other two-dimensional work, the objects occupy positive space, while there is negative space around them. **Chapter 6** and **13** teaches a bit more about positive and negative spaces.

Look at Figure 1.4 (page 9) again. How does the amount of space for the hand and pen compare to the remaining space around them? How is the illusion of space created inside the posture of the hand?

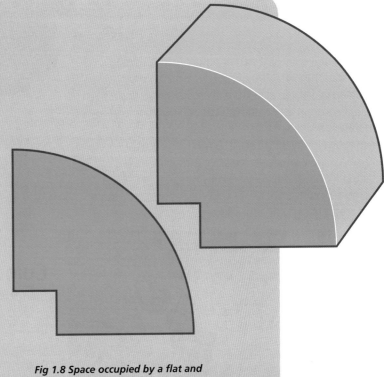

Fig 1.8 Space occupied by a flat and its corresponding solid shape.

> **Key term**
> **value:** *variation of light and dark on an object*

Value

Any object is constantly affected by the light around it. The artist uses **value** to represent the effect light has on the object. By using value, the illusion of form, depth or distance is achieved. When representing value, it is important to observe the direction from which the main source of light is generated. The light may follow a path to the object from the front, left, right or rear. It may come from above or below or be at the same level as the object. When you begin to use value, three variations are suggested: heavy, middle and light. The lightest values are often used to represent surfaces of the object that are in direct light. The middle values may be used to represent diffused light that comes into contact with a surface that does not directly face the light source. This surface is therefore neither directly facing the light source nor in the area of shadow. The heaviest values represent surfaces in the shadow of the light source. Areas that require heaviest value tend to be behind and furthest away from the main source of light. Learn more about creating values of pencil in **Chapter 4** and paint in **Chapter 5**.

Examine Figure 1.4 (page 9). Comment on the use of value in the drawing. Which areas of the hand have the lightest and which the darkest values? Why is this? What does the change in value tell about the form of the hand?

Fig 1.9 Various values.

Texture

Texture is the way the surface of an object feels. The feel may be suggested or actual. Surfaces may vary from smooth to rough, soft to firm, feathery to coarse. An artist uses texture in an artwork to appeal to our sense of touch and may do this by using various materials that have these characteristics on their surfaces. However, the artist may also create the illusion of how an object feels: for example, the skin texture of an iguana may be well represented using a combination of points, lines and shapes that indicate the creature's rough, scaly skin.

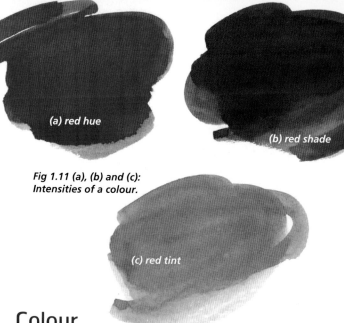

(a) red hue

(b) red shade

Fig 1.11 (a), (b) and (c): Intensities of a colour.

(c) red tint

Fig 1.10 Various textures.

Artists have also created textures by applying paint to a surface in an uneven manner so that it is rough to the actual touch. This technique may be enhanced by mixing sand, styrofoam beads, seeds, pieces of pottery, gravel or other fragments into paint or sprinkling them over paint that has not fully dried. Yet another way to produce texture is to overlap pieces of materials. This is often done with collage, using paper, fabric, plastics and plant matter among others. Texture adds to the visual impact of the artwork. As a general rule, attempt to represent value before texture in your artwork. More about texture, and the types of texture, is discussed in Chapters 4, 8 and 9.

Examine Figure 1.4 (page 9). Do the lines on the drawing represent the actual markings on the palm of the artist's hand, or do they represent something else, or both?

Is the type of texture employed suggested or actual? Can you say why?

Colour

Colour is light reflected from an object to the viewer. Natural light or sunlight is made up of several colours. The colours that we can see are red, orange, yellow, green, blue, indigo and violet. We see colours differently because each travels at a different rate to our eyes.

A colour can be defined by its chroma, **intensity** and value. Chroma or **hue** is the pure colour. 'Pure' means it is not mixed. The colour red is a hue. Intensity is the brightness or dullness of a hue. The intensity of a hue is changed by adding black or white to the hue. If black is added, a shade is formed. For example, black paint mixed with red paint produces a dull red shade. If more black is added to this, an even duller shade of red is formed. If white is added, a tint is formed. For example, white paint mixed with red paint produces a bright red tint. If more white is added to this, an even brighter tint of red is formed.

The value of a hue is the amount of light that hue reflects. A hue with more white has a higher value and appears lighter because it reflects more light, while a hue with more black has a lower value and appears darker because it reflects less light. Your learning about colour will continue in **Chapter 5**.

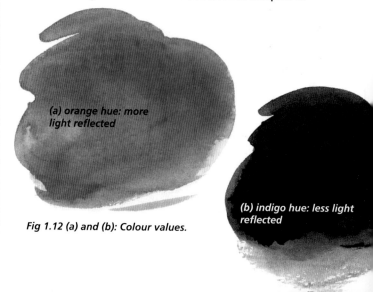

(a) orange hue: more light reflected

(b) indigo hue: less light reflected

Fig 1.12 (a) and (b): Colour values.

The principles of art and design

The principles of art and design are the organisational tools of an artwork. They suggest to us where, how and why the elements of art are to be applied. They help us to express ideas and to communicate a visual message in a structured manner.

It is equally important to see, interpret and explain how other artists use the principles of art and design to compose their artworks and send their messages. The principles of art and design are balance, contrast, emphasis, gradation, harmony, proportion, variation and unity.

Like the elements of art, the **principles of art and design** may be discussed separately, but also work together to produce a successful artwork. As you begin to read and understand, you must make a conscious effort to use some of the principles in your work. Try working to achieve one or two at a time in any one artwork. They are easier to grasp than you may think, and will improve your artwork over time. In the beginning, consider varying the position, direction, weight, size and shape of objects in your artwork. A bit later, you may also wish to relate these principles to one another: that is, be able to say how each principle of art and design works with the others.

Key term

principles of art and design: the organisational tools of an artwork

Fig 1.13 Colours creating contrast.

Contrast

Differences in the use of an element of art create contrast, which adds interest to your work. The artist therefore aims to achieve contrast by creating these differences. Any of the elements may be manipulated to create contrast, for example short and long lines or narrow and wide spaces. A bright blue kite against a light blue sky presents a sharp contrast of one colour. When contrast is created, the viewer has much more to look at, to examine and to interpret, because many things are happening at once. The artist can therefore use the principle of contrast to achieve centres of interest, focus or excitement. Complementary colours tend to have very high contrast, while analogous colours have low contrast. **Chapter 5** introduces you to these groups of colours. **What creates contrast in Figure 1.13?**

Key terms

texture: how a surface feels or appears to feel

colour: light reflected from an object

intensity: brightness or dullness of a hue

hue: (chroma) a pure colour

13

Balance

The principle of balance may be applied to one or more of the elements of art in an artwork. For instance, you may achieve balance in the use of line in the shapes you make. Balance attempts to steady the artwork by creating countering visual weights. Balance is therefore affected by location and variation of the elements of art in an artwork. In the visual arts it is not advisable to produce equal balance, as in the case of half the space for the earth and half for the sky in a landscape. This sort of formal balance is generally an unnatural division of space. A better result is achieved through informal balance, in which different objects or spaces are varied and counter one another. **Discuss how balance is achieved in Figure 1.14.**

Fig 1.14 Illustration of balance.

Emphasis

Emphasis or dominance is the quality of allowing an object or area of an artwork to stand out. Emphasis is closely related to contrast because the differences among the elements tend to emphasise one more than others, or emphasise the use of a particular element to a greater degree in one area than in another area. This tends to grab the attention of the viewer. You may wish to emphasise one object among a group of similar objects as a part of one artwork, but in another artwork you may make one object the overall centre of interest. Patterns formed by repeating the elements may reduce emphasis if used over a large part of an artwork, but may create emphasis if used in a specific smaller part of the artwork. **What creates emphasis in Figure 1.15?**

Fig 1.15 Illustration of emphasis.

Gradation

Gradation refers to the subtle changes that may be achieved by manipulating an element of art in an artwork. It is best employed over large areas to maintain interest and encourage our eyes to move through an artwork. This is easily achieved by reducing or increasing the size of objects to hint at depth. A sense of space can also be created by using a value range from vibrant rich colour through to dull to give a distant effect. Gradation is often used in this way to achieve perspective (refer to **Chapter 5**).

Fig 1.16 Illustration of gradation.

Proportion

Proportion is the relation between the space occupied by parts of an object or an entire object in an artwork when compared to other parts of that object or other objects in that artwork. In the early stages of your art education, try to develop a keen sense of the size, location or amount of objects. Proportion may be **linear**: for example, the height of an object may be twice its width. Proportion may refer to area: for example, the space occupied by one object may be almost equal to that of another, and arms and legs are in a particular proportion to our bodies. Proportion also defines volume. In three-dimensional artworks, a sculpture may be in perfect proportion to a human subject, and the space in which an installation is exhibited is affected by size of the exhibition area. **Discuss proportion in Figure 1.17.**

Fig 1.17 Illustration of proportion.

> **Key term**
> **linear:** referring to a length, measured with a rule or tape measure

Variation

Variation refers to the use of elements of art in different ways. For instance, the lines used in an artwork may change from short to long, thin to thick, broken to continuous, over different parts of the artwork. Similarly, the artist may add further variety by using different shapes and forms: small, large, regular, irregular, positive and negative. Value may move from heavy to middle to light. Texture may render different surfaces from smooth to rough, and soft to hard. Colours can be manipulated to produce a range from light to bright, or used as complements. **How is variation achieved in Figure 1.18?**

Fig 1.18 Illustration of variation.

Fig 1.19 Artwork of harmony.

Harmony

Harmony may be achieved through the repetition of similar lines, shapes, values, textures or colours. Here, repetition does not mean an identical copy of elements you used elsewhere in the artwork. Rather, you must learn to repeat them with small, delicate changes. The range of colour from light to bright suggested for the principle of variation on **page 15** could also lend harmony. So too would lines that gradually reduce or increase in length, thickness or value. Some examples may also add rhythm to an artwork, as the elements may repeat to make a pattern or sequence, such as a **tessellation. What elements cause Figure 1.19 to show harmony?**

> ### Key term
> **tessellation:** repeated use of a basic shape to create a pattern or artwork

Unity

Unity is the main principle at work in art and design. It brings together all the elements of art and the principles of art and design to provide the viewer with a complete artwork that is appealing and stimulating. The objects or parts within the artwork relate to one another in a way that shows that all belong together and to that artwork. Unity may well be considered the adhesive that eventually binds the elements and other principles into a finished artwork.

From time to time select an artwork from this book, or elsewhere, it and discuss how the elements of art and the principles of art and design are used in it.

> ### Helpful hint
> When you view an artwork, look for the elements of art first. See how the artist uses them to represent his or her ideas and how they attract and guide your eyes over the artwork. Also identify how the elements are organised to create the whole artwork.

Fig 1.20 Illustration of unity.

Teaching and learning in the visual arts

The rationale for the visual arts (refer to the CD-ROM) helps you to understand why we need to learn about the visual arts. We also need to find out how to do so. The following provides some general guidelines.

In order to best learn and develop as a visual artist, one important consideration is the finished artwork. You, your teacher and other viewers may look at the artwork and comment on it.

But what is even more important is how you went about creating your artwork, particularly because this is the beginning of your learning. In other words, the intention is to continue to make more artworks that will show progress over your previous work. You may learn a thing or two if you do something once, but if you continue to work you learn a lot more, improve your skill and add new ideas as well.

Greater understanding, skill development and appreciation come from the art you made previously. What you did will indicate to you which of the basic questions you need to more carefully ask yourself the next time you make your artwork. As a general rule, revisit these questions each time before you begin to make an artwork. The questions you ask yourself help with a full range of things that you need to know, do and appreciate as an art student. They include ideas for art history, art-making, art criticism and art appreciation. They are discussed separately below, but are best taught and learned together.

Here are some basic questions that apply from the very start each time you begin an artwork.

- Did I come up with a good enough idea based on the topic or theme?
- Did I research to get information and pictures of relevant similar ideas or artworks?
- Do I have the necessary materials, media, equipment and facilities?
- How do I intend to use the elements of art and the principles of art and design within the artwork?
- How did I develop the final idea for the artwork? Was it the first and only thing that came to my mind? Or did I come up with a few ideas, then select the best one?
- What are the stages in the creation of this artwork? Are there different techniques involved? Did I select one? How will I go about doing it?
- At what stages and times can I pause to improve the artwork as I make it?
- What is expected of me after completing the artwork? How do I feel about my achievement? Can I talk about what I liked and did well at? Is there some part that may be improved?
- What else is expected of me after completing the artwork? How will I present the artwork? What skill did I learn, use or develop?
- Did I make art journal entries to record what I did, felt and understood about my artwork?
- Am I ready to take what I have learned into my next art-making effort?

Did you know?

The best critic of your artwork is you. The more you allow yourself to make visual art, and the more you observe what you do over time, the more you see and learn how to improve. Try pinning up your artworks and looking at them some time later. Amazingly, you will find yourself getting a new sense of what you did.

Art criticism

Learning in the visual arts is aided by what you can identify in an artwork. In the visual arts, the term 'criticism' does not mean 'to speak negatively of'. Rather, **art criticism** means to 'say what you see, think and feel about an artwork'. Both the positive and negative may be mentioned, but suggesting ways for improving are important. Many times you may see and feel differently from others who view an artwork. Discussion helps you to see the points of view of others, perhaps things you did not notice, that may improve your interpretation of the artwork.

For artworks made by you and your classmates, you may wish to begin by talking about the theme, what you did, and how the elements of art – line, shape, space, value, texture and colour – were used. You may talk about the composition of these elements and how they use the principles of art and design – balance, contrast, emphasis, gradation, harmony, proportion, variation and unity. Try to understand what the message of the artwork is. Is there a mood or feeling? How do you react to the lines or shapes or colour and how does the entire artwork appeal to you? It is important to be able to identify these aspects in your own artworks and any others that you view. During the main activity for each of **Chapters 4** to **13**, you will get the opportunity to constructively criticise your own artwork. In **Chapter 16**, you will learn how to analyse an artwork and talk or write about it.

Key term

art criticism: speaks about artworks and how the elements of art and principles of art and design are used to make them

Art history

History is a record of human experiences and achievement. **Art history** is a record of what artists do, how they go about doing it and how their actions impact on their art and the art of others. It includes learning about the artist, his or her influences and style. To do so requires some research about the artist. You may be surprised by what you uncover. Try to find out who the artist is, their experience as an artist or art teacher, and when the artwork was made. Maybe there was a reason for doing the artwork in a particular way. You may wish to read about or talk to the artist. Visiting an art exhibition or talking to someone who knows the artist can provide wonderful information.

You will notice that your artwork will be different from the artworks of your classmates because you understand and interpret the topic differently. You also respond in your own way at each stage of the art-making process, using materials, tools and techniques differently. What you do, how you go about doing it and the artwork you make are evidence of your own history as an art student. Seeing and understanding help to develop this personal history. Throughout all the chapters of this book, you will get the opportunity to begin to develop your own art history. **Chapter 16** will guide how you give others an opportunity to better understand your art.

Art-making

The making of visual art begins from the idea the artist has in mind. This idea must be interpreted and expressed. Even artists may interpret their own ideas in different ways, and must decide which way is best to turn it into art. Decisions must be made about what are suitable techniques, materials and tools. The stages for making art of a particular type must be learned and practised; an 'eye' for seeing where and when to improve begins to develop.

In your own **art-making**, try to think carefully about what you are doing before you do it, while you are doing it, and after you do it. In this way you actually improve your understanding, techniques and skills, and your ability to say what you have done and how you went about doing it. So art-making is about having fun while creating and learning at the same time. Throughout **Chapters 4** to **13**, you will be exposed to the art-making process for each of the ten areas of the visual arts.

Art appreciation

Art appreciation requires an explanation of the meaning of an artwork. In order to explain this properly, an adequate knowledge of the making of the artwork, the artist and the art-making process is required so that you can develop your understanding of the visual arts and of a particular artwork. In this way value is given to humankind's effort in the visual arts. The rationale for the visual arts (refer to the CD-ROM) teaches you an appreciation for this field of human endeavour.

When your teacher looks at your art and makes a comment, he or she shows an appreciation for your artwork, what you know and learned about the process, your art history and your all-round development throughout your learning. When you are assigned grades for your artworks, project, journal and portfolio, you are being judged on all of these factors (refer to the CD-ROM). In your classroom, you will be called on from time to time to exhibit and explain your artwork, and the processes you used and new learning you needed to arrive at that artwork. Throughout all the chapters of this book, you will get the opportunity to show an appreciation for the visual arts and their history, for artworks and artists, and for your own visual art.

Key terms

art history: record of all that contributes to the making of an artwork

art-making: use of your imagination, techniques and skills, tools and materials to produce artwork

art appreciation: level of understanding of an artwork

Chapter summary

In this chapter you have learned to:

- define key terms, categorise artworks as 'art' or 'craft', and know the ten areas of practice in the visual arts

- understand the elements of art and the principles of art and design and how they come together to create good artworks

- explain why and how teaching and learning take place in the visual arts

- apply your knowledge and understandings to speak and write effectively about the visual arts.

Activities

Individual

1. a) List the elements of art.
 What purpose do they serve?
 For each element, write a brief description. Use your own illustrations to support your answers.

1. b) List the principles of art and design.
 For each principle, write a brief description. Find an artwork that demonstrates each principle.

2. Write an essay that discusses the visual arts. Use the introduction from each of the **Chapters 4** to **13** to provide some information about each of the ten areas of practice in the visual arts. How are the visual arts beneficial to humankind and to you, the art student? Perhaps you can think of others ways that the visual arts may be beneficial to us.

3. Create an artwork using the elements of art and the principles of art and design. At another time, do this again and compare your efforts.

Group

4. Examine the artwork in **Figure 1.2**, The Hay Wain by artist John Constable. Discuss the use of each of the elements of art and the principles of art and design in this artwork.

5. In groups of five students, write and make a presentation about the elements of art and principles of art and design to your class. Each student of your group should research one of the elements and speak about it. Use an artwork of the group's choice to explain

 a) how each element was used

 b) how each principle was used.

 At another time, you may wish to repeat these activities using another artworks.

Integrated

6. Mr Victor Visual Arts wishes to open a school because many parents and children enjoy his creative and expressive methods for teaching and learning. However, many students prefer to learn through certain subject areas.

 The students who wish to attend include Ellen English, Sue Lin Spanish, Frank French, Makeba Mathematics, Steven Science, Ravi Reading, Pierre Phys-Ed, Anita Art, Ayo Agriculture and Sara Social-Studies.

 Select any three students and write on behalf of Mr Visual Arts telling the parents of these students how their preferred subjects may benefit from the visual arts.

Art appreciation

7. As a class, select an artwork from this book. Observe it and discuss what you understand and appreciate about the artist, the materials, the subject, the technique and the effect of the artwork.

 To develop fully as a student of the visual arts, you will need to perform this exercise for as many artworks as you can.

 More activities for this chapter are included on the accompanying CD-ROM.

Chapter 2 | World Art

Fig 2.1 Neolithic. Stonehenge: Megalithic (Stone) Art. c. 4500 years ago. Original diameter 110 m, height 5 m. Salisbury, England.

Outcomes

After reading this chapter and practising its activities, you will be able to:

- define, explain and use the term 'world art'

- trace the development of world art chronologically, by movements and periods

- be aware of some artists who have influenced world art

- use key terms and understandings to effectively speak and write about world art

- apply theory and practice from other chapters to complement your understanding of world art

- reflect on evolving concepts and technology in world art today.

Resources

You will need:

- notebook or art journal

- pencils, coloured pencils

- glue, scissors

- computer with internet access

- school and public library access.

Introduction to world art

What is world art?

World art is the sum of all visual art that has been created throughout the world from prehistory to the present. It is a field of study that is so broad that many art historians tend to understand and explain world art through a timeline that traces the major developments, beginning with prehistoric art and ending with the art of today. Other art historians sub-divide world art into major regions, for example 'Africa' or the 'South Americas', then use a timeline to show the development of the art of that region.

Your learning about world art (and Caribbean art) in this book will be divided into blocks of time and arranged in sequence to show particular influences and shifts in art-making. You will begin with man's earliest ancestors, who are thought to have evolved in Africa and, over time, migrated into Asia and Europe.

Key term

world art: all visual a that has been created throughout the world from prehistory to the present

Early man moved from place to place to seek out food. As herds of animals migrated, so too did the humans that depended on the animals for survival. This led to a movement from Europe across the frozen Bering Strait during the last Ice Age about 20,000 years ago. People then spread throughout North America, down to Central America, then to South America and finally into the chain of Caribbean islands. At about that time, people also moved across Asia and down through the Pacific Ocean islands and to Australia. Wherever they settled, our early ancestors left behind some of their art, but also they carried their art-making skills and ideas with them when they moved again. Over thousands of years, and at different cradles of civilisation, their art evolved and became more and more refined.

History of world art

Perhaps the best way to trace human history is to develop a **timeline**. A timeline separates humankind's existence on planet Earth into periods that may be placed into a sequence beginning from the first, the Palaeolithic era, and leading up to present day.

Very often, art and art history help to define human history and development. The examples of invention and innovation historians use to show human progress are often recorded and seen through the visual arts, or are themselves examples of visual art. For instance, early cave paintings tell about our early diets, shelters, clothing, weapons, beliefs, customs, rituals and religions.

Later, when humankind settled into the earliest civilisations, our ability to remain in one fixed place was aided by developments in language, architecture and agriculture. These all required basic artistic inputs. Marks and drawings were used to represent ideas, symbols were used for language sounds and early alphabets, and early design drawings represented tools.

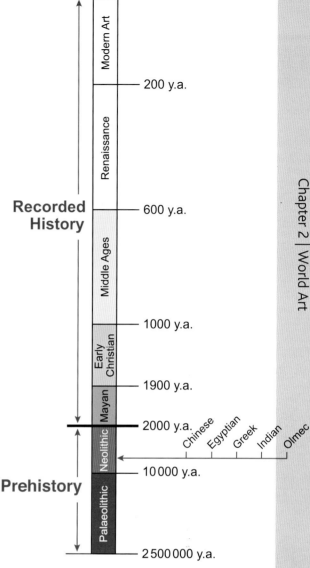

Fig 2.3 Timeline of some major World Art periods.

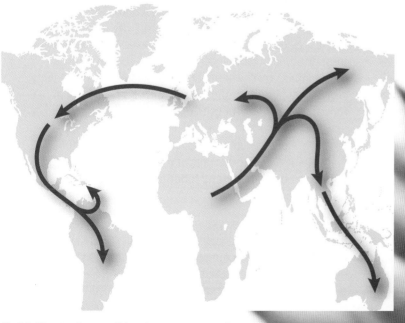

Fig 2.2 Map tracing possible migratory pattern from Africa into Europe, Asia, then Australia and the Americas.

Key term

timeline: an illustration of events occurring in order over time

21

Palaeolithic era

The Palaeolithic era began at the time when humankind first inhabited the Earth, about 2,500,000 years ago, and ended about 12,000 years ago. 'Palaeolithic' means the Old Stone Age, and the era is characterised by the use of stone tools by man to serve **utilitarian** purposes. During this time, humans roamed the planet in small groups, chasing after herds of animals for food. They were not settled in one place as we are today. Their tools were made from bone and wood, but the most advanced were made from stone, hence the name 'Stone Age'. Such tools included stone hammers and chisels for shaping other useful objects, including weapons. One such weapon was a crude spear with a head made from stone.

Key terms

utilitarian: used for a practical purpose, such as a clay pot for storing water or food

aesthetic function: used with the purpose of beautifying, such as a picture hung on a wall

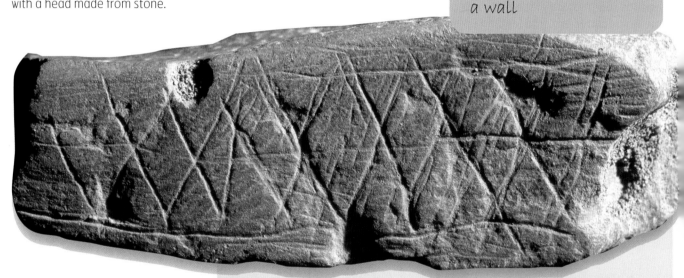

Fig 2.4 Paleolithic: South African. Engraved plaque. c. 70000 years ago. Stone. Found at Blombos Cave.

Did you know?

No written records were made during prehistoric times. What we know is learned from archaeology and its related fields. Artworks from prehistory cannot be identified by their individual artists, so they are credited to their cultures, for example 'Mayan' or 'Taino'. Prehistory ended with the invention of the earliest writing, called 'cuneiform', about 5,000 years ago in Mesopotamian culture. In other cultures, writing was invented later.

The first evidence of our ancestors' artistic ability appears through stone and bone carvings, and through drawings and paintings on cave walls and rock shelters, which became convenient homes for the hunter-gatherers. Very few of these have survived for us to appreciate. Today historians consider these artefacts as art, and suggest that they were probably made to represent gods, to bring good fortune during hunts or for use in rites and ceremony. But they may have also had an **aesthetic function**, to simply decorate people's homes.

Perhaps the earliest pieces of art on record were created approximately 70,000 years ago at the Blombos Cave on the southern coast of Africa. The ochre stone plaques were decorated with intricate patterns of geometric lines. The patterns not only prove humankind's early artistic ability, but suggest our ability, way back then, to use images as symbols, similar to those used in language and mathematics today.

Neolithic era

The Neolithic era followed the Palaeolithic era. It began about 12,000 years ago. Neolithic means 'New Stone Age', and the era saw much advancement in the technologies used by humankind. With time, people became much more aware of their environment and used their wits to begin to adapt themselves.

It was perhaps one of the most fascinating times in human history, boasting some of the most important inventions and discoveries. It set the foundation for the development of civilisation. Neolithic times saw the birth of agriculture and the domestication of animals. The first forms of language came about, the wheel was invented, the firing of clay for pottery became known, leather was produced, tools made from polished stone were invented and monumental art was constructed. Specialist artists and craftsmen emerged.

Some of the most well-known **monumental art** was produced, including the famous Pyramids of Giza in Egypt. In fact pyramids were built in many ancient cultures in Belize, China, Greece, Indonesia, Iraq, Japan, Mexico and Peru. **Research and compare them. What are other examples of monumental art?**

Because there was no contact between the early civilisations, each evolved separately and developed its own distinctive **artistic style**. Most of the visual art of these early civilisations was religious and represented the people's gods, and it was used for rituals, for good fortune and for burial. Some of the early civilisations that emerged were the Chinese, Egyptian, Greek, Indian and Olmec.

Can you name any others? Choose one early civilisation as a topic to research each term. As you learn more about the art of these civilisations, compare their art styles with one another.

Chapter 2 | World Art

Activity

Conduct research to find out about each of these early civilisations and their art. Use the following questions to guide you.

When did they exist? What types of art did they make, such as pottery, paintings or sculpture? What materials did they use to create their art? Where are examples of their art found today? What were the possible purposes of their art? Examine examples of their art to find common elements or characteristics that identify that civilisation.

As you begin your learning in Part 2 of this book, from **Chapters 4** to **13**, you will discover some facts about each of these cultures from their earliest times. What you see and read about their visual art will also help you to piece together their contribution to the development of world art throughout the ages and up to the present day, and help you to identify the unique characteristics of each civilisation's style of art.

Key terms

monumental art: large-scale artworks, most often architecture or structures in stone, usually designed and built to last

artistic style: characteristics that help to identify the art of a civilisation, time period, group of artists or an artist

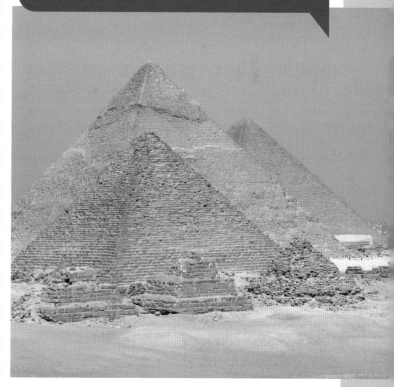

Fig 2.5 Neolithic: Egypt. Pyramids at Giza, c. 4500 years ago. Nile stone and limestone. Khafu Pyramid: 230 x 230 m base, 146 m tall.

Art movements in recorded history

After the Neolithic era, we can, for most cultures, depend on recorded history to help us understand the development of societies and their art, including Early Christian, Middle Ages, South American, Renaissance, Meso-American and Modern art. These are introduced to you below, but there is much more you can find out about each of them.

Early Christian

Early Christian art began to appear about 100 years after the death of Jesus Christ. The earliest known artworks existed as frescoes in the catacombs of Rome in Italy, and are dated at 1,800 years ago. Other artworks included mosaics and sculpture that followed the existing Roman styles, and which were themselves patterned after the Greek. Because the early Christians were persecuted, their art had to be hidden away or disguised. For this reason, they used the fish, peacock or lamb to represent Christ. In the year 313, Christianity became a tolerated religion in the Roman Empire, allowing for free practice of the faith, and the depiction of Christ as a representational form.

Look for artwork of this time that represented Christ in disguise.

Middle Ages/Medieval

The Middle Ages comprise a period of time that spans more than a thousand years, and includes the visual art of Europe, North Africa and the Middle East. The major artworks included paintings, sculpture, **illuminated manuscripts**, mosaics and architecture. Some art historians include Early Christian art as part of the Middle Ages. The period began as the Roman Empire crumbled. One art style that evolved was Islamic art with its distinctive calligraphy, architecture, painting and ceramics. Islamic art was based mainly, but not entirely, on religion. The calligraphy was Arabic and mainly quoted from the Quran, the Islamic holy text. The typical glazed ceramics displayed intricate designs. Islamic architecture was easily identified through its domes.

Another art style was Romanesque, a revival of the best art of the Roman Empire about 1,000 years later. This was demonstrated in its architecture, and many churches were built in this style. Gothic art came at the end of the Middle Ages. Major art forms included fresco, stained glass, painting on **panels**, and sculpture. The artists of the Gothic era used space more freely than in earlier times to create the compositions for their paintings. **Collect examples of Early Christian, Middle Ages, Islamic and Romanesque art, and compare them.**

Key terms

illuminated manuscripts: handwritten texts decorated with pictures, borders and fanciful first letters. They are an early form of graphic design (see **Chapter 7**)

panel: flat wood used for oil painting before the use of canvas

tempera: oil paint mixed with egg and water

South American: Inca

The Inca were a South American civilisation that flourished around 800 years ago. Their art included majestic architectural works, textiles and pottery. Their pottery often featured birds, cats and geometric-pattern motifs. Inca textiles date back more than 2,000 years and were considered more important than gold or silver. The Inca tradition of fine textiles was developed from a previous culture, the Paracas. These textiles display intricately woven patterns that had symbolic and spiritual meaning, not **representational** meaning, and were used to robe their rulers and the dead.

Inca architecture comprised mainly carved stone. The large granite blocks were so well cut then smoothened with sand that when set into place they needed no mortar to hold them together. Inca craftsmanship can best be seen at the city of Machu Picchu, located high in the Andes mountains. The site comprised temples, an observatory, living quarters, store houses and public buildings. The entire complex is protected by its location, unseen from below and with steep drops at the edges of the city. **Find out why this site is considered a wonder and is a protected World Heritage site. What are some other World Heritage sites that possess ancient visual art?**

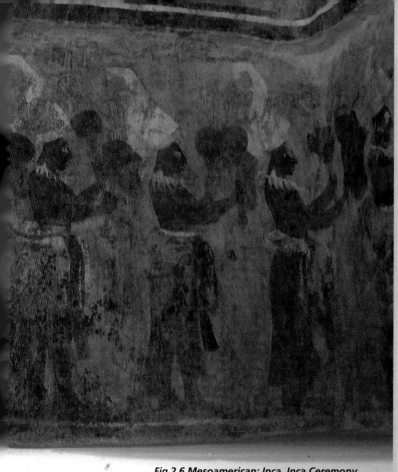

Fig 2.6 Mesoamerican: Inca. Inca Ceremony. c.1500 years ago. Fresco. Bonampak Temple, Mexico.

Mesoamerican: Maya

'Mesoamerica' refers to the area of Central America made up mostly of the neck of land that connects North and South America. The area was settled in by many cultures including the Olmec. Later, the Maya and Aztec cultures occupied Mesoamerica. As with the first civilisations of Asia, the area was chosen for settlement because of its rich soil. Mesoamerican art included pyramids, relief sculptures, temples, courtyards, stone and wooden sculpture and **stelae**, and a wide assortment of pottery. The pottery of native Caribbean peoples before European conquest bears some resemblance to that of Mesoamerican cultures. Mesoamerican step pyramids are unmistakable, with a temple at the top, all carved from stone. Within the temples were placed many artefacts including pottery with designs painted on the wet clay when it was made. Other pieces were buried with their rulers. Some Mayan paintings have survived. These artworks focused on the representation of human and animal figures in a distinctive **anthropomorphic** style. The finest examples of Mayan mural paintings are found at Bonampak in Mexico, and San Bartolo in Guatemala. The paintings, each occupying an entire wall, were painted in one session as fresco. **What details of Mayan culture are revealed? Comment on the artists' use of shape, colour and space.**

Renaissance

The Renaissance was a period in European history that lasted almost 300 years. The word 'renaissance' means 'rebirth'. It began near the end of the Middle Ages, in the 14th century, in Italy and spread across the continent, establishing remarkable growth in intellectual and creative activity.

In the visual arts, there was new interest in understanding nature and man's relationship with it. This idea was called 'Humanism'. Artists sought to represent nature in a realistic manner, and over time the use of perspective was developed and composition in art improved (refer to **Chapter 4**). These techniques have become the basis for all of western art. During the Renaissance, materials also improved and changed: for example, in painting, canvas replaced the wooden panel and the preferred paint was oil rather than **tempera**. Art schools emerged and the age of the recorded history of art began. It was during this time, too, that European explorers first reached the Caribbean, and their influence on the art of the 'New World' began.

The period also saw many shifts in how art was understood and made. Different schools of thought on art evolved, leading to various movements that defined art for about the next 500 years. Among the most notable were Mannerism (16th century), Baroque (17th–18th centuries), Impressionism (19th century), and Expressionism and Cubism (20th century). **Make a list of as many art movements as you can.**

> **Key terms**
>
> **stela (pl. stelae):** a sculpted stone or wooden slab exhibited upright
>
> **anthropomorphic:** giving human features or qualities to gods, plants or animals
>
> **representational art:** artworks that show clear likeness to their subject

Modern art

The Modern art period began around 1850, and lasted for about 100 years. The style of this period is characterised by both **Abstract** and **Experimental** art as artists searched for new ways to express themselves. More than at any other time in the history of world art, artists began to use new materials previously not common in the visual arts, including wire, straw, plastics and an assortment of found and discarded objects. Artists also began to combine the separate disciplines of the visual arts: for example, sculpture was made from decorative stained glass and picture collages were made from textiles. Ideas from more than one earlier movement were combined, so new ideas evolved such as 'Neo-Expressionism', 'Post-Modernism' and even 'Geometric Abstract', seen in **Figure 2.7. What aspects of this work may be considered different from artwork of earlier art movements and periods? Consider the work's location, size, shape and materials. What illusion does the artwork create?**

The art of today continues to follow the earlier experimental trend of the Modern art era, finding even more unique means of creativity with themes such as world hunger, war and nuclear power, HIV/AIDS, deforestation, and global warming and dimming. **Try to find art that addresses these themes and issues.**

Key term

Abstract art: artworks that require interpretation – their meaning is not at once clear as the artworks do not resemble any subject or object and often rely on the expressive use of line, shape, form, space, colour and texture

What is an art movement?

An art movement occurs when a group of artists share common thoughts and understandings about their art, causing their collective work to bear certain similarities. Art movements introduce new concepts and approaches or styles to art-making, and tend to influence many artists of that time.

An art movement may go through various stages called art periods (see opposite), where the approach or style develops as new ideas are added. Very often throughout history, a newer art movement has emerged out of an existing one, both existing at the same time but with one declining while the other increases in its popularity.

World art movements include Cubism, Expressionism and Impressionism, each with an early, mature and late period. These movements, fondly called 'isms', are an important part of art history. As an art student, it is important for you to be able to know the basic ideas of major artists and the movements to which they belonged. Many of them are mentioned throughout this chapter.

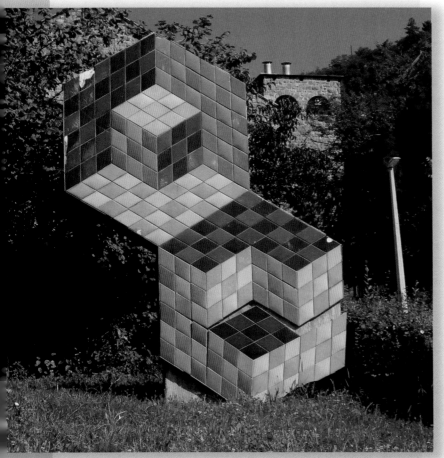

Fig 2.7 Victor Vasarely. Outdoor Artwork. various materials. Church of Palos, Pecs, Hungary.

Helpful hint

One way of understanding art throughout the ages is to look for similarities between different cultures and their art styles. For example, some used special materials or techniques, while others represented animal and plant forms only. Others combined human images with writing, or drew the human form in a unique way. Today this can also be done to trace changes as individual artists pass through various periods in their lives.

What is an art period?

An art period is a phase of time in the development of an artist or an art movement. For artists, the approach to making visual art tends to change over their lifetime. These changes may be due to:

- life experiences, both past and present
- influences of other artists, past and present
- developing new ways of seeing and making meaning from what they see and do in their art
- growing experience as an artist, in the use of media and materials, and techniques
- use of technology, inventiveness and experimentation
- a single life-changing event during the artist's lifetime.

Pablo Picasso's work over his lifetime was produced in periods. His first period can be referred to as 'early work', which demonstrated realism in its approach and was done while he was still a teenage artist. Next was his 'Modernist' period, which emerged from earlier ideas and the influence of seeing a more symbolic and less natural way of painting. The third was his 'Blue Period', followed by the 'Rose', 'African Influenced', 'Cubist' and 'Surreal' periods. **Observe the painting in Figure 2.8. In what period was it probably painted? Perhaps the two faces to the right can provide a clue. What can you say about the use of geometric shapes? Are the influences in the painting perhaps taken from more than one period?**

Today, because more and more artists wish to express their individual understandings and approaches to art, visual art is no longer defined by movements. However, art periods are generally used to trace the development of an individual artist over his or her life's work.

> ## Key term
> **Experimental art:** artworks that use ideas and materials in non-traditional combinations. Such art helps to 'invent' new art and new ways of thinking about art

> ## Did you know?
> These newer approaches to visual art caused many different reactions to artists and artworks. Other artists, art critics, art historians and art viewers began to express different opinions about what they saw, what they considered to be 'good' art and why. Writing about opinions on art became popular as many interpretations of a single artwork could be made. Find and compare two different articles about the same artist, artwork or art exhibition.

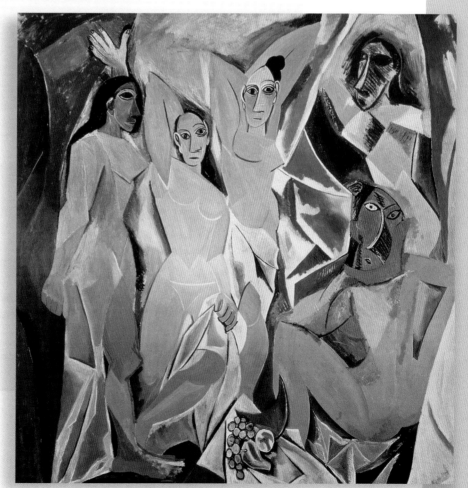

Fig 2.8 Pablo Picasso. Les Desmoiselles d'Avignon. 1907. Oil on canvas. 244 x 234 cm. Museum of Modern Art, New York.

Influential world artists and their art

Leonardo da Vinci (1452–1519)

An Italian architect, painter, sculptor, musician, writer, inventor and engineer, Leonardo da Vinci is considered by most to be one of the finest visual artists ever. He won several major commissions and made detailed sketches and studies for his works, the majority of which were for churches.

Leonardo spent a lot of time on his projects, constantly developing his detailed studies in order to perfect his art. Because of this he became highly respected among other artists, and his influence on younger Renaissance artists, including Raphael and Michelangelo, is obvious.

Leonardo's paintings display a keen sense of light, space and expressive quality through the use of gesture. **Study the painting in Figure 2.9. How effective is the use of space? Observe the gestures of the figures. Are they able to communicate the drama that unfolds in the scene?**

Leonardo's work as an artist constantly reminds us of the links between the ability to think up ideas, express them as drawings and use them to create or invent. That sense of invention helps to develop the technique, style and process of the artist. Leonardo was the first painter to make a scientific study of the effect of light, and combined architecture and the use of perspective in his compositions.

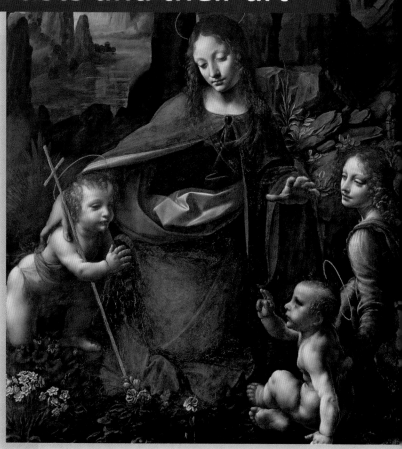

Fig 2.9 Leonardo Di Vinci. The Virgin of the Rocks. 1505-1508. Oil on panel. 190 x 120 cm. National Gallery, London.

Did you know?

The study of art history began during the Renaissance. Giorgio Vasari wrote about artists of that time. As an artist himself, he was able to make sound judgements in his records. His book names artists and their methods and describes the lives of artists, similarly to a modern encyclopedia. The work also includes his autobiography, the writer recording his own life's experiences. Discuss how records about visual art and artists are important to students and other artists.

Albrecht Dürer (1471–1528)

The German-born printmaker, engraver and painter Albrecht Dürer's reputation grew from his flare for detailed artworks. His understanding of perspective and proportion in drawing was developed with the experience he gained from his father, a goldsmith, and later when he worked as a printer and publisher. He travelled throughout Europe, where he learned other printing techniques and collaborated with Raphael and Leonardo.

Dürer began to use the ideas he gained to develop a new German style. He improved his wood-cutting and carving skills, and also mastered the difficult art of using the burin or graver, an engraving tool with a metal point. His engravings and woodcuts made him one of the most respected artists of the German Renaissance. One highly skilful work depicted an Indian rhinoceros. What is amazing is that Dürer never actually saw the animal himself, but based his drawing only on a sketch and a written description. **Do research to find a picture of this artwork. A print by Dürer is shown at the beginning of Chapter 6. Examine it and comment on the detail and skill of the artist.**

Michelangelo Buonarroti (1475–1564)

Perhaps one of the best-known artists of all time, the Italian Michelangelo was a sculptor, architect, painter, writer and engineer. His works demonstrate the versatility of the artistic mind. He welcomed a challenge. He often produced artworks of large size, yet he always managed to achieve excellent proportion, balance and symmetry.

It is difficult to select one area or artwork that stands out, but perhaps Michelangelo's ability as a sculptor deserves special mention. His skill was encouraged from an early age as his father owned a marble quarry where Michelangelo learned from a stonecutter. Later, he learned about the anatomy of the human body by studying corpses in detail.

He practised drawing each day. As a painter, one of his major works was the ceiling of the Sistine Chapel, which comprised over 100 figures, and took four years to complete. The artist often had to lie in cramped spaces to accomplish the task!

Among his other artworks, the sculpture David **(Chapter 9, Figure 9.4)**, cut from a single block of marble, is unmatched in its craftsmanship. As a sculptor, he had to free the form hidden within the block of stone. **What comments can you make about the proportions of the David's body? How realistic is its posture? In your opinion, did Michelangelo manage his task of freeing the form from inside the block of stone?**

Diego Velasquez (1599–1660)

The Spanish painter Diego Velasquez was educated in languages and philosophy, but demonstrated an early inclination for art. He studied perspective and proportion and later became the portrait painter for the royal family of Spain.

He travelled to Italy, where his style was influenced by other artists. Velasquez's works began to show his subjects' postures and facial expressions in fine detail. His painting of Pope Innocent X captured the sitter's expression in a way no similar paintings had done before and its acceptance by the Pope himself encouraged the painter to take this approach in his portraits. When he returned to Spain, the works he produced displayed this brilliance and are considered the best of his career. Among them is the painting shown in **Figure 2.10. In your opinion, who or what is the centre of interest in this picture? Observe, too, how Velasquez has included the panel on the left. Why do you think he has done so?**

Velasquez's works influenced the Impressionist movement as well as the artists Salvador Dali, Pablo Picasso and Francis Bacon.

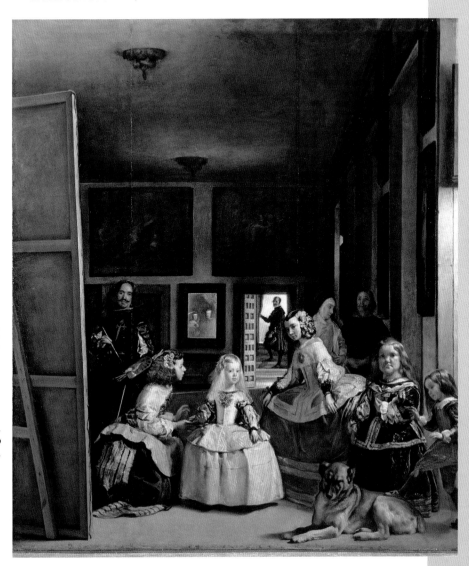

Fig 2.10 Diego Velasquez. Las Meninas. 1656. Oil on canvas. 108 x 276 cm. Museo del Prado, Madrid.

Rembrandt van Rijn (1606–1669)

Rembrandt van Rijn was a Dutch painter and printmaker who had studied art and art history. By the age of 18 he had opened his own studio and also begun to tutor art students. He later moved to the capital city of Amsterdam, where he painted portraits and continued his career as an art tutor.

Rembrandt's major works are biblical scenes, portraits and self-portraits. The paintings and etchings reveal wonderful compositional skills and an in-depth knowledge of the Bible. This knowledge made his pictures tell a story, the unfolding drama supported by the use of strong contrast and movement in the paintings. In his maturity, these dramatic effects were complemented by the actual application of the paint, the more uneven finish adding a textured quality. **Examine the self-portrait in Figure 2.11. What can you tell about the painting or the artist? How does Rembrandt use colour and value to create the feeling you get from the painting?**

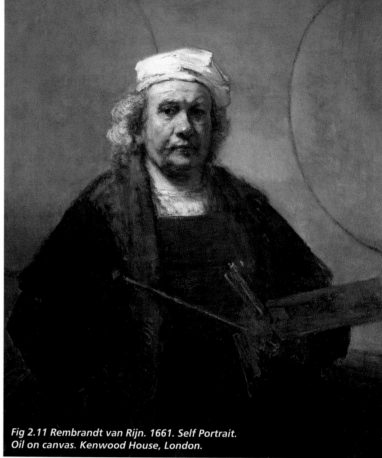

Fig 2.11 Rembrandt van Rijn. 1661. Self Portrait. Oil on canvas. Kenwood House, London.

Francisco de Goya (1746–1828)

A Spanish painter, printmaker and draughtsman, whose father had experience in the art of gilding, Goya made tapestries for the Spanish Church and royalty. These **tapestries**, which were up to six metres wide, had a cartoon-like quality and were quite unlike any tapestries seen before. Goya distinguished himself as a teacher of painting, and became the painter to the Spanish royal family. His works of this period reveal a natural style, influenced by the Velasquez pieces in the royal collection. One work, the Maja desnuda, is considered to be the first painting in the western world that intentionally showed nudity.

Later, when Goya became ill, his art explored themes of war, punishment and abuse. He created prints based on war showing suffering and death, perhaps not unlike what he was experiencing himself owing to his mental illness. During this period of his life, Goya painted a series of works called the 'Black Paintings' on the walls of his home, using oil paint. **One of the works is illustrated in Figure 2.12. Observe the artist's use of colour, shape and form and the expressions on the faces. What mood do they convey? What is the primary purpose of light in this painting? Who is the central figure? How do all other figures contrast with the figure of the girl to the far right?**

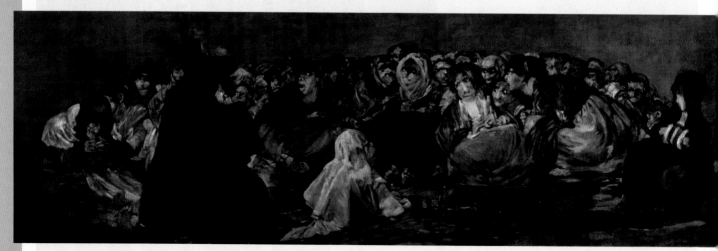

Fig 2.12 Francisco Goya. Witches' Sabbath. c.1820-23. Oil mural, transferred to canvas. 140 x 438 cm. Museo del Prado, Madrid.

Key terms

tapestries: woven textile artworks designed to hang

mood: feeling created from viewing an artwork

J.M.W. Turner (1775–1851)

This British artist began to create art at the age of 12 and started formal training at 14. Renowned for his watercolours and oil paintings, Turner displays a remarkable understanding of and ability to represent light. This is arguably easier to achieve with watercolour, but Turner was able to recreate a similar transparency and freshness with oil paints. He did this by incorporating watercolour techniques into his oil painting.

Turner became one of the foremost painters of landscapes, able to represent highly dramatic scenes. Among the pictures he painted were many showing the power and fury of nature. He was also very much influenced by ancient history, literature and his travels throughout Europe. Later in his career, he began to paint in a more abstract manner, using themes of beauty, power and weakness. For many years, Turner was a professor of art, and at his death left his work to the British people and also left money to assist other artists. Such was his influence that an annual award, the Turner Prize, is given for achievement in the visual arts.

Observe Figure 2.13. What does the play of light and colour do to represent the atmospheric conditions at the pier? How does contrast in the colour used in various parts of the painting help to create the feeling you get from the painting?

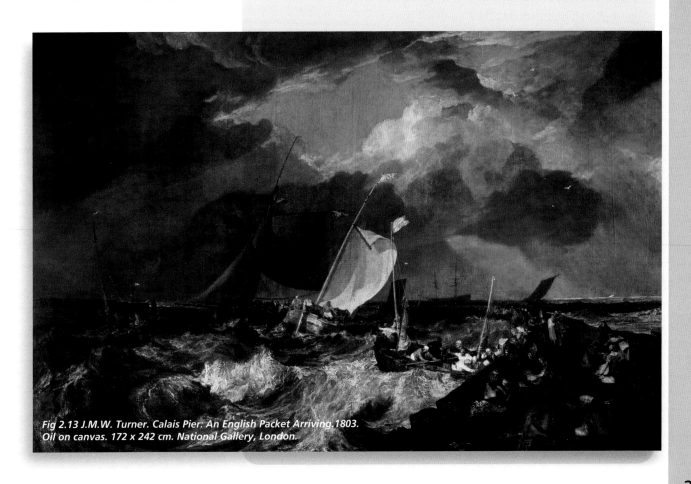

Fig 2.13 J.M.W. Turner. Calais Pier: An English Packet Arriving. 1803. Oil on canvas. 172 x 242 cm. National Gallery, London.

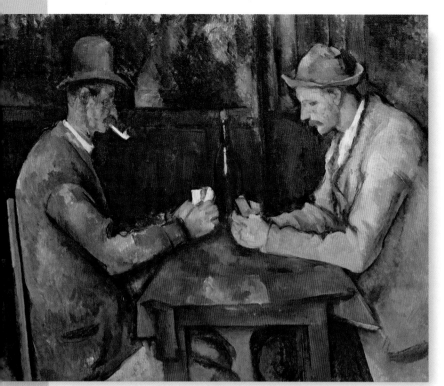

Fig 2.14 Paul Cézanne. The Cardplayers. 1892-1895. Oil on canvas. Auvers-sur-Oise, Paris, France.

Paul Cézanne (1839–1906)

The French painter Paul Cézanne loved art and studied painting from a young age. In Paris, then the centre of European art, he developed a style that is characterised by its use of colour and perspective. He represented what he saw in simplified planes of form and colour. In this way his paintings captured the relationships of the objects in compositions. This simplification of form and perspective in art was to influence Cubism, the next major movement of world artistic endeavour. Indeed, Cézanne is often regarded as the bridge between 19th-century Impressionism and 20th-century Cubism. His paintings were completed only after repeated visits to the site of the work. He achieved the depth and balance in his painting by focusing on subtle variations in value and slight distortions of forms.

Cézanne visited the location of his landscapes on many occasions before the paintings were completed. He observed subtle variations in value and slight distortions of form to achieved detail and balance in his work. **Examine Figure 5.2 in Chapter 5. Comment on the artist's use of line, shape, form and texture.**

Fig 2.15 Claude Monet. Soleil Levant (Impression Sunrise). 1872. Oil on canvas. 48 x 63 cm. Musee Marmottan, Paris.

Claude Monet (1840–1926)

Claude Monet is regarded as the best of the French Impressionist painters. At the age of 17 he met Eugéne Boudin, who taught him to use oil paints and introduced him to **plein-air** techniques for outdoor painting. While in England and Holland, Monet also studied the works of John Constable and J.M.W. Turner.

Monet's landscape and seascape paintings provide a record of the French landscape. Later, he settled in the small town of Giverny, where he planted a huge garden of which he painted many scenes. He made a series of works that showed the same landscape in different weather conditions and at different times of the day. His style celebrated the artist's unique way of seeing, capturing fleeting effects of light with vibrant colour rather than mixing the colours themselves. Monet's plein-air paintings became popular, and simple everyday scenes began to form the subject matter of the entire Impressionist movement of the 19th century.

Observe Figure 2.15. What can you say about the artist's use of colour? Consider the use of blue, and the relationship between the blue and orange used. How does he use the elements of art to suggest that the picture was painted at sunrise?

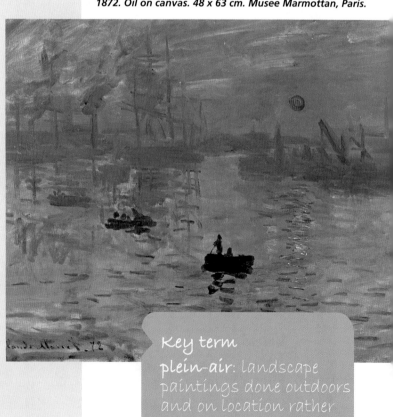

Key term
plein-air: landscape paintings done outdoors and on location rather than in a studio

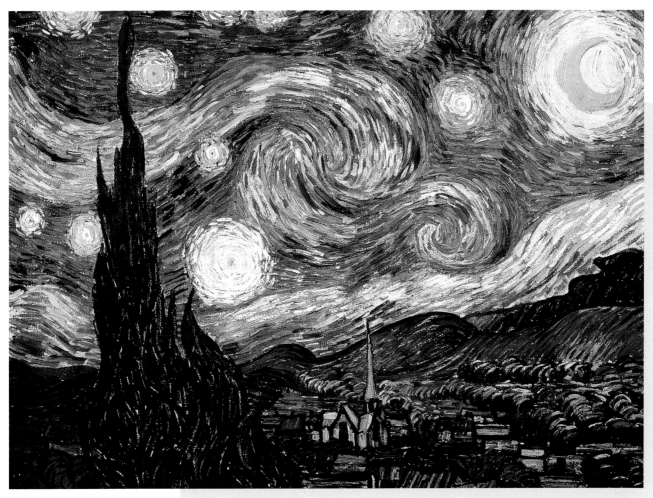

Fig 2.16 Vincent van Gogh. The Starry Night. 1889. Oil on canvas. 73 x 92 cm. Museum of Modern Art.

Vincent van Gogh (1855–1890)

The family of Dutch painter and draughtsman Vincent van Gogh had been involved in art for generations. Van Gogh became an art dealer and later travelled to work in England and France, where his exposure to art grew. However, he did not like art being marketed as a product, and this caused him to lose his job. He then became a preacher, and was so moved by the poverty he saw among everyday people that he gave away his worldly possessions.

In 1880, van Gogh decided to become an artist. He studied human anatomy and perspective. His works were drawings in charcoal and black chalk, and paintings in oil paint. His drawing emphasised the simplicity of farmers and ordinary people. In Paris, van Gogh became influenced by artists Degas, Gaugin, Seurat and Toulouse-Lautrec, and began to paint with a more symbolic use of colour applied in swirling, emotionally charged brushstrokes.

When he later became ill, he chose to enter an asylum. Looking through the window of his room, he painted images such as **Figure 2.16. Examine the picture and discuss it with your teacher. What area is the focus of the painting? How did the artist achieve this? Comment on his use of line, shape, space, colour, value and texture. What effect do the swirling brushstrokes have on your eyes?**

Van Gogh's influence on the art of the 20th century has been tremendous, contributing to the Expressionist and early Abstract movements.

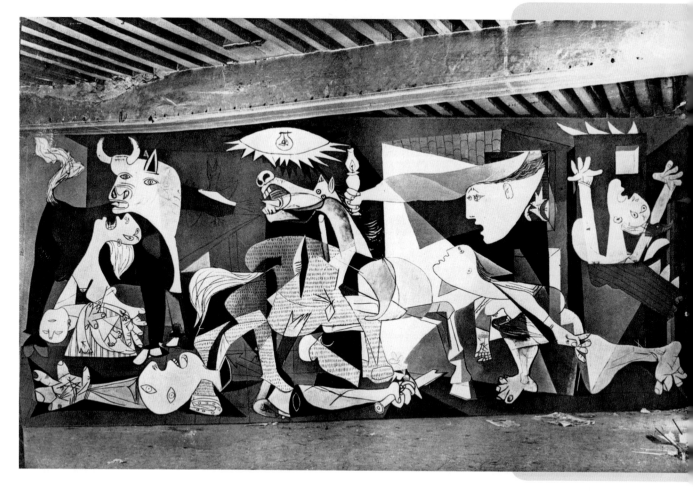

Aubrey Beardsley (1872–1898)

As a child, the English artist, illustrator and author Aubrey Beardsley performed in musical concerts. Before he was 20, he worked with an architect and took up art as his profession. He had a short but substantial career. He was an art editor and created illustrations for books and magazines. His illustrations and drawings are characterised by the wonderful use of line and the contrast between the ink used and the white negative space intentionally left to create a balance in the use of space. Another typical characteristic of Beardsley's artworks is the very intricate detail that appears in some areas and which contrasts with other areas that show no detail whatsoever. The style of his work was influenced by the graceful and fluent movement of fine line typical of Japanese art, which in turn would influence the **Art Nouveau** movement of that time and just after.

Much of Beardsley's work was erotic in nature and inspired by historic and mythical themes. He also created political cartoons that were forceful and witty enough to create quite an impact and cause controversy among those who viewed them. **Examine Figure 2.18. How does the artist use the elements of line and shape to present the subjects of this piece? Would you say that these are effectively used? How does he achieve balance in the drawing?**

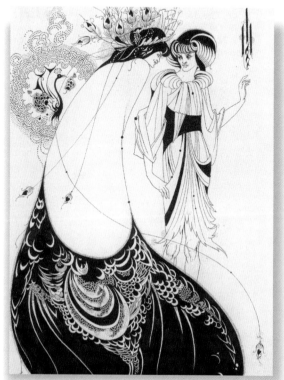

Fig 2.18 Aubrey Beardsley. The Peacock Skirt. 1893. Illustration. Ink and graphic on paper.

Pablo Picasso (1881–1973)

Picasso's father was an art professor, museum curator and artist who had much influence on his son from the beginning. Born in Spain, Picasso first studied there and then moved to Paris, where he studied, painted and founded an art magazine. He travelled widely and shared an interest in the performing arts; his experiences had great influence on his art. His career went through many periods, each with its own features. During these periods, his works are characterised by certain elements or motifs, for instance, in the 'Blue Period' the majority of his paintings were done in values of blue or blue-green, while during his 'Neoclassical Period' a regular motif of his work was that of the Minotaur, a mythical creature half man and half bull.

Among his famous paintings is Guernica, a statement on the sad realities of war, and a response to his experiences of World Wars I and II and the Spanish Civil War. **What characteristics of the images of Figure 2.17 convey the ideas of war? How does the artist use the elements of art to emphasise this? Try to find out how the painting got its name.**

Fig 2.17 Pablo Picasso. Guernica. 1937. Oil on canvas. 349 x 776 cm. Museo Reina Sofia, Spain.

Did you know?

Very often, the best works of an artist are based on the experiences of that artist during his or her lifetime, and the feelings and moods that these experiences evoke. Just as other people may use their body language and speech to express their experiences, artists use art to do the same. Many successful pieces of artwork express very strong sentiments and powerful messages.

Key term

Art Nouveau: late 19th-century art movement featuring flowing lines derived from plant life and female forms in art and architecture

Georges Braque (1882–1963)

The French painter and sculptor Georges Braque was educated in art in Paris. His early paintings represented the forms of objects as loose structures, using intense colour. He was greatly influenced by the painter Paul Cézanne, whose artworks he saw as early as 1907. Braque's paintings began to explore multiple perspectives using geometric forms: for instance, the front and sides or back of a form would be painted as if they stood side by side on the same plane. Together with Pablo Picasso, he developed a new style that revolutionised painting. Their work seemed to be composed of many smaller cubes that were able to represent many sides of the same object at once. This type of expression, known as Cubism, is an abstract method to show the form of the object on a flat surface. **Observe Figure 2.19 and its title. What objects are visible? Comment on the way they appear. Are there any 'cubes' of space that are similar to each other? What elements did the artist use to achieve this effect?**

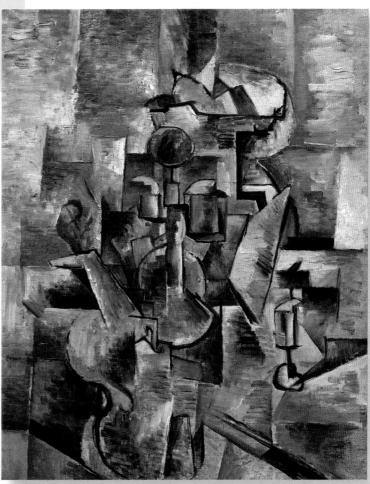

Fig 2.19 Georges Braque. Violin and Candlestick. 1910. Oil on canvas. 61 x 50cm. San Francisco Museum of Modern Art.

Frida Khalo (1907–1954)

Mexican painter Frida Khalo's artworks were influenced by the native culture of her homeland and those of her parents. Her father was German while her mother was of mixed Amerindian and Spanish ancestry. Khalo used images as symbols to represent certain meanings: for example, each of the many animals used has a particular meaning in indigenous Mexican cultures such as the Olmec and Mayan.

After a near-fatal accident Khalo began a career as an artist, concentrating on portraits of herself. She recognised that she was her best subject. Her paintings generally featured her troubled past, usually coupled with various Mexican-influenced elements. There are many important symbols in her paintings that tell of her life and experiences. **Conduct research to find out what symbols and motifs she used in her paintings.**

Khalo's works became more recognised in the 1980s, when there was renewed cultural awareness in Mexico. Many books, including her biography, and movies have been based on her life and work.

Wilfredo Lam (1902–1982)

Cuban painter, illustrator, sculptor and ceramist Wilfredo Lam's unique style won him acclaim the world over. He is perhaps the most recognised artist to emerge from the Caribbean region. He studied art in Cuba, Spain and then France, where he also lived for some time. He developed a style using simplified forms. In Europe, he met Picasso and the two artists developed a mutual regard.

Lam's works matured as he explored the traditions, culture and beliefs of the Cuban and Caribbean peoples. His mixed ancestry, particularly his African roots and the Santeria religion, were his strongest influences. This religion, native to Nigeria, was disguised during slavery, with Catholic saints symbolically used to represent Santeria deities. This symbolism is characteristic of Lam's work, which was further influenced by his visits to Haiti and Martinique.

Lam saw the difficulties the Cuban people faced, and used his style to highlight them. The figures in his paintings resemble part human, part animal and part plant forms. Like the works of the Surrealists, his images provoke surprise and confusion that the viewer is forced to interpret. **Turn to Chapter 5, Figure 5.1. How many human-like figures can you see? What parts resemble human, animal and plant forms? Do any parts of the painting remind you of Caribbean life or culture?**

Other great artists

Here are some other great artists whose works have contributed significantly to the developments and shifts in trends in world art.

Hieronymus Bosch

Michelangelo Caravaggio

El Greco (Domenikos Theotokopoulos)

Peter Paul Rubens

Edgar Degas

John Constable

Georges-Pierre Seurat

Jan van Eyck

Paul Gauguin

Henri de Toulouse-Lautrec

Wasilly Kandinsky

Henri Matisse

Edvard Munch

Salvador Dali

Paul Jackson Pollock

Emmanuel Radinsky (Man Ray)

Diego Rivera

Pierre-Auguste Renoir

Andy Warhol

Select an artist from the list and find out about that artist. Record personal data such as life history, what artistic movement the artist was a part of and influences on the artist's work. List some of the artworks, and present your own analysis of the artist and his or her works. Refer to **Chapter 16** to help your research and writing about these artists.

Discuss with your teacher the presentation and submission of your findings about the selected artist along with your end-of-term portfolio.

Select and research one of these artists each term. In this way you can compile your very own catalogue of world artists.

Evolving concepts and understandings in world art

Major developments in world art have taken place slowly over time. The developments are perhaps due mainly to man's desire to find new and more creative ways of self-expression. Each of the artists discussed in this chapter found new ways of making art, and shared these ideas with fellow artists. But they could not have achieved these developments without understanding the basic elements of art and the principles of art and design, or without experiencing what was happening in the world of art at the time or knowing about what had occurred before.

Artists try to say what they see and feel, to create, to achieve, to explore and to be understood. Through this pursuit, artists have continued to redefine what art is, how we view art and what art means. As a student of the visual arts, you must take every opportunity to try to understand what an artist has done. This includes considering your own art, the art of your peers and that of artists. Here are some factors that both affect the visual arts and are affected by the visual arts.

Philosophies

Different individuals understand art differently. There are three main points of view that the art student and the artist must be aware of. They concern how you and others see and try to understand visual art.

- Some of us believe an artwork must look lifelike. The concern here is that good art depends on how well you observe and represent what you see, remaining true to the subject.

- Others believe an artwork must effectively use the language of the visual arts. The elements of art and the principles of art and design should be used thoughtfully to construct the artwork and create visual appeal.

- Another group may say that an artwork must send a message and have a 'meaning'. This meaning includes the viewer's reaction to the work based on the feeling or mood it causes.

Which of these is most important to you? Discuss why. Compare your ideas with those of your peers.

Many art critics now combine these basic philosophies of art and design to provide more detailed understandings and multiple perspectives about the artworks of today. **Do you agree with this approach?**

Observe the artwork in Figure 2.20 and discuss which of these philosophies may have been considered. As you continue your learning throughout this book, it is important to repeat this activity as often as possible for as many artworks as possible.

Select another artwork from this book and discuss which of these philosophies have been considered in its creation.

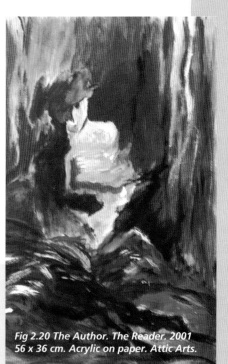

Fig 2.20 The Author. The Reader. 2001 56 x 36 cm. Acrylic on paper. Attic Arts.

History

With the unearthing of new sites and objects of art, we are slowly adding to our understandings of our early ancestors and their art-making. The recently discovered plaques at the Blombos Caves in southern Africa (**Figure 2.4**) are one example. The geometric markings prove that humankind was able to express ideas using abstract representations thousands of years before it was previously believed that they could. Learning about human visual arts development is learning about human history. **Discuss how the visual arts have contributed to human history. Also consider how human history has influenced the visual arts.**

Society and culture

When the understandings of individuals are shared and become accepted by others and by larger groups, artistic ideas may develop to their fullest potential and find support in society. This may cause such ideas to become a part of culture. For example, the visual art of the Caribbean is collectively expressed through our carnivals, which have become known all over the world. This helps us to define our own culture and to contribute to world culture. Over time, many annual Caribbean-like carnivals have developed in other countries, giving them an appreciation of our expression and culture. **Find out about the carnivals of other Caribbean territories, and of London, Toronto and New Orleans. What are their similarities to ours?**

Other fields of human study

Today, because of the sheer amount of information that exists, teachers and students must find creative ways of balancing what we want to know, use and develop in the visual arts. One way to do this is to look at information that other subjects and fields of study share with the visual arts. You will realise that in your classes you can use visual art ideas to help your learning in other subjects. Similarly, other subjects can help you understand the visual arts. **Discuss how the subjects you study at school are influenced by the visual arts and how the visual arts are influenced by them. Chapter 15 discusses this further.**

Influence of other artists

All the artists mentioned in this chapter have both been influenced by other artists and tended to influence later artists. Current artists look towards the great masters of the past, as well as towards their contemporary peers, to express themselves. Because of the wealth of easily accessible information on artists today, the influences on present-day artists come from numerous sources. Today's artists observe, study and learn from all that is available, and combine this with their individual experiences and understandings to create unique styles, techniques and approaches. **Is there an artist who has influenced you? Say why and how, and use your artwork to illustrate this. If you have not as yet had this experience, can you name one artist whose work is of strong interest to you, and say why?**

Style of representation

As artists mature from experiences over time, their way of understanding, seeing and representing what they see changes. While an artist may develop from an early to a mature style, their artworks continue to undergo changes throughout their careers. The artist's way of seeing and representing may vary from naturalistic or representational to abstract or non-representational. A naturalistic artwork presents an object, scene or idea in a more realistic manner. An abstract artwork presents what is not as easily seen or interpreted, and is figurative or symbolic in intent. The topic 'Ways of representing', discussed in **Chapter 5** on **page 84**, explains this further. Along the way, many other ideas, approaches, techniques and experiments may influence the degree and type of representation. **Find examples of varying styles in this book. Which styles do you find more appealing, and why? Also consider why you do not find certain artworks as appealing. Does this make them less effective or less appealing to others too?**

Evolving technologies and practices in world art

The visual arts continue to develop because of new and innovative technologies and their applications. Some of those that influence art and artists are: materials, techniques, use of space and fusion of technology and ideas.

Materials

The materials and media for the visual arts today include almost anything you can think of. Many of them have been used successfully because of their wide availability and through experimentation.

Pigments for expression include various types of the more traditional pencils, charcoal, paints, varnishes, crayons, pastels, chalks and markers. Others, less conventionally, are saps, blood, pastes and resins. Their applicators include hands, brushes, sticks, trowels and other, tools, syringes, paint guns, buckets, straws and blowers, and aerosol cans.

The surfaces on which visual art is made include papers, boards, canvas, plastics and other synthetic materials, rock, wood, bone, shells, our bodies, walls, floors, ceilings and other pieces of art.

Materials used for three-dimensional artworks include rocks, cement, wood, bone, fruits, vegetable and plants, papier-mâché, moulds, casts, papers, boards, canvas, plastics and other synthetic materials, walls, floors, ceilings, and other artworks.

The equipment and tools for visual artworks range from the small to large, having general or specific applications. Each area of the visual arts discussed in **Chapters 4 to 13** introduces you to many of these.

Make a list of the ones mentioned here, and add those discussed in other chapters as you go along.

> **Key term**
> **applicators:** any instruments or tools used for placing and spreading pigment on a surface

Techniques

Not only are the materials artists use evolving, but also how they are used. The tradition of using one pigment on one surface with one applicator has also been reinvented. Artists experiment with a variety of materials, pigments, surfaces and **applicators** to create mixed media artworks. In this way, they may achieve a greater variety or emphasis in the use of the elements of art and the principles of art and design.

How can an artist add real texture (texture that can be felt) to a flat surface? How can an artist emphasise line while using watercolour?

Use of space

The use of space for creating and presenting art has also broadened. Two-dimensional spaces or surfaces are quite common. So too are solid raw materials for three-dimensional artworks. But more and more, artists are becoming inventive, using the space in which their artworks are presented as an integral part of their artistic vision and presentation. Exhibition rooms have been used to install and suspend artworks or parts of an artwork. In these installations, the space for the exhibit is harmonised with the artwork itself. In other cases, outdoor artworks have been erected as permanent monuments.

Fusion of ideas

One aspect of creativity is finding new ways of doing things. This comes from innovation and invention. Many artists seek to do so by combining aspects of one area of the visual arts with another: for instance, pottery techniques may be used to create sculpture; fibre arts methods may be applied to working with leather; or drawing and painting media may be combined. This has given us visual art in mixed media.

Can you think of any artworks or artists who demonstrate the use of mixed media? What may be some of the skills that the artist must master in order to be able to combine these areas of the visual arts?

Other artists have sought to combine areas of the visual arts with other art forms, such as the performing arts, or subjects outside the arts. **Chapter 15** introduces such ideas. Today these are very important ways of experiencing art in classrooms and in your everyday life.

Digital technology

As technologies continue to develop, artists find new and innovative ways of using them. One major use of technology today is to store, retrieve and send information. Photography has made it easy to capture an image or event, using still or motion photography. Digital photography assists the artist and art student to record and store works of art. These images are evidence of your practice and effort throughout the stages of your art-making processes. They become very important to present along with your finished artworks, and will give your teacher a good idea of what you did and how you went about doing it. This is especially so when you work away from school, perhaps at home or on visits to an artist or an art exhibition. In the future, these photographs will provide a record of what you achieved as an art student. They may very well become your inspiration for a bright future as a young artist or designer.

The computer has helped to revolutionise some of what an artist can do. Computer-aided design software is now a basic tool of graphic designers and architects. It is important to note, however, that using these tools does not make you a designer or architect. Rather, it is your learning, practice, development of skills and understanding over time that will get you there.

The internet provides an avenue to experience almost anything and everything. A world of information for your art-making, art history, art appreciation and art criticism is at your fingertips. This provides support for the many other sources of information that are available to you, including this book. **Chapter 16** discusses such sources of information. The internet has another valuable function. It allows you to transfer information, including images and sounds, via email and social networks. Images of your art can now go anywhere. **Discuss these uses further, and explore other ways in which the technology of today has been or may be useful to an artist or art student.**

Chapter summary

In this chapter you have learned to:

- trace the development of visual art throughout the world
- identify some influential world artists and their art
- explore some concepts related to world art, and which relate world art to your own art
- use your understanding to speak and write about world art.

Activities

Individual

1. Make a list of five world artists.

 Research to compile
 a) some facts about each of the artists and their art

 b) a picture of each artist's work .

 Find two artists who are not yet as well known but who demonstrate emerging talent.

2. Spectacular pyramids are not as far away as you may think. Conduct some research on the first civilisations of Mexico, Belize and other parts of Central America. Gather as much information as you can about the pyramids, how they were built and their purpose. Your history class may help you in this. Present your project and discuss some of the fascinating facts that you discovered.

3. Explore the variety of ways that current technology can aid a visual arts student in learning about the visual arts; developing artistic skill; and advertising and marketing their artworks. Some current technologies include:
 - the computer
 - the internet
 - digital still photography
 - digital motion photography
 - digital voice recording
 - computer-aided design software
 - presentation software.

Group

4. Why not take a walk back in time! If possible, plan a field trip to the ancient city of Teotihuacan, home of the Pyramids of the Sun and Moon, in Mexico, or to the Caracol Pyramids in Belize. This has to be properly planned long in advance. Combine the ideas you get from your research, guided tour, photographs and experiences to present your findings about 'Ancient Cultures of Central America'. When you return, make a presentation of all you have found out that might not have been possible from research and reading alone. Such experiences teach you about the visual arts in a completely different way. At another time, field trips may be planned for you to go elsewhere to experience artworks, but begin with opportunities in your own community or home territory.

5. Discuss with your teacher and merge your individual lists to form a master list of as many artists as your class can think of. If you work on this over your years of secondary schooling, you will have sufficient information to perhaps publish a register of artists. If your school continues with this project, the school itself may become an authority on visual artists the world over. The information in your school's library will be unlike that in any other. And you will become a contributor to this, opening up a wonderful opportunity to further explore and develop your contribution to the visual arts. As the years go by, other students can add to the information you documented. In this way the information grows, and more and more resources for information on the visual arts are created.

Integrated

6. Begin a project to transfer your artworks into digital format. As you work to develop your skill through sketches, studies and final artworks, be sure to photograph them at their various stages. Save and store your work as separate files, and place the files into folders by the area of the visual arts you are working with, or by school year and term. Use thumbnails of your photographs to create an introduction to your catalogue of artworks.

This becomes your first step toward creating an electronic art portfolio. **Chapter 17** gives you further ideas about building a portfolio.

Art appreciation

7. Select any one of the following themes: world hunger, war, nuclear power, HIV/AIDS, tropical rainforest depletion, world climatic change. Alternatively, you may suggest and discuss another theme with your teacher.

Produce an artwork that creates an awareness of your theme and promotes the visual arts as a means for highlighting such a global concern.

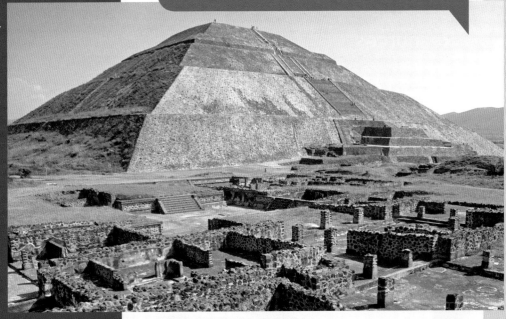

Fig 2.21 Mayan. Pyramid of the Sun. c. 2000 years ago. Stone. 225 x 225 m base, 75 m high. Teotihuacán, Mexico.

 More activities for this chapter are included on the accompanying CD-ROM.

Chapter 3 Caribbean Art

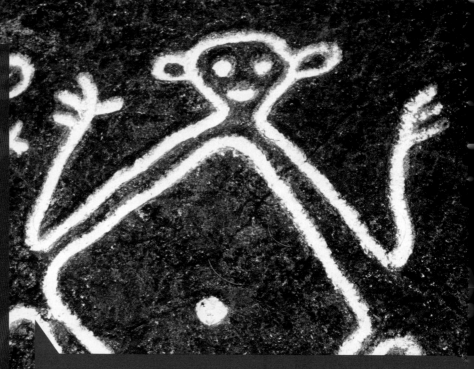

Fig 3.1 Pre-Columbian: Taino. c. 800 years ago.
Petroglyph on basalt rock. St Kitts.

Outcomes

After reading this chapter and practising its activities, you will be able to:

- define, explain and use the term 'Caribbean art'

- trace the development of Caribbean art

- name some artists who have influenced Caribbean art

- use key terms and understandings to effectively speak and write about Caribbean art

- apply theory and practice from other chapters to complement your understanding of Caribbean art

- recognise ideas and trends that influence Caribbean art in today's world.

Resources

You will need:

- notebook or art journal

- pencils, coloured pencils

- glue, scissors

- computer with internet access

- school and public library access.

Migration of peoples to the Caribbean

In **Chapter 2** you read about how early humans migrated, chasing after herds of animals for food. They moved with the seasons of the year. But we also know that over time the Earth's climate changed, and this caused more permanent and broader migration within and across continents.

Evidence shows that man evolved in Africa, and then entered Asia and Europe, before crossing into the Americas. It is only after settling in North, Central and South America that tribes ventured out to sea, and into the islands of the Caribbean. The first settlers in the Caribbean islands are widely thought to have come from the Amazon basin, through the Orinoco valley northwards to Trinidad, then up the Lesser Antilles and finally into the Greater Antilles. Another theory tells that the Greater Antilles – the islands of Cuba, Hispaniola, Jamaica and Puerto Rico – may have been first inhabited by tribes migrating eastwards from Mexico. A third theory points to a movement southwards from Florida into the Bahamas. This hints that the art and culture of our pre-Columbian Caribbean ancestors were brought from Central, North or South America, or from all three regions. It also suggests that the Caribbean is perhaps one of the last regions of the world to have been populated by humankind.

Major time periods in Caribbean art

Trying to tell someone about the boundaries of the Caribbean is not as easy as it seems. Some people may say it is the islands of the Caribbean Sea, while some may include parts of the continent, such as Belize and the Guianas. Others may refer to the Dutch-, English-, French- or Spanish-speaking Caribbean. Just as there are no commonly agreed boundaries for the Caribbean, there is no commonly agreed understanding of all that makes up Caribbean art.

Caribbean art varies from island to island, and place to place, because the islands are separate, with different languages and dialects, peoples, cultures, religions and history. Each island's state of development also plays a vital part. Because these factors differ, the places differ, and so does their art.

> **Key term**
>
> **Caribbean art:** all visual arts that are created by any artist who has a Caribbean heritage

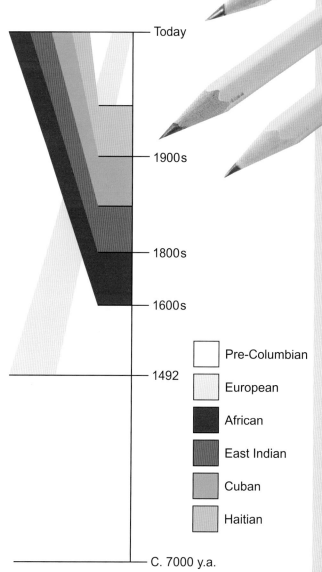

Fig 3.3 Timeline of Caribbean Art.

The art of a people is a true and continuous reflection of them. In the Caribbean, our art reflects our society, its history, beliefs and aspirations. It is born out of what we experience, know and feel. These characteristics develop and stay with us throughout our lifetime, and are enriched by the experiences of our forefathers, adding to our awareness of ourselves and our culture.

The migration of Caribbean nationals to other parts of the world has caused an increased awareness of the art of the region. Today, Caribbean art has evolved to include the visual artworks made by any artist with a Caribbean heritage, no matter where that person now lives. Nationals from countries outside the region have also made the Caribbean their home, and their ideas have added to the rich diversity of our art-making.

Can you name any artist who now lives away from, or has migrated to, your home territory?

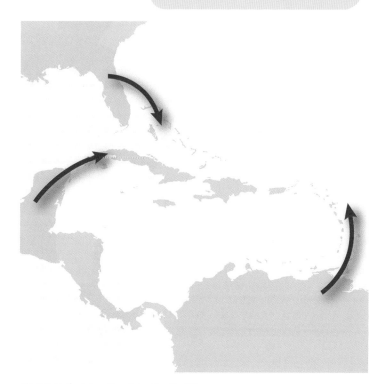

Fig 3.2 Early migration into the Caribbean.

Pre-Columbian art

The visual art of the Caribbean can be traced back to about 7,000 years ago. By that time, humans were already masters of exploration and agriculture. They were food-gatherers and hunters but they also planted their own crops. The first pieces of **Pre-Columbian art** were recorded on the walls of caves throughout the Caribbean, and in particular the Greater Antilles, by the Taino peoples. These artworks include drawings and carvings of numerous birds, fishes and reptiles.

The Tainos considered caves sacred, and they produced art in **charcoal** and paint made from vegetable pigment and animal fat in honour of their gods. There are hundreds of cave art sites throughout the Caribbean, mainly in Cuba, Puerto Rico, Hispaniola and Jamaica, but perhaps the most extensive site is the Pomier Caves located in the Dominican Republic. It is a system of over 50 connecting caves that contain more than 4,000 paintings and 5,000 drawings. For Caribbean people, the caves are as important as the pyramids of Yucatan are to Mexicans. Another cave system at the Isla de la Juventud, Cuba, houses the fascinating Solar Calendar. **Research this artwork and discuss the various shapes, images and concentric circles, and what they represent.**

Indigenous American influence

What is left of indigenous American art is preserved mainly in museums across the Caribbean. It includes samples of pottery found at various sites where the indigenous Arawak, Carib and Taino tribes settled. Some territories, for example Dominica, are fortunate to still have a population of indigenous Kalinago Carib people, from whom much valuable information can be gained about their history and culture, which has been passed down from generation to generation.

Unfortunately, many other wonderful pieces of our islands' legacy has been shipped away only for others to appreciate. Among these items is the beautifully carved 'Birdman', a wooden zemi sculpture found in 1792 in Jamaica, which has been in England ever since. **Did you know about this sculpture? Would you like to see it? What can Caribbean countries do to preserve and recover such priceless works of art?**

European influence

The presence of Europeans in the Caribbean began with the arrival of Christopher Columbus in 1492. The majority of the island chain was claimed over a total of four of his journeys. Within the next few centuries, the sovereign states of Europe – Spain, France, Holland, Portugal and Britain – fought endlessly for these territories as part of their New World wealth. As this conflict unfolded, the indigenous peoples of the Caribbean region disappeared, and with them, most Amerindian visual art as well.

The legacy of European influence is today visible in the Caribbean's political, social, cultural, linguistic, religious, academic and sporting spheres. The visual arts played a large part in shaping our colonial inheritance. **Architecture** is perhaps the most visible example, but many others exist. **Identify and discuss a few examples of European art and architecture.**

Fig 3.4 Taino. Deity Zemi. c. 500 years ago. Wood carving. The Metropolitan Museum of Art.

Key terms

Pre-Columbian art: visual art of the 'New World' made before the arrival of Christopher Columbus

charcoal: burnt wooden sticks used for drawing

architecture: the design and use of space for living. It is a form of visual art

Art of interaction

The coming of Europeans to the Caribbean brought with it the end of native indigenous American civilisation. The Arawak, Carib and Taino peoples were wiped out. Precious little of their culture has been left, but we have been able to piece together quite a bit about them from their art. These indigenous people used shell, bone and wood to make tools. They made pottery that was decorated with wonderful **incised** patterns. However, one particular wall painting found in the José Maria Cave in the Dominican Republic, tells of their conquest by the Europeans. The images move from left to right very much like the modern writing of the western world. They depict a grater for cassava, the baking of bread, their chief with his ceremonial headwear, and the bread being loaded onto and sent away in a Spanish boat. The painting is an example of the historical evidence that can only be captured through the visual arts. **Research and discuss how this artwork is able to tell the story of the Taino Indians. How has the artist used the elements of art in this painting?**

But the Europeans who came to our islands found new subject matter for their art. Many sketches, drawings and paintings of the Amerindians and their way of life were done by artists and taken back to be exhibited and sold in Europe. This gave Europeans a glimpse of life in the Caribbean at that time.

Key terms

Naïve art: Haitian art style characterised by its lack of formal Western composition and perspective

incised: a design cut into a solid surface

Did you know?

Apart from the groups mentioned here, many others have also contributed to the visual arts of the Caribbean. Examine your society to identify some of the groups that have contributed. Find examples of their artworks to show their contributions. How has their visual art made you aware of their presence and contribution as a people in the Caribbean?

African influence

The Africans were the first people to populate the Caribbean against their free will. Our African ancestors were made to endure many hardships from the time of their captivity and throughout their lives on the plantations of our islands. Remarkably, and despite many efforts to stamp out their cultural and religious beliefs and practices, some traditions survived; others were adapted to European cultures.

The earliest forms of art of our Africans ancestors represented their own ancestors and the spirit world. Artists represented their gods and carved ceremonial tools, furniture and utensils. Later, as European influences took root, the cultural and religious practices of both worlds began to merge. Religions such as the Orisha, Santeria, Shouter Baptists and Voodun are a few examples of this. The distinctive Haitian or **Naïve art** style evolved from these influences. Its lack of traditional perspective and rules of composition gives it a remarkably simple yet expressive and powerful quality quite unlike any other art style. Today there are many 'Afro-centric' artists whose artworks reflect their strong sense of self, their society and identity. **Can you name any such artist? Examine samples of the artist's work to explain your opinion.**

East Indian influence

Indentureship, a system of hired labour, brought peoples of India and China to the Caribbean. European plantation owners needed cheap and effective labour after the end of slavery. These workers were misled and made to endure severe hardships, and at the end of their indentureship were prevented from returning to their homelands. They brought with them their religions and cultures. Their art was displayed in their religious images, clothing, jewellery, musical instruments, tools, utensils and pottery. **Chapter 11** teaches you about pottery. The religions of Hinduism and Islam, each with its own distinctive artistic style, are ever present in traditional artworks, adding to the Caribbean's cultural and visual diversity.

These influences have managed to establish and maintain a firm presence in Caribbean art and society. Today, many artists have emerged who are considered 'Indo-centric'. Their artworks reflect their strong sense of self and their society, religion and identity. **Can you name any such artist? Examine samples of the artist's work to explain your choice.**

Caribbean artists and their art

Michel Jean Cazabon (1813–1888)

Cazabon was a Trinidadian painter and **lithographer** whose work in watercolour made him well known at home and in other islands of the Caribbean. Born in Martinique, Cazabon was trained in England and Paris. He studied under Paul Delaroche at the Barbizon School (a group of French landscape painters who painted the landscape for its own beauty) and developed a distinct watercolour and oil painting style, which he applied mainly to Caribbean landscape paintings. He also painted many portraits.

Cazabon completed many commissions for officials and other influential people in Trinidad. He also taught art students. Today, Cazabon's paintings form part of the National Collection of Trinidad and Tobago and are admired for their technical skill and style and for the visual historical record they captured. His work continues to be of interest to art researchers and historians. Cazabon's contribution is similar to that of Augusto Brunias, an Italian painter whose works recorded life in the Lesser Antilles.

Examine the painting in Figure 3.5. Comment on what it tells us about that time. Why is it important for us to preserve our visual art for future generations?

Francisco Oller (1833–1917)

Oller was a Puerto Rican painter and musician. He painted many portraits and landscapes that tell us about life in his times, and of the sugar plantations and their society. He began his art education early, and later moved to Madrid in Spain, then Paris in France, where he became strongly influenced by the Impressionists Paul Cézanne, Camille Pissarro, Claude Monet and Pierre Renoir. In 1859, he exhibited his work alongside that of Renoir and Monet.

Oller frequently visited Puerto Rico during his years abroad, and eventually returned to the Caribbean in 1865. He believed that art was meant to contribute to society, and therefore used his painting to highlight the problems his people faced. He condemned colonial rule and the practice of slavery. He founded an art school where he taught, and he also wrote a book on perspective and drawing. Because of poverty later in life, Oller was unable to buy art materials and he painted on any surface he found, including cigar boxes.

Discuss how artists can be resourceful in their use of materials and the spaces they make or present their art in.

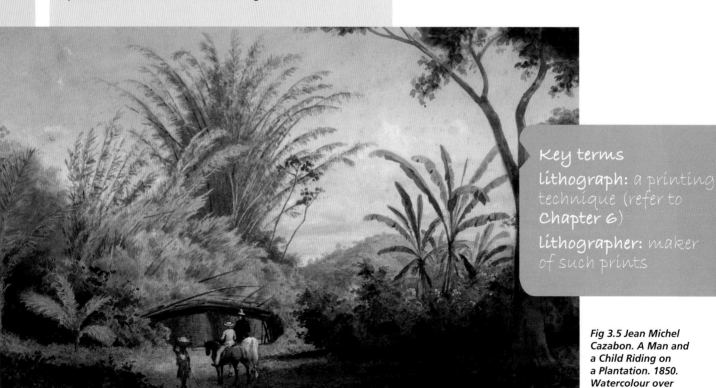

Key terms
Lithograph: a printing technique (refer to Chapter 6)
Lithographer: maker of such prints

Fig 3.5 Jean Michel Cazabon. A Man and a Child Riding on a Plantation. 1850. Watercolour over pencil, heightened with bodycolour. 29 x 43 cm.

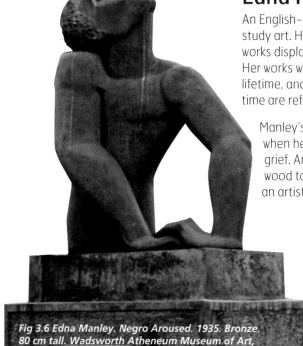

Edna Manley (1900–1987)

An English-born Jamaican sculptor, Edna Manley later returned to England to study art. Her sculptures were mainly in cedar, mahogany and redwood. Her early works displayed **geometric forms**, which later became larger and more rounded. Her works were deeply influenced by the changes in Jamaican culture during her lifetime, and the new consciousness and independence in Jamaican life at that time are reflected in her sculptures.

Manley's works underwent numerous other changes. One of these occurred when her husband died, and she used her art to express and overcome her grief. Another change came later when she switched from the medium of wood to **terracotta** and plaster. **Chapter 1** tells you about such changes in an artist's life.

She is credited with the birth of modern Jamaican art and helped to found the Jamaica School of Art, where she taught. The Edna Manley College of the Visual and Performing Arts is named in her memory. During her lifetime her sculptures were exhibited frequently in Jamaica and England. Today they continue to bring a strong sense of Caribbean pride to us all. **Examine Figure 3.6, Negro Aroused. Comment on the roundness of its form. What emotion does it evokes?**

Fig 3.6 Edna Manley. Negro Aroused. 1935. Bronze. 80 cm tall. Wadsworth Atheneum Museum of Art, Connecticut.

Angel Acosta Leon (1930–1963)

This Cuban Expressionist painter's artworks spanned only nine years of his life. Although he came from an extremely poor family, he never wavered from his love for art. His earlier works were landscapes and seascapes of Cuba, painted in oils.

In the late 1950s, he began a series of self-portraits that were similar to those of Mexican artist Frida Khalo (see **Chapter 2**). Because he took on many jobs to make ends meet, he had many different experiences, which he cleverly used in his art. For instance, his knowledge of metals and tools was transferred through images of machinery in his painting. During the 1960s, Acosta's art became a symbol of the Cuban people's reaction to the political and social events that marked this period of the island's history. These works demonstrate the power of the visual artist to represent the thoughts and feelings of an entire society.

Other artworks by Leon contained very personal **motifs** of the cross and medical syringes, which he used to represent his religion and his sickness. He often used these images with themes of illness and death. Leon's works were exhibited in Cuba and Europe during his lifetime.

Examine Figure 3.7 and its title. What mood does it create? What elements of art does the artist use to achieve this effect?

Fig 3.7 Angel Acosta Leon. Carousel. 1959. Oil on masonite. 123 x 244 cm. National Museum of Art, Havanna, Cuba.

Key terms

geometric forms: three-dimensional artworks with mainly flat surfaces and easily identified edges and corners

terracotta: fired clay, usually reddish-brown in colour

motifs: the main elements or repeated symbols in an artwork

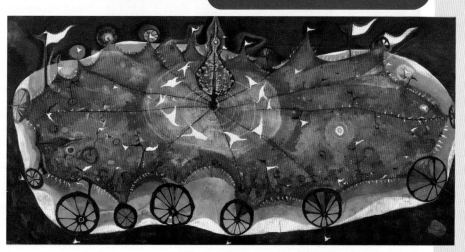

Isaiah James Boodoo (1932–2004)

A Trinidadian painter and educator, Isaiah James Boodoo studied visual art at home, in England and in the United States of America. His early paintings reflected European style, but soon he searched for new ways to express himself. His visit to the United States brought him new understanding of the **function of art**. His work began to reflect statements on social and political life at that time in Trinidad and Tobago. In many ways, his artworks were visual representations of themes sung by calypsonians.

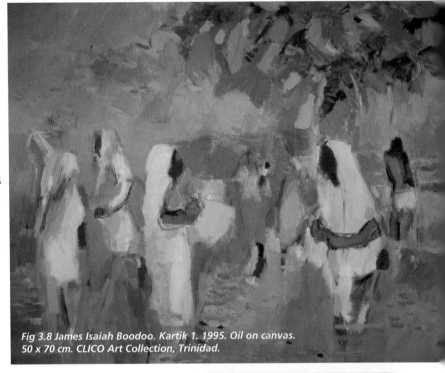

Fig 3.8 James Isaiah Boodoo. Kartik 1. 1995. Oil on canvas. 50 x 70 cm. CLICO Art Collection, Trinidad.

Later, as his style evolved, Boodoo's works began to reflect the beauty of the land and the people within it. In the series 'Caroni' he combined the people, their culture and the land to create painting where all these elements seemed to become one, achieving a sense of balance and harmony in the artworks which communicated the message of shared belonging between the land and its people. **Examine Figure 3.8. How does the artist manage to make the people and the landscape appear as one?**

> **Key term**
> **function of art**: the reasons for making visual art

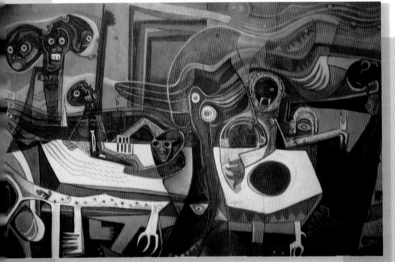

Fig 3.9 LeRoy Clarke. De Meeting, from the Douens' Series. 1973. Oil on canvas. 60.75"x 85". Ministry of Community Development and Gender Affairs (Trinidad & Tobago) Collection.

> **Key term**
> **symbolic:** containing meaning apart from what is actually seen

LeRoy Clarke (1938–)

This Trinidadian artist, art educator, curator and poet has exhibited extensively in the Caribbean and internationally and is easily one of the Caribbean's premier artists. His art is **symbolic** and represents his understandings as a person, in a place and through time. He uses his canvases to provide snapshots and perspectives of his rich and deep philosophy, allowing us to see his skills as a storyteller. His life's works are a continuous series of related paintings.

In 1973, after spending six years in New York, he returned to Trinidad and began a major series of works titled 'Douens'. Today, his El Tucuche studio is a major source of inspiration for his paintings.

Clarke's works are characterised by the use of colour and motifs that reflect the energy and vibrancy of our people and our Caribbean region. His deep sense of pride in his African heritage is also evoked in his works.

Comment on the artist's use of line, shape and colour in Figure 3.9. What elements does the artist use in this scene?

Peter Minshall (1941—)

Peter Minshall is the foremost artist working in the art form of **mas**: a performance art built on the traditions of costumed masquerade in the carnival of Trinidad. As a young boy in Port of Spain, the influence of street mas and his talent for design merged, and he created mas costumes even before he graduated from school. Later, he studied theatre design in London, where his exposure to international art and theatre expanded his appreciation of what might constitute "art" and the artistic possibilities of the mas. He turned his artistic practice to the mas in the mid-1970s and over the ensuing three decades created works for the Trinidad Carnival that have become legendary. In the individual pieces his structural innovations created unprecedented statements of kinetic and dramatic expressiveness. In his large masbands he makes what he calls "visual symphonies," deploying variations in colour, shape, movement, and gesture to portray themes that have included political satire, global social issues, deep spirituality, and pure abstract aesthetics. He is the only internationally-aware contemporary artist to choose the mas as his primary form of expression. He has described his work as the creation of "vehicles for the expression of human energy".

Minshall has designed for many international productions and events, including the ceremonies of the Pan American Games (1987), the football World Cup (1994), the Cricket World Cup (2007), and three Olympic games (1992, 1996, and 2002). **Research Peter Minshall's work at your school or public library, or online. Find three examples that appeal to you. What do you find imaginative about these costumes? Comment on the elements of art and the principles of art and design.**

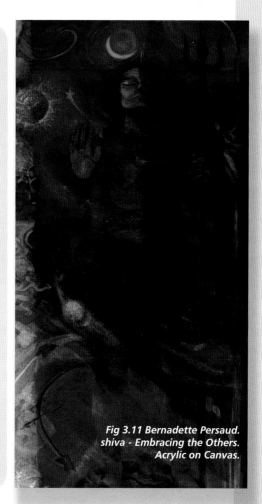

Fig 3.11 Bernadette Persaud. shiva - Embracing the Others. Acrylic on Canvas.

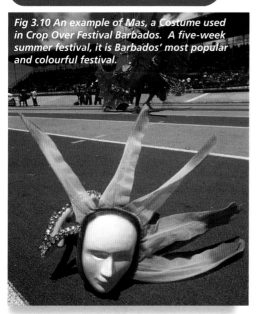

Fig 3.10 An example of Mas, a Costume used in Crop Over Festival Barbados. A five-week summer festival, it is Barbados' most popular and colourful festival.

Bernadette Persaud (1946—)

Bernadette Persaud is one of Guyana's best-known artists, writers and educators. Her paintings are expressionist in style and present her perspective on her homeland's society as seen through the eyes of an East Indian woman.

Her painting career began in the early 1980s, when she felt a need to express her ideas through her creativity. In 1985, she became the first woman to win the Guyana National Visual Arts Competition, and she continues to produce artworks that encourage a social, political and historical consciousness. Her visit to India through a cultural exchange produced a group of works that record scenes of ordinary life in India through her eyes and were exhibited in Guyana on her return. She points out that the experience has been a refreshing source of **artistic inspiration** for her. **Comment on the theme of the painting in Figure 3.11. Does knowledge of a figure or motif used in an artwork help the viewer to better understand it?**

Persaud's paintings have been exhibited and her writings published in Canada, the Caribbean, the United Kingdom, the United States of America and Guyana. **How helpful is it to read what an artist has written about her own work?**

Ras Akyem-I Ramsay (1953–)

This Barbadian artist's themes have explored betrayal, death and sacrifice. These themes very often have direct reference to African experience in the New World. Ramsey studied art in Jamaica and Cuba. He has exhibited throughout the Caribbean, Europe, Latin America and the United States of America.

Like his colleague Ras Ishi Butcher, Ramsay considers his work an act of magic that allows the artist to create a painting. The application of the paint – in blots, blobs, splashes and bold vigorous brushstrokes – evokes an energy that tells about the artist's excitement and his need to send his message. He is able to use these brushstroke methods to create varying contrasts in his compositions that emphasise his theme and create a powerful sense of expression and **emotion** in his work.

What emotions do the shapes, colour and posture that make up the figure indicate?

Discuss how advantageous it may be for artists to share a common working space and experiences over time. In what ways can they learn from each other? Why is it, at the same time, also important that these artists maintain their own individuality?

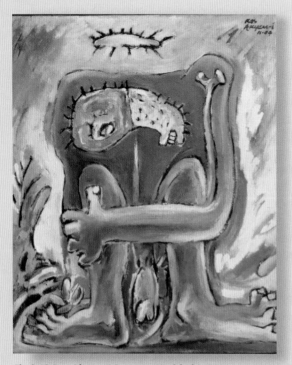

Fig 3.12 Ras Akyem-I Ramsay. Untitled 2. 2004. Acrylic on Canvas. 45 x 38 cm.

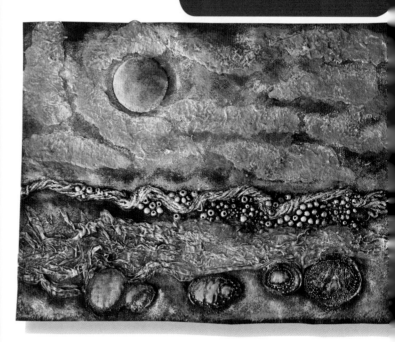

Fig 3.13 Heather Doram. Texture of Life, from the Essence of Life series. 2007. Mixed media on felt. 35 x 45 cm.

Heather Doram (1953–)

An Antiguan artist, designer, educator and actress, Heather Doram has studied the visual arts in Jamaica and in the United States of America. Her designs have won her recognition throughout the Caribbean and in Dominica, where her skill is evident in the annual carnival designs and the island's national dress.

Doram is inspired by the multiple meanings in old bark paintings, which are reflected in her **fibre arts** pieces. Her materials include fibres and textiles that are manipulated through cutting, stitching, layering, painting and dyeing. She uses additions of beads and other ornaments. Similar techniques are discussed in **Chapter 13** on decorative craft. The artworks make statements about her personal experiences, the people of Antigua and Barbuda, and women in general: their history, culture and lives.

Doram manages her own art gallery, and has exhibited throughout the Caribbean and in Europe. **Suggest some local natural fibres, seeds, bark or vines that may make interesting additions to works similar to this artist's. Comment on the artist's use of shape, texture and colour in Figure 3.13.**

Earl Etienne (1957–)

The works of Dominican painter and educator Earl Etienne are usually related to the life and culture of his home country. He studied art at the Edna Manley School of Art in Jamaica.

Etienne is perhaps best known for his innovative **bouzaille** technique, which allows smoke and soot to settle on his canvases, leaving an array of patterns. The artist examines the smoky shapes and then begins his work, allowing pictures to emerge from his canvas. His technique was developed when he accidentally burned the ceiling of his art school studio and noticed the remarkable images that were formed. His willingness to experiment has encouraged him to use non-traditional materials including fibreglass, coconut fibre, banana latex and modelling paste.

Etienne has exhibited widely, and has worked on numerous projects including ones that recognise his island's Amerindian Carib peoples. **Chat about an occasion when you learned a visual art or other skill by chance. How does the bouzaille technique encourage creativity?**

Observe Figure 3.14. Discuss the artist's use of colour and texture in this painting.

Fig 3.14 Earl Etienne. Kweyol in the Rainforest. 2007. Coconut gauze and acrylic on canvas. 112 x 88 cm. Rivers, Valleys, Hills and Mountains collection.

Ras Ishi Butcher (1960–)

The works of Barbadian painter and educator Ras Ishi Butcher have explored a variety of themes based on Caribbean culture and show an appreciation for the variety of cultures that exist in the region. He studied art in Barbados and in Cuba. He has exhibited throughout the Caribbean, Canada, Europe, Latin America and the United States of America. Many of these exhibitions have been shared with his long-time friend Ras Akyem-I Ramsay.

Butcher considers the act of painting to be a **ritual**. The way he forms images is very much like the act of magic, as he uses his ideas, feelings and experiences to conjure an object of beauty. The success of his art depends on his ability to learn from his drawings and the way he divides the space on his canvas. He does these things before he begins his final painting so that he understands what he has to do. At times, he works on a series of artworks at the same time because that way he is able to see and therefore express what he understands in more than one way.

Comment on the use of shape and space in this painting. Compare it to the graffiti style seen in Figure 3.18. Discuss, too, how similar Ras Ishi's belief about the magic of his painting is to the beliefs of our Palaeolithic ancestors, whom you read about in Chapter 2.

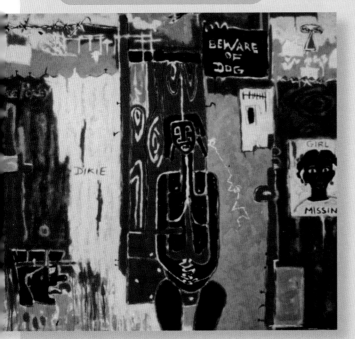

3.15 Ras Ishi Butcher. Vassalage. 1989. Oil on Canvas.150 x 210 cm.

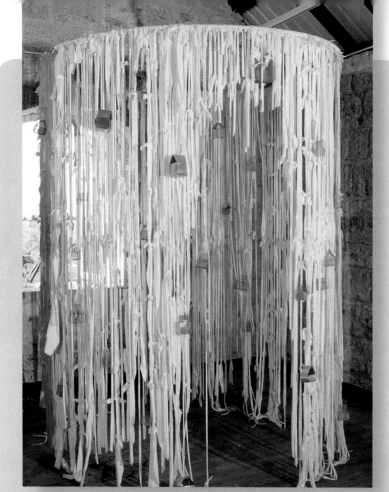

Fig 3.16 Annalee Davis. An Alliteration, A Soliloquy and a Sonnet. 1998. Multi-Media Installation. About 150 cm in diameter.

Annalee Davis (1963–)

Barbadian artist, educator, entrepreneur and writer Annalee Davis studied visual arts in the United States of America. Her works reflect a search for identity and understanding of the circumstances that she, as an artist, faces in her everyday life, relationships and interactions. One of her **installations** explores her role and experiences as a woman, wife and mother, and encourages the viewer to ask similar questions about themselves. She has exhibited within the Caribbean, Europe, and in New York, South America and South Africa.

Davis also manages an art-oriented business. Her company produces artworks that mirror the beauty of the Caribbean region and the energy of its people. By doing this, she promotes our art and culture. **Discuss how important it is for us to promote the work of our Caribbean artists. What advantages does Davis's business provide to her as an artist?**

Discuss what elements of art are most obvious in Figure 3.16.

Winslow Craig (1967–)

Guyanese sculptor Winslow Craig began carving and painting in childhood. He has a knack for producing large-sized sculptures in wood, metal and concrete based on many varying themes. He credits the range of themes in his works to his mixed African, Amerindian, East Indian and European ancestry, and the mystery of his homeland and the childhood experiences he had there.

Craig was educated at the Burrowes School of Art in Guyana and later in New Zealand, having been awarded a Commonwealth scholarship. In New Zealand, he learned to appreciate the use of found objects and began to produce works in mixed media, including steel and bronze.

Craig's connection to the spirit world and to the land itself is demonstrated in a project he worked on in the Belize rainforest. He carved a sculpture entitled the Forest Keeper on the trunk of a living sapodilla tree. The work, showing an axe and human head, warns against humankind's greed and exploitation of our forests.

In what ways can artists create awareness in art to preserve our natural environment?

Key terms

installation: a large-scale assemblage, usually occupying a space that allows the viewer to move through it

awareness in art: message of an artwork

Did you know?

Today, there are thousands of Caribbean visual artists spread across the region and beyond. Many work in various areas of art, for example as Carnival artists, as designers and as cultural ambassadors. They help to promote our regional visual arts and visual culture by exhibiting their work globally. Many of them, past and present, have won international acclaim and awards for the art of our region. Find out about some international exhibitions and galleries, and some seasonal events that attract our artists both within the Caribbean and internationally.

Jean-Michel Basquait (1960–1988)

The son of a Puerto Rican mother and Haitian father, Jean-Michel Basquait was born in New York. He spoke English, French and Spanish and read widely. At the age of 17, his early talent for art emerged to the wider public through his spray-painted graffiti art on public buildings, streets and subways.

Later, Basquait worked in music and in film. His experiences continually changed his style of painting, which moved on from a first period that featured images of the city along with skeleton-like figures and masked faces. His early **graffiti** style was later combined with **collage** and more writing on the canvas. The works of this period were influenced greatly by his African identity and by events in African American history. His final period introduced newer themes and saw him work with Pop artist Andy Warhol.

In 1980, Basquait won worldwide recognition through reviews of his work in art magazines. This helped to popularise graffiti art beyond New York City. During his lifetime, his works were exhibited throughout the United States and Europe. Several articles, a biography and films have been made about the artist. **Examine Figure 3.17 and comment on the artist's use of line, shape and colour. How does this artwork differ from other artworks you have met in this chapter?**

3.17 Jean-Michel Basquait. Pyro. 1904. Acrylic and mixed media on canvas. Cropped. Private collection James Goodman Gallery, New York, USA.

Other great artists

Here are some other artists whose works have contributed significantly to developments and shifts in trends in Caribbean art. Perhaps you can add a few more to this list.

Kenwyn Crichlow

Joseph Browne

Louise Kimme

George Robertson

Ralph Baney

Ilene Theman

Alison Chapman-Andrews

Hector Hyppolite

John Dunkley

Francisco Cabral

Michelle Chomoreau-Lamotte

Cecil Cooper

Milton George

Carlyle Chang

Belkis Ramirez

Tina Ebanks

M. P. Aladdin

Cedric George

Hector Charpentier

Prosper Pierre-Louis

Select an artist from the list to find out more about. Record personal data such as life history and influences on the artist's work. List some of their artworks, and present your own analysis of the artist and the works. Refer to **Chapter 16** to help your research and writing about these artists.

Discuss with your teacher the presentation and submission of your findings about the selected artist along with your end-of-term portfolio.

Select and research one artist mentioned in this chapter each term. In this way you can compile your very own catalogue of Caribbean artists.

> **Key terms**
>
> **graffiti art:** spray-painted or scrawled images and letters, usually done on the street and other public spaces
>
> **collage:** a picture made by sticking down pieces of materials, usually paper or textile

Art of the Caribbean today

The visual arts of the Caribbean today are perhaps the most significant contributor to our regional heritage. It is through our arts that the world has come to identify the peoples of the Caribbean. Our music – calypso, reggae, jazz and zouk – with their infectious rhythms, and our carnivals with their splendour and excitement, provide gateways through which our talent, energy and creativity are recognised and enriched. Our visual arts have given to the world the magic of street theatre: of Carnival, **Phagua** and **Hosay**. This has developed a whole new way of viewing the colour, flare and rhythm of a people, their cultures and their beliefs.

Caribbean art helps us to search out our identity. Many of our artists use the visual arts as a way to understand, explore and present their interpretations of our past, present and future. The artworks act as a window through which we and the world can look to find our common identity and purpose. This provides everyone with the opportunity to see and understand our people, our culture and the beauty of our territories. It also encourages us to want to say something about what we see and understand and urges us to paint our own pictures that will tell even more about us.

Many of our artists also use their art as a symbol for some deeper meaning. Their work aims to use various media, materials and creative ideas to relate to some experience, idea or feeling, what we enjoy and our aspirations. These artworks call for an interpretation of our past or some present-day event that has affected us as a people.

Other artworks explore themes of the individual, whose emotions and personal experiences play an important part in what they wish to say. These artists do exactly what writers or filmmakers do: they present a point of view, add new meaning, or present an opinion on events of our everyday lives. They help us to share our thoughts and feelings, and allow the world to see and understand our contribution to humankind.

Discuss how our artists help people from around the world to learn about us as a people and about our culture. Name an artist and use his or her work to illustrate this contribution.

Key terms

Phagua (or Holi): Hindu festival welcoming Spring

Hosay: Islamic festival enacting a story from the Holy Koran in artwork and theatre

Connecting world art and Caribbean art

The arts of each Caribbean island and the Caribbean region are no longer isolated from the rest of the world. Because of advances in travel and technology, people are able to share their thoughts, ideas, feelings, innovations and inventions. Artists are able to relate these to their art and share them with anyone anywhere very quickly. All that is required to send a digital portfolio (see **Chapter 17**) is a computer with internet access. This allows someone from outside our region to find examples of our art, to look at them and learn about them. Such an opportunity exposes our art to a wider audience, and gains recognition for our artists and for the Caribbean. At the same time we can compare our understandings and practices in the visual arts with what is understood and done elsewhere. This activity is further strengthened when artists from the Caribbean visit and study abroad, and when artists from elsewhere visit us. Thoughts and ideas about our visual arts are shared in order to enrich us. Maybe one day you will enrich our lives in this way.

Why not join an art group or society that has a website, and that promotes artists and their artworks on the internet. If there is none in your territory, write to encourage existing art groups to do this. Use key word searches for 'visual arts', 'world art', 'Caribbean art', 'world artists', 'Caribbean artists', 'fine art', 'fine artists', 'painting', 'modern art' and 'post-modern art' to find out about such websites. Visit these websites as the 'cyber-art' galleries of today.

Helpful hint

Make a list and add to it each time you meet or read about artists or art groups, or visit art galleries and museums. Encourage your parents and teachers to take you along to these places. Get contact information and be aware of upcoming activities. From time to time, visit these people and places to show your interest, see new art and meet new people. Many artists admire this in students.

Chapter summary

In this chapter you have learned to:

- trace the development of visual arts in the Caribbean region
- identify some influential Caribbean artists and their art
- explore some current trends in Caribbean art
- use your understandings to speak and write about Caribbean art.

Activities

Individual

1. Create your own timeline of the visual arts of the Caribbean. Use the time periods you have traced in this chapter as a guide. Perhaps there are others that you can discuss before adding.

 For each time period, compile research so that you are able to:

 a) write two paragraphs about the visual art of each time period

 b) collect four pictures of the visual art produced during each time period

 c) draw your timeline and put in the dates that begin each time period

 d) stick your pictures within the relevant time period along the line.

2. For your home territory, make a list of ten artists.

 Research to compile

 a) some facts about each of the artists and their art

 b) a picture of each artist's work.

 In your list, find two artists who are not yet as well known, but who demonstrate emerging talent.

3. Visit an art exhibition, art gallery or museum, or artist's studio. Use the guidelines provided in **Chapter 16** to gather and write about an artwork or artist you have selected. Present your work.

Group

4. Merge your individual lists from Activity 2 above to make a master list of as many artists in your country as you can. If you work on this over your years of secondary schooling, you will have sufficient information to publish a register of artists.

 If your school continues with this project, the school itself may become an authority on visual artists in your home territory. The information in your school's library will be unlike that in any other. And you will become a contributor to this, opening up a wonderful opportunity to further explore and develop your contribution to the visual arts.

5. In your class, group yourselves according to Caribbean territories. Make a list of four artists for the territory of the Caribbean that you represent. Research to compile

 a) some facts about each of the artists and their art

 b) a picture of each artist's work.

 Present your findings under the heading 'Artists of the Caribbean'.

Integrated

6. Plan a field trip to another Caribbean territory. Be sure to visit the country's museums and art galleries. Perhaps the territory has examples of pre-Columbian cave art or hieroglyphs etched in stone, or maybe the remains of an Amerindian settlement.

 Discuss how these examples of our past affect our understanding of our history, culture, geography and tourism, and our awareness of our heritage and the need for its preservation.

Art appreciation

7. The art of the Caribbean region today has been influenced by many peoples, cultures, religions, ideas and individuals. In your class, discuss these influences and decide whether this is an advantage or a disadvantage for the peoples of the Caribbean. Use examples of artistic practices and artworks to support your decision.

 More activities for this chapter are included on the accompanying CD-ROM.

Drawing

Fig 4.1 The Author. Alec. 2000. Chalk pastel on paper. 45 x 64 cm. Attic Arts.

Outcomes

After reading this chapter and practising its activities, you will be able to:

- define and explain the term 'drawing'

- trace the history and development of drawing as an art form

- list, understand and follow the stages in the process for creating your own drawings

- use key terms and understandings to effectively speak and write about drawing

- apply theory and skills from other chapters to complement your drawing

- critique a drawing, using the elements of art and the principles of art and design

- engage ideas and techniques for the further development of your drawing skills.

Resources

You will need:

- sketchpad or drawing paper, notebook, art journal

- pencils, coloured pencils, charcoal, markers, pen and ink

- erasers, fixative, drawing board

- computer with internet access.

Introduction to drawing

Drawing is the representation of an object or idea using line in any suitable medium. It is the most important skill of the visual artist, and is used in all areas of the visual arts. Painters, graphic designers, sculptors and architects all begin their work with drawing. The better they are able to represent their ideas as drawings, the better they are able to develop these ideas. In this chapter, you will learn about drawing, before moving on to the other areas of the visual arts in the next few chapters. This is wonderful news because you will also get to practise and develop your drawing skills while doing other activities throughout this book.

Drawing is like taking a line for a walk. When you put your pencil on paper, or on any flat surface for that matter, and it leaves a mark, you have drawn. Numbers, letters, scratchy lines or sketches are all drawings. But there is much more to drawing than this. Drawing is a creative experience because you exercise your imagination and use your hands to express what you see or imagine. In order to draw well, you must first learn to see. 'Learning to see' means to practise the skill of careful observation. A bit further into this chapter, you will learn how to improve your ability to observe. **Comment on the use of line in Figure 4.**

Key terms

drawing: the representation of an object or idea using lin

weight: darkness or lightness of the lines of a drawing

Surfaces

A drawing may be made on any surface. The most popular, suitable and available surface is paper, but other surfaces include boards, fabric, plastic, canvas, glass, leather, walls or rocks. Your paper is usually supported by a sketch pad or drawing board. The most popular medium to draw with is graphite pencil. These pencils are available in different types determined by the **weight** of the lines that they make. **Table 4.1** tells you about the character of pencils and erasers.

Table 4.1 Types of pencils and erasers

Pencil/eraser type	Description and character	Main use
HB	A medium pencil, neither too hard nor too soft, generally used as an everyday tool	Everyday student pencil
B	A black or soft pencil capable of making lines that are darker than the HB or H pencil. B pencils are graded from B to 9B. As the number increases, so too does the softness of the graphite, and the blackness of the mark that pencil makes.	Art student pencil
H	A hard pencil capable of making lines that are lighter than the B or HB pencil. H pencils are graded from H to 9H. As the number increases, so too does the hardness of the graphite, and the lightness of the mark that pencil makes.	Technical drawing pencil used for making guidelines
2B	A softer pencil than the B pencil, quite suitable for the visual arts student	Art student pencil
5B	An even softer pencil than the B and 2B pencils, quite suitable for the visual arts student	Art student pencil
Coloured pencils	These pencils contain coloured pigment mixed into graphite. They are quite good for sketching that emphasises colour, and make a good transition from graphite pencil drawing to painting.	Art student set of 12 pencils
'White' eraser	A 'white' or plastic eraser is softer and will not damage your drawing paper. It erases more cleanly than ordinary pencil end eraser. Now you know why a good artist pencil does not carry a pencil-end eraser.	Art student eraser
'Putty' eraser	The kneaded or putty eraser is usually greyish-white in colour. It can be shaped or kneaded to reveal clean areas for erasing, and does not leave behind any residue from erasing.	Art student eraser

Media

Other drawing media include charcoal, chalk, pen and ink, crayons and pastels. Because of the range of artists' materials and media available, many 'drawings' may appear with colour. What tells them apart from paintings is the artist's emphasis on the use of the element of line. The elements of art were discussed in **Chapter 1**. Further on in this chapter you will learn some more about using line and shape in your drawing.

History of drawing

Early drawings

The first drawings have been found in caves and rock shelters. Some were drawn more than 40,000 years ago. These artworks include images of animals, hunting scenes, religious ideas and abstract forms. Palaeolithic artists drew with natural colour pigments made from soft rock, animal blood, and ground leaves and the sap of plants. Their best examples are powerful images that capture the imagination of the viewer. **Describe the drawing in Figure 4.2. What animals are represented? Notice how the drawings are superimposed on one another. Discuss why this may have been done.**

Many thousands of years later, drawing became the basis for symbolic and then written communication.

The Tartaria clay tablets (**Figure 4.3**) found in Romania are probably the earliest surviving example of writing. The tablets were made by the Neolithic Sumerian civilisation almost 7,500 years ago, and people may have worn them as amulets. The drawings on the tablets represent animals and other symbols. They were placed in rows, to be read either vertically or horizontally. Symbols such as these would later evolve into the basis for the Sumerians' written language. The three tablets in the illustration have some images that are easy to recognise, and others that are not. Nevertheless, all the drawings most probably carry a meaning and capture our attention because of the creative use of line.

Observe Figure 4.3. In what directions do the lines lead your eyes? What could these symbols mean?

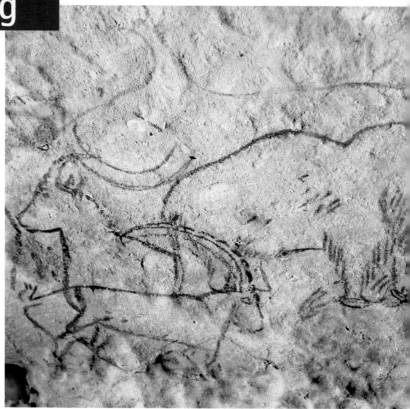

Fig 4.2 Palaeolithic. Mammoth and ibex. c. 12,000 years ago. Cave drawing. Rouffignac Cave, France.

Helpful hint

The element of line helps to draw the eye of the viewer to certain parts of the artwork, leading the viewer to pay attention to the artwork. Look for lines in any artwork that do this. Clever artists use lines to guide your eyes through the work and to main areas of interest. Practise doing this whenever you draw.

Key term

superimpose: to place one drawing or artwork over another so that both are seen

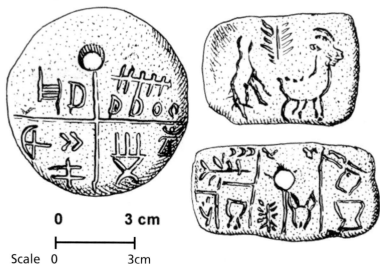

0 3 cm

Scale 0 3cm

Fig 4.3 Neolithic: Vinca Culture. Tantaria tablets. c. 4,700 years ago. Clay. 6-7 cm diameter.

Egyptian drawing

About 3,300 years ago in Egypt, drawings began to depict humans in greater detail but with exaggerated forms, such as having enlarged heads. This was done for emphasis and to show details. The Egyptians' drawings combined different points of views in one picture (**Figure 4.4**). A drawing of a human usually comprised the head viewed from the side and the torso viewed from the front. The lower body was also viewed from the side. Such drawings were done on religious texts and were placed inside coffins and mummy cases. These drawings were done in colour and were quite detailed, containing both symbolic writing and drawings. **Observe the hieroglyphs and posture of the persons in the picture in Figure 4.4. What could indicate to you that the scroll may be interpreted by moving from left to right?**

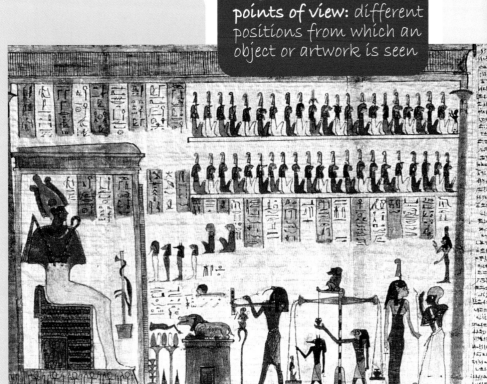

Fig 4.4 Ani. Papyrus of Ani. c. 3100 years ago. Papyrus scroll. Originally, 23 metres long. British Museum.

Key term
points of view: different positions from which an object or artwork is seen

Key term
studies: preliminary drawings or paintings to develop a final artwork

Greco-Roman drawing

The Greeks and then the Romans created their drawings and other artworks to resemble nature as closely as possible. They used balance as a main principle of art and design. Many of their drawings were **studies** for large paintings on wooden panels, most of which have been lost many centuries ago. However, evidence of their drawing skill has survived on their vases, and probably many drawings were made as studies for their remarkable sculptures. The drawing in **Figure 4.5** occupies a cicular space. **Comment on the use of proportion and space. How does the Greek use of proportion contrast with the Egyptian style?**

The Romans are also credited with the drawing of the first maps about 2,500 years ago.

Fig 4.5 Greek. Drinking cup decoration. c. 2,400 years ago. Tondo drawing on ceramic. 33 cm diameter. Staatliche Antikensammlungen, Munich, Germany.

Middle Ages

During the Middle Ages in Europe, monasteries created illuminated manuscripts on parchment. Parchment is a material made from the skins of animals and was widely used at this time for writing and drawing. During the later part of the Middle Ages, the western world realised the growing popularity of paper for drawing on. It had already been in use for some centuries in China, where a clear calligraphic style of art combined both writing and drawing in one.

Also at this time, Islamic art developed into its own unique calligraphic style, using Arabian lettering. In the Middle East, drawings were created in a highly stylised manner and often depicted themes involving legendary creatures. Another common theme in the drawings of this time was leaves. The drawing in **Figure 4.6** was done with a reed pen. **Observe the lines used to represent the dragon. How do they vary as they create the creature's shape and form?**

During the Middle Ages, trade developed across much of the known world. The arts of China, Asia, the Middle East and Europe began to be influenced by one another. Knowledge, experience and new ideas were shared and they encouraged experimentation. This experimentation continues today, encouraging artists to invent and innovate new ways of expressing themselves, their cultures and ideas through their art.

Fig 4.6 Ottoman Empire. Dragon. c. 350 years ago. Reed pen.
17 x 27 cm. Cora Timken Burnett Collection.

> **Key terms**
> **caricature:** a drawing with exaggerated personal features of the subject
> **comic strip:** a series of cartoons with words, used to tell a story

Animation today

Drawing also produced **caricature** and **comic strips**, and has entered the world of animated motion pictures as television **cartoon** series and movies. Software has made drawing on the computer less time-consuming, and easier to save and store. Traditional drawing, however, continues to be the basic way in which art students and artists gain their skill and develop their ability to express thoughts and ideas.

> **Key term**
> **cartoon:** a drawing often found in newspapers and magazines, symbolising an action, subject or person

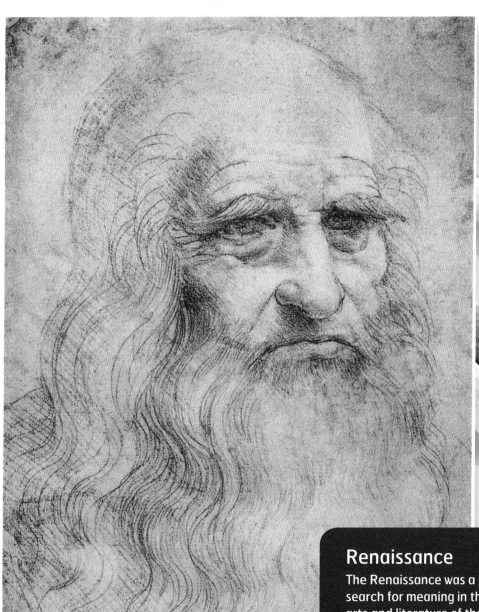

Fig 4.7 Leonardo da Vinci. Self Portrait. c. 1512. Chalk drawing. 33 x 22 cm. Royal Library, Turin.

Renaissance

The Renaissance was a period of revival and the search for meaning in the arts. During this time the arts and literature of the ancient Greek and Roman worlds were widely studied by Europeans. The drawings of Leonardo, Michelangelo and Raphael, to name a few, demonstrated the expressive use of line to represent various forms in different ways. Ideas (styles) of realism and abstraction (also see Chapter 2) began to develop as different ways to show the ideas artists had.

Leonardo da Vinci was perhaps the foremost artist of the Renaissance. He used drawing to understand the form and structure of the human body, and to illustrate his ideas for inventions. Can you suggest how **studies** of the human head may have helped Leonardo to exercise the skill in producing the self-portrait in **Figure 4.7**?

Learning to see

Learning to 'see' is learning to observe. The better you observe, the better you will be able to draw. This will improve your confidence. The drawings in this chapter show how differently lines can be used. Always try to use various types of lines in your own drawing.

So how do you really begin to see? Well, the first stage is to look at the object you wish to draw. Focus your attention on the lines that make up the outline or **contour** of the object. Are these lines completely straight, completely curved, or are parts of the line straight while other parts are curved?

Next, examine the shape that the outline of the object makes. Do this by carrying your eyes along the perimeter of the object. You will soon come to realise that the object may be made up of a few shapes that are combined. **Figure 1.7** in **Chapter 1** is an example of this. Once you begin to see this, you are on your way. Continue to draw, and make changes as you progress. In drawing, lines make up shapes, and shapes make up objects. Lines used within a shape create the form of the object.

Key term

contour: an outline of a person or object

Did you know?

A contour drawing is an outline of an object. A good practice is to draw the outline of the object first. To do this, pay careful attention to the qualities of the lines: their lengths, thicknesses, directions and curvatures, and to the overall shape and proportion of what you draw.

Fig 4.8 Rembrandt Van Rijn. Gesture drawing. 1640. Chalk on paper. British Museum, London.

Gesture drawing

A good way to learn to see main aspects of line, shape, form and value is to practise gesture drawings. Each gesture drawing captures one position in a set of positions, either made by a movement of the subject or as a result of a shift in the point of view of the artist. They are quick and fun. Gesture drawings of still life subjects may be varied by shifting the point of view from which you draw or by rearranging the objects that make up the composition. You will find that gesture drawings help you to see the entire subject or composition as a whole, rather than just seeing the separate parts or individual objects. Because gesture drawings capture the human or animal form at a point while it is in motion, you see and draw different shapes without much detail. As you draw, you begin to understand the ways in which the body positions itself, how weight is transferred, and which muscles extend or contract in various positions.

Examine the gesture drawings in Figure 4.8. Do the drawings appear complete? How are the lines drawn, and what do they tell you about the objects? Is there any evidence that the pencil was not lifted from the paper?

Try some gesture drawings of your own. Set up a group of objects such as a cube, cylinder and sphere. Look at the objects as they come together and relate to one another. See them as one. Then draw them as one. Use pencil or charcoal. Do not let your pencil or charcoal leave the paper from start to finish.

Draw a student from your class. Represent shape using line, and form using value. Draw for 20 seconds, then stop. Have your model go to another position, and draw for another 20 seconds to represent shape and form, then stop. Repeat this for five drawings. Display your drawings side by side and compare them with one another and with those of your classmates.

Was it easy to draw without lifting the pencil (or charcoal) at all, or did you lift it at some point? How did you vary the use of your pencil (or charcoal)? Where and why was this done?

How did you represent the form (solid shapes) you drew?

You may wish to follow up this exercise with a series of gesture drawings on another composition of shapes, your pet at rest, or a human figure. Another strategy is to change the amount of time you draw for, maybe to 30 seconds.

Did you know?

Straight lines may be drawn vertically, horizontally or diagonally, while curved lines may curl around or snake themselves in many directions. Artists use different lines to represent their different thoughts and emotions and the objects they see. They vary the direction, length, thickness and weight or intensity of the lines they draw to do this.

Key term

gesture drawing: drawing that captures one position from a set of positions

Introduction to line

A line is a pencil point moving across your paper. The lines that make up your drawing will tend to vary, depending upon how well you observe the object you draw. The character of lines may vary by length, direction, curvature, thickness or intensity.

Use a single pencil and a sheet of paper to draw as many lines as you can that show variation. Be creative and include an extended line that varies in character as it moves along. Your lines may go over one another. Present your drawing and be sure to point out how you made the lines vary in this activity. **Compare your drawing with one done by a classmate. What are some of the similarities and differences between the drawings?** Perhaps you may wish to add another variation of line into your drawing now.

1. Use a single **line** to represent each of the following: strength; weakness; speed; laziness; rhythm; balance; unity; similarity; difference. Vary the length, direction, curvature, thickness and intensity of your lines to convey your ideas.

2. For each of the following, use three lines in any manner to represent: peace; fear; confusion; anger; love; calm. Here is a hint: repeating the lines in a similar manner helps to emphasise your intention.

 Which of these feelings and emotions seem similar? To what extent do your lines remind you of cartoons or comic strips? Perhaps you can use comic strips to help you express these feelings and emotions. Can you use these three lines to represent two other emotions or moods that are not suggested here?

3. Create one drawing that demonstrates the use of the following types of line: long, short, straight, curved, vertical, horizontal, diagonal, curvilinear, thick, thin, soft, solid, fuzzy, broken .

Did you know?

Many great artists have investigated the form and structure of objects from the inside to get a complete understanding of how and why their outsides look as they do. Leonardo da Vinci even studied the inside of the human body so that he could see it, understand it, and then draw it accurately as a solid form.

Key term

line: a point in motion. The character of lines may vary by length, direction, curvature, thickness or intensity.

Fig 4.9 Lines creating unintended shapes.

Introduction to shape

A **shape** is formed when a line returns to its point of origin without crossing itself. Shapes vary because the lines you use to create them vary. A shape is an outline that contains an area within it. This area varies according to the direction and length of the line you use to draw the shape.

The shapes you draw may be geometric, having straight lines. Where your line turns, an angle is formed. You learn to draw such shapes by observing line lengths and their angles. Other shapes may be more abstract, made from lines that go in many directions and create irregular forms. **Name and draw some common geometric shapes and also draw some abstract ones.**

Look at the drawings you did for the 'Introduction to line' section opposite. **What are some of the shapes created by the lines? Do any of these shapes resemble an object that you know?** The shapes that you now see were created unintentionally while you were focusing on how to use lines (**Figure 4.9**). In drawing, it is important to understand and note this. You must also be able to create shapes intentionally. Do so by first thinking about a shape and then using lines to create it. Try this with a cube, cylinder and sphere separately.

Earlier in this chapter you read that lines make up shapes and shapes make up objects. The shapes are **flat**, while the objects they make up are **solid**. A flat shape has no thickness while a solid has thickness. To see how flat shapes help the artist to create solid forms, look at **Table 4.2** on page 66. The flat shapes to the left have no thickness because they are two-dimensional. They can be drawn and cut out from a sheet of paper. The solid shapes to the right have thickness because they are three-dimensional. If they are cut out from a sheet of paper, they must be folded to form the solid.

Shapes that you can identify by name are called regular shapes. Unusual shapes have no common names and are called irregular shapes.

Name each of the flat and corresponding solid shapes shown in Table 4.2. Give a name of your own to the irregular shapes. For each of the solid shapes, name three objects that resemble it.

> ### Key terms
> **flat:** shape without thickness, having two dimensions
>
> **solid:** shape with thickness or depth, having three dimensions

> ### Key term
> **shape:** the outline formed when a line returns to its point of origin without crossing itself

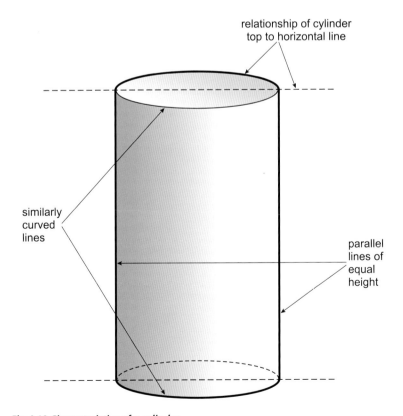

relationship of cylinder top to horizontal line

similarly curved lines

parallel lines of equal height

Fig 4.10 Characteristics of a cylinder.

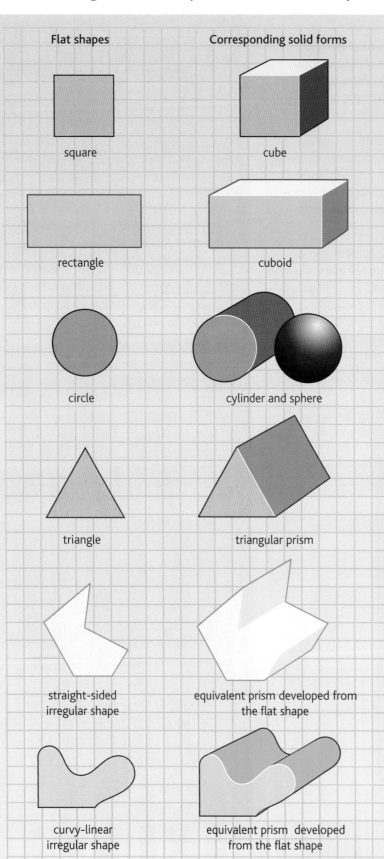

Table 4.2 Regular flat fhapes and their corresponding solid forms

Flat shapes

Corresponding solid forms

square

cube

rectangle

cuboid

circle

cylinder and sphere

triangle

triangular prism

straight-sided
irregular shape

equivalent prism developed from
the flat shape

curvy-linear
irregular shape

equivalent prism developed
from the flat shape

Here are activities that use variation in shape

1. Create a drawing that shows as much variety in shape as possible. Use shapes of varying size, position, direction, thickness and intensity of outline.

2. Use one shape to represent each of the following ideas: strength; weakness; speed; laziness; rhythm; balance; unity; similarity; difference. Vary the length, direction, curvature, thickness or intensity of your lines; and the size, position, direction and intensity of its outline to convey your ideas. Be creative and use your own unique shapes, rather than the common ones.

3. Select one regular shape, for example a circle. Repeat and manipulate this shape to represent each member of your family performing the following actions:

 a) your family standing in a line

 b) your family posing for a family portrait

 c) you being chased by your family

 d) your family celebrating your improvement in drawing.

 Do not be afraid to change the shape somewhat, and the lines, to indicate each member's size, age, position, movement or emotion.

Stages in the drawing process

The drawing process has nine stages that are intended to help you to develop your drawing from your initial idea to a completed drawing. You will begin with research and then go on to selecting what to draw; creating your composition; introducing perspective; adding details; presenting your work; making a journal entry; and making another drawing. Along the way, you will also be reminded about using the elements of art and the principles of art and design.

1. Research drawing techniques and processes

Refer to **Chapter 16** to guide your research for Stage 1 of your drawing process.

2. Select the object, composition or theme

Select what you wish to draw. There is no need to rush into a complete composition or **theme**. A theme is a general idea for an artwork, for example 'Carnival'. It has to be interpreted as aspects of costume, masquerade, calypso, steelpan, or any other Carnival-related idea. Having a theme allows you to use your personal interpretation and creativity in your artwork from the beginning of the drawing process. You will have many opportunities throughout this book to work from themes.

For now, an ideal place to begin drawing is with regular solid shapes. Select a cube, a cylinder and a sphere. Because of the variations of their surfaces, each presents a different challenge. With the guidance of your teacher, draw a cube, a cylinder and a sphere as separate objects. As you gain confidence and improve, you may wish to create a composition of all three objects.

In an artwork, an object is contained within its single overall outline. An object is a single item used as part of a **composition**. A composition is an arrangement of various objects to form a picture. Effective composition is pleasing to look at, and helps to communicate a clear meaning. Creating an effective composition for your drawing therefore requires careful thought about what you intend to do before using line to express this.

Fig 4.11 (a) Line drawing of a cube.

Fig 4.11 (b) Illustration of a composition of the outlines of a cylinder, sphere and cube.

> **Key terms**
>
> **theme:** a general idea used to create an artwork or group of artworks
>
> **composition:** arrangement of objects in an artwork

Understanding composition

Composition is the arrangement of the objects in an artwork. The objects of your drawing (or any other visual arts area) must be arranged effectively. Good composition therefore requires good arrangement of objects. The elements of art and the principles of art and design will guide you. It also requires developing an 'eye' for arranging objects creatively in space.

Generally, the space available to draw or paint on may be divided into a foreground, a middle-ground and a background. The **foreground** is the area that appears closest to the viewer. It is located nearest to the bottom of the frame. Objects situated in the foreground therefore have their base closest to the bottom of the frame, and appear larger relative to other similar objects within the picture.

The **background** is the area that appears farthest away from the viewer. Objects situated in the background therefore have their base further up the frame, and are generally obstructed from full view by objects situated in the foreground and the middle-ground. Objects in the background appear smaller relative to other similar objects in the picture.

The **middle-ground** is the area found between the foreground and the background. Objects situated in the middle-ground have their base further up the frame than those in the foreground, but not as high up as objects in the background. The middle-ground traditionally carries the main focus of interest for a composition. It is for this reason that care must be taken when composing your picture to prevent objects in the foreground from obstructing the view of objects situated in the middle-ground.

With a landscape picture, a further division of space is made for the sky. The illusion of a **horizon line** is formed where the land or horizontal plane seems to meet the sky or vertical plane in the distance. **Figure 4.12** illustrates these divisions of space.

Discuss the differences among the elements of art in the foreground, middl-ground and background.

Key terms

foreground: in an artwork, the area that appears closest to the viewer

background: in an artwork, the area that appears farthest away from the viewer

middle-ground: in an artwork, the area between the foreground and the background. The middle-ground traditionally carries the main focus of interest for a composition

horizon line: where the land or horizontal plane seems to meet the sky or vertical plane in the distance

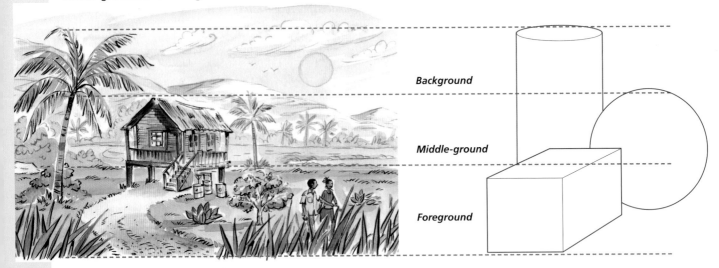

Fig 4.12 Rural Caribbean landscape.

68

Fig 4.13 (a) Portrait orientation.

Composing on paper

If you are drawing a single object, such as a cube, think carefully about the orientation of your paper. You may choose a **portrait** orientation if the object is taller than it is wide, or you may choose a landscape orientation if the object is wider than it is tall.

Compare **Figure 4.13** (a) and (b). Which orientation is more suitable to this drawing? Discuss why.

To create good composition, you must also consider the location of the object on the paper. Avoid drawing the object exactly in the centre, or too much to either side or too close to the top or bottom of your paper. A more effective position may be just off centre towards the lower left or lower right side. Which location of the object in **Figure 4.14** seems most appropriate? Explain why you think this.

Fig 4.13 (b) Landscape orientation.

Key terms

portrait orientation: frame that is higher than it is wide

landscape orientation: frame that is wider than it is high

Fig 4.14 (a) Exactly at centre.

Fig 4.14 (b) Too much to lower left.

Fig 4.14 (c) Just off-centre.

3. Create your composition

When you are drawing many objects, relationships begin to form among them. As a general rule, it is more difficult to develop relationships and interest when objects in a composition are placed completely apart from one another. Good composition is achieved by arranging the objects effectively. In the case of a still life composition (see **Chapter 5**), this is achieved by arranging the objects and then observing them. You may find it necessary to rearrange objects until they form a pleasing group. This is often achieved when the principles of art and design are applied effectively.

(b)

Getting the right composition is not as easy as it may seem, and often it is arrived at through developing an 'eye' for composition. The composition in **Figure 4.15** (a) is successful because of the way the objects are arranged: the tallest object is at the back and the shorter are at the front. They seem to relate to one another and create unity. The viewer can see them all, although two objects are partially hidden. Notice, too, how the lines of the drawing seem to converge towards the corner of the cube that is located near the middle of the composition. The variety and direction of the lines near the centre of the composition create interest for the viewer.

Compare the compositions in Figure 4.15 (a), (b) and (c). Which of the three seems most effective? Why? For each of them, suggest the more appropriate orientation of the paper for a drawing.

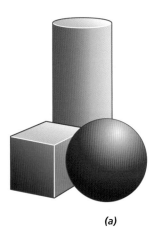

(a)

Good composition depends on many factors including the number of objects, their sizes, their locations within the picture, and the levels of interest you wish to create. If you are drawing a landscape composition (see **Chapter 5**), it is not possible to physically shift around the objects that make up your picture. You may do so in your imagination, perhaps shifting the location of a tree or some rocks to improve your composition.

You may also wish to add interest by including an object that is not actually there: for instance, someone flying a kite or birds in the sky will add life to your picture. At other times, you may wish to remove an object or reduce its size to reveal a more important area of the picture, perhaps omitting a tree that blocks the view of the centre of interest. Sketch the changes you make and ensure that the objects relate to one another through the good use of space.

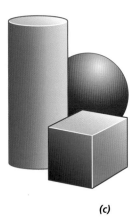

(c)

Fig 4.15 (a), (b), (c) Variations of composition of a cube, cylinder and sphere.

When objects are arranged for a composition, they seldom appear in a linear arrangement – that is, either side by side or directly one behind another. Rather, they are placed in such a way that they may all be seen by the viewer yet relate to one another. Because of the way objects appear when placed together, it is not possible to see each object completely. Some objects may be partially hidden by others. Knowing how much to hide and how much to show is one aspect of creating good composition that comes with practice.

To start creating good composition, include a suitable number of objects: neither too many nor too few. The size of the paper and the objects themselves will guide you. Consider, too, the emphasis you wish to place on one or more of the objects, and the resulting balance, contrast, harmony and unity the objects create.

Compare the compositions in Figure 4.16 (a), (b) and (c). Which of the three seems most effective? Why? Comment on each.

Next, aim to vary the sizes of the objects. If you intend to draw more than one similarly shaped object, make them of different sizes. Doing this may cause you to reconsider the number of objects to include and where you place them.

Compare the compositions in Figure 4.17 (a), (b) and (c). Which of the three seems most effective, and why?

As you compose, objects are placed at varying distances from the viewer, some closer and others further away. The depth, or distance away from the viewer, may be separated into three areas: the foreground, closest to the viewer; the background, furthest away; and the middle-ground, between the foreground and the background. This division of space occurs because the viewer's line of sight is carried towards the horizon line.

A good composition should have a **centre of interest** or focus. This may take the form of an object – or a group of objects that are close together – that causes the viewer's eyes to be drawn to it. In a drawing of one object, the area of interest may be the object itself or a part of the object. In a composition such as a landscape, it may be a particular object within the landscape. Usually, the centre of interest or area of interest is located within the middle-ground of a picture.

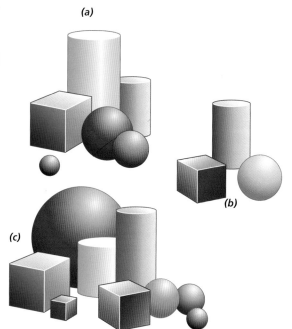

Fig 4.16 (a), (b), (c)
Variations of composition of cubes, cylinder and sphere by quantity.

Fig 4.17 (a), (b), (c)
Variations of composition of cube, cylinder and sphere by size.

Key term
centre of interest: the most appealing part of an artwork

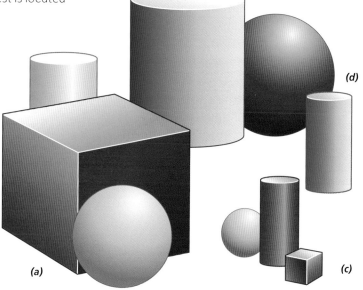

71

Observe Figure 4.18 (a) and (b). Can you identify the centres of interest? What are the reasons for your choices? Try to use the elements of art to explain your choices.

In a picture, the objects at the front must be made to appear closest to the viewer. These objects are drawn larger, and their bases must be closest to the lower horizontal edge of your paper. Objects at the back seem furthest from the viewer. They are drawn smaller in size than those in the foreground, and have their bases at a higher point on the paper. **Figure 4.19** (a) shows objects in a composition, while **Figure 4.19** (b) identifies the corresponding positions of the bases of these objects.

As your experience grows, you will recognise that certain other factors contribute to good composition. Can you think of any other factor to discuss now?

(a)

4. Introduce perspective into your drawing

Perspective is the illusion of depth in a two-dimensional artwork. This concept is based on the reality that objects generally recede in space, rather than occupy space side by side at an equal distance from the viewer. Objects do not all occupy space directly behind one another either, for if they did the viewer would only see the object at the front and nothing else! Effective composition works in harmony with perspective. By manipulating the thickness of the lines and the size of the shapes, and the intensity and contrast among colour and value, the artist attempts to convince the viewer that there is depth or distance within the flat surface of an artwork.

There are two types of perspective: **linear** and **aerial**. Together they convince the viewer of the apparent third dimension of distance, or depth, in an artwork rendered on a flat surface.

(b)

Fig 4.18 (a) Still life composition, (b) Rural Caribbean landscape.

> **Key term**
> **perspective:** the illusion of depth in a two-dimensional artwork

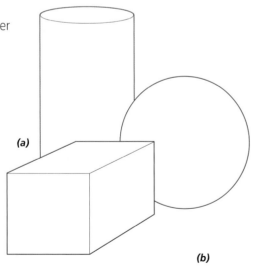

(a)

(b)

Fig 4.19 (a) and (b) A composition of objects and the location of their bases.

Drawing in Perspective

Linear perspective may be drawn in three different ways: one-, two- or three- point linear perspective.

One-point linear perspective

All lines that move back into space seem to go towards one vanishing point on the horizon line. Lines running horizontally become shorter in width as they move toward this point.

Two-point linear perspective

All lines that move back into space seem to go towards two vanishing points on the horizon line. Lines running vertically become shorter in width as they move toward these points.

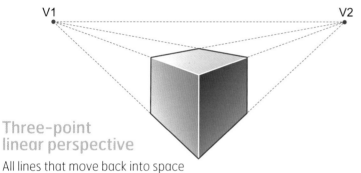

Three-point linear perspective

All lines that move back into space seem to go towards two vanishing points on the horizon line. But a third point is placed either at the top or below, causing the vertical lines to also appear to meet either high up into space or way down below.

Observe Figures 4.21 (a), (b), (c) and discuss the differences in vanishing points, line movement and line length.

One and two-point perspectives are good for learning about linear perspective.

Linear perspective

The word 'linear' comes from 'line'. In reality, and therefore in attempts to represent reality, objects appear either closer to or further away from the viewer according to their size. **Linear perspective** creates the illusion of depth or distance by manipulating the amount of space occupied by similar-sized objects. Objects closer to the viewer and that appear in the foreground of the picture will be drawn larger than similar objects that are further away from the viewer and appear in the middle-ground or background of the composition. For instance, **Figure 4.20** contains utility poles along a road that recede into the picture; the utility pole that is closest to the viewer is drawn larger than any other (similar-sized) utility pole drawn in the middle-ground or background.

Find a composition with at least three similar objects, such as houses or trees. Make a drawing that uses variation in line to represent them. If you are working in class, set up a composition of three objects to draw, such as paint jars or potted plants. Allow some space among the objects, and select a point of view that clearly has one object closest to you, one object a bit further away and a third even further away.

> **Key term**
> **linear perspective:** the illusion of depth created by manipulating the size of objects

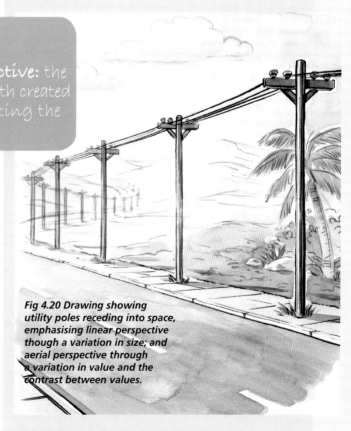

Fig 4.20 Drawing showing utility poles receding into space, emphasising linear perspective though a variation in size; and aerial perspective through a variation in value and the contrast between values.

Aerial perspective

Aerial perspective creates the illusion of depth by manipulating the effect of light caused by distance. Objects closer to the viewer and that appear in the foreground of the picture will appear with the greatest **contrast** between their brightest and darkest areas. The edges and details of objects closest to the viewer will therefore be much clearer, more detailed and more easily recognisable.

Objects further away from the viewer will appear to have less contrast between their brightest and darkest areas. The further these objects recede into the picture, the greater the loss of value. This will produce areas where the different values seem to fuse into one 'weaker' value, with little or no detail or sharpness of edges.

In **Figure 4.20** the utility pole that is closest to the viewer will appear with much sharper edges, and a marked difference or contrast between the brighter and shadowed sides. The utility poles in the distance will seem to have edges that are not as sharp, and there will be very little contrast between their brighter and shadowed sides. Little or no detail is evident on the utility poles in the background of the picture compared with those in the foreground.

Aerial perspective is generally applied after linear perspective. **On the drawings you have made to demonstrate linear perspective, add value to create aerial perspective.**

Key terms

aerial perspective: the illusion of depth created by manipulating the effect of light

contrast: the degree of variation of pencil tone (or paint colour) used on an object or in an artwork

Introduction to value

Value or tone is used to represent the effect of light on the objects in your drawing. Each object has a form, made up of surfaces. As each surface is at a different angle to the light source, it is exposed to different amounts of light, making some parts of the surface appear brighter and other parts darker. This is most easily illustrated on a cube, which has a small number of flat surfaces. The surfaces that are in direct light appear brightest in value while surfaces opposite to the source of light and within the shadow appear darkest in value. Surface areas that are in indirect light appear neither as dark as the darkest value nor as bright as the lightest value.

Value is added to a drawing to give an object its form or mass. To indicate form or mass, you must carefully observe all of the object's visible surfaces. Each surface interacts differently with light, because each surface receives a different value or amount of light. As a student of drawing, you must learn to see and use the correct value of light on each of the surfaces of all the objects you draw.

A good activity for achieving values is to create a value chart or tonal scale. Begin by drawing a series of five or seven equal-sized similar shapes of your choice. Place them in a line either one above another or side by side. Beginning at one end, apply extreme pressure to achieve the heaviest possible tone of your pencil. Next, move to the shape at the opposite end and apply a feather touch to your pencil to achieve the lightest possible tone. Then, starting at one end, move progressively towards the other, increasing or decreasing the pressure in each space to create your scale. Use your pencil in one direction throughout. Be careful to ensure that the values move as uniformly from step to step as the movement you make up or down a staircase. You will find that this exercise requires practice to achieve a successful and consistent scale.

Helpful hint

Intensity causes value or tonal contrast to change. Bright midday sunlight gives greater contrast, showing a wider range of tones, while late evening sunlight gives less contrast, showing more similar, merging tones. This effect also occurs when you use perspective to show distance. In the foreground, there is greater contrast in value than elsewhere. You will learn more about this when you begin painting (see **Chapter 5**).

5. Add value

Basic solid shapes – the cube, cylinder and sphere – are the best for practising adding value. Before you begin, get simple models of each and observe them carefully. A box, a fabric or tinfoil core, and a ball are quite adequate. See the variation in the light on the surfaces of these objects. Then close your eyes, and hold the objects. Develop an understanding of how the various surfaces of the objects allow your hands to move across them. This gives you a full sense of the physical character of the object you are about to draw, and helps you to decide the directions in which the lines you use should move.

The surfaces of the cube are separated by its edges. These edges show obvious changes in value. With a cylindrical shape, the surface along its body is curved and as a result there are subtle changes in the effect of the light around the form; the flat top of a cylinder is a flat surface, similar to the face of the cube. A spherical object such as a ball is perhaps most challenging to observe or draw, as there are no edges but just one continuous curved surface.

Drawing and applying value to these shapes in pencil goes a long way in helping you to understand how various forms are affected by light. Draw each object separately at first and apply value. Then create a composition of the three objects and apply value. Later on, you may wish to re-draw these forms with the main source of light coming from a different direction.

Fig 4.2 Composition of a cube, sphere and cylinder showing values on their surfaces, and direction of the light source.

6. Add detail

Visual arts students tend to want to add detail into a picture as early as possible. The excitement of representing what is most readily seen and creates most interest can get the better of us. However, this is not the best approach to building up a picture. Details should only be added after the object has been drawn. If the object is not well drawn, then no matter how well the details are placed on it, the drawing will still be poor: consider a badly proportioned drawing of a face with beautifully drawn eyes, or graceful birds and exciting kites flying in the sky of an unrealistic-looking landscape drawing.

Detail for a drawing may be added to generate interest for the viewer. The foreground and middle-ground carry greater detail than the background. Select an artwork from this text and identify and discuss the artist's use of **detail**.

> **Key term**
> **detail:** small but eye-catching part of an artwork. More details may appear at the centre of interest

Introducing texture

When you draw, you may wish to represent the way the surfaces of the objects you draw feel. Surfaces may be smooth, rough, sharp, bumpy, uneven, slimy or even sticky. All surfaces have texture, and as an art student, recognising and representing these textures becomes important because it adds variety to your drawings. In the visual arts there are two kinds of texture. First, there is the actual texture or feel of a three-dimensional object. This **real (tactile) texture** is discussed in **Chapters 8** and **9**. The other type of texture is **visual (apparent) texture**. This texture is created when the artist makes a surface appear to have a particular 'feel', and is therefore more important for two-dimensional artworks such as drawings, paintings and graphic designs. To create apparent or visual texture, the artist uses the elements of art to represent the way the surface will feel. Textures are generally produced by repeated representations of one or more elements. For instance, repeating certain lines may suggest the rough grain of wood, the specks and veins on the leaves of plants, or even the spots, stripes and fur on an animal.

In drawing, the element of texture is not as effective as line, shape, space, colour or value, and it should be the last element that you use.

Collect pictures that show five types of real and visual textures. Paste them into your art journal and name each texture. Carefully examine each picture to identify what element is repeated, and make short notes.

Key terms

real (tactile) texture: the actual feel of a surface

visual (apparent) texture: the representation of the 'feel' of a surface

7. Present the drawing

Be sure to autograph your drawing. This may be done anywhere, but is perhaps best at the lower left or right side. Next, apply fixative to protect your drawing from smudging or fading. Hair spray is a good substitute for artwork fixative. Your drawing will look complete with a mat or a frame around it. Go to **Chapter 17** (page 277) to complete this exercise.

Take a digital photograph of the composition you worked from and present it along with your drawing. From this, your teacher will be able to see how well you used your understanding of the elements of art and the principles of art and design in creating your composition. He or she will be able to point out corrections that you may need to make in the arrangement of the composition itself, the use of perspective or colour, the centre of interest, and the suitability and range of techniques you used.

Also present the studies that you have made. They will help your teacher to assess the amount of effort you put into your thinking, and which objects and techniques you focused on. Another useful idea is to photograph your work at the various stages of development. This will create a photo essay of what was required and how skilful you were at doing it. Most importantly, these photographs will provide you with an idea of the areas where you may need to improve the next time around.

Be sure that you can say what you did and explain why. Use your understanding of the elements of art and the principles of art and design that you met in **Chapter 1** to help you along.

8. My art journal entry

Refer to **Chapter 16** to guide your art journal entry for Stage 8 of your drawing process.

9. Make another drawing

To improve your drawing, you must practise regularly. Do not depend only on what is done in class. A good suggestion is to keep a small sketch pad with you. Make time to draw as much as you can of what you see anywhere. Drawing regularly helps you to improve what you do and to know what to avoid. The experiences of your previous drawings will help you. Here are some other ideas that you may also wish to consider for your next drawing.

a) Use basic shapes to simplify objects and improve proportion

In **Chapter 1** you were asked to examine the drawing My Left Hand and consider the question of what simple shapes make up the drawing of the hand. Simplifying an object like this is one way to better understand how to draw it. Try replacing the actual object with a combination of simple flat shapes to begin with.

b) Vary the use of line

The lines you use to draw should vary to best represent the objects you draw. To help you do this, consider the object itself: for example, how will the lines representing the bark of a tree differ from the lines representing the contours of the human body? Or how does the edge of factory-cut paper differ from that of torn paper? The quality of the **contour line** you use should tell if the edges are soft or rigid, smooth or rough, thick or thin, curved or straight. Practise doing contour drawings of your own.

c) Use hatching and cross-hatching

Use the techniques of **hatching** and **cross-hatching** to show value. Hatching is the use of a series of lines that run in a similar, near parallel direction; cross-hatching is the use a second set of hatching lines, drawn over the first in a near perpendicular direction. Cross-hatching is used to render darker values and may be varied by reducing or increasing the distances between the lines. See **Figures 4.23** (a), (b).

Fig 4.23 (a) Hatched lines.

Fig 4.23 (b) Cross-hatched lines.

Key terms

contour line: a line that creates an outline

hatching: the use of a series of lines in a near-parallel direction to render value

cross-hatching: the use of two sets of hatching lines, one set drawn over the other, to render darker value

d) Draw from your imagination

Another way to experience drawing is to work from your imagination. As an art student, this does not mean that you simply imagine something and draw it. You will need to learn the basics of drawing and then add imaginative ideas to what you see or compose while you draw. Think carefully about what you wish to add, remove or shift within your composition. A good idea is to take an object from elsewhere and include it in your composition. For example, a branch with fruits may be complemented with the creative addition of a butterfly at rest. Do not attempt to draw the butterfly from memory.

e) Draw in other media

As an art student, it is important that you continue to practise your drawing in pencil in order to 'get a feel' for it and improve your skill with it. This can only be achieved with practice. However, it is equally important that you experience other media. Try drawing in pen and ink, charcoal, chalk, pastel or marker. Each new medium has different qualities that broaden your experiences. Select and draw a subject in three media.

f) Applying colour

You may be inclined to think that drawing means the use of pencil or the use of only one colour. This is not necessarily so, but pencil is highly recommended. Graphite pencil allows for greater articulation and control than other drawing media, but most of all, allows you to focus on using value in one colour. When you use many colours, you must add value in many colours too. So learn to master drawing in graphite pencil first, then perhaps move on to coloured pencils.

Many artists draw using colour. The idea of a drawing is to use lines. The trick is to learn how to use colour to emphasise the use of lines. Popular coloured drawing media include coloured pencil, pastels, crayons or different coloured writing or calligraphy pens. Another popular approach that combines drawing and painting is pen and ink with wash. The artist first uses a pen to draw with, then applies washes of colour over the drawing. In this way, both the lines and the colour become emphasised. **Examine the drawing in Figure 4.1. How does the artist emphasise the use of line over his use of colour? Consider the number of colours that were selected, how they were used, and their intensity.**

Chapter summary

In this chapter you have learned to:

- trace the history of drawing
- explain and use terms associated with drawing
- follow the stages for creating your own drawings
- introduce ideas that will further develop your drawing skill
- apply your knowledge and understanding to speak and write effectively about drawing.

Activities

Individual

1. Select three different fruits or vegetables that vary in size, shape and texture. Arrange your fruits into an effective composition. Use the elements of art to render a pencil drawing of the arrangement. Create a name for your drawing and date it.

 At another time, you may wish to use three different fruits or add a few more fruits or vegetables to the composition. Or perhaps you might draw the same composition using a different drawing medium, such as charcoal or coloured pencils.

2. Create a drawing based on a composition entitled 'A combined object'.

 Use three or four basic solid shapes such as the cube, cuboid, cylinder, sphere and triangular prism to build your combination. Pay attention to the principles of art and design in combining the shapes. Use suitable adhesive to hold the objects together.

 Make a pencil drawing of the arrangement. Add value to show the effect of light and the textures. Give your drawing a title and date it. Later on you may decide to attach two or three more solid shapes to create a more complex combined object to draw.

3. Draw a shoe from three different points of view.

 As a follow-up activity, you may draw another point of view of the shoe. Alternatively, select another object altogether. A CD player, your school bag or a large sea conch shell would make interesting drawings.

Group

4. Select one of the 'combined object' models that you created for Activity 2, or create a new one for your group. Each student draws the selected object from a selected point of view. Display the drawings as a series along with the actual 'combined object'. Make comments about use of media, line, shape and value.

5. In groups of four or five, take turns to hold a position for 30 seconds. While one group member holds his or her position, the other members of the group do a gesture drawing. Each member holds four positions. You will end up with 12 to 16 human figure gesture drawings. Remember to see and draw the main features. Do not lift your pencil, but learn to control the pressure as needed. Pin up the drawings and compare all of yours and all those from your group. Talk about the positions you held, what you drew, and what you learned about observing and drawing.

Integrated

6. Select one of these themes: 'Musical instruments', 'The dancer' or 'Theatre production props'. Complete a series of three drawings based on your selected theme.

 Talk about what influenced you to select your theme and what you chose to draw. Explore ways in which the visual arts can contribute to the performing arts of dance, drama or music. Consider also how the performing arts can contribute to the visual arts.

Art appreciation

7. Discuss the importance of drawing and illustration for each of the other subjects you do at school. Present some of those that you have done to support your discussion.

 More activities for this chapter are included on the accompanying CD-ROM.

Chapter 5 — Painting

Fig 5.1 Wilfredo Lam. The Jungle. 1943. Gouache onpaper. 230 x 239 cm. Museum of Modern Art, New York.

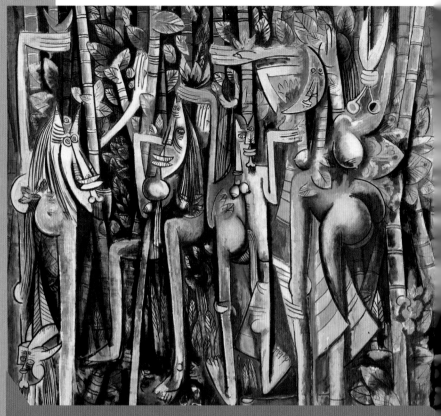

Outcomes

After reading this chapter and practising its activities, you will be able to:

- define, explain and illustrate the term 'painting'

- trace the history and development of painting as an art form

- list, understand and follow the stages in the process for creating your own paintings

- mix colours and apply them using techniques suited to water-based paints

- use key terms and understandings to effectively speak and write about paintings

- apply theory and skills from other chapters to complement your painting process

- critique a painting, using the elements of art and the principles of art and design.

Resources

You will need:

- notebook, art journal; sketchpad, pencils, coloured pencils

- paints, paintbrushes

- palette, craft knife, paper towels, cloth towel or rag, masking tape, gum tape

- art kit, art bag

- **viewfinder**, colour wheel

- computer with internet access

- school and public library access.

Introduction to painting

Painting may be done on any surface, with any type of paint, and paint may be applied using a variety of techniques. Surfaces for painting include rocks, paper, canvas, wood, panel, glass, walls and metal sheets. Generally, paintings are made and displayed on vertical spaces such as walls, but may appear on horizontal planes such as ceilings and floors also. **Comment on the use of shape and colour in Figure 5.1.**

Any painted surface may be a complete and separate artwork, or may be part of a larger collection or series. Museums, art galleries and everyday people who show an appreciation for art have collections. You can easily begin your own collection, comprising either your own artworks, or prints and photographs of paintings pasted into your art journal.

Many artists work on a series to develop a theme, idea or style. This may include work done over a few months, similar to a school term, or it may take several years. A series of paintings aims to develop common ideas made among any one or more of materials, media, painting techniques, themes or objects, and the style in which the artist paints.

> **Key term**
> **viewfinder:** a window cut-out used to select a composition for a drawing or painting

Paints

There are many types of paints to choose from. They may be grouped according to their 'base': there are water-based paints, oil-based paints, and even 'dry' paints. Water-based paints are perhaps the most popular because they are quick-drying, less costly, require only water as an additive, and in some cases are easier to apply. An additive is an ingredient that is put into paint to change its character. Additives may be used to soften, **dilute**, **retard** or **build the body** of a paint.

Find out about acrylic, watercolour and oil paints. What characteristics make them different? Which is best for using at school?

Discuss in class why diluting, retarding or building the body of paints is useful to the artist.

Key terms

dilute: thin or weaken paint

retard: slow down the drying of paint

build body: thicken paint to a paste

palette: surface for mixing paints

Painting media and materials

The term 'painting media' may be used to refer to more than one thing. It may include the type of paint, for example watercolour, that is applied to create an artwork. It may also includes the type of surface, for example paper, that the artwork is created on.

The materials used may include palette, paintbrushes, toothbrush, masking tape to affix paper or create sharp edges, stencils and sponges, blotting paper, water containers and towels.

Themes and subjects for painting

As an art student, you can paint just about anything you wish. However, what you decide to paint may belong to one of the categories below. Since drawing and painting are closely related, these categories are also used for drawing.

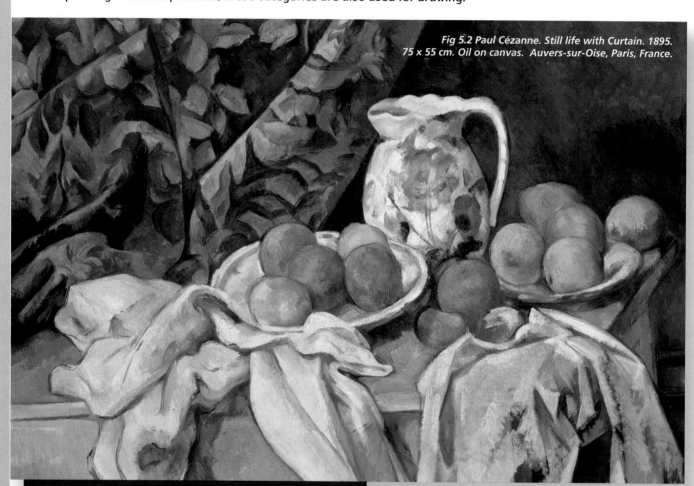

Fig 5.2 Paul Cézanne. Still life with Curtain. 1895. 75 x 55 cm. Oil on canvas. Auvers-sur-Oise, Paris, France.

Still life

'Still life' traditionally refers to a composition made up of living things that do not move, such as flowers or a branch with fruit. The composition may also include a vase, perhaps with patterns to add variety. You may wish to do the branch with a butterfly resting on it to add interest. Still life themes have broadened over time to include subjects such as kitchen implements, tools or sporting equipment, all of which have no life. **Comment on the use of the elements of art in Figure 5.2**.

Landscape

A landscape is a composition that uses natural scenery as its subject. Early on, landscapes were only painted as the backdrop to portraiture. However, landscape painting has become more popular, demonstrating an awareness and appreciation of nature, its hills, rock formations, waterfalls, rivers and varying vegetation. A good landscape painter arranges the parts of the landscape into a successful composition. Other artists harmonise architecture with the natural environment, uniting what occurs in nature with the more geometric man-made forms. Rivers and seascapes may be included in this theme even though they include a body of water. **Turn to Figure 3.5 in Chapter 3. Comment on the composition and use of colour.**

Human figure

'Figure' drawing and painting refers to artworks that represent the human body and its form. The artist generally may present the human body from many perspectives and positions. One person is usually the subject or model. Figure drawing requires an in-depth understanding of how the body moves and rests in various positions. It is an area of the visual arts where success is dependent upon knowledge of human anatomy and careful observation. Successful human figure painting results from the artist making many studies of the model. **Research examples of human figure drawing and painting in this book and elsewhere.**

Portraiture

Portraiture is the representation of the human face. Portraits show the head and neck, but may also include the upper body. Some portraits may represent the entire body, but from as close a distance as possible, to give good detail in the subject. The subject always faces the artist. **Suggest some reasons for wanting to have a portrait painted.**

Observe and comment on the portraits in Figure 2.11 in Chapter 2 and 4.7 in Chapter 4. Point out the similarities and differences in their composition.

Fig 5.3 Cynthia Crawford. Goose at sunrise. 2002. Watercolour on paper.

Animals

Paintings of animals may include those kept as pets or those in the wild or even prehistoric beasts. One problem for the artist is that animals will hardly sit and hold a pose for a painting. This is often overcome by photographing the animal then doing a painting based on the photograph. Another way of tackling the problem is to use gesture drawings. These help to develop your power of observation, which in turn makes you aware of the animal's form and posture even if it has moved from the position that you were painting. **Comment on the artist's use of colour and level of detail.**

Ways of representing

Artists try to find the best ways to represent ideas, objects and themes. But artists differ in their approaches to painting. If, for instance, more than one artist is asked to paint an object, they will all interpret this object differently. They may use different media and materials, use the elements of art and the principles of art and design differently, use different colours, apply the paint in their own unique ways, speak and write differently about the object and the artwork, and present the work differently.

The way in which an artist interprets, or 'sees', an object and represents it helps you to understand the artist's approach or style. Artists learn as their painting styles change. Over time many artists master more than one style, and work with flexibility, mixing and matching various styles. In this way, artists are able to 'invent' new ways of seeing and expressing ideas.

Fig 5.4 The Author. What I See and See 2. 2005. Board and pastel. 57 x 72 cm. Private collection.

Key terms

representational: art that shows a distinct likeness to its subject

non-representational: art that does not show a distinct likeness to its subject

Artworks may be broadly categorised into representational and non-representational work. Representational art aims to show what is seen based on good observation. The artwork shows a distinct likeness to the subject and can be easily recognised as a representation of that subject. As an art student, your main focus should be to develop a keen sense of observation and composition in your work. A **representational** style allows you to compare your artwork with your subject, and gives you the opportunity to develop proportion and perspective as basic concerns in your artwork.

A **non-representational** artwork does not depend in the same way on a subject or reference that exists. The artwork may be based on an actual subject, but does not resemble its outward appearance. Writing is non-representational or abstract because it uses symbols, or letters. The letters themselves do not tell us their sound. Similarly, abstract art is intended to produce a view different from what is seen. The forms may be painted in unnatural colours, or the artist may use an experimental approach.

Observe the two artworks on this page. Which do you think is representational and which is non-representational? Explain why. Select any other artwork within this book and discuss it in a similar manner.

Fig 5.5 The Author. Mayaro: Mother and Child. 1998. Watercolour on paper. 58 x 46 cm. Attic Arts.

History of painting

Early painting

Human history is recorded in the evidence left by people. In the beginning, there was no technology such as books or computers for recording events. What we know of the first peoples of the world has been based on archaeology and accidental discoveries in ancient dwellings. Palaeolithic or Old Stone Age peoples created magnificent paintings and etchings overlaid with paint on the ceilings and walls of caves. They also left behind in their caves and shelters, and in graves and lost and abandoned settlements, many artefacts that tell us about their lives, culture, practices and beliefs.

Artists of this era were considered men of magic and spirituality. The earliest artists painted themes of animals, hunting scenes and interpretations of the spirit world. The paintings on the walls of caves at Altamira in Spain, Lascaux and Chauvet in France, Laas Gaal in Africa and Bhimbetka in India are some of the finest examples. Many other sites across the world are estimated to be 40,000 to 100,000 years old. **Comment on the cave paintings shown in Figure 5.6, and find out about some other sites.**

As humankind settled and civilisation began to develop, the visual arts started to take shape. During the Neolithic era, separate groups of people began to create their art and separate artistic styles and functions evolved. In **Chapter 2**, the discussion on Neolithic art identified the Chinese, Egyptian, Greek, Indian and Olmec as some civilisations that emerged with their own distinctive forms and styles of art. Thanks to archaeology, many other cultures are slowly being recognised for their contribution during this time.

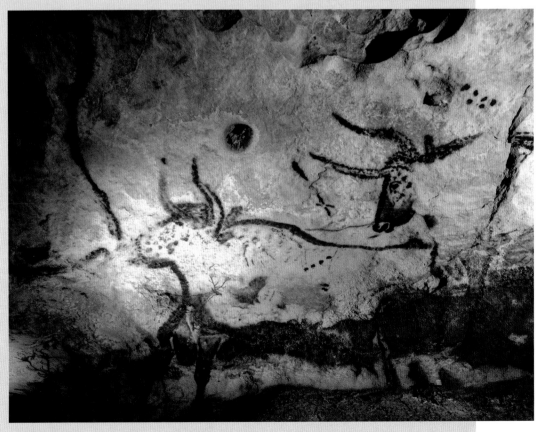

Fig 5.6 Paleolithic. Bulls and deer. Paint on calcite walls. Lascaux Cave. 30000 years ago.

The Middle Ages

During the Middle Ages, the artistic styles of Europe and the Middle East merged. Paintings emphasised religious themes. The majority were found in manuscripts in monasteries, but over time paintings began to appear as murals in churches. Unfortunately, very few of these have survived. Later, mosaic began to become the more popular medium for art in churches. You can learn more about mosaics in **Chapter 13**. Paintings were also done on panel. Panel was made of wood and this type of painting remained popular until the Renaissance.

The Renaissance

The Renaissance period brought a new philosophy to artistic expression. The word itself means 'rebirth', and referred to a renewed attempt to understand man and nature. Art schools opened and there were many supporters and patrons for the arts. This encouraged many young artists to express themselves more readily and in new and different ways. Artists focused on the growing independence and recognition of their work, and great artists such as Michelangelo and Leonardo da Vinci emerged (see **Chapter 2**). These Renaissance artists saw the human form as a beautiful part of God's creation and aimed to paint it as such. **Do you agree that the human form shows the beauty and perfection of a creation of God? How is this idea achieved in Figure 5.7?**

Fig 5.7 Michelangelo Buonarroti. The Last Judgement. 1538-1541. Fresco. 12 x 13.7 m. Sistine Chapel, Rome.

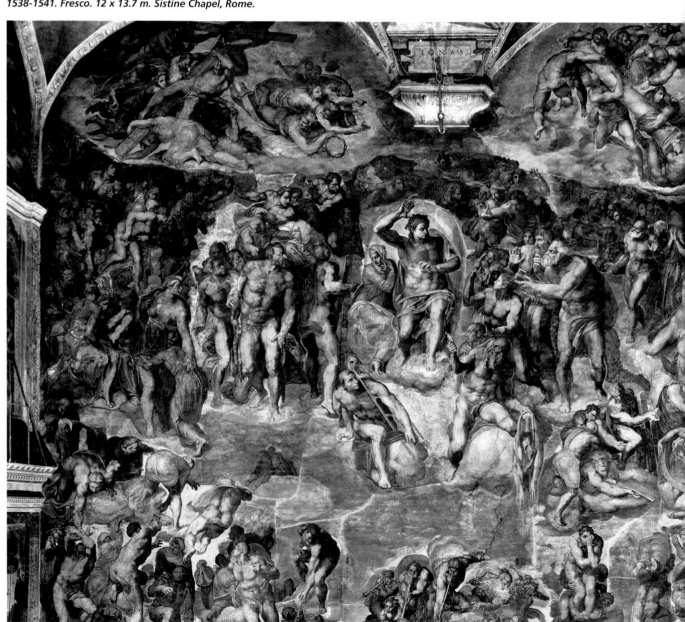

19th century

After the Renaissance and the art of the 17th and 18th centuries, a gradual shift away from representation of the natural appearance of the human form and of nature began to occur. Artists continued to strive for new ways to express themselves. Movements such as Expressionism began to explore the 'reality of the mind', rather than what was obvious to the eye. More and more artists attempted to paint the thoughts, feelings and emotions of their subjects and their lives, therefore changing the intention of their artworks. The viewer needed to understand the subject, the artist, the setting and the intention of the artist to fully appreciate an artwork. Because of these factors, artworks became subject to more than one interpretation. **Examine Figure 5.8. Has the artist painted what he was actually looking at or something else? Can you think what the artist's intention might have been?**

Fig 5.8 Edvard Munch. The Scream. 1893. Mixed media on cardboard. 91 x 74 cm. National Gallery. Oslo. Norway.

Painting today

Today, different artists go about painting a subject or theme in a variety of ways. Our ideas of what art is and how to go about doing it have broadened, and our understanding and horizons have expanded. The art of previous times has continued to guide us, so any of the artworks we produce and view may have a relationship to a style, a movement or a period that went before. These are discussed in **Chapter 2**. The medium of painting itself has gone beyond the simple flat surface. After all, paint can be applied to anything. **Examine Figure 5.9. In this artwork, oil and emulsion paints have been applied to straw, photographs and lead fixed to canvas. What are your thoughts about the artwork and the intention of the artist? Does the title help? How does this painting compare with the other piece of modern art shown in Figure 5.1?**

Fig 5.9 Anslem Kiefer. Wayland's Song. 1982. Mixed media. 380 x 280 cm. Saatchi Collection, London.

Moving from drawing into painting

As an art student, it is sensible for you to begin your drawing in pencil. Pencil is easy to hold and manipulate, and you have good control. Changes can be made quite readily. Pencil is also monochromatic, allowing you to better see, create and apply the element of value in your artwork. Here are three ways to begin your transition from pencil to colour.

Using coloured pencils

Coloured pencils help you to adjust to using colour while allowing you the degree of control of using pencils. You are able to achieve value in the same way that you did with your ordinary pencil, by increasing or releasing pressure on the pencil point. But you can do this for as many colours as you have available. Coloured pencils are available in numerous colours, but a set of 12 will do nicely to begin with.

Complete an artwork using coloured pencils, based on a theme discussed in class. Ensure that the work demonstrates the effective use of value in the colours you use. The element of value is discussed in **Chapter 1**.

Helpful hint

Here is how you can go about mixing your paints in various values (shades and tints). Place six quantities of blue paint on your palette. To three quantities, add varying amounts of black, increasing the black paint from the first to the second and third. Add white paint to the remaining three quantities of blue paint, also increasing from the first to the second and third. Now you have six values (three shades and three tints) to work with.

Did you know?

'Mono' means one, and 'chroma' means to colour. The word 'monochromatic' refers to a range of values you can get from a single pencil or hue of a colour. For pencil work, this range is achieved by varying the pressure you apply to the pencil point. For paint work, it is achieved by mixing black or white paint into the hue. Apart from pencil, what are some other media that achieve values by varying the pressure applied?

Using a monochromatic palette

A basic monochromatic palette can consist of one hue, for example blue, along with black and white paints. The trick is to paint the value of the colour you see using the matching value that is available on your palette: a dark red surface could be represented by an equivalent dark blue colour in your painting. This method teaches you how to mix and apply paint, and more importantly, to represent the values of what you see using the paints that you have.

Complete an artwork using a monochromatic palette, based on a theme of your choice. Try to paint the range of values you see on your actual subject. Study **Figure 17.3** in **Chapter 17**. What is the main colour used by the artist? Discuss how other colours were mixed together.

Pen and ink with wash

This method was introduced in **Chapter 4**. It combines drawing, through the use of line, and painting, through the application of colour **pigment**. Initially, instead of using a pen to draw with, you may choose to use a dark pencil. This pencil work develops the drawing part of your painting. Remember that a good painting depends on a good drawing (see **Chapter 4**). Draw, then use hatching and cross-hatching techniques to achieve lights and darks, before introducing colour to your drawing. The washes of colour are intended to highlight the values of the pencil. The results of this approach can become a wonderful mix of the use of line and colour. The lines remain visible through the transparent washes of coloured paint.

Complete an artwork in pen and ink (or pencil) and wash, based on a theme of your choice. Work to make the painting show a range of line and a simple yet effective application of colour.

Key term
pigment: a substance that transfers its colour to a surface

Stages in the painting process

The painting process has eight stages, which are described below to help you to develop your ability to paint from your idea through to a complete painting. You will begin by thinking about what to research; selecting what to paint; creating your drawing for the painting; applying ideas for good composition, perspective, colour and painting techniques; adding details; presenting your work; making a journal entry; and considering ideas to include or improve the next time you draw and paint. Along the away, you will also be reminded about using the elements of arts and the principles of art and design.

1. Research painting techniques and process

Refer to **Chapter 16** to guide your research for Stage 1 of your painting process.

2. Select the object, composition or theme

Select what you wish to paint. There is no need to rush into a complete composition. Many artists do studies for their work. Remember, a study is a sketch, or rough drawing or painting, made to develop a part of an artwork. For instance, an artist may focus on studies of the human eye in order to improve his or her ability to paint a portrait. Many of the world's greatest artists do many studies to create their visual art.

Studies for a composition of three solids may include paintings for each one done separately. Refer to the activities outlined at the end of this chapter.

Begin with a painting of a single solid object such as a cube or cylinder, which you can master easily. Then move on to putting these shapes into a composition. In an artwork, an object is a single shape. It is usually used as part of a composition. Creating an effective composition is discussed in **Chapter 4** and is reviewed further on in this chapter.

3. Create your drawing

To begin with, a successful painting depends on a successful drawing. In **Chapter 4**, you learned that drawing is the main skill of an artist, and that good drawing requires good observation (page 62). As you draw to help build your painting, you also further improve your drawing skills. Later, as your skills in drawing and painting improve, you may reduce the amount of drawing you do to a **sketch**. The level of detail you include will vary according to the object, composition or theme you select, and with experience over time as you continue to paint.

Key term

sketch: a drawing that gives limited but important details of a composition, used for a painting or other application

Fig 5.10 Sketch for a landscape painting.

Introduction to colour

Let's take a break from our learning to examine and understand colour. What is colour? How do we mix colours? Why are different colours and tones of colour necessary for painting? How do colours and tones of colour build composition and perspective in your painting? After answering these questions, you will be more ready to move on to Stage 4: Applying colour.

The urge humans feel to use **colour** can be exciting, inspiring and satisfying. And it is quite okay to use paint spontaneously. Many artists who have grown to understand colour apply colours solidly and vigorously in order to capture the crisp, vivid and magical imagery of our Caribbean home; our peoples and our expressions; our forests and wildlife; sleepy villages and bustling towns; romantic sunsets and forceful hurricanes; our dress and cultures; activities and beliefs; religions and festivals; our charm and creativity; sports and recreation; trials and achievements; our past, present and future. Colour surrounds us as much as our Caribbean Sea, both physically and psychologically.

> **Key term**
> **colour:** light reflected off an object

Colour is light reflected off an object. Sunlight, or 'white' light, is made up of a **spectrum** of colours. When this light is split, it produces seven visible colours as illustrated in **Figure 5.11**. All objects absorb some light and reflect other light. What is reflected is the part that we see as colour.

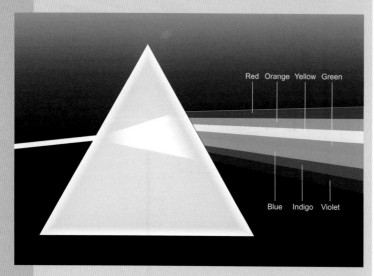

Fig 5.11 The visible spectrum. (light split through a prism, resulting in seven colours.

Red Orange Yellow Green

Blue Indigo Violet

The colour wheel

A basic **colour wheel** displays the three primary colours and the three secondary colours.

Fig 5.12 The basic colour wheel.

Primary colours

A primary colour is one that cannot be formed by mixing any other combination of colours. There are three primary colours: red, blue and yellow. They are the colours from which any other colour can be mixed. On the colour wheel, the primary colours appear an equal distance apart.

Fig 5.13 Three primary colours.

Neutral colours

These are important to the artist for colour mixing. They include black, white and grey—a mixture of black and white. In **Chapter 1**, you learned that shades are formed by adding black, and tints are formed by adding white to a colour. These colours do not appear on a colour wheel.

Secondary colours

A secondary colour is one that is formed by mixing any two primary colours in equal amounts. There are three secondary colours: violet, orange and green. On the colour wheel, the secondary colour formed from the mixture of two primary colours is represented between those two primary colours: for instance, orange always appears between red and yellow.

Fig 5.14 The Secondary colours.

Complementary colours

A pair of complementary colours appear directly opposite each other on the colour wheel. On the simple colour wheel, each pair consists of a primary and a secondary colour. For instance, yellow and violet are complements: because violet is made up of red and blue, ensuring that the three primary colours maintain a balance.

Fig 5.16.

Tertiary colours

A tertiary colour is formed by mixing one primary colour and one secondary colour: for example, a mixture of blue and green gives blue-green. There are six tertiary colours.

Fig 5.15 The tertiary colours.

Analogous colours

These colours lie side by side on the colour wheel. On a simple colour wheel, an analogous group of colours is yellow, orange and red. On a colour wheel showing the tertiary colours, an example is blue–violet, blue and blue-green. An analogous group usually consists of three colours. **Identify another group of three analogous colours.**

Fig 5.17 Analogous group of colours.

Key terms

colour wheel: a chart that represents colours and their relationships to one another

spectrum: the range of colours we are able to see

Activities

1) Draw a large circle and separate it into six equal sectors. Paint in the three primary colours, leaving an unpainted sector between each pair of primary colours.

 Now mix each of the secondary colours using the three combinations of any two primary colours. Be sure to mix these using equal amounts of each primary colour. Paint in each secondary colour between the two primary colours that were used to mix it.

2) Draw a large circle and separate it into 12 equal sectors and repeat the instructions at (1) above to paint in the primary and secondary colours. Make sure that a sector is unpainted between each pair of primary and secondary colour.

 Now mix each of the primary and secondary colours to complete the six tertiary colour sectors. Be sure to use an equal amount of the primary and secondary colours to create each tertiary colour.

Hues, tints and shades

Tints and shades of a **hue** together create the range of values or tones for a colour. You may increase the **tint** value of any colour by adding a greater amount of white paint. You can increase the **shade** value by adding a greater amount of black paint.

Select a primary or secondary colour. Mix and paint three progressively whiter tints and three progressively blacker shades of the colour you selected. Create a painting with them.

Key terms

hue: a pure colour. Common hues include the primary and secondary colours.

tint: a colour formed by adding white paint to a hue.

shade: a colour formed by adding black to a hue.

Water-based painting

In water-based painting, you must learn to apply colour from the 'back moving forward'. To master this, you must apply two concepts. The first is composition, and the second is perspective.

Composition

Good composition requires good arrangement of objects. The main points of composition are covered here, but it will be useful to turn to **Chapter 4** (pages 68–71) to read about the concept fully. You must ensure that:

- Objects in a composition are of varying sizes and shapes to create and keep interest.

- The objects in your painting seem to be arranged as they appear in reality. Objects should not be placed side by side or directly behind one another. Neither should they be placed as separate, unrelated objects on the paper.

- A central point of focus is created. Lines may be used to draw the viewer towards this point of focus.

- The objects at the front of the picture have their base closest to the bottom of the paper. Objects at the back have their base at a higher point on the paper.

Perspective

Perspective is the illusion of depth in a two-dimensional artwork. This concept is based on the reality that objects neither stand side by side at an equal distance from the viewer nor stand directly behind one another. By manipulating the size of similar objects, and the intensity and contrast among colour and value, the artist attempts to convince the viewer that there is depth or distance within the flat surface of an artwork.

Using perspective in your painting is similar to using it in drawing, as described in **Chapter 4**. The main points are recapped here, but it will be useful to return to **Chapter 4** (pages 72–74) to apply the concept fully. You must ensure that:

- The objects you wish to appear at the front, and closest to the viewer, are larger. Similar objects in the background become increasingly small as they recede into space.

- The objects in the foreground show greater contrast. Bright colours appear brightest and dark colours appear darkest.

- Objects recede into space. This means you should avoid placing objects side by side or directly behind one another.

- Objects in the foreground exhibit greater detail, are most easily seen and have sharp edges. Objects further away appear less detailed. In the distant background, objects and their colours begin to merge into one, giving a hazy effect.

- Objects at the front have their base closest to the bottom of the paper. Objects at the back have their base at a higher point on the paper.

93

4. Applying colour

To apply colour from the 'back moving forward' effectively, you need to consider the location of the objects in your composition. Consider too, the apparent changes in lengths and areas due to distance; and the apparent changes in focus, intensity, sharpness and contrast due to the effect of light.

For a still life composition, paint your background first. For a landscape composition, paint your sky first, then the background. In the sky, the areas closest to the viewer, just above the viewer's head, have the brightest sky colours and the greatest contrast among colours, and appear nearest the top of your paper. As the sky recedes into the distance towards the horizon line, colours become weaker and clouds and the sky itself seem to merge, losing contrast.

Colours in the background tend to be the weakest in the entire painting. Mix paints to get the desired colours, then create a range of each colour by adding an increasing amount of white or black to separate amounts of each hue you mixed. You may wish to further weaken a colour by adding more water.

As you gain experience in painting, your brushstrokes will become more convincing rather than being unsure. As a general rule, the direction your brushstokes go in should follow the movement of your eyes along a surface.

Observe and draw a composition of a simple landscape. Paint your composition.

Key terms

water-based paint: paint that dilutes in water

wash: a layer of fluid paint

painting technique: a method for applying paint to a surface

Helpful hint

Water-based paints are a wonderful choice for artists and art students. The paints provide a fresh appearance, require little preparation, are quick-drying and provide opportunity for experimentation and variety. Common water-based paints include watercolour, acrylic colour and poster colour. Water is added to paints to increase their fluidity. The more water paint has added to it, the more it runs!

Painting with water-based paints

Water-based paint is applied in washes or layers of transparent colour, one over another. Its transparent property allows you to see one layer through another placed over it. It is therefore important to decide beforehand which colours you will use, so that you paint on the lighter and weaker colours first, then paint areas of brighter and darker colours second. If lighter or weaker colours are painted over darker or brighter colours, you will not see the lighter or weaker ones. As a general rule, try to use one **wash** of colour, then build over this wash with a second. You should apply a third wash only sparingly, perhaps when you are adding details (in Stage 5). Do not apply more than three washes, as the paints lose their freshness, become murky and make that area look muddled.

As you paint, you use **painting techniques**. Different painting techniques require different amounts of water. This includes not only how much water you add to the paint, but also how much water you allow to dry off before you add more paint. The common techniques are now discussed to help you determine which ones may be better to use in different parts of your paintings.

Painting techniques

Blotting

Blotting involves the use of blotting paper or any other absorbent medium such as tissue or sponge to remove paint pigment that has already been applied but has not yet dried. It may be used when too much paint is applied or where the colour is incorrect. It is, however, much more useful when the removal of the paint creates the desired effect of faded colour or to vary the intensity of one colour over a wide area.

You will need to pay attention to:

* how much paint you need to remove

* how absorbent the blotting paper, tissue paper or sponge is

* how quickly you work – you need to do this before the paint dries.

> **Key term**
>
> **highlights**: unpainted areas of paper, used to indicate strong light

Masking

Masking hides away parts of a painting while a wash is applied. Masking tape or masking fluid is used to cover the space that you wish to reserve. After the wash of paint is applied and has dried, the masking tape or masking fluid is peeled off to reveal the unpainted surface. This technique produces crisp, sharp edges. It is very useful for creating free movement of the paintbrush even when the white of the paper or other colours are to appear over that wash. The unpainted areas may then be painted. Masking may also be used to create areas of strongly reflected light, called **highlights**. Highlights generally appear on some objects in the foreground of your painting.

You will need to pay attention to:

* cutting the masking tape or painting on the masking fluid precisely

* securing the masking tape so that no paint seeps under it

* removing the masking tape or fluid so that no tearing of your paper occurs and no paint outside of the masked area is removed. If you use tape, remove it by pulling the ends towards and into the masked area

* appyling another wash only after the first has dried completely.

Fig 5.18 Blotting technique.

Fig 5.19 Masking technique.

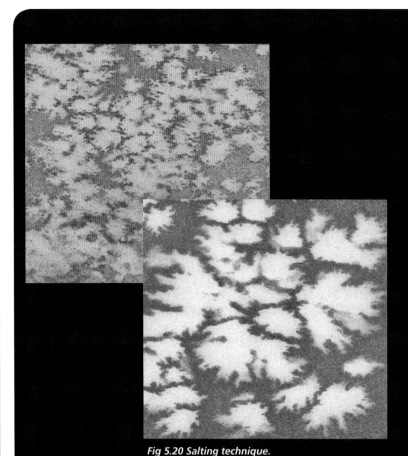

Fig 5.20 Salting technique.

Salting

When table salt is applied to paint, it begins to absorb the moisture around it. This creates a textured effect that is very useful for your painting. After the paint dries, the salt particles on the painting are simply dusted off.

You will need to pay attention to:

- gauging the extent to which the paint has dried off – the technique is best applied when the paint has begun to dry, but is not completely dry

- how much salt you use – a little salt goes a long way

- what objects or areas of your painting you select to apply this technique to.

Splattering

Splattering produces wonderful textures. Paint is mixed and applied using a stiff bristle brush. An old toothbrush is highly recommended: the toothbrush allows you to flick the paint onto the paper, so that you create splatters of paint that come together to create the effect. Of course, you will need to ensure that other areas where you do not wish paint to go are covered up as you splatter. This technique may be used along with masking so that the area in which you work is outlined.

You will need to pay attention to:

- completely covering any surface that you do not wish paint to be splattered on - this includes both your painting and the tabletop

- not diluting the paint too much – this causes weak colours

- not overloading the brush with paint – this causes paint to drip off the brush onto your work

- allowing the paint to dry before removing any masking tape – this prevents smudging.

Fig 5.21 Splattering technique.

Fig 5.22 Scraping technique.

Scraping

This technique is applied to selected areas where you may require the white of the paper to be seen as a highlight, or to produce lines of 'white' colour among other colours. The technique is applied for two main reasons. First, there are areas on surfaces, especially in the foreground, where light is reflected with great intensity. Scraping removes dry paint off the surface to reveal the white of the paper. Second, the technique can be used to produce interesting textures. Scraping into a large rock you have painted produces cracks on its surface, while scraping into a forested area can give the trees some details on their trunks among their clusters of leaves.

You will need to pay attention to:

- when the painting is completely dry so that you can begin the scraping

- the sharpness of your scraping instrument and the thickness or weight of the paper – be careful not to scrape right through the paper.

Sponging

A sponge may be used to either remove or apply paint. Using the sponge to remove paint is discussed in the blotting technique on pages 95. A sponge may be used to apply paint to produce expressive textures. This adds variety to the painting techniques you use, and always provides interest.

You will need to pay attention to:

- when the painting is completely dry so you can begin

- making sure the sponge is clean and free of other paint

- how much water you use to dilute your paint – less rather than more water is suggested, or you will lose the textured effect

- the size of the sponge you use – if it is too large, the paint may be accidentally applied to areas where it is not required.

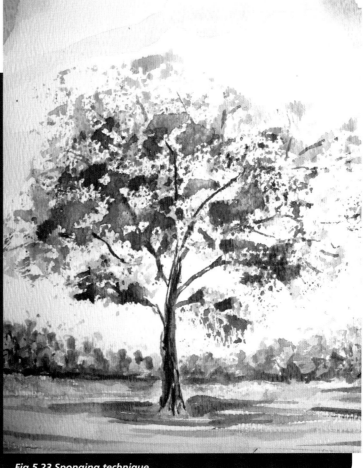

Fig 5.23 Sponging technique.

Stencilling

Recurring motifs in a painting may be painted in after setting a stencil. A motif is any object that repeats itself in an artwork. The stencil is drawn, then cut out. Use a plastic transparency or Bristol board to cut out your stencil. Place the stencil in the desired position and apply paint. The stencil helps to maintain the accuracy of shape, size and location in your composition.

You will need to pay attention to:

- the size of the stencil in relation to the painting
- carefully cutting out the stencil
- holding down the edges of the stencil so that paint does not seep under and outside of the area of the stencil
- how fluid the paints are that you use.

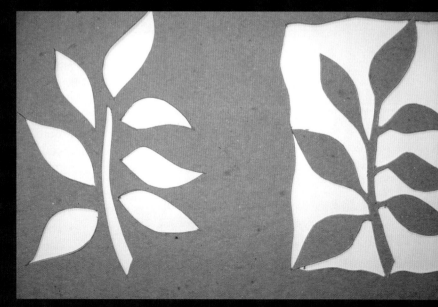

Fig 5.24 Stencilling technique.

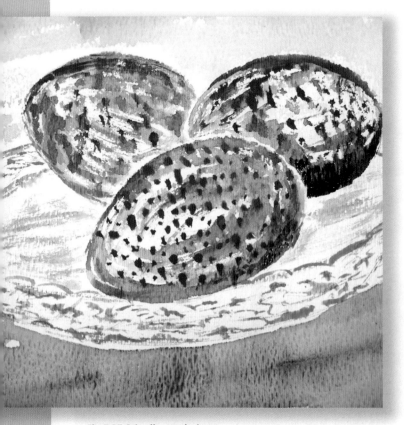

Fig 5.25 Stippling techniques.

Stippling

Stippling, or Pointillism, is a technique that uses dots of colour to create a picture. Dots are made to create the outline of the object, then more dots are added within the outline to complete the picture. The technique is used to mix colour in a different way. When sets of two or more different coloured dots occupy a space, they appear to have actually been mixed: for instance, if you stipple red and yellow dots among each other, amazingly they will seem to appear as orange paint. The dots may be splattered on as well.

You will need to pay attention to:

- the size of the brush and dots you create – a fine brush is advised
- the distance apart that the dots are placed – a closer arrangement gives an improved effect
- the objects or spaces where you choose to apply the technique
- how fluid the paints are that you use.

Wet on dry

Wet on dry is achieved when a second wash of colour is applied over a first wash that has dried sufficiently. This technique ensures that the colour of the first wash is visible through the layer of the second wash without allowing the first to mix into it.

You will need to pay attention to:

- how fluid the paints you use are and how long the first wash requires to dry

- the weight of the paper and how long it requires to dry – the weight of the paper determines rate of absorption and evaporation, as well as 'buckling' of the paper, which occurs when paper temporarily loses its flatness owing to absorption of too much water

- placing layers of lighter colour first, then layers of brighter or darker colours over them.

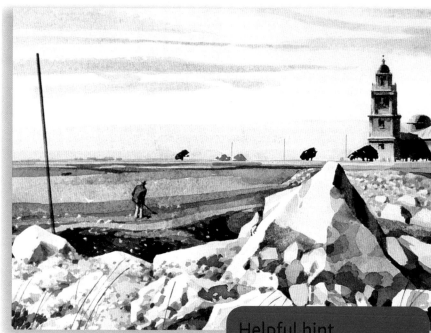

Fig 5.26 Wet on dry technique.

Chapter 5 | Painting

Helpful hint

Paper for painting comes in various 'weights' or grades. For water-based painting, the heavier the paper, the more water it is able to absorb without buckling. To avoid buckling, always stretch the paper and tape it to your drawing board along its perimeter. Masking tape does the trick. Remember to remove the tape by pulling away from your painting.

Wet-in-wet

The wet-in-wet technique is achieved by applying a second wash of colour over a first wash before the first wash dries off completely. The two washes of colour begin to fuse and mix as the colours run into each other.

You will need to pay attention to:

- how fluid the paints are that you use

- the weight of the paper – this determines rate of absorption and evaporation, and 'buckling' of the paper, which occurs when paper temporarily loses its flatness owing to absorption of too much water.

- whether the colours in different washes mix too much or too little

- how quickly you work – you must apply the second wash before the first dries.

Fig 5.27 Wet-in-wet technique.

Activity: painting techniques

Select a simple object such as a single fruit. Separate your paper into ten equal sections, and repeat the drawing of the fruit in each section. You may use a stencil if you wish. Apply each painting technique, one at a time, to the fruits you have drawn. Label each technique used and display your work. Be sure to do the following:

a) Compare each of your techniques with those of your classmates. Was yours as successful? Try to identify what you may need to improve and how.

b) Also, compare all of your techniques with one another. You will begin to see the differences in their effect. Which techniques do you prefer for the painting of this fruit? Say why. To what other objects or areas of other paintings could this technique be successfully applied?

For techniques that require improving, try them again on separate paper. Cut them out and paste them over your previous effort for that technique. The more you practise the techniques, the better you will be able to use them.

5. Adding details

There is always the urge to add details to a painting at the first possible opportunity. This occurs because they are the most eye-catching parts. A good rule is to be patient enough to add in these details at the last stage of your painting. In a still life, details may include patterns or markings found on leaves or the label on a bottle. In landscape painting, details may include a picket fence, utility poles, windows on a house, birds in the sky or a person going about an activity. Each of these details adds to the final picture and provides much-needed interest. They are, however, generally only a part of the sky, background, middle-ground or foreground of your painting. Details must therefore be put in to complete the painting.

Select a painting in this book. Identify the details that add interest to the picture. Were they done at the beginning or closer to the completion of the painting? Say why. What might have occurred if they had been painted in before?

6. Present the painting

Be sure to autograph your painting. This may be done anywhere, but is perhaps best at the lower left or right side. Paintings look complete with a mat or a frame around them. Go to **Chapter 17** (page 277) to complete this exercise.

Take a digital photograph of the composition you worked from and present it along with your painting. From it, your teacher will be able to see how well you used your understandings of the elements of art and the principles of art and design in creating your composition. He or she will be able to point out corrections that you may need to make in the arrangement of the composition itself, the use of perspective, the use of colour, the centre of interest or the range of techniques you used.

Also present the studies that you have made. They help your teacher to assess the amount of effort you put into your thinking, and which objects and techniques you focused on. Another useful idea is to photograph your work at various stages of development. This will create a photo essay of what was required and how skilful you were at doing it. Most importantly, these photographs will provide you with an idea of the areas where you may need to improve the next time around.

Be sure that you can say what you did and explain why. Use your understandings of the elements of art and the principles of art and design you met in **Chapter 1** to help you along.

7. My art journal entry

Refer to **Chapter 16** to guide your art journal entry for Stage 7 of your painting process.

8. Make another painting

To improve your painting you must practise regularly. Do not depend only on what is done in class. Begin another painting. This time, however, the experiences of your earlier efforts will help you. Your sketches and studies will prove invaluable. Keep them handy so that you know what to do and what to avoid, how to plan your painting and how to apply paint. Here are some ideas to consider next time.

a) Painting based on an object or theme

Beginning to paint solid geometric forms helps you to understand how light affects colour. As you begin to paint objects, it is important to see the basic solid geometric shapes that make up the object. One example is a building. It has the shape of a cuboid, and the colour will be affected by the position of its various surfaces in relation to the sunlight. Another example is the trunk of a tree, which has the general shape of a cylinder and is affected by light in a similar manner to a cylinder.

Themes generally include groups of related objects that are placed into a composition.

b) Using colour more effectively

One way in which your painting develops is through the use of colour. Water-based painting requires you to lay the lightest colours first, painting from the back moving forward. Practice teaches you how to do this, allowing you to 'build up' your painting, adding intensity and contrast as the objects closer to the viewer, in the middle-ground and foreground, begin to emerge. As all of this happens, try using your colour wheel to guide your general selection and use of a range of colours that explore complements and highlights. In this way, principles of art and design such as balance and harmony are achieved in your work.

c) Using various painting techniques

Varying the application of paint in your work adds interest because different techniques produce different results. You will find that as you paint you achieve better results with some painting techniques. The other techniques simply require greater practice. Keep working at them on additional paper. You will also realise that different painting techniques may be better suited to certain parts or objects in your painting. A good skill to develop is being able to work out when it might be better to use a particular technique.

d) Painting in varying light

In **Chapter 2**, we read about artists such as Monet, who painted the same objects or scenes at different times of the day and in different weather conditions. The aim was to understand fully the effect of light that changes with each passing moment. Set up a simple composition near a window. Paint it in sharp early morning sunlight, then at midday, and perhaps again in late afternoon. Use the same one colour or a simple colour scheme for each painting. Compare the paintings to get a good idea of the effect of light at different times of the day.

Chapter summary

In this chapter you have learned to:

- trace the history of painting
- understand painting, paints, materials and media
- explain and use terms associated with painting
- use techniques for water-based painting
- follow the stages for creating your paintings
- introduce ideas that will further develop your skill in painting
- apply your knowledge and understandings to speak and write effectively about paintings.

Activities

Individual projects

1. Select a cube, a cylinder and a sphere-shaped object.

 Draw each one carefully on separate sheets of paper, following the steps outlined in **Chapter 4** for drawing.

 Paint each object. Pay attention to the different planes and the effect of light on your use of colour.

2. Paint a landscape that you see looking through the window of your classroom or your home. Before you begin to paint, consider the composition, and the use of the elements of art and the principles of art and design. Also bear in mind which painting techniques may be most suited to each area of your composition.

3. Create a painting in mixed media. Use at least two media, one of which is used mainly for drawing and another mainly for painting. Consider combinations such as watercolour on pen and ink; charcoal on poster colour; pastel on a wash of paint; or marker and aerosol paints. Perhaps you can come up with your own unique combinations. Use any theme or subject of your choice.

Group projects

4. Select a scene that stretches for some distance, such as along the road leading to your school. Determine which part of the scene each member of your group will paint. Select the same size of paper to use and a common scale. Each member of the group will draw and paint his or her scene, working separately. Present the work as a combination of all the individual parts, thus forming a composite painting. Discuss how the individual parts combine to form the whole. What is most striking about the appearance of the different approaches of each individual in the composite painting? How does this painting compare to the paintings of the other groups? If you had to do another similar painting, what would you do differently?

5. As a class, agree on a theme for painting, for example 'My pet', 'Still life' or 'Schoolyard tree'. Draw, then paint, the composition. The painting should be on a standard size of paper, but may use any colour medium or techniques. The point of view of each artist may be the same or may differ. Perhaps this can be determined beforehand. Present the paintings as a series, and discuss what you see. At another time, this exercise may be done again using another of the suggested themes or a theme of your own.

Integrated projects

6. Create a painting based on a theme or topic that you are currently studying in another subject, or for an upcoming cultural festival or event. Select a suitable scale, space, materials and media for the artwork. Discuss with your teacher whether the painting may be part of a larger school-wide thematic project, or may be a collaborated effort between your school's visual arts department and the related subject's department.

Art appreciation

7. Today, computers provide another medium for the application of colour. Do you consider this to be 'painting'? Can you suggest any advantages or disadvantages of this application? Are there any ways that it can assist in developing your skills as an artist?

 More activities for this chapter are included on the accompanying CD-ROM.

Chapter 6 Printmaking

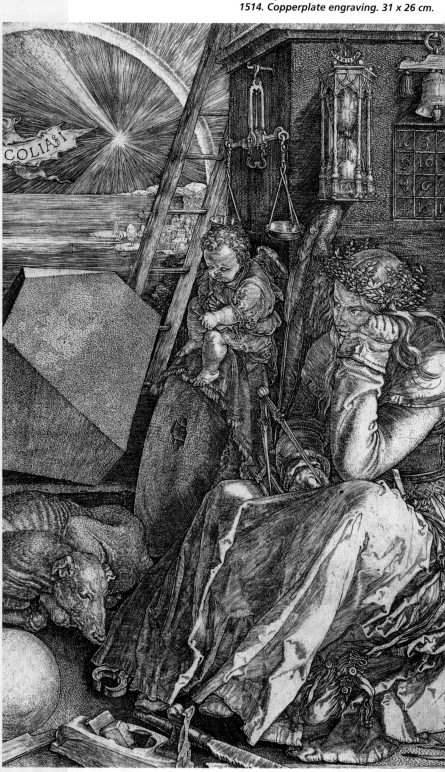

Fig 6.1 Albrecht Dürer. Melencolia I.
1514. Copperplate engraving. 31 x 26 cm.

Outcomes

After reading this chapter and practising its activities, you will be able to:

- define, explain and illustrate the term 'printmaking'

- trace the history and development of printmaking as an art form

- list, understand and follow the stages in the process for creating your own mono and linoleum prints

- use key terms and understandings to effectively speak and write about prints and printmaking

- apply theory and skills from other chapters to complement your printmaking

- criticise a print, using the elements of art and the principles of art and design

- engage ideas and techniques for the further development of the skills learned for printmaking.

Resources

You will need:

- notebook, art journal, paper, pencils, coloured pencils

- materials for creating your printing blocks: vegetables, linoleum

- materials for printing on: paper, fabric, wooden panel, a wall

- paint brushes, roller (brayer) and flat glass or plexiglas surface

- ruler, protractor, craft knife, lino-cutter and gouges

- inks or paints

- computer with internet access

- school and public library access.

104

Introduction to printmaking

Printmaking produces art using the process of **printing**. When we print, each image is an original because it is not a copy of the first image. Many originals can therefore be printed from one surface. Each transfer of ink or paint is referred to as an impression, and the set of impressions that is made is called an edition. The surface on which the ink or paint is applied is called the block, plate or matrix. In order to print, you must find or create a block, ink the block, then transfer the image to another surface.

A block may be made from either natural or man-made materials. Naturally occurring materials include vegetables, wood, metals and stone. Man-made materials include paper, plastics, fabrics, glass, plexiglas and linoleum. Some of the materials can be used in their original state while others must be manipulated. Leaves or the palm of your hand make interesting prints just as they are. Other materials are often manipulated: for instance, paper may be crumpled, fruits and vegetables may be cut, metals may be scratched and linoleum may be carved. Some materials are chosen over others because there are tools and materials available that can cut into them efficiently.

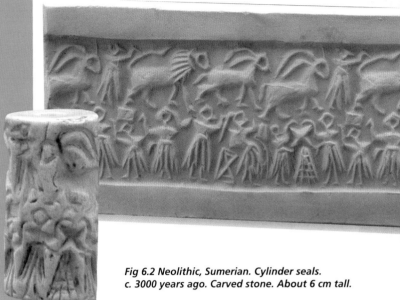

Fig 6.2 Neolithic, Sumerian. Cylinder seals. c. 3000 years ago. Carved stone. About 6 cm tall.

Key terms

printing: the transfer of an image from one surface to another

engraving: artwork incised or cut into a surface

relief: a sculpted form projecting from a surface

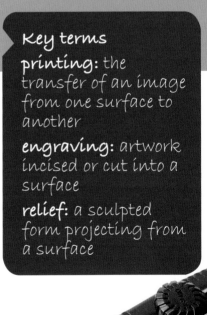

History of printmaking

Early printmaking

Printmaking was practised by pre-historic man. It was done through the process of applying paint to hands and transferring to cave walls, and by **engraving** on walls and stone. After drawing, the engraving technique was perhaps the next most popular way of representing images. Across the world there are many sites, most especially caves, where engraved art has been preserved. Later, the Sumerians, who lived 3,000 years ago, made engravings of religious rituals and mythology on stone cylinder seals. These seals, which were from two to six centimetres tall, were used to stamp their documents. The cylinders were rolled over envelopes, clay tablets and clay building blocks to leave an impression in **relief**. Because the prints were made from a cylinder-shaped block, the length of the prints could be easily varied through the continuous rolling of the seal. This activity coincided with the early settlement of humankind into ancient city states, and the prints most probably marked ownership of property. Today similar practices are used to create prints, such as stamps, on original documents. Perhaps you have seen such a stamp.

Chinese printmaking

About 1,800 years ago the Chinese had developed the first prints, using paper to create their images. The use of paper signalled the birth of printmaking as we know it today. The text from their scriptures had been carved into large flat stones for study. Later, they learned to press paper into the incised areas of the stone using a technique called 'stone-rubbing'. This caused the image to be transferred onto the paper. The Chinese are also credited with the invention of the **woodcut**. The earliest known woodcut image is the Buddhist Scroll, housed at the British Museum in London.

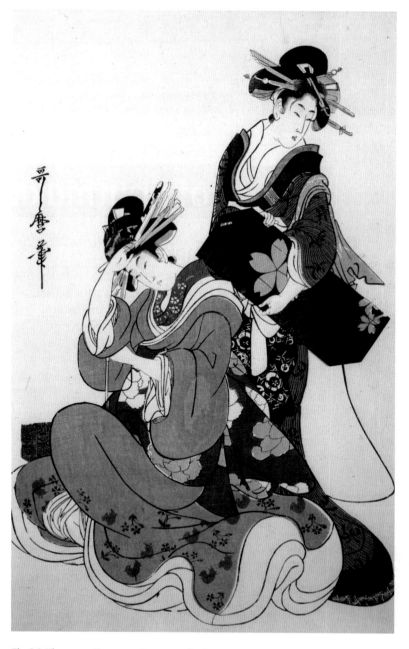

Fig 6.3 Kitagawa Utamaro. Two Female Figures c. 1800. Colour woodblock print, 12th block. 36 x 25 cm.

Key terms

woodcut: printing block made from wood

commissioned work: artwork requested of an artist, for which he or she is paid

Japanese innovation

During the 8th century, the Japanese were producing scrolls for their temples. The empress at the time **commissioned** an edition of one million prints of a Buddhist chant for distribution. By the 11th century, the Japanese were producing books with printed text and images. Printing techniques spread across the known world owing to increased trade, and the quantity of editions also grew.

Renaissance period

Paper mills were well established by the 15th century, and with them came the first woodcuts in Europe. Prints were popular for playing cards, and then were later used for books that contained both text and illustrations. During the Renaissance, the works of Albrecht Dürer, in particular, brought printmaking into the fine arts, and encouraged the teaching of printmaking using the techniques of engraving, etching and woodcuts. **Examine Figure 6.1 and comment on the use of line and shape and the level of detail in the print.**

Japanese Ukiyo-E

During the 18th century, the Japanese again came to the forefront of printmaking, introducing a distinctive style called Ukiyo-E. The prints were well known for their unusual design, appealing use of colour and thoughtful composition. They included prints made for postcards, home décor, fashion and theatre advertisements. Printmaking, by this time, was fast becoming an established commercial enterprise. **What comments can you make about the use of line and colour in the print shown in Figure 6.3? How does it compare to Figure 2.18 in Chapter 2.**

Printmaking today

Today, printmaking has evolved to include four main processes. These include relief, incised, planographic and seriographic (see **Table 6.1**). Each of these processes may be used to produce various types of prints that may be transferred to an array of surfaces for numerous purposes. The field has become so demanding that most artists tend to specialise in one printing process and type in order to master the techniques involved. Prints of today are based on almost all aspects of life and imagination. Once an idea is drawn, it can be printed. **Comment on the artist's use of the elements of art in Figure 6.4. What shapes or objects can you recongnise?**

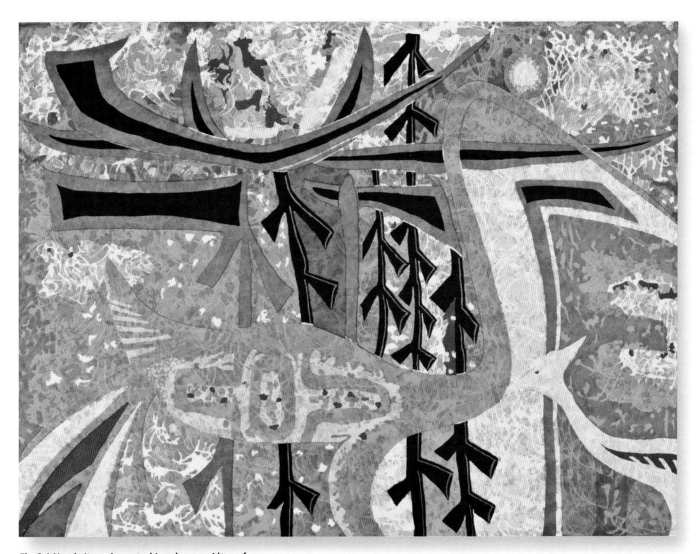

Fig 6.4 Norris Iton. Ancestral Landscape: Altar of Life. 1996. Seriograph. 45 x 60 cm.

Printing processes

Each of the four printing processes has sub-types that achieve varying results. Conduct some research to find out about each of the four types of printmaking processes. Pay particular attention to the relief and incised processes because they are more important for you to understand.

Relief block printing

A relief print is created from a raised surface called a **relief block**. A design is drawn on a flat surface, and then the block is cut, using the design as a guide. The (negative) areas around the design are removed. This is done by cutting into the surface, then chipping away so that the level of the plane that is cut away is lower than the level of the plane of the actual design. Refer to 'Creating postive and negative prints' at Stage 10 of the lino-cut printing process in this chapter. Ink or paint is then applied to the designed surface (block) and pressed onto another surface (paper) so that the image is transferred. A rubber stamp is an example of a **relief print**.

A variation of this may be achieved by cutting away the actual drawing after the design is transferred to the flat surface. The areas that are inked or painted will represent the parts around the actual design. When the image is transferred, the colour appears around the design, creating a negative print. Refer to the topic 'Creating positive and negative prints' on page 118 of this chapter.

Key terms

relief print: an artwork created from an elevated surface used for printing

relief block: an elevated surface used for printing

Table 6.1: Printing Processes and sub-types

Relief	Incised	Planographic	Seriographic
Aquatint	Collograph	Lithograph	Screen print
Drypoint	Linocut		Stencil print
Engraving	Woodcut		
Etching			
Mezzotint			

Fig 6.5 Judy Thorley. Ballerina. Monoprint.
Watercolour and oil. 30 x 18 cm.

Key terms

plate: printing block
made from metal

incised block: a pattern
cut into a flat surface
used for printing

Incised block printing

Another name for the **incised block** print technique is 'intaglio'. An incised print is created from grooves that are cut into a surface. The grooves or incisions form lines. These incised lines are filled with ink, then paper is placed over the surface. Pressure is applied to force the paper into the incisions, transferring the inked lines. One feature of incised prints is the embossed or raised edges that remain from forcing the paper into the incisions of the block or **plate**.

Mono-printing

'Mono' means one. **Mono-printing** is a technique that produces only one print because the ink or paint is transferred from a flat surface. Because the surface is neither in relief nor incised, repeating the exact location of the ink or paints is impossible. In this way, a mono-print is very much like an original drawing or painting that cannot be repeated. You may wish to begin your introduction to printing by creating a mono-print, because the procedure is simple to follow. Mono-printing will help you to learn and refine your understanding and skill in applying colour, transferring the image and improving the quality of the **registration**.

Key terms

mono-printing: printing process that can produce only one image

registration: the quality of the impression of the printed image

Stages in the mono-printing process

The printing process has ten stages that are intended to help you to create your own linocut prints. You will begin with what to research, selecting a topic, transferring your design, cutting the block, trial printing, refining the process, printing an edition of three, presenting your work, making a journal entry, and considering ideas to include or improve the next time you print. Along the way, you will also be reminded about using the elements of art and the principles of art and design.

1. Research printmaking techniques and process

Refer to **Chapter 16** to guide your research for Stage 1 of your **mono-printing** process. Discuss, too, the effect created in the mono-print in **Figure 6.5**.

2. Create your picture

You may wish to create a picture based on a drawing, a painting, a form or model, or from your imagination. Although inks are preferred, you may use paints in as many colours as you wish; however, one or two colours are recommended to begin with. The picture you paint must be on a flat, non-porous surface such as glass or plexiglas. Such surfaces do not absorb the paint. Use paintbrushes, a sponge or your hand to spread the paint. The paint should be neither too fluid nor too thick. Instead, try to lay the paint flat and keep the colours strong and vibrant. Your picture should be about 20 cm x 15 cm in size.

3. Transfer the image

The paper you use to transfer the image should be larger than the picture you wish to transfer. A suitable guide is to ensure that there is a 10 cm edge all around the image. Carefully lay the paper over your painting. Stand over the picture holding the paper taut. Gradually lower the paper onto the picture so that the entire area of both surfaces (the picture and the paper) come gently into contact. Use a roller to apply pressure uniformly over the paper, causing the image to be transferred. The roller pushes and spreads the paint as it goes, so if you use too much paint it will smudge your image. Leave the paper in place for a few seconds, then remove it by gradually peeling it off from one side. Allow your print to dry.

4. Present the artwork

Make a mat for your mono-print (refer to **Chapter 17,** page 277). Name the mono-print and present it. Be prepared to explain what you did and what you have learned. Maybe there are some things that you may have to correct the next time around. **Compare your mono-print with those of your classmates and comment on the prints.**

Examine the prints to see whether the paint was sufficiently well laid and gave a sharp image with all the details you desired. If not, maybe there was too little or too much paint. Repeating your mono-printing exercise gives you the opportunity to perfect the process.

5. My art journal entry

Refer to **Chapter 16** to guide your art journal entry for Stage 5 of your mono-printing process.

Key term

mono-printing: printing process that can produce only one image

Did you know?

Linocuts are made from linoleum which was invented in the 1860s. The material is preferred by printmakers, because linoleum is softer and this makes it easier to cut into. Unlike wood, it does not have any grain, and therefore the cuts can go in all directions. It is also less time-consuming to make a lino-block. Renowned artists Henri Matisse and Pablo Picasso used linocuts effectively.

Stages in the lino-cut printing process

1. Research printmaking techniques and processes

Refer to **Chapter 16** to guide your research for Stage 1 of your linocut printing process. Use your knowledge of the elements of art to describe the linocut print in **Figure 6.6**.

2. Select the topic, theme or brief

Because of the many skills that are involved in the process, it is advisable to begin with a simple design, perhaps a geometric shape such as a rhombus. As you progress and your confidence grows, you can use more detailed designs. First, consider the area of your lino-block. A good size to begin with is 15 cm x 15 cm. It is useful to cut out a few pieces of paper to this size and draw sketches of your rhombus (or other selected shape) on them. Manipulate the drawing of the rhombus on each piece of paper. Examine each shape you have manipulated against its 15 cm x 15 cm square outline.

Key term

off-centre: the position of an object near, but not precisely at, the middle of a surface

Fig 6.6 The Author. Sails. 1993. Linoprint on paper. 15 x 15 cm. Attic Arts.

- Look at the size of the positive space occupied by the rhombus, and compare it to the size of the space left outside the rhombus (negative space). Increase one to decrease the other.

- Look at the direction of your rhombus. Did you draw it 'standing' on its vertical axis or 'lying' on its horizontal axis? Try doing both to see which you prefer. You may wish to draw one or two rhombuses on an axis that is at 45 degrees to the vertical axis. A protractor will help with your accuracy.

- Check the position of the rhombus on the paper. Would you prefer it exactly in the centre or perhaps shifted a bit **off-centre**? Consider the element of shape and the principles of proportion and balance discussed in **Chapter 1**.

You may have realised that the skills you just used are those for creating good composition, and that they were introduced to you in **Chapters 4** and **5**. As you continue to use space, these decisions will become easier to make and to explain. Always ensure that you can tell someone why you made each of your choices. It is useful to keep all of the drawings you made as you worked towards your final piece.

3. Transfer the design

Some detergent in hot water may be brushed onto the lino-block to remove any film left on the surface. This ensures that the ink or paint you use will hold to the surface of the lino-block later on. Allow the lino-block to dry.

Select the design that you find most appealing and that best fits your brief. Carefully transfer your design to the lino-block. Because we worked on paper that was the same size as the lino-block, your **scale** is 1:1, or actual size. This means that the image you will produce from your block will always be identical in size to the block itself. Now examine your drawing to see whether it is what you intended. You may need to make adjustments. Use your sense of observation and your tools to help you along.

Finally, be sure to colour the area of the rhombus you wish to cut or gouge out. Coloured pencil may be best for this.

Fig 6.7 Two variations by size of the design on a lino block.

4. Cut/gouge the block

To begin with, you may wish to affix your lino-block to a flat solid wooden block. Light glue is best but pins may also work. Do not over-use either. Affixing the lino-block keeps your working surface stable and also prevents any cutting that is too deep from causing damage to the table on which you are working. The best tool to use is a lino-cutter, which comes with different shapes and sizes of blades designed for cutting.

Determine the thickness of the cut or gouge that you wish to make. For your first attempt, you may wish to use one smaller-sized gouging blade throughout. However, later on be sure to experiment with different widths, depths and angles of your gouges to produce varying widths and depths in the cuts you make. Learn to hold and manipulate your lino cutter.

Use a soft pencil or marker to colour lines or spaces that you wish to cut away. The thickness of these new lines will determine the size of the blades you need to cut your block. Later on, with more intricate cuts and details, your lino-block may not be finished in one session of cutting. This gives you time to think your design through between sessions.

Fig 6.8 Two variations by direction of the design on a lino block.

> **Key term**
>
> **scale:** the relative size used to represent an object (such as a country, a person, a bottle) on another surface (for example, a map, a three-dimensional model, a billboard or sketchpad)

> ## Did you know?
>
> The scale you choose may be smaller or larger than the actual object. For instance, you may create a design for printing a beetle that is larger than the actual insect, but the one you would use for our solar system will obviously be smaller. Choosing the right scale will ensure that the principles of balance, contrast, emphasis, harmony and unity are achieved in your work. **Chapter 7** discusses the use of a grid to maintain an accurate scale drawing.

5. Print a trial

Next, ink the block. Squeeze out a bit of ink onto a smooth surface. A 30 cm x 30 cm glass or plexiglas sheet is suitable. Use the roller to spread the ink across this surface. Make forward and backward rolls, then side-to-side rolls, until the ink is well and evenly spread on the roller. Begin slowly, then increase your speed only slightly. Applying the ink should not be too hurried. In the end, you should have spread the ink over an area that is a bit wider than your roller and about 20 cm long.

Ink that is rolled out dries quickly, so you need to be ready to ink the block. Place the roller with ink on the lino-block and roll in a similar manner as described above. Change directions to ensure that the transfer is uniform. Look carefully to see if any ink has gone on to the gouges where it should not. Use the cutter or craft knife to remove any unwanted ink. Again, extreme care must be taken. However, if there is too much unwanted ink you may be better advised to wash off the block then reapply the ink. Sometimes the block may require re-cutting in some areas before you apply ink again. Place the paper you wish to transfer the image to onto the inked lino-block. The procedure is as described for mono-printing, earlier. Avoid sliding the paper onto the lino-block or it will smudge. Once the paper is flat on the surface of the block, use another roller to apply pressure evenly (**see Figure 6.11**). Stand over the block to achieve the best result. Another method of transferring the ink is achieved by placing the paper down first, then pressing the lino-block, face down, onto the paper. You may grow to prefer one method. However, for printing on fabric the second method is suggested. Tacks can be used to stretch and hold your fabric tautly in place to ensure proper transfer.

Care must also be taken when separating the block from the paper. Lift directly upwards. Do not allow any part that is lifted to again come into contact with the other surface. Clean the surface of your block carefully. You will definitely need it again. Do not allow any ink to harden on it. Examine your print for evidence of adjustments that may have to be made.

Fig 6.9 Two variations by position of the identical rhombus. First- on centre, next- 2 cm off centre to left on square.

Helpful hint

Be very careful in your handling of these tools. Read instructions and listen to your teacher's advice. Fix the tool to the handle securely before beginning to cut. Always cut by pushing away from your body. Stand while cutting so that you can exert and vary your force, and so that you can actually see the point of contact between the tool and your lino-block. Use your non-cutting hand to hold the block firmly but keep your fingers alongside and not too close to the point of contact of the blade to the surface.

Refer to the accompanying CD-ROM for tips on safety in the classroom.

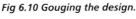

Fig 6.10 Gouging the design.

6. Refine the process

a) Design

Every printmaker faces the possibility that what was intended from the design is not what was produced. Applying the ink not only shows up what is good and skilfully done, but also what is not so good and could be improved. Keep the trial print(s) next to your block. Compare them constantly to determine which parts of your design need to be improved. You may wish to examine the following:

- **The design itself.** Was it well drawn? Are the lines and shapes accurate? Use your previous sketches to improve it.

- **The transferred drawing which has been cut.** If too little has been cut away, you can always re-mark, then widen the cuts on your block. If, however, too much has been removed, you have no choice but to cut another block.

- **Adding design interest.** Perhaps you are happy with your design, but it appears too plain. Maybe another design can be placed within or around the original design. Be sure to sketch first, to 'add' to your first design idea.

- **Variation of cuts.** You may wish to enhance your work by experimenting with a variety of cuts. Perhaps use one gouge for the outline of the design and another for cuts within the design, or to add a texture within or around your design.

b) Registration

Good **registration** means that the image quality is convincing and pleasing to look at. The design and cuts reflect careful use of the elements of art. In the beginning, you should aim to create designs that display good use of line and shape. Small cuts can provide good textural effect. Plan them into your design first, or if a good idea comes while you are cutting, draw it into your sketches. Have a good look, decide whether it should be considered for your design, then continue cutting. The principles of art and design must also be evident. In the beginning, try to focus on the balanced use of space and perhaps move towards including variety through the cuts you make. Use more than one gouging tool to cut in different directions, depending on the needs of your design. To improve the overall quality of your registration, pay attention to these points:

- **The spreading of the ink.** Perhaps too little or too much ink was used. Did you apply sufficient ink to the entire lino-block? Was it applied evenly? Did the ink begin to dry out before you began the transfer?

Key term

registration: the quality of the impression of the printed image in printmaking. Design, use of colour and quality of print are key to good registration.

Did you know?

Any image you print from a block appears in reverse, or is laterally inverted. The artist must therefore keep this in mind as she designs. To illustrate this point, create a block with your first name. Each letter should be drawn in reverse, and all the letters will appear in opposite order, the first letter appearing last when read from left to right. Now print your name.

- **Ink transfer.** Were some areas of your image of a better quality than other areas? Perhaps the pressure on the roller was not even throughout. Maybe an area that was gouged out was really too large, causing a 'sink-in' effect that warped the edge of the image. Was any unwanted ink completely removed, or did you excitedly rush to transfer the image? If there is ink in areas where it should not be, maybe the cuts you made were not sufficiently deep.

- **Lifting the print**. If you are lifting the print off the block, was this done from one side of the paper and in a fluent action? Did the **image** accidentally make any further unwanted contact with the block? Did you slide the paper rather than lift it off? If you are lifting the block off the paper, did you lift directly upwards? Did you hold the paper down firmly as you were doing this? Did you slide the block along the paper?

After considering these points on your trial print, you can now do another to see your improved effort. If you are quite satisfied, move on to the actual printing.

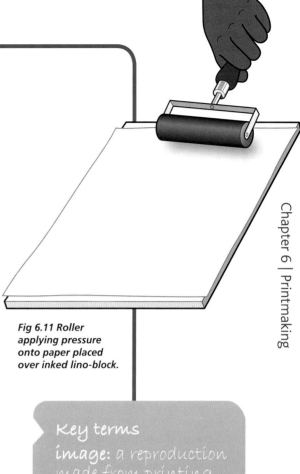

Fig 6.11 Roller applying pressure onto paper placed over inked lino-block.

7. Print an edition of three

One practice of printmaking is to establish and maintain the quality of the design and its registration over a set of prints. The set of repeated images is called an **edition**. Remember that each image is considered an original. The quality of the edition is judged by the extent to which the images printed are identical to one another. For now, you will attempt an edition of three images. All you need to do is repeat the process for printing after you have refined the trial block. You may wish to repeat this five to ten times, and then select the three images that are of highest quality for presentation.

Key terms

image: a reproduction made from printing

edition: a series of images printed from the same block

Fig 6.12 An edition of three prints.

8. Present the edition

A nice way to present your works is to mat them (refer to **Chapter 17, page 277**). You may choose to do this separately or to cut a mat with three windows so that you emphasise the repeated quality of your work. Either way, ensure that you number each image within the edition.

A common way of doing so is to write your name, the date of the print and the number of the print within the edition: for example, the first print in your edition of three prints is named as '1/3'.

Do not discard the remaining images. These are equally important for your teacher to assess the amount of effort you put into your thinking, the design ideas, the cutting of the block, the trial, the refinements, and the selection of the best prints. Another useful idea is to photograph your work at the various stages of development. This will create a photo essay of what was required and how skilful you were at doing it. Most importantly, these photographs will provide you with an idea of the areas where you may need to improve the next time around.

Be sure that you can say what you did and explain why. Use your understandings of the elements of art and the principles of art and design you were introduced to in **Chapter 1** to help you along.

9. My art journal entry

Refer to **Chapter 16** to guide your art journal entry for Stage 9 of your printmaking process.

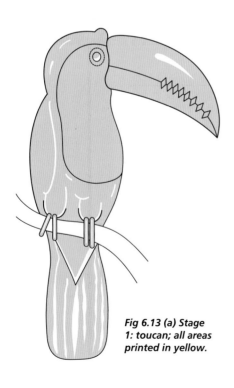

Fig 6.13 (a) Stage 1: toucan; all areas printed in yellow.

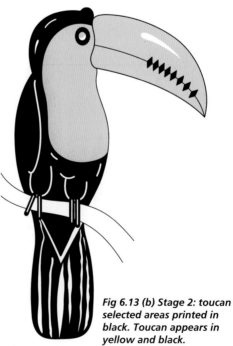

Fig 6.13 (b) Stage 2: toucan selected areas printed in black. Toucan appears in yellow and black.

10. Make another linocut

Your effort at printing does not end here. It is now time to begin another. This time, however, you have the experiences of your first effort to help you. All that you have done will prove invaluable. Keep the prints handy so that you will know what to do and what to avoid in order to improve. Here are some ideas that you may wish to incorporate next time.

a) **Adding more details**. The rhombus you printed was a simple outline. Maybe you could be more adventurous and place another shape within or around the first shape. This may be possible either at the beginning of the design process or, in some cases, after initial printing.

b) **Designing based on an object or theme**. The rhombus was a print based on a simple geometric shape. Perhaps you wish to design for printing a fruit or your pet. Or maybe you can create an idea for 'In Space' or 'The Fisherman'. Be careful when you plan that you do not go for too much or unnecessary detail. What is easy to draw may be much more difficult to cut away.

c) **Using more than one colour**. Try two colours first. It is a good idea to use black and a much lighter hue such as yellow. You will need to pay particular attention to where each colour will appear, and be able to say why. This procedure is a bit more complex as you must transfer the image as many times as you have colours. For instance, with yellow and black, the yellow ink is registered first, and then cleaned off the block. The areas where yellow ink was applied are now cut away, leaving only the areas on the lino-block where you need only the black to appear.

Next, apply the black, which easily covers the yellow areas that were registered first. This is called the reduction method. Be sure to make many more (about 20) prints with the yellow before moving on to cut away at your block. Remember, once you cut away an area of your block it is gone for ever! Another important point to note is that the lighter hue is always registered first. This is done because a darker colour can register over a lighter one, but a lighter one cannot be registered over a darker. Ensure, too, that before you register the black, the block is well aligned to the surface you are printing onto. This prevents the black ink from missing its mark. Using a standard size of paper and a pencil to mark lines to guide where the block comes to rest will help. **Figure 6.13** shows an image using two colours, one printed over the other.

> **Key term**
>
> **reduction method:** the cutting away of parts of the block after the registration of a colour, but before printing the next colour.

Creating positive or negative prints

The rhombus you designed may have created either a positive or a negative image. A positive image is created when the actual object of your design, such as the rhombus, contains the ink. A negative image is created when the actual object does not appear as the inked surface.

To begin with, creating either a positive or a negative image must be planned from the beginning, in Stage 1, where you research the printmaking process. After you have selected your topic in Stage 2, illustrate your image using both the positive and negative images in order to compare them.

This is quite simple. In both illustrations, there are areas to colour for cutting away, and there are areas to leave blank that you wish to keep as your design. On the positive image you will colour and cut away parts around the design. On the negative image, you will colour and cut away the parts that you did not colour and cut on the positive image.

You may find that you prefer one method or the other for various reasons. Remember to list these reasons and keep the illustrations to add to your art journal.

Ideally, you are advised to experiment with both positive and negative blocks. You will find that the areas you cut away and the areas you apply ink to are in direct contrast. This is best observed if you cut both a positive and a negative block for the same design, print with them, then compare. **Comment on Figures 6.14 (a) and (b)**. Positive and negative spaces are further discussed in **Chapter 13**.

Activity

Follow the Stages (1 to 9) described above to create your own lino-print. You may wish to use a rhombus or any other geometric shape for your first lino-cut design.

Observe and compare the prints that you have created with one another and with those of your classmates. Include these observations in your art journal.

Now go to Stage 10. Be a bit more adventurous in your selection. Perhaps you may select to:

a) add more details and interest to the shape used in your first printing effort

b) design from an object or a theme, rather than a shape

c) use two colours in your design

d) create a positive and a negative print based on the same shape, object or theme

e) combine ideas from any of (a) to (d) above.

Fig 6.14 (a) Orange as a positive image.

Fig 6.14 (b) Orange as a negative image.

Chapter summary

In this chapter you have learned to:

- trace the history of printmaking
- explain and use terms associated with prints and printmaking
- follow the stages for creating your own prints
- introduce ideas that will further develop your skill in creating prints
- apply your knowledge and understandings to speak and write effectively about prints and printmaking.

Activities

Individual

1. Use one of your hands to produce a sequence of ten palm-prints demonstrating varying positions of your palm. Print in one colour only. Try labelling each position with an emotion or mood: for example, happy, sad, afraid, excited, curious, thoughtful, unsure. Think of some others!

 You may want to repeat this activity using improved positions and different colours for each image.

2. Use lino-blocks to:
 a) create an edition of three prints of your school's logo or monogram
 b) re-design your school's logo or monogram and make an edition of three prints
 c) design a new logo or monogram for your school and make an edition of three prints.

3. Use vegetable blocks to:
 a) create designs for a greeting card based on any occasion or theme
 b) make a greeting card using printing techniques for the images
 c) design a logo or monogram for a new school and make an edition of three prints
 d) examine your first card, and then produce another that demonstrates an improvement in theme; use of materials; selection of lettering and illustrations; size of blocks and card; use of colour; arrangement and distribution of space.

Group

4. Cut paper in squares of size 25 cm x 25 cm. Print your palm. Combine all the prints from your class to create a collage (see **Chapter 13**) to exhibit as an 'artistic autograph' for your class. Discuss the work in class, then make an art journal entry.

5. Select a theme, for instance 'Caribbean Carnival' or 'Technology today'. Create a design for a picture of size 60 cm x 90 cm. Individual students may create printing blocks for selected parts of the picture. Print the picture. Discuss the work in class.

 In your art journal, write about the process and how your group members all involved themselves.

Integrated

6. Use as many trial prints as possible from other printing activities to create the longest sequence of combined prints that you can. Make the width 20 cm. Measure the length of your sequence.

 Compare it with sequences made by other classes at your school to establish the record for your school. Perhaps combine all your individual class projects to increase your overall school record.

 Compare this with records at other schools to establish a National School Record. Encourage the media to visit and publicise your art. Be sure to have a written statement about the project, and nominate a student or two to be interviewed as representatives for your school. Think about how learning from other subject areas may help you to promote this activity. Have you ever wondered whether Guinness keeps a record for the longest sequence of picture or print images?

Art appreciation

7. Use any suitable printing technique, or combination of printing techniques and processes, to create a unique gift-wrapping paper for a special occasion for someone of your choice. The design should relate to the person in some meaningful way: for example, the person's hobby, job, favourite movie or book.

 Present your gift-wrapping paper sample (minimum 40 cm x 30 cm), and discuss how the printing process was combined with your ideas to create a wrapping design that will be appreciated by that person.

 More activities for this chapter are included on the accompanying CD-ROM.

Chapter 7

Graphic Design

Outcomes

After reading this chapter and practising its activities, you will be able to:

- define, explain and illustrate the term 'graphic design'

- trace the development of graphic design

- list, understand and follow the process to create your own graphic designs

- use your understandings and key terms to effectively speak and write about graphic design

- apply theory, understandings and skills from other chapters to complement your designs

- criticise a graphic design and its applications.

Resources

You will need:

- notebook, art journal, pencils, coloured pencils

- paper, craft knife, stencils, set squares, protractor, compass, T-square

- paints, paintbrushes, markers

- computer with internet access

- school and public library access.

Introduction to graphic design

Graphic design combines lettering and **illustration** to communicate a message to others. Lettering refers to the written alphabet to which you are accustomed. The letters of the English alphabet may be written in the upper or lower case, and may be written in any of many styles called letter **fonts**. Illustration refers to the image that is used along with the lettering (words). The lettering and image combine through the use of a shared space, to communicate a message in a unique way.

Graphic designs are found all around us. They include maps and diagrams; logos and monograms; signs and billboards; labels and packages; advertisements and posters; newsletters and brochures.

The message of a graphic design must be clear, cost-effective, accessible and relevant. When used effectively, a graphic design can become a very powerful tool for sending a message. An effective and eye-catching graphic design shows good judgement in selecting a letter type and image or illustration suited to the message you wish to send. But more than that, the lettering type for the text and the image must share their space harmoniously.

Graphic designers are therefore often employed in the media and industries where advertising is regularly used. The designs they do have been further developed through the use of computer-aided design. Graphic designers now have the opportunity to select lettering and illustrations from those that exist in software programmes. As a result, more attention may be given to the use of the elements of art and the principles of art and design in creating the composition of the graphic design. **Can you give some examples of types of media and industries that use advertising regularly?**

Fig 7.1 The Author. Attic Arts Information Card. 2001. Computer Aided Design on board. 5 x 9 cm. Attic Arts.

History of graphic design

Early Sumerian writing

The first form of writing was done by the Sumerians of Mesopotamia and dates back more than 5,000 years. Their **cuneiform** writing, which consist of small drawings called **pictographs**, was engraved on clay and limestone surfaces with a pointed tool called a **stylus**. As this first society settled, it became necessary to record ownership and trade and it is thought that this is how recorded writing began. If the clay was fired, the writing became a permanent record. Later, the writing evolved to be read from left to right and was arranged in horizontal rows. The **hieroglyphics** of the Egyptians developed in a similar manner to the Sumerian cuneiform. **Observe Figure 7.2. What basic shapes we use today can be seen? How do these images compare with Figure 4.3 in Chapter 4?**

Fig 7.2 Sumerian. The Kish Tablet. c. 5500 years ago. Engraved limestone. 30 x 50 cm. Ashmolean Museum, Oxford, England.

The first prints and books

The first printed graphic designs were done by the ancient Chinese. Very early on, they carved images from their holy texts on large flat stones for printing. Later, when paper was invented about 1,900 years ago, text was written on thin sheets of paper that were then glued to wooden blocks and the letters and symbols were carved out to make wood-blocks for printing. In time, 'block-book' prints, in which both the written language and accompanying pictures were made from a single woodcut block, were used as an early printing method. The first printed book, the Diamond Sutra, was also created in China in the 9th century, nearly 1,200 years ago. The prints were made from woodcuts. **Chapter 6** discusses the types of blocks used for printing. **Notice the writing and images in Figure 7.3.**

Fig 7.3 Chinese. The Diamond Sutra: Buddha preaching to disciple Subhuti. 868. Woodcut ink print on paper. 500 x 30 cm. British Museum, London.

Middle Ages: illuminated texts

Almost a thousand years after its invention, paper became known in Africa, then Europe. The importance of writing was established and many different styles, or 'hands', began to emerge for writing beautifully. Illuminated manuscripts became popular, and writing began to be transformed into an art form. The first capital letter and page borders of handwritten texts were usually illuminated. Religious texts with decorative writing and images were created at first, mostly in monasteries, which were the storehouses for knowledge then. Some examples of writing were so elaborate that they were actually painted using gold or silver. Later, other non-religious writing also became illuminated, and with this came the use of non-religious motifs. **Figure 7.4 is an example of printed illumination. Comment on the font used and the decorative details.**

Development during the Renaissance

During the Renaissance, printing on paper became popular in Europe. The invention of the printing press increased the output and quality of printed materials. The printing press was a machine that applied pressure to an inked surface and onto the paper to register the image. Printers partnered with paper mills and made printed materials available for mass reproduction, and so the age of commercial graphic design was born. This meant that printed materials such as advertisements and announcements, fliers and books, became more available. Design for these purposes became a profession, which employed printmakers and graphic artists. **Comment on the elements of art used in the machine-printed design of Figure 7.4.**

Fig 7.4 Literature. Psaltery of Mains. Mainz, 1459. Chapter 69, book, fine arts illumination, 15th century. Printed by Fust & Peter Schöffer.

Graphic design in the 19th century

During the 19th century, the Art and Crafts Movement published books with a very high quality of image and text. There was a ready market for these machine-printed books, and so graphic design as a fine art form was separated from the other fine arts.

The Industrial Revolution was noted for its mass production in factories, driven by increased human labour and machinery. It required cheap, quick and widespread advertisements. The poster became the graphic designer's main tool for this, advertising jobs, products and services. The power of the poster became fully recognised, especially for buying and selling, because of its influence on ordinary people. And so the use of colour and eye-catching images became more and more appealing.

The influence of Japanese prints

Posters and prints also helped to change trends in the fine arts. The Ukiyo-e prints of Japan (**see Figure 6.3 in Chapter 6**)not only influenced painters like Degas and Toulouse-Lautrec but also brought a new approach to **illustration**. This new approach added new ideas to the way printed advertisements were made and newspapers and books were designed, but also encouraged other uses such as greeting cards and labels. **Figure 7.5 shows a poster designed by artist Henri de Toulouse-Lautrec, for a show. Discuss the impact of the image and the text. Note the amount of text used and the use of space for image and text.**

Fig 7.5 Henri de Toulouse-Lautrec. Troupe de Mlle Elegantine. 1896. Poster.

Key term
illustration: an artwork inserted in written text to explain or beautify

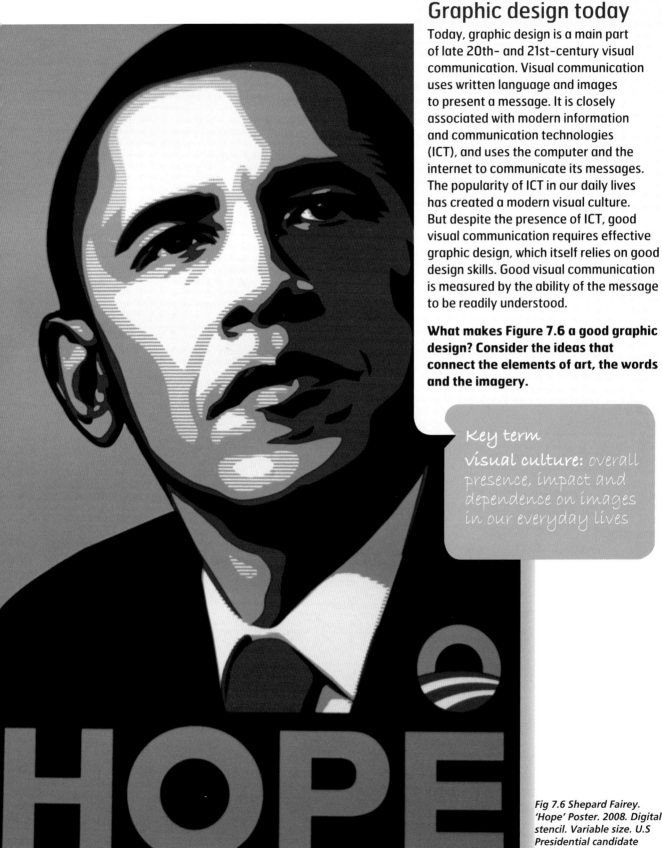

Graphic design today

Today, graphic design is a main part of late 20th- and 21st-century visual communication. Visual communication uses written language and images to present a message. It is closely associated with modern information and communication technologies (ICT), and uses the computer and the internet to communicate its messages. The popularity of ICT in our daily lives has created a modern visual culture. But despite the presence of ICT, good visual communication requires effective graphic design, which itself relies on good design skills. Good visual communication is measured by the ability of the message to be readily understood.

What makes Figure 7.6 a good graphic design? Consider the ideas that connect the elements of art, the words and the imagery.

Key term

visual culture: overall presence, impact and dependence on images in our everyday lives

Fig 7.6 Shepard Fairey. 'Hope' Poster. 2008. Digital stencil. Variable size. U.S Presidential candidate Barack Obama campaign poster.

Categories of graphic designs

There are many types of graphic designs, used to give a different amount of information to the viewer. Here are some for you to consider. Pay close attention to their use, content and the relationship between the text and images that appear on them. Collect a few examples of each of the types in **Table 7.1**. Perhaps you can think of some other types of graphic designs and get some examples.

Table 7.1

Graphic design type	Function/use/purpose	Criteria	Example
Logo	A design intended to identify its subject: a person, group or institution	i) reflects its subject ii) is compact and clear iii) is usually more image than text iv) can be reproduced in any size v) usually uses between one and three colours	
Invitation	Generally to inform about a social activity	i) reflects the event ii) is compact and clear iii) usually has more more text than image iv) bears specific information about the event v) is usually in one colour	
Greeting card	Used to celebrate or acknowledge an occasion	i) reflects the occasion ii) may contain verse or poetry iii) has a balance between image and text iv) draws emotion v) generally folds vi) is made from card or paper	
Information business card	Used to introduce a subject in a specific field, for example an artist or salesperson	i) gives selected information about the subject ii) usually has more text than image iii) contains follow-up information iv) is pocket-sized v) is made from card	
Flier	For a relatively inexpensive and quick passage of information	i) contains selective information in an eye-catching manner ii) is usually passed by hand iii) may have a varying ratio of image to text iv) is a single sheet	

Graphic design type	Function/use/purpose	Criteria	Example
Brochure	Provides specific information for a special event, usually for commercial purposes	i) reflects the event ii) is eye-catching iii) contains clear description and details of items/contents iv) may have a varying ratio of image to text v) may be of variable/unusual sizes vi) is multi-page vii) is made from paper or card viii) is usually richly coloured	
Magazine	Gives a wide range of information on issues that generally appeal to a particular audience	i) contains a variety of information ii) is audience-specific iii) has text mixed with multiple images for visual appeal iv) is detailed and informative v) is multi-page vi) is bound	
Newsletter	A cross between a newspaper and a magazine	i) highlights events, activities and achievements, giving fair detail ii) has a selective target group iii) is a few pages in extent, with or without a cover	
Print media advertisement	Provides specific information for a wide general audience; includes commercial and non-commercial activities	i) specifies a single purpose ii) is eye-catching iii) ratio of image to text varies iv) contains follow up information	
Map	Provides information for locating a place in relation to other places	i) image covers a specific area, as a plan or bird's eye view ii) contains a legend or key for identifying specific sites or characteristics iii) text names locations iv) scaled and generally detailed	
Label	Identifies the contents of a container	i) gives specific information about a product: name, producer, details ii) sized relative to package iii) ratio of image to text varies iv) may contain warnings and instructions v) wide range of materials, shapes and designs	

Designing to scale

Scaling your drawing

The objects that the artist uses as references to make visual art are seldom the size of the drawing, painting, sculpture, print or graphic design that is made. The object is drawn to scale, either larger or smaller in size: for example, a landscape scene is reduced to be represented as a painting, while an insect may be enlarged to create the block for a lino-print.

In the area of graphic design, repetition and reproduction of the design are major concerns of the designer. This is because the design may have to be reproduced on a variety of surfaces that are required for advertising and marketing, manufacture, packaging; and promotions. For instance, a logo on a fast-food box may also have to appear on a paper napkin and on a billboard. For each of these spaces, the graphic design remains the same except for its size (dimensions). An **enlargement** or **reduction** requires a scale to maintain the exact proportions while you change the size. The **scale** ensures that both dimensions (length and width) are manipulated in equal proportion to their original measurements. **Figure 7.7** (a) shows the letter 'L' at actual size, a scale of 1:1. In **Figure 7.7** (b) the shape is reduced to a scale of 1:2, while in **Figure 7.7** (c) the same shape is enlarged to a scale of 2:1.

Key terms

scale: the relative size used to represent an object (such as a country, person, bottle) on another surface (for example, a map, three-dimensional model, billboard, or sketchpad) (also see Chapter 6)

enlargement: increase in size, using a scale

reduction: decrease in size, using a scale

Fig 7.7 (b) Reduced to a scale of 1:2.

Fig 7.7 (a) Actual size.

Fig 7.7 (c) Enlarged to a scale of 2:1.

Using a grid to scale your drawing

Lines drawn vertically and horizontally, at equal distances apart, form a grid. A grid may be drawn over a picture, and then redrawn to a scale on paper. This enables the artist to recreate the drawing to a different size by following the lines that appear in each square of the picture, one at a time. Use the following steps to guide you:

a) Divide the picture you wish to enlarge or reduce into squares that form a grid. From the edge along the top of your picture, measure and place points 2 cm apart. Repeat this procedure along the base of the picture. Use a ruler to join the parallel pairs of points to form vertical lines on your picture. Repeat the entire procedure along the left and right sides to produce the horizontal lines on the picture to complete your grid.

b) Use one of the squares on your picture to help you determine the scale of your drawing. Ask yourself whether your drawing should be twice as large (for an enlargement) or half as small (for a reduction). Enlarge or reduce the square to a size that is appropriate, to your drawing paper, then recreate the entire grid on your paper. The grid you draw must be similar to the one on the picture. For example, if the picture has four columns and three rows of squares, so too must your drawing paper.

c) Beginning with any square you prefer on the picture, observe the lines then draw them on the corresponding square of your drawing paper. Repeat this procedure for each of the squares on your picture grid. When you have completed the lines in each square, your new drawing to scale is complete. Compare your drawing to the picture to make any adjustments.

Fig 7.8 (b) Reduced to scale of 1:2. *Fig 7.8 (a) Actual size.* *Fig 7.8 (c) Enlarged to a scale of 2:1.*

Stages in the graphic design process

The graphic design process has **9 stages** that help to develop you as a graphic design student. You will do research, choose a theme, create your written message, create an image, combine the writing and image, refine your design, present your work, make a journal entry, and meet ideas to improve the next time you attempt a graphic design. Along the away, you will also be reminded about using the elements of arts and the principles of art and design.

1. Research graphic design techniques and process

Refer to **Chapter 16** to guide your research for Stage 1 of your graphic designing process.

2. Select the topic, theme or brief

It is wise to begin with a simple graphic design, perhaps a flier for your class's cake sale. Your topic, theme or brief will help you to determine the colour scheme, the type of lettering or font that may be best suited for the design, and the image or illustration that will best complement the lettering and complete the design.

Consider the application of your graphic design: for instance, will it be used on paper, a banner or a billboard? This helps you to decide on the dimensions and shape of the overall design. The dimensions and shape will in turn help you to decide how much information can possibly appear in the design.

Another important consideration is the target audience for your message. The message and its design must be appealing to that audience in order to improve your market. Once these design basics are determined, select a suitable size and **orientation** of paper (refer to 'Understanding composition in **Chapter 4**).

Helpful hint
Although a 2 cm side for the squares is suggested, another measurement may be used instead. One way to decide is to measure the complete length of the picture then divide this into equal intervals. A good consideration is whether there are too many or too few boxes in the grid you use. A grid with more squares increases accuracy because there is less visual information per square. However, too many squares will each provide too little information and become difficult to work with.

Key term
orientation: the position of your paper, usually either portrait or landscape (see **Chapter 4**)

What ... Cake Sale / types – chocolate/sponge/fruit/sweetbread

When ... (date)
Where ... school/near cafeteria
Who ... Our class
Why ... Funding for Art project/supplies

Illustrations ... cake slices

cake

Fig 7.9 Notes for planning a flier

3. Select your written message

Begin by writing all the pieces of information that you can think of that you may wish to tell your audience about. Keep your audience in mind: for instance, if the cake sale is held in school, the target audience and target market will be students like yourself. So consider what you would like to know about this cake sale (if you were one of those other students), and write down each thought as a short sentence or group of words. Have someone read these in order to add ideas that you may have left out or to remove unnecessary information. Now place these thoughts in order of importance. Next, rewrite the first five thoughts. As you do so, consider reviewing the information again: for example, some pieces of information may be presented in fewer words (or more) to improve the clarity of your design. The final information in the exact words you wish to use in your graphic design is called the **text**. Also consider what lettering type or font is most suitable for this flier. Different lettering types are suitable for different messages and audiences. Make rough sketches of your ideas. The challenge is to be able to make a careful selection. **Figure 7.16** provides a sample of a few lettering types, but your research will provide many more. Go to Individual Activity 3 on the list at the end of this chapter to get started with this project.

> **Key term**
> **text:** written information (words) in a graphic design

Activity

Graphic designs are scaled to fit different spaces. Select a simple graphic design of your choice from a newspaper or magazine. Reproduce it using a scale of 2:1. Using this scale, which will be larger, the actual graphic design or your reproduction? Present the actual graphic design along with your reproduction. Suggest one place where your scaled version of this graphic design may be used.

Forming letters and digits

The alphabet may be written in upper case (capital letters) or lower case (common letters). When you use letters to create text for your graphic designs, you must decide which case is to be used. If you examine sufficient graphic designs, you will realise that the rules of capitalisation that govern your general writing are not necessarily applicable to graphic design. The visual arts allow you the opportunity to be creative, so the letters of your text may be a combination of both cases, upper-case only or lower-case only.

Letters may be grouped into categories based on their dimensions. A lower-case letter may belong to any of the five categories: normal, narrow, wide, tall or hooked. An upper-case letter may belong to any of three groups: normal, narrow or wide. For most lettering font, the categories are similar to those illustrated in **Table 7.2**.

Fig 7.10 4 Versions of the word 'design'.

Table 7.2 Categories of Lower and Upper case letters

Case	Category	Category
	normal	a c e i* n o r s u v x z
Lower	narrow	i* l*
	wide	m w
	tall	b d f h k l* t
	hooked	g j p q y
	normal	A B C D E F G H J K L N O P Q R S T U V X Y Z
Upper	narrow	I
	wide	M W

* indicates a letter having a characteristic for more than one category

132

Forming letters

a) To form a letter, first identify its category from **Table 7.2**: for example, the letter 'y' is categorised as 'lower-case hooked'. The letter 'Y' is categorised as 'upper-case normal'.

b) Create the guide-box in which you will form the letter. The guide-boxes must be in a ratio that considers all the possible letter categories. Also determine the ratio of the height of an upper-case letter as compared to a normal lower-case letter.

c) Determine the width of the various strokes that form the letter. Outline these stroke widths within the guide-boxes.

d) Form the letters. Follow the examples in **Figures 7.12** and **7.13**, which will assist you.

Once you have selected a suitable lettering type, begin to practise forming the letters of the alphabet for that particular type. Follow the guidelines provided in Stages 1 to 4 of 'Forming Letters' above. Redraw any letters that were not quite successful so that you begin to master the formation of all the letters.

Fig 7.11 Letters 'y' and 'Y'.

Fig 7.12 Lower case letters by category: normal, narrow, wide, tall, hooked.

Fig 7.13 Upper case letters by category: normal, narrow, wide.

Lettering styles

Here are a few samples of lettering styles. Comment on the variation among them. Suggest a use for each. Perhaps you can create a lettering style of your own.

4. Select your image

The image or illustration you wish to use in your graphic design must first relate to the main idea of your graphic design, and then relate to the words. The main idea for your flyer is a 'cake sale', and the obvious image to use will be a cake. But a cake can become an image in a variety of ways. Some of these are suggested in **Figure 7.15**. Examine each and say which you prefer and why. Perhaps you may have another image in mind that relates just as well. Make rough sketches of your ideas, then develop the drawings. Offer your suggestions and discuss them in class. Remember that they must relate well to the main idea and to the text you wish to use.

You may quickly find yourself wanting to consider more than one of the images. For now, however, select one image only. Develop your ideas for that one image, and put all your energy into improving its quality. This is done by drawing and re-drawing the image until you perfect it. **Chapter 4** will help you with this. Afterwards, consider the location and direction of the image, and experiment with the use of colour. Coloured pencils are best for this.

5. Combine written message and image

Once you have decided on your text and image, it is time to begin putting them together. Combining text and image is not as simple as just putting both on your paper. Because there are countless ways in which these two parts may be combined, try to come up with four different possible combinations for presenting the graphic design. You will find that as you complete one design, new ideas to change it will come to mind, and it is these differences that should encourage you to create the other designs. Ideas change when you add or remove lettering or image. They also change when the location, orientation, size, font style, colours or other elements are manipulated. All the ideas may not come to you at once, so give yourself some time to look at your first idea as well as other graphic designs to help you along.

The quality of any of your four designs will be judged according to seven factors that you must carefully consider:

- relevance of words (text) to the main idea of the graphic design
- relevance of the image to the main idea
- relevance of the text to the image, and the image to the text
- use of space
- use of appropriate font and font size

Gill Sans
ABCDEFGHIJKLMNOPQRSTUVWXYZ
abcdefghijklmnopqrstuvwxyz
1234567890/& _ ,.

Old English
ABCDEFGHIJKLMNOPQRSTUVWXYZ
abcdefghijklmnopqrstuvwxyz
1234567890/& _ ,.

Copper Black
ABCDEFGHIJKLMNOPQRSTUVWXYZ
abcdefghijklmnopqrstuvwxyz
1234567890/& _ ,.

Italicized Script
ABCDEFGHIJKLMNOPQRSTUVWXYZ
abcdefghijklmnopqrstuvwxyz
1234567890/& _ ,.

Garamond Bold Italic
ABCDEFGHIJKLMNOPQRSTUVWXYZ
abcdefghijklmnopqrstuvwxyz
1234567890/& _ ,.

Commercial Script
ABCDEFGHIJKLMNOPQRSTUVWXYZ
abcdefghijklmnopqrstuvwxyz
1234567890/& _ ,.

Fig 7.14 6 Lettering fonts or hands.

Did you know?

Letters may also be grouped because they share similar features. What is common to each group of letters? Look for relationships among letters, for example
c a d g q // b p // v w //
b d l k // u y // f t
Perhaps you can think of other letters that share a particular common feature and may be grouped together: for instance, all letters with curved strokes.

- use of appropriate colour scheme
- overall application of the elements of art and principles of art and design to create a harmonious, pleasing and effective design.

Examine the four designs presented in Figures 7.15 (a), (b), (c) and (d). Discuss how each variation for the design responds to the seven factors given above.

6. Select and refine the final design

From your examination and discussion of the four designs, select the one that best suits the seven factors you considered. However, you may find that if you combine ideas from two (or more) of your four designs, you may come up with a fifth design that is even more pleasing and effective. Considering this may represent a bit more work, but may well be worth it.

Refining the design adds to its effectiveness. Here, you need to consider the principles of art and design (balance, contrast, emphasis, gradation, harmony, proportion, variation, unity) again. To do so, turn to **Chapter 1** and compare what you have designed to each principle.

Which principles exist in your graphic design? Can any be improved or can another be added?

7. Present your graphic design

Be sure to autograph your drawing. This may be done anywhere, but is perhaps best at the lower left or right side. Your drawings look complete with a mat or a frame around them. Go to **Chapter 17** (page 277) to complete this exercise.

Take a digital photograph of the composition you worked from and present it along with your drawing. From it, your teacher will be able to see how well you used your understandings of the elements and the principles. He or she will be able to point out corrections that you may need to make about the arrangement in the composition itself, the use of perspective, use of colour, the centre of interest, and the suitability and range of techniques you used.

Also present the studies that you have made at Stage 5. They help your teacher to assess the amount of thought you put into your work, the techniques you used, and your ability to make intelligent design choices. Another useful idea is to photograph your work to create a photo essay of what you did and how skilful you were at doing it. This will also inform you about the areas where you may need to improve the next time around.

Be sure to say what you did and explain why. Use your understandings of the elements of art and the principles of art and design that you met in **Chapter 1** to help you along.

Did you know?

Leon Battista Alberti was a Renaissance artist and architect who believed that the circle and the square were the most perfect geometrical forms, and therefore all arts, architecture and alphabets should use them as a base. In this way, symmetry, proportion and geometry could be achieved and repeated. He revived the ancient Roman tradition of inscribing letters on the **façade** of a building.

(a)

(b)

(c)

Fig 7.15 Ideas for the illustration for a cake sale flier.

(d)

Key term
façade: decorated front face of a building

8. My art journal entry

Refer to **Chapter 16** to guide your art journal entry for Stage 8 of your graphic design process.

9. Make another graphic design

To improve your graphic designing ability you must practise regularly. There are many sources from which you can observe and learn about graphic designs. These include billboards and signs found in cities, towns and streets, shops and supermarkets, electronic and printed media. Because you now have the experience of creating a graphic design, your attention will be drawn to details that can help you, even as you walk along the street, browse at the mall or shop at the supermarket. Here are some ways to improve or vary your next graphic design.

a) Select another topic or theme to create a graphic design for.

b) Add a second, or more, images or illustrations. Do so without over-emphasising the use of images, which creates an imbalance in the overall design. You may introduce the idea of a **motif** here, by repeating the use of an image.

c) Add colour or use an additional colour. As a general rule, avoid using more than two or three colours. Consider colours that are complementary or analogous (refer to **Chapter 5**). Also consider the background colour in your design.

d) Select a different font (letter style, or hand).

e) Use multiple fonts, but perhaps no more than three. Use a primary one, and then include the others selectively for variation or emphasis.

f) Use multiple font sizes, preferably with one font style.

g) Change the direction of selected text, or images. Consider presenting writing vertically or diagonally. Images may be laterally inverted, as in a mirror, to repeat its use in space.

h) Reduce or enlarge your graphic design and present it on different items, for example on a letterhead, a monogram, a flier, a poster or a sketchpad.

i) Try using a computer-aided design approach to create your graphic design. This teaches you to appreciate which parts of the process require original ideas and effort, and which parts may be assisted by today's technology. Stages 4, 5 and 6 of your design process will require work on a computer.

> **Key term**
> **motif:** the main element or repeated symbol in an artwork

Chapter summary

In this chapter you have learned to:

- trace the history of graphic design
- explain and use terms associated with graphic design
- follow the stages for creating your graphic designs
- introduce ideas that will further develop your skill in creating graphic designs
- apply your knowledge and understandings to speak and write effectively about graphic design.

Activities

Individual projects

1. The pages of this book provide you with examples of graphic design. Select any page and consider its use of lettering and illustration and the use of space. Consider the font, font size and reasons for any variation in the fonts used on that page. Also consider the image(s), image size, location and quality. Finally, discuss how the font and the image(s) relate to one another on the page. Are they carefully placed? Say why or why not. If you were the graphic designer for this page, what changes would you recommend? Redesign the page to illustrate your changes.

2. Create a graphic design for advertising an exhibition of visual arts that your class wishes to host. Alternatively you may choose any other project. Consider what type of graphic design is necessary, and the information that is required. Use two colours on white paper. Apply colours in any suitable quick-drying media.

3. Create your own 'Book of Lettering Types'. Use your computer and internet access to find and print as many varying styles of the alphabet as you can. Be sure to name each and get a brief history of how the style was developed and where it is used. Different lettering types are used for different applications and purposes. Suggest one application for each of the lettering types that you have researched.

 Perhaps you can create a lettering type of your own! Exchange copies of the lettering types you have found with your classmates to improve your collection. Why not create a unique graphic design for the cover for your 'Book of Lettering Types'.

Group projects

4. As part of the promotion for this book, the publisher wishes to hand out bandanas to students. But before they do, they require a logo that best represents the subject, content and name of the book. In groups of four or five students, complete the following:
 a) Write the title of the book.
 b) Write one paragraph about the content of the book.
 c) Complete the 'Stages in the Graphic Design Process' using these two pieces of information to guide you. At the end, you should produce a logo to be printed on the bandanas.

5. The producer of your favourite movie wishes to create various graphic designs to advertise it. In groups of four or five:
 a) Select a movie that you all like.
 b) View the movie to get your ideas for your designs.
 c) Use the various themes, characters and scenes from the movie to discuss your ideas for creating a suitable graphic design.
 d) refer to **Table 7.1** to select your design type.

 Each member of the group will produce a different type of graphic design based on that movie.

 Exhibit the series of graphic designs as a group. Each member should explain how he or she developed their graphic design using ideas from the movie. Try to include excerpts from the movie in the presentation. Perhaps as a result, others may be encouraged to view this movie.

Integrated projects

6. Complete a series of graphic designs that relate to activities that are held annually at your school. The series may relate to a particular theme, and may be spread across the three terms (perhaps one per term) of the school year.

 Themes may include: national holidays; cultural festivals and activities, religious festivals and activities; school events, for example sports day, open day, graduation ceremony, art exhibition day, special events, such as a field trip; a special visitor, a ceremony or a special achievement.

Art appreciation

7. Visit a website you and your class have discussed. Describe the website and say what skills the designer must have had in order to create the website. Examine the use of the elements of art and the principles of art and design the designer used in constructing it.

 More activities for this chapter are included on the accompanying CD-ROM.

Chapter 8

Textile Design

Outcomes

After reading this chapter and practising its activities, you will be able to:

- define, explain and illustrate the term 'textile design'

- trace the history and development of textile design

- list, understand and follow the stages in the process for creating your own textile designs

- use key terms and understandings to effectively speak and write about textiles and textile designs

- apply theory and skills from other chapters to complement your understanding and creativity in textile design

- criticise textile designs, using the elements of art and the principles of art and design

- engage ideas and techniques for the further development of the skills learned for textile design.

Resources

You will need:

- notebook, art journal, paper, pencils, coloured pencils

- plain white cotton textile

- paints, paint brushes, craft knife, stencils, masking tape, pins, large drawing board, newsprint, plastic sheets, large garbage bags

- fabric paints and dyes, fixative, iron

- stove, buckets, pots, gloves, clothes pegs

- computer with internet access

- school and public library access.

Introduction to textile design

A **textile** is a fabric made up of interwoven threads. To produce a textile, the threads must be compressed, knitted, knotted or woven. The threads are made from **fibre**, which either occurs naturally or is man-made. Natural fibres are made from plant, animal or mineral matter. Plant fibres include bamboo, coconut, cotton, grass, reed and straw, all of which can be found in the Caribbean.

Textiles are traditionally used to make clothing and household furnishings. Animal fibres, such as those from the goat and sheep, are popularly used for thicker clothing and spreads, while silk, produced by the silkworm, is a fine fibre admired for its natural texture, strength and length. It is used to make finer clothing and soft furnishings. Mineral fibres, such as asbestos, fibreglass and optical fibres, are man-made from natural materials and are used for industrial purposes. Synthetic fibres include acrylics, nylons, polyesters and spandexes. They are used for a variety of purposes including different types of clothing and household objects and for commercial and industrial purposes. Synthetic fibres have similar properties to natural ones, but are often cheaper. Many synthetic fibres are made from petroleum, natural gas or coal.

In the Caribbean, textiles form a main part of our popular culture. Our creativity is expressed through the use of various coloured fabrics to beautify our bodies, and for costumes and stages for Carnival and many other annual festivals.

Fig 8.1 Mud cloth clothing.

Key terms

textile: *fabric made up of interwoven threads*

fibre: *a length of unbroken material used for weaving*

Designing textiles

One method of textile design is achieved by creating patterns as the textile itself is made. This requires the desired patterns to be woven, knitted, knotted or compressed into the textile as it is being produced. For instance, different colours of thread may be used together to achieve the lines, shapes, colours, values of colour and textures of a textile.

A second method is achieved by designing on the surface of the textile that has already been made. Dyes, paints or inks are applied to plain textile using a textile design technique. Because textiles are absorbent, the colour works its way into the threads of the fabric. The fabrics are then used to make colourful clothing, handbags and decorative wall hangings and spreads. Your learning in this chapter will be about this second method, called **surface design** of textiles.

History of textile design

Key term

surface design: *designs and decorative elements applied to textiles*

Early textiles

Surface textile designing began at about the same time as the first textiles appeared, and has developed as the textile industry has developed. The earliest examples of needles and hooks have been discovered in France and are estimated to be about 20,000 years old. The needles were made from bone and are thought to have been used for sewing. Man probably began wearing clothing more than 100,000 years ago. Clothing then was made from skins and leather that were sewn together. However, the earliest evidence of actual textiles was a compressed felt made about 8,000 years ago in what is now the Czech Republic.

Textiles used for clothing developed in many ancient cultures at the same time during the Neolithic era. In Turkey, linseed was used to make woven linen and dyes that coloured the cloth. The people there also used wool made from the fleece of sheep. In Egypt and India, cotton was spun and woven into textiles. In China, the discovery of silk led to the production of the world's most refined fabrics. Silk fabrics were woven in intricate detail and dyed, creating exquisite designs that were worn mostly by royalty. **Examine Figure 8.2. Discuss the designs, patterns and trimming on the garments.**

Fig 8.2 Hang Dynasty. Chinese Guardian Spirits. c. 2000 years ago. Tile painting

Early South American textiles

At the same time, in South America, very intricate designs were appearing on the textiles of the Nazca and Huari civilisations of Peru. They used a **loom** to weave fabric with threads made from cotton. **Embroidery** was another popular technique. To these peoples, their textiles had more value than gold and other precious metals. This is not surprising because the pieces of clothing made represented the status of the various members of their societies. The textiles were used for rituals and ceremonies, including burials. As for the Egyptians, fine textiles were placed to accompany the wearer into the next world. The textiles also tell us of the level of skill and detail with which the artists approached their tasks. The patterns were symbolic, no two designs being identical. **Examine the textile in Figure 8.3. What do the images seem to represent? How are they similar and how do they differ? Can you suggest what technique was used to design the textile? Comment on the use of colour.**

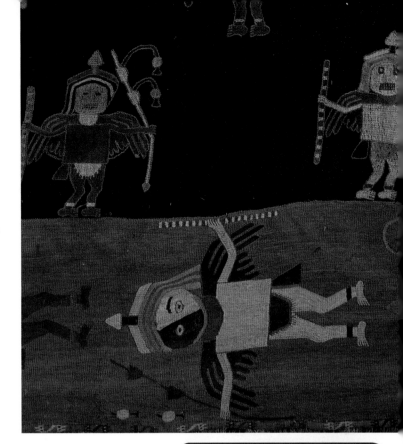

Fig 8.3 Andean. Birdmen. c. 2400 years ago. Woven cotton. Paracas Peninsula. Peru.

Key terms

loom: machine for weaving textile

embroidery: decorative needlework usually done on textiles

The sharing of tools and ideas

By the end of the Neolithic era, trading was a common practice throughout Asia and Europe, and the knowledge of textiles and textile designing spread throughout the world. Innovations in textile design included the use of woodblocks to print, the use of dye-resist techniques, the foot-powered loom and the spinning wheel. Trading caused the ideas of design and workmanship to spread and be shared. For instance, silk painting, traditionally done in China, began to be done elsewhere, and with designs influenced by other places. **Examine Figure 8.4. Comment on the artist's use of the elements of art. In what ways would painting on paper vary from painting on fabric, and why?**

Fig 8.4 Chinese. Silk painting featuring a man riding a dragon. c. 2600 years ago. Painting on silk.

Fashion is born

During the Middle Ages in Europe, the idea of fashion began to appear. Textiles began to be separated by their texture. Clothing worn next to the skin was made from linen, while that worn on the outside was made from wool. Techniques and designs from as far away as Indonesia and China were combined with those of the Middle East and Europe, creating designs that were in and others that were out of popular use – similar to today.

Fig 8.5 Modern batik design

Early machines

The switch from mostly hand-made textiles to machine-made ones occurred during the Industrial Revolution in the 18th century. Textile factories were built. The invention of machines such as the spinning jenny, power loom, water frame and cotton jin transformed the manufacturing of textiles. Synthetic dyes too were introduced, creating greater variety in textile designs. **Find out about some of these inventions on the internet or in the library.**

Today's textile designers

Textile artists produce an array of innovative surface designs for their textiles. Common techniques include hand-painting, block-printing and various methods of dyeing. For these artists, the fabric is their canvas, and the designs are their art. Many textile artists therefore produce 'one of a kind' designs that, like the drawings, paintings and sculpture of the fine arts, are appreciated as unique works of art.

What has the artist represented in Figure 8.5? What aspects of the design do you find interesting? Comment on the use of the elements of art.

Introduction to texture

Human beings use touch to perceive their environment. We react to the feel we get from the things we touch, hold or come into contact with. It is one of our strongest senses. **Texture** is so important to the visual artist that it is one of the five elements of art. You will remember that you learned a bit about the elements in **Chapter 1**. All surfaces have a particular feel, but how the surfaces feel differs. For example, there may be surfaces that are smooth or rough, hard or soft. In the visual arts, the artist may choose to present the actual texture, or create the illusion of a texture for the viewer to respond to. This is done to add interest or variety in an artwork, and to appeal to our sense of touch and not to our sense of sight alone. There are two types of texture.

Tactile texture

The word 'tactile' means touch. It refers to the actual feel of a surface of an artwork: for instance, a sculpture made of wood may have a rough, grainy feel or may be polished smooth. Two-dimensional artwork may also emphasise the element of texture by building up the body of paint, which may be applied in a thick and rough manner. Other artists achieve this by adding materials such as sand or gravel to their paint, or by simply working on a rough or jagged surface. **Can you think of what other material may be added to give texture to artworks? Can you find some examples of artworks in this book that have a tactile texture? Separate them into two-dimensional and three-dimensional works and discuss them.**

Visual texture

Visual texture refers to the illusion of texture on a flat surface. The artist arranges elements, particularly point, line and shape, to evoke a sense of touch. A drawing may utilise visual texture to create the illusion of the texture of skin. Very often, to emphasise this, the artist applies a variation on other surfaces next to the skin, for example on clothing. Stippling, hatching and cross-hatching techniques may be used to effectively suggest various textures. The use of sponges and toothbrushes to apply paint, salt added to wet paint, and scraping out dried paint are simple and effective ways to create textures. The repetition of certain lines forms a pattern that also conveys a sense of texture. **Select a few artworks from this book that show visual texture, and discuss them.**

One of the key characteristics of textiles is that each has a particular texture. Their textures go a long way in determining their use, especially for clothing: where these pieces of clothing are worn, as either outer or under wear on our bodies, for particular seasons of the year, or for making conscious fashion statements.

Did you know?

The repetition of a pattern can create the illusion of texture. A **motif** is the device used to achieve this repetition. Motifs are commonly used by artists to create designs and build themes in their artworks. A motif may be created through the repetition of line, shape, colour or object, or a combination of all of these.

Key term

texture: the way a surface feels or appears to feel

Key term

motif: a repeated element or symbol used in an artwork

Textile designing processes

There are a few processes for the surface design of textiles. Textiles may be dyed to make them available in many colours, but may also be further enhanced by creating designs on them. The most suitable surface to design on is a plain white textile, such as cotton. Once the textile has been prepared, the technique you select to apply your design will determine the process you need to follow. This chapter will teach you about creating textile designs using three processes: painting, printing and dyeing. While each of these processes uses different techniques, one has been selected for discussion for each process.

Fig 8.6 Completed sun painting.

Painting process
Hand-painting: sun-painting technique

Textile painting uses paints to create designs on textiles. One technique is hand-painting. Although regular poster or acrylic paints may be applied, the best paints to use are fabric paints, which adhere well to the surface of the textile and are better able to withstand washing and wear.

Sun-painting is a simple yet wonderful technique, very much suited to the climate of the Caribbean. Instead of painting as you would on paper, sun-painting provides the opportunity for you to experience a bit more. The technique teaches you how paints react to textiles, which have a different rate of absorbency, causing different effects of the paint. It also combines painting with a simple printing application. Sun-painting allows sunlight to evaporate the water from the fabric, leaving the colour behind. Specially prepared transparent fabric paints are used. The Setacolor™ brand of fabric paints is highly recommended. As the paints are sensitive to light, if areas are blocked off from the light, only a very weak image of the object placed on the surface is formed as the paints dry. The objects you place should block off the light completely to achieve greatest contrast between the areas where the paint will remain and the areas where the objects or stencils were placed. The painting techniques to use are all discussed in **Chapter 5**, but the most popular ones for sun-painting include wet-in-wet, blotting, salting, splattering and sponging.

Printing process

Textile printing: vegetable block technique

Printing transfers an image from one surface (block) to another surface such as paper or fabric. The block may be cut from any suitable material with a flat surface, but a good block for learning to print may be made from a vegetable. The potato is recommended because it is common, inexpensive and easy to manipulate. The block that is formed is sturdy and provides many editions.

Refer to the accompanying CD-ROM for tips on safety in the classroom.

Vegetable block printing allows you to create simple designs that can be transferred to the potato surface using a dark pencil, then cut away to create the printing surface. Either the relief or the incised technique may be used to create the design. Paint is then applied to the block and it is pressed against the textile to register the image. The life of the blocks may be extended somewhat by storing them in the refrigerator. **Chapter 6** provides you with all you need to know for printing.

Key terms

dyeing: the process of adding colour to a textile

dye bath: vessel for immersing textile for dyeing

Fig 8.7 Completed block printed textile. Observe its repeated motif design.

Dyeing process
Textile dyeing: tie and dye technique

Humankind has used dyes for over 5,000 years, the most popular ones being derived from plants and animals. Today, there are many different types of dyes, including man-made ones. **Dyeing** techniques allow you to apply dye to the whole piece, or to selected parts of the textile.

For our classroom activities, we will design on white textile. A cold or hot water dye may be used. The simpler method uses cold water dyes, but the dyes, though strong, will not produce deep colours. Hot water dyes require the dye solution to be boiled. Before dyeing, the textile must be thoroughly washed and immersed into a dye solution contained in a **dye bath**.

This technique achieves deeper colour if left for a longer period of time, and requires a fixative to maintain the colour. A fixative is an additive to the dye solution that prevents fading after colouring. You may wish to begin with a cold water dye because the process is simpler, quicker and safer.

Dyes may be removed from a textile by bleaching. Selective bleaching can also be used to create designs on dyed textiles. However, the textile itself may become damaged.

When you tie and dye, a unique pattern is created. This allows you the opportunity to have fun and at the same time display your creativity. Experimentation is encouraged. Perhaps you may invent a new method for dyeing textiles! **Figure 8.5** is a fine example of a dyed textile.

Stages in the textile design process

The textile design process has ten stages that are intended to help you to develop your ability to design on the surface of your textiles. You will begin with what to research; selecting the topic, a textile design process and technique; creating a design; preparing the textile; transferring the design; creating the artwork; finishing the artwork; presenting your work; making a journal entry; and exploring ideas to include or improve the next time you attempt to design textile. Along the away, you will also be reminded about using the elements of art and the principles of art and design.

1. Research textile designing techniques and process

Refer to **Chapter 16** to guide your research for Stage 1 of your textile design process.

2. Select the topic, process and technique

Because of the wide variety of materials and techniques available to design your textile, you will need to make many decisions early on. Begin with a topic or theme that is simple to design. For the main activity in this chapter, a suitable theme may be 'Caribbean flora'.

You will also need to select one process and one technique for that process, to work with. The process and technique you choose will narrow down the type of materials you will need. For instance, block printing will require the creation of a block for the designs you wish to print, and relates to the printmaking ideas in **Chapter 6**. Hand-painting will require materials for painting, including brushes, and relates to painting techniques discussed in **Chapter 5**. The dyeing process will require techniques in folding and tying. You will learn about these later in this chapter.

Fig 8.8 (a) Sunflower.

Fig 8.8 (b) Hibiscus flower.

3. Create the design

From your research, collect actual samples or pictures of leaves and other floral parts. Get as many as you can so that you are able to select the best possible design ideas. Examine the samples or pictures to make decisions about your design that are most interesting and appealing to you. Prepare drawings for your design ideas so that you explore many possibilities. Add colour using coloured pencils. Pay close attention to the elements of art and the principles of art and design in creating your design drawings. Select the best design to work with.

You will begin to realise that, because of the nature of the processes involved in the surface design of textiles, the amount of control you have over the outcome may vary from near total control in block-printing, to lesser control in painting, to even less control in a dyeing technique. As you work, the greatest learning takes place as you experience the various processes.

Once you have selected the design to work with, you will need your textile, and a sturdy surface similar to a large drawing board, on which to do your artwork.

4. Select and prepare the textile

Perhaps the best textile to work with is white cotton. Cotton is readily available and cheap. It is soft, light, absorbent, durable, washable and easy to fold and to iron. Clothing made from cotton drapes well and is comfortable. It does not produce allergic reactions. One disadvantage is that cotton wrinkles easily, but ironing takes care of that.

Textile is prepared for designing by pre-washing. It must be washed thoroughly to remove any finishes that the manufacturer may have used, or impurities that hamper the colouring process.

- **Sun-painting** requires the textile to be ironed in order to remove any wrinkles. Cotton is best ironed while damp. Once it is dry, stretch the textile and affix it to a board that is suitable for use as your working surface. A drawing board made from plywood, masonite or plexiglas is suitable. A combination of masking tape and pins will hold the textile, but a wooden stretching frame is best for mounting your textile.

- **Vegetable block printing** also requires the textile to be ironed in order to remove any wrinkles. Cotton is best ironed while damp. Once it is dry, stretch the textile and affix it to your drawing board.

- **Tie and dye** textiles should also be ironed: though this is not absolutely required, it is recommended. The fewer wrinkles the better, unless the possible effect on a wrinkled surface is what is desired.

5. Transfer the design

The design process for work on textile is similar to that for work on paper. Your design ideas must reflect careful application of the elements of art and the principles of art and design. For painting or printing, use light pencil to trace the outline of objects or the stencils you use on the textile. For tie and dye, the general locations of where you wish to tie the textile should be marked.

- **Sun-painting**: Locate the positions of the designs on the textile. Use your drawing of the design as the main guide, but another good idea is to place the actual objects or stencils on the textile and move them around until you have achieved the best possible composition for the design.

- **Vegetable block printing**: Locate the positions where each repeated impression of the various blocks will appear on the textile. Your design drawing will guide you.

- **Tie and dye**: Identify the general areas where you wish to tie, and the type of tie you wish to make. Your design drawing will guide you.

6. Create the artwork

Have your design drawings, materials and equipment ready. A useful idea is to photograph your work as it progresses from step to step.

Sun-painting

a) Use a spray bottle, sponge or wide paintbrush to wet the textile until it 'sticks' to the board.

b) Apply your first colour using broad fluent brush strokes. If you are using more than one colour (two or three are suggested), the dominant colour should be applied first. Ensure that you leave spaces for the other colours. Apply the other colours next. You may wish to overlap the colours in some places. You will need to work fairly quickly, so having a clear idea of which colours go where helps.

c) Using your design drawing and the pencil outlines on the textile as guides, lay your objects or stencils into position. If you use objects such as leaves, you may need to have them pinned, stuck or held flat in place with weights.

d) Carefully lift your board and place it with the objects or stencils in position in direct sunlight. About 15 to 20 minutes of good Caribbean sunshine is quite sufficient, but monitor your work so that the good Caribbean breeze does not upset your design. If the sunshine is not as bright, the work may need to be exposed for 30 to 60 minutes. It is quite okay to lift the objects or stencils to check to see that the desired contrast is achieved. Alternatively, you can simply allow the water to dry off.

e) Return indoors and remove the objects or stencils to uncover your painting. Remove the tape and pins. The steps in the process are illustrated in **Figure 8.9**.

Fig 8.9 Steps in the sun painting process.

Vegetable block printing

a) Transfer and mark the design for each of the blocks you wish to use for your prints. Decide beforehand between a relief and an incised block. Cut the potato into comfortable sizes to work with. The face of the potato should be flat. Use a knife or cutter to make a complete cut in one fluent movement. Transfer the design onto the face of the potato and cut away the unwanted areas of the potato to form each block. As a beginner, use simple designs that are easy to cut.

Guidelines for the safe use of cutters are found on the accompanying CD-ROM

b) As you progress, trial-test your blocks on paper or scraps of cotton fabric. Using a piece of the same fabric is always advised because you will also get a good idea of how absorbent the textile is, and how fluid your ink or paint should be in order to achieve proper registration. Registration is discussed in **Chaper 6**.

c) Apply ink or paint, and register the designs. If you are using various colours, it is always best to print all of the lightest colours first. Darker colours may then be registered over the lighter ones. Be careful not to overdo this as it causes a muddy effect. For early efforts, two or three colours are recommended. A block may be used to apply one particular colour, or many colours each placed on different parts of the same block.

Tie and dye

(a) bump

(b) spiral

(c) single stripe

(d) donut

(e) marble

(f) different ties

Fig 8.10 Various tying techniques.

a) Determine the pattern you wish to create. The popular ones include variations of circles, stripes, spiral and marbled patterns. The pattern you select will determine how the textile is folded and the ties that are required.

Lay the textile flat, then pinch at the desired points, lift and fold or twist in the desired manner. The process is quite simple, but must be done properly in order to achieve the best results. Some patterns are illustrated in **Figure 8.10**.

b) Select your dye colour, and follow the instructions on the label to prepare the dye. It is a good idea to use plastic sheets (large garbage bags are suitable) and newsprint to work on. This minimises staining and reduces clean-up time. A suitable dye-bath for cold water dyes is a large white plastic bucket. Hot water dyes require a large boiling pot.

c) Prepare the textile. You will have already washed the textile properly to remove any finishes, but some dyes require the textile to be soaked in hot water.

d) Dye the textile. Follow the instructions to immerse, churn, lift and re-immerse, and remove the textile from the dye-bath.

e) After dyeing, the textile must be rinsed in order to wash off the excess dye. Again, the length of time after dyeing to rinse is in the instructions. Some dyes require washing immediately, while others require washing some time later. In some cases this may be as long as 24 hours after, so securing the textile becomes a factor. Generally your textile should be washed in cold (regular room temperature) water.

f) Dyes are stains. You must therefore have detergents and warm water ready beforehand to wash up your utensils. A suitable sink is also advisable. Secure newsprint and unwanted materials in plastic garbage bags and dispose of them appropriately.

g) Iron your textile.

Create samples of tie and dye textiles that display the different techniques discussed and illustrated above.

7. Finish the artwork

The method of finishing the artwork differs for each of the design processes and for the selected technique. As you work, adjustments may need to be made. You may not have recognised these at the design or drawing stage, and you may need to address them as you work. The extent to which they may be addressed will vary depending on the process and technique you have selected.

- **Sun-painting:** Once the work has dried, the painting is complete and any adjustment to the work itself is not recommended. Any observation or recommendation for improvement may be applied to the next sun-painting you make. For example, you may observe changes in the selection or arrangement of your objects or stencils, the selection of colour for your paints, the quality or size of the textile, or the intended use of the textile after designing. As with all areas of the visual arts, practice provides you with experience to help you improve.

- **Vegetable block printing:** A printed work may be adjusted by adding more impressions to the composition, though this should have been carefully considered at the design stage. Improperly cut blocks with a surface that is not flat, those with overworked designs, or those not well cut create the most problems. To avoid these, always trial-print. Reconsider or simplify designs, and work to improve the quality of the registration. Re-registration of an impression must be done with care, if you attempt it at all. Alternatively, if only slight corrections are required, they may be more effectively achieved using a fine paintbrush to apply the paint directly on the design. Problems such as a muddy mixture of paints or overuse of colour should be noted and avoided in future prints. You can add a decorative border if you want.

- **Tie and dye:** Once the dyeing is complete, there is little that can be done to the design. It is important to re-emphasise that the beauty of the tie and dye technique is in its production of a one-of–a-kind design each time it is used. No two designs produced will ever be the same.

 You should take note of ways to improve the quality of the design process. Consider the number or folds or ties you made, how tightly the knots were banded, and the width of the bands of colour that were created. Consult your teacher about adding a decorative border if desired.

The textile itself may be finished by creating a border that may be hemmed or completed by attaching a further decorative border. Alternatively, you may choose to mat your work (see **Chapter 17, page 277**). Consult your teacher before you proceed, as the aim of the visual artist is to create an effective design on the textile first. If the textile is to be used to create an item, for instance a garment or bag, you may proceed to do so.

Did you know?

To maintain the colour after dyeing textile, it must be 'fixed'. Fixing allows the colour to be drawn into the fibres of the textile. If you use paints, fix the colour by ironing on the reverse side of the textile. Alternatively, avoid washing the textile altogether for about a month. If you use dyes, the textile is fixed by steaming. An iron is not suitable for this. The textile is rolled with newsprint, then placed in a steamer specially designed for this purpose.

Helpful hint

Once your design is complete, adjust the iron to the 'cotton' setting and iron the textile for about three minutes. Ironing 'fixes' the colours to the textile so that it maintains its brightness and does not run when washed. Always iron on the reverse side while the textile is damp, to draw the dye or paint into the textile.

8. Present the artwork

Be sure to autograph your textile design. Use fabric paint applied with a fine brush. For the vegetable block print, you may choose to design a block with your initials. This may be applied anywhere, but is perhaps best placed at the lower left or right side. Depending on the size of the piece, a mat is a good way to complete work to be exhibited on a wall. There are, however, many other creative ways to present textile designs. Make use of the elegant qualities of textiles to fold, fall and drape in many different ways. Examine magazines on drapery and textile furnishings to give you some ideas.

Present photographs and the drawings you worked from along with your textile design. From them, your teacher will be able to see how well you used the elements of art and the principles of art and design in your composition.

9. My art journal entry

Refer to **Chapter 16** to guide your art journal entry for Stage 9 of your textile design process.

10. Make another textile design piece

a) Make another textile design using an item of clothing. Designs on plain items of clothing tend to breathe new life into them. Consider T-shirts, shorts, vests or swimwear. Household items such as curtains, drapery, table mats and runners also provide excellent opportunities.

b) Use another textile design process. Switch among hand-painting, printing and dyeing. Although they follow similar processes, each technique works with different materials and skills. To gain the widest possible experience, it is advisable to try them all. Compare your process and completed artwork with other students' work.

c) Combine two methods for the surface decoration of your textile. For instance, after a fabric has been sun-painted, you may add prints; or after it has been dyed, you could create a patchwork effect using appliqué pieces for unique results.

d) Use another textile design technique. For the hand-painting, printing and dyeing processes, there are other techniques that may be applied. One method for each process is discussed next.

Other textile design techniques

Hand-painting using stencils

Hand-painting may be combined with the use of stencils. Instead of painting directly onto a sketch, you can create and paint within or around a stencil. Stencils may be made for letters, numbers and your own unique designs. To paint within a stencil, cut out the stencil from a sturdy material such as Bristol board. Alternatively, your stencils may be drawn on contact paper, which is then peeled and fixed in the desired position on the textile before you paint. You may wish to use aerosol paints. If you do, be sure to completely cover all areas except the area where the paint is required. Aerosol paints have a terrible habit of going where you do not want them to.

Cut stencils and paint a textile banner for an upcoming event in your school or community. If you choose to add other designs that complement your writing, you are creating a graphic design on textile. **Chapter 7** provides you with many ideas for this.

Did you know?

You may create either a positive or a negative stencil. A positive stencil actually creates a negative shape, since the paints appear around the cut-out, leaving the actual shape covered up from the paint. A negative stencil creates a positive shape. As the design itself is cut out, the paint appears within the shape, colouring it.

Refer to the accompanying CD-ROM for further advice for using aerosol paints

Key term

squeegee: tool with a rubber blade that spreads and pushes ink

Fig 8.11 Logo Design. Paradise Swimwear Company. Attic Arts.

Screen-printing

Screen-printing is very popular today. The technique can repeat a single design exactly and quickly. It is therefore very suitable for printing items such as your school's monogram on your uniform. The technique uses a fine mesh, called a screen. The screen is usually made from nylon and is held on a wooden frame. A simple screen may be prepared by cutting the design on a non-absorbent material, which is then placed under the screen, or by painting the design directly onto the screen with a special filler. This creates the stencil, which is placed over the textile. Next, ink is placed on the screen and a fill bar is used to fill the mesh openings with ink. The ink is then pressed through the stencil onto the screen using a **squeegee**. This technique is referred to as 'flat-bed' screen printing. More colours may be added, using another screen, while the first print is still wet. The design on the screen may be reused after it is cleaned, or may be removed completely using a stencil remover. If this is done, a new design may be created on the screen.

Fig 8.12 Indonesia Java Yogjakarta crafts. Textile design: Bird (cropped). c. 2004. Batik.

Batik

Batik is another dyeing technique, practised for centuries in Indonesia, India, Malaysia, Nigeria, Ghana and Mali in particular. An applicator, called a tjanting tool, is used to pour melted wax on the textile to create patterns. The wax may also be applied with a brush or on a woodcut or metal block, which is then stamped on the textile. As wax does not dissolve in water, it prevents the dye from reaching the areas of the textile it covers. This technique is referred to as a 'resist method', and the wax is used to resist the dye. Understanding how to design for batik is very important because your design must be able to accommodate the application of the wax.

Knowing where to apply the wax is just as important, as it determines which areas get dyed and which do not. When placed in the dye bath, the dye penetrates into the unwaxed areas of the textile only. Therefore, if you wax the design, the dye appears around the design; and if you wax around the design, the dye appears on the design itself. It is also possible to create cracks in the wax by crumpling the textile. This allows the dye to seep into some areas under the wax, resulting in intricate line patterns that resemble vein-like or streaked effects.

A second colour may be applied in one of two ways. First, wax may be removed from areas that were waxed before the first colour of dye was applied, and the textile can be dyed again. Alternatively, wax may be applied after the first dyeing to preserve the first colour, then the textile can be dyed again. When applying two colours, always dye with the lighter colour first. After the textile is dyed completely, it is ironed between paper towels to absorb the wax. Larger pieces of textiles may be dipped in a wax solvent, which removes the wax.

Chapter summary

In this chapter you have learned to:

- trace the history of textile design
- explain and use terms associated with textile design
- follow the stages for creating textile designs using a technique from each of three textile designing processes
- introduce ideas that will further develop your skills and creativity in designing textiles
- apply your knowledge and understandings to speak and write effectively about textile design.

Activities

Individual

1. Use any textile designing process and technique to create a textile for any one of the following themes: 'Christmas', 'Divali', 'Eid-ul-Fitr', 'Emancipation', 'Hosay', 'Independence', 'Phagwa'. Alternatively, you may propose a theme of your own after discussing with your teacher. Reflect on the meaning of and associations with the festival or occasion. What themes, motifs and colours are in harmony with the festival or occasion? Perhaps the textiles may be displayed for your school's activity for the chosen festival or occasion.

 At another time, you can select another theme to base your design on.

2. Create a design that produces a pair of inverted images, such as two similar objects facing (or moving away from) each other. Discuss which technique(s) may be most suitable for this design. How may the space on the textile best be divided to suit such a design? Consider themes such as 'A Couple', 'Birds', 'Butterflies', 'Flowers', 'Fruits', 'Shellfish'.

 At another time, you can select another theme to base your design on, or create a textile that replicates your design three or four times on one piece of textile.

3. Design a textile based on a pattern derived from a Caribbean animal, for example 'Feathers', 'Fur', 'Scales', 'Shells', 'Specks', 'Spikes', 'Spots' or 'Stripes'. Identify the animal and find pictures that will help you with your design ideas. You may wish to look in magazines or books from your local library, or even take photographs if you can.

Your design should emphasise the pattern itself, rather than the entire animal. Be sure to discuss the level of detail your work will require, and think carefully about how you can represent your pattern in an original way.

At another time, you can select another theme to base your design on.

Group

4. Gradation of colour is the change of colour (hue) values from light to dark. In groups of eight to ten students, select a technique for the dyeing process. Assign a colour to each group. Each member of your group will produce a textile design using that colour but in different intensities (values of that colour) on plain white cotton.

Creatively display your work: for instance, as scarves on a model, hand towels on a table, or as a sewn table cloth, as drapery or as a bedspread. Your display should emphasise the variation, harmony and range of the values of the colour you selected.

5. As a class, collect and display as wide a range of textiles as possible. These samples of textiles teach you about the visual and tactile quality of textiles. Consider the following categories for your samples:

- plain white samples of multiple textiles
- coloured samples of an identified category of textile, such as cotton
- patterned textiles
- textiles with woven designs
- class-dyed textiles
- class-painted textiles
- class-printed textiles
- class-made appliqué-decorated textiles (see **Chapter 13**).

Cut your samples to a standard letter size (280 mm x 215 mm) and catalogue them into a three-ring binder folder. Use dividers to separate the categories of samples. Decorate the cover and dividers. A textile finish may be quite appropriate. As your catalogue grows, a separate folder may be required for each category of your catalogue. Enter your catalogue into your school's visual arts library or the relevant section of the general library. If neither of these exists, here is the perfect opportunity to begin them.

Integrated

6. Create a work in textile that demonstrates the use of at least two design processes: for example, hand-painting and printing, or tie and dye and appliqué.

Discuss and select a theme to work with. Here are some suggestions: 'Buttons', 'Christmas motifs', 'Geometric shapes', 'Abstract shapes' or 'Leaves'.

Decide which of the techniques is better to apply first and which should come after. How will the application of the first technique affect the other? Consider the use of the elements of art: line, shape, colour, tone and texture; the composition for your work and the principles of art and design.

Art appreciation

7. Create one of the following using textiles to be recycled:
 a) a picture using textile
 b) a textile design that resembles a picture
 c) four drawings, closely resembling the texture of four different textiles
 d) pieces of textile, cut into narrow strips or shredded and stuck to produce a line drawing such as a gesture or contour drawing.

Present and discuss your work emphasising the use of discarded, found or old textiles. At another time, you may wish to choose another of these activities to do.

 More activities for this chapter are included on the accompanying CD-ROM.

Chapter 9 Three-dimensional Art

Outcomes

After reading this chapter and practising its activities, you will be able to:

- define, explain and illustrate the term 'three-dimensional art'
- trace the history and development of three-dimensional art
- list, understand and follow the stages in the process for creating your own three-dimensional artworks
- use key terms and understandings to effectively speak and write about three-dimensional artworks
- apply theory and skills from other chapters to complement your work in three-dimensional art
- critique a three-dimensional artwork, using the elements of art and the principles of art and design
- engage ideas and techniques for the further development of the skills learned for three-dimensional artwork.

Resources

You will need:

- notebook, art journal, pencils, coloured pencils, eraser, markers
- Bristol board, card, stag blanc, foam core, styrofoam, drawing paper, 'brown' paper, newsprint, coloured paper, plastics, clay, wood, soap, balsa foam
- rulers, set squares, French curves, protractor, compass, stencils, scissors, craft knife, masking tape, glue, stapler
- chisel, hammer, clay tools: scraper, sponges, soft leather or cloth, wire, sandpaper, paints, paintbrushes, petroleum jelly
- computer with internet access
- school and public library access.

Introduction to three-dimensional art

Three-dimensional art includes artworks that generally can be viewed from all around. Three-dimensional artworks differ from two-dimensional works because they are not flat. Drawings and paintings are examples of two-dimensional artworks. They are done on a flat surface such as a sheet of paper or a wall, and may be seen from one direction only. However, three-dimensional artworks have the three dimensions of length, width, and height or depth. They include sculptures, architecture, architectural and other models, furniture, jewellery, mobiles and Carnival costumes. In three-dimensional design, various views from different angles must be considered to understand the artwork as a whole.

Artists use many materials, natural and man-made, to create three-dimensional artworks. Common naturally occurring materials include stone, wood, clay and bone. Man-made materials include plastics, glass, metals, foams, boards and textiles. Discarded and found objects (discussed in **Chapter 13**) are also used. The artist may choose to combine many materials to create these artworks.

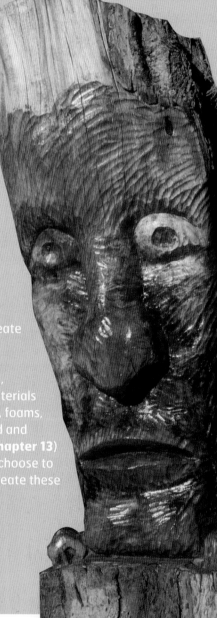

Fig 9.1 Tree carving. Palm Grove Beach, Banjul, Gambia.

History of three-dimensional design

Prehistoric designs

The first three-dimensional designs were probably tools and utensils used by prehistoric peoples in their everyday lives. Their tools for hunting and eating were made from **found objects** or **discarded objects** in their environment. Stone, bone, wood and ivory were shaped using other pieces of similar materials. Three-dimensional artworks were also made for household, religious, funerary and ceremonial purposes.

One particular type was miniature sculptures of the female human form, carved by hand. Each is of these is referred to as a 'Venus' and over time many have been found across Europe. **Examine the Venus of Dolni in Figure 9.2. Comment on its shape and symmetry. How does it compare with the Venus of Willendorf in Chapter 1 (Figure 1.1)? What are some possible reasons for the general shape and exaggerated form of these objects?**

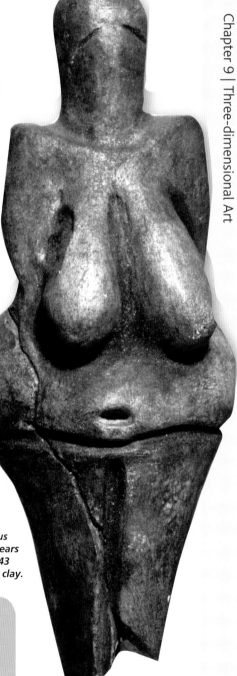

Fig 9.2 Paleolithic, Czech. Venus of Dolni Vestonice. c. 31,000 years ago. Fired clay. 111 mm tall x 43 mm wide. Czech Republic.ired clay.

Key terms

three-dimensional art: artworks that occupy space, having length, width, and height or depth

discarded objects: previously disposed-of objects reused to make art or craft

symmetry: arrangement and balance of parts (usually two) of an artwork

exaggerated form: part of artworks created larger than proportionate size

Key term
found objects: naturally occuring items reused to make art or craft

155

Greek sculpture

About 2,500 years ago, the **sculpture** of Greece had reached its classical period. Based on themes of myth, Greek sculptures were made of marble and cast bronze, and mainly depicted the human male form in its ideal **proportion** and with a youthful appearance. The combination of the materials used, the posture of the human form and the symmetry were used to signify strength and project a sense of dignity.

Fig 9.3 Indian, Rashtrakuta Dynasty. Wedding of Shiva and Parvati. c. 1500 years ago. Carved rock. Ellora Caves, Ellora World Heritage Site, India.

Key term

religious art: visual artworks based on religion and religious beliefs and practices

Indian sculpture

Early humankind was fascinated by three-dimensional art, especially sculpture. Civilisations in Africa, the Americas, China, Europe and India each developed their own unique style. They used wood and stone, cut with great skill. Later, metals became a new material for sculpting. Indian sculptures are good examples of **religious art**, based on Hinduism and Buddhism and taken from stories in their sacred texts. **Figure 9.3** is one of hundreds of wall carvings cut from the natural rock surface at the Ellora complex in India, which took almost a hundred years to complete. Notice how the main forms have been cut deeper into the rock. **What effect does this have on the viewer?**

Key terms

sculpture: artworks carved, cast or built up into three dimensions

proportion: measurements relative to other measurements

cast: to pour liquid material into a mould to solidify into a finished artwork

Central and South American artworks

Ancient cultures of the Aztec, Chavin, Inca, Maya and Olmec produced their own unique styles from stone and wood. Many of the stones used for the sculptures did not come from the areas where the sculptures were found, and in most cases were moved there from far away. Art historians know that many of these artworks were related to religion and cultural practices, but many questions have been left unanswered. For example, the large Moai stone sculptures of Easter Island were carved with stone chisels from single blocks of volcanic stone weighing several thousand kilograms. **Do some research to find out more about these sculptures.**

Renaissance sculpture

About 500 years ago, during the Renaissance, the ideas of Greek sculpture were rediscovered. The great sculptors worked towards achieving balance, symmetry and proportion in representing the human form as a part of the natural world. **How does the posture of the sculpture in Figure 9.3 compare to that of David, Figure 9.4? Discuss the principle of balance and use of proportion in Figure 9.4.**

Fig 9.4 Michelangelo Buonarroti. David. Marble. 450 cm tall. Galleria dell'Accademia, Florence, Italy.

Key term

installation art: large-scale assemblage, usually occupying a space that allows the viewer to move through it

Three-dimensional art today

The three-dimensional artworks of today vary in the materials used and approaches to creating them. Artists use new materials and combinations of materials for creative self-expression. In **Figure 9.6**, the artist has created a nearly 25-metre-tall **installation art** from fishing line. What does this artwork look like? **How do you suppose it was held up in place? How important is the use of light for this artwork?**

Fig 9.5 Anniken Amundsen. Transition. 2003. Fishing line. 240 x 190 x 95 cm.

157

Introduction to form

Form is the space occupied by a three-dimensional artwork (see **Chapter 1**). The element of form suggests viewing 'in-the-round'. This means that the viewer is able to look at the object from multiple points of view, including from the sides and behind. You can walk around the artwork, and in some cases look up or down at it.

Examining an artwork this way gives a sense of its dimensions: not only its length and width, but also its height or depth as the third dimension. It also begins your understanding of how the artist used the elements of art and the principles of art and design in creating the artwork.

The element of form reveals much about the texture of the material used and how it was manipulated. Form also develops a relationship to the space where the artwork is displayed, so much so that the artist must also think carefully about the effect of the space for display, and the position, direction and lighting for the artwork.

Examine a three-dimensional object or artwork. Describe its physical appearance, then look for relationships that exist among its dimensions. You will soon realise that in order to make detailed statements, you must consider what you see from all around. This sets a three-dimensional artwork apart from a two-dimensional one. So, when you write about such artworks, photographs taken from various points of views will become essential to support your description.

Understanding nets of solid forms

Flat shapes combine to create a **solid shape** or form. Therefore, if you deconstruct a solid form, you can see the flat shapes that are used to make up that solid. This is called the **net** of that shape.

To deconstruct a solid form, you need to observe the form from all around. Identify the flat shapes that make up each surface of the solid shape. Use an actual model of the solid forms to help you to do this.

Cut the shape along its edges so that it unfolds and lies flat. Try this with a box that has the shape of a cube. Trim off the unwanted flaps so that six similar squares remain, but do not separate the squares. Now fold the net of squares upward to reconstruct the cube.

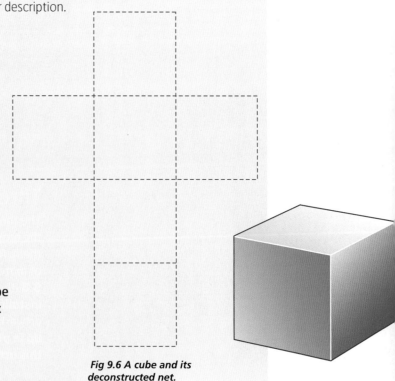

Fig 9.6 A cube and its deconstructed net.

Key terms

flat shape: two-dimensional shape, without depth or thickness

solid shape: three-dimensional shape, with depth or thickness

net: arrangement of the flat shapes that make up a solid form

Constructing a solid from its net

You can also construct a solid form by observing its three-dimensional form. First, identify the number and shape of the surfaces of the solid. See which surfaces are identical and which are different from the others in shape and area. Note, too, which ones are next to, away from or opposite to each other. This helps you to see the relationships among the separate flat surfaces that make up the net of the solid shape.

Take careful measurements of each surface. Draw the flat shape that represents the base of the solid shape first, then draw each of the surfaces that are connected to the base. The lines will indicate the edges on the solid shape.

Each flat surface of the solid should be represented on your drawing once, and should be connected to at least one other flat surface. Carefully cut out the outline of the net then, beginning with the base, fold upwards to construct the solid. Use tape to hold the solid form together. Later, as you become more experienced, flaps may be added to hold the net together. (A flap is an extra fold of material used to hold the three-dimensional shape in place.) Glue may be used to hold the structure permanently in place as you fold it into its form.

For each of the solids (cube, cuboid, triangular prism, cylinder, cone, pyramid), get a model to observe and draw their nets, then construct their solid forms. Present the model, the drawings and your constructed solid forms for discussion.

square

square in perspective

combined perspectives

Fig 9.7 Constructing a cube.

Sculpture

Sculpture is one type of three-dimensional art, traditionally formed by carving or cutting away from a material. Traditional materials such as stone or wood are made up of compact particles, and require great imagination and care in removing unwanted material in order to reveal the sculpted form.

The process of carving or cutting away at the solid material is called whittling (refer to Stage 4 of the three-dimensional art-making process). **Name some other materials that may be whittled.**

Did you know?
Understanding nets of solid forms is useful not only for constructing them, but also for drawing them. As you learn how various flat shapes appear separately, you are better able to combine them to successfully represent a solid shape. These solid shapes in turn help you to understand the form of three-dimensional artworks and objects.

Methods for creating three-dimensional art

There are three major methods for creating three-dimensional artworks. They vary because of the raw materials and processes that are used.

Subtractive method

The subtractive method is used to remove material by chipping, carving or cutting away from a larger block. Materials suited for subtracting include stone, wood, soap, ice and styrofoam. The form is revealed by working from the outside moving in, generally using one piece of material, and so no glue is required. **Figures 9.1** to **9.4** have been created using the subtractive method for three-dimensional design.

Additive method

The additive method builds up the form as more material is added. Material in a liquid form may be poured into a mould and allowed to solidify into the three-dimensional form; the mould is then removed. Metals including gold, silver, bronze, plaster of Paris, clay, all-purpose plaster filler, dry-wall joint compound or concrete may be used. The parts of **Figure 9.8** were moulded separately then assembled.

Materials in a semi-solid state may also be used to build up the form by working the material into shape. Papier mâché, clay, paper clay, sawdust and wood glue, fabric and glue, all-purpose plaster filler, or dry-wall joint compound may be used in this way. Layers may need to be left to dry before others are added, and mesh, frames, armatures and moulds may be used to create and support the artwork.

Construction method

The construction method generally uses solid materials that are manipulated by cutting then assembling to create the solid form, very much as a carpenter works. Materials include boards, foams, **plexiglas**, glass, metal sheeting and wood. Methods for joining must be appropriate to the materials used, and therefore include adhesives, clips, nails, screws and pins, **Velcro** and welding. Knots, ties and twists can hold textiles, fibres and wire **frames** together. Other materials may be cut in such a manner that the sides fasten or snap into place.

Key terms

plexiglas: a plastic-like transparent material, available in sheets

Velcro: a fastener with hooks and loops that sticks and unsticks

frames: skeletal supports for artworks

Stages in the three-dimensional art-making process

1. Research three-dimensional art-making techniques and process

Refer to **Chapter 16** to guide your research for Stage 1 of your three-dimensional art-making process.

2. Select the topic, theme or brief

Because of the wide variety of materials and techniques available to use, you will need to make many decisions early on about what direction you want your work to go in.

Begin with an object, topic or theme that is simple to design, and also materials simple to find and manipulate. For the main activity in this chapter, a suitable theme may be 'An award', such as a trophy. Examine various awards and trophies to get good ideas and materials to use.

Very often you may find that what method you choose to work with helps to narrow down the type of materials you will use. For instance, for the subtractive method, styrofoam is a suitable material to begin with; the additive method may require wire mesh and papier mâché; while a suitable material to begin the construction method is cardboard or foam core. There are, however, many alternative materials that will work equally well.

Can you name some?

3. Create the design

From your research, select the design you wish to work with. Use pictures or actual models of trophies or awards to help with your ideas. Give careful thought to the shape, dimensions, materials, colour scheme and purpose of the award.

The purpose of the award will be a main concern in its design, but remember to keep the design simple and symmetrical at first.

Sketch your design ideas. Do as many drawings as possible to play with your ideas, and choose your best design to work with. Once you have selected your final design, create your drawings in **orthographic projection** (see **Chapter 11**) using a suitable scale (see **Chapter 7**). The ideal scale to begin work with is full or actual size, as this gives you the best possible idea of the measurements of your design on paper. Now begin to gather your materials, tools and equipment.

Fig 9.8 A trophy

> **Key term**
>
> **orthographic projection:** drawings that shows the viewer multiple points of view of a single object, including the 'front', 'end' and 'plan' of the object

4. Select the method for creating your three-dimensional artwork

Each of the three methods teaches a different approach to creating a three-dimensional artwork. Choose one to work with at first, and repeat its use to improve your skill. However, it is also important that you experience all the other methods, as they teach you new skills that will give you different ideas to work with.

The method you choose now will help to determine the materials you require.

- The subtractive method requires a styrofoam, wood, balsa foam, clay or other suitable modelling material block, metal rulers, French curves, protractor, utility knives and cutters, pencils and an eraser.

- The additive method requires a mould or wire mesh frame, papier mâché or paper clay, sheets of newsprint, scissors and glue.

- The construction method requires cardboard construction board, foam core or any similar sturdy material, a cutter or craft-knife, and a suitable adhesive.

5. Create the artwork

Once you have your design ideas and your tools, you are ready to begin your work. Pay particular attention to the tools and materials you use and the safety procedures that are required, since many of the tools may have sharp edges. Follow your teacher's demonstration of their use.

- The subtractive method begins with a rough outline in dark pencil of the various points of view on the respective surfaces of the block. Next, begin cutting away from the vertices the unwanted areas. Switch from one **vertex** to the others, constantly shaping the form into its 'in-the-round' appearance. Larger cuts may be made at first, but they are reduced in size as the form of the object begins to emerge. Use a knife or other sharp instrument to **whittle** the block you are sculpting. Be careful not to cut away any part that you will need. Patience and care in studying your design drawings and imagining the finished artwork are important. Another good idea is to frequently redraw after cutting so that there are always guidelines to help you along.

 A useful introductory exercise is to carve out a simple symmetrical geometric form such as a cylinder, seen in **Figure 4.4** in **Chapter 4**. This practice helps you to become familiar with the material and the tools you use, and develops your feel for carving and shaping. Cutting or carving in different directions and at different depths produces different results. So as you approach the depth that you desire, how you hold your tools, how you hold the block, how you stand, the direction in which you cut, the depth at which you cut, and how you gouge or remove material change. Your skills will improve as you continue to work with subtractive techniques.

- The additive method for papier mâché uses a mould or wire mesh over which the paper pulp or paper layers are spread. For a design such as a trophy or award, a wire mesh or **armature** may be required. Wire mesh may then be shaped around this frame. Next, material is laid over the frame to build up the artwork.

Key terms

vertex (pl. vertices): the meeting point of three or more edges of a solid shape

whittle: to carve, chip or cut away solid material to create a three-dimenstional artwork

armature: skeletal frame created to support the body of the artwork. It is used from within, and it is usually not seen when the artwork is complete

 Refer to the accompanying CD-ROM for tips on safety in the classroom.

Did you know?

An armature may be made of any sturdy material, but wire, wood or a combination of wood and nails create simple and effective frames. Others may be made from pieces of PVC stuck or fastened together, or pieces of metal welded together. The armature allows the artist to apply and build up the material into the desired form. The armature must be sturdy enough to hold the shape and weight of the artwork. For this reason, armatures rely on the principle of balance.

Papier mâché

Papier mâché is a French term meaning 'chewed-up paper'. It is a handy and environmentally friendly technique that reuses paper in a unique way. Papier mâché is capable of producing almost any design, ranging from trinkets and jewellery to masks and vases to free-form sculptures and furniture. When completely dried, the product is amazingly strong and lasting.

There are two common methods for creating artworks in papier mâché:

1. Laminate

Sheets of two different types or colours of paper are cut into squares. Newsprint and 'brown' paper are two readily available and inexpensive papers. These are stuck in layers over each other to create the body of the artwork. The squares of paper should be about 3 cm x 3 cm in size, and each square should be stuck in a manner to overlap another by one-third. Apply the adhesive to the squares, one at a time, and lay them into place. Paper glue or flour paste is suitable. Ensure that each square is laid flat, and follows the desired form of the mould or mesh.

If a mould is being used, a layer of clear plastic such as cling wrap is used to cover the mould. A clear plastic bag may also be used, but you will need to apply a film of petroleum jelly on the mould, then lay the plastic over it. Ensure that the entire mould is covered and that the ends of the plastic sheeting are folded around the mould and rest under it. Clear plastic has the advantage of allowing you to see the mould as you begin to apply the laminate.

Once the first layer has completely covered the mesh or mould, clean off any excess adhesive and then begin a second layer using the second type or colour of paper. This second layer should be placed in a direction diagonal to the first. Five to eight layers of paper are suggested. These multiple layers of pieces overlapped in different directions are what give the artwork its strength. Why do you think two different types or colours of paper are used?

2. Pulp

Paper is torn into narrow strips of about 3 cm width. These are then placed into boiling water and 'cooked' until the paper breaks down to a pulp-like consistency. You will need to stir regularly to achieve the best results. An anti-fungal treatment may be added to deter the growth of mould, and a fragrance may also be added if desired. Pour out the mash and allow it to drain. This mash or pulp is next mixed with flour or clay, and then is ready for application on the mould or frame.

Next, apply the mash to the mould or frame to create the form that you desire. Lay and spread the mash in such a way that it creates the form as you work. Try to use a consistent thickness of mash. About 5 mm is recommended, but you will recognise that some areas may require a different amount.

Helpful hint

It may not always be practical to complete the application of the mash in one session as the object may require turning or a particular surface may have to be built up in stages, and this will require the papier mâché you have already applied to dry before you can continue. You may wish to work on one area then move to another while the first dries off.

Key term

bevel: a cut at an angle (usually 45 degrees) to join pieces of materials or to finish an edge

The construction method requires the various flat surfaces of your design to be drawn to actual size, then cut out. As much as possible, try to fold your material to form the edges, rather than cutting out each separately and then joining them with glue or tape. Folding is not always possible, but it improves the strength of your design. Be sure to create a net of your design, and carefully consider where cuts are essential or optional. Where cutting is necessary, **bevel** the edges that must come together to create a perfect seam. The optional ones should be folded rather than cut. Begin with the base for your design and build up the sides. Join the sides to the base using a suitable temporary method to hold the parts in place — for cardboard or foam core, headpins are quite good. Doing this allows you to see the design before you apply the final adhesive. In this way, minor changes and adjustments may be made without having to tear apart well-glued sections. While constructing, support side pieces from the inside using straps, flaps, buttresses or bars. These connect the various parts, helping to stabilise the form. Think carefully about where they are placed, as you may not wish them to be visible in your finished design.

Continued use of the construction method allows you to gain experience in cutting, folding and uniting parts to form designs.

163

6. Finish the artwork

The next step is to complete the artwork. As you do so, keep in mind the importance of highlighting the grain of the material you used. This emphasises the element of texture in your work.

- The subtractive method will require you to make smaller and shallower cuts as the form continues to emerge. Use smaller tools with greater care. These cuts begin to add finer details and texture to your work. Always aim to enhance the natural texture (see **Chapter 8**) of the material you are working with. This is a main goal for a sculptor.

 However, finer details are not as important as achieving good proportion, symmetry and balance throughout the entire artwork. So a sculptor should work to achieve this overall proportion, symmetry and balance first. To do so, keep focusing your attention on the entire artwork as a whole, rather than on each part separately. This will prove a bit difficult at first, but with practice you will begin to develop a sense of how each part relates to the whole artwork.

 It is possible to add a projection or extension of material to a sculpture. To do so, carve the parts separately. Prepare both surfaces where the parts are to be joined, then apply a suitable adhesive. Your teacher will be glad to advise you on this. Follow instructions for roughing and cleaning of the surfaces, and the procedure for application of the adhesive (some adhesives require mixing). Allow the adhesive to 'stand' on the surfaces before actual bonding, and keep the parts supported as the adhesive dries.

- The additive method may require either the addition or the removal of material. Where the form needs to be built up, simply add material. To remove material, you may wish to sand off areas that require shallow alterations after they have dried. For deeper alterations, you may choose to gouge or cut away excess material. It is much easier to do this before the material has dried. Next, apply a new layer of material if necessary and allow it to dry. Use sand paper to smoothen.

- The construction method requires a careful check of the surfaces. See whether they are of accurate size and if they mesh properly at the edges. Ensure that the design has achieved balance and symmetry.

Helpful hint

Where a surface requires a shape to be cut out, do so before you assemble the parts because better results are achieved while working flat. Use your design drawings to measure and mark in pencil what you wish to remove, then carefully score and cut. This also avoids placing unnecessary pressure on the artwork during and after its construction.

Points to consider in achieving and improving good form:

- Always see the artwork as a whole, from all around. This helps to prevent you from over- or under-working any part of the artwork, avoiding an unintended imbalance in the work.

- Keep in mind that, as you work, your ability to use materials and acquire skills will improve. You will not build on your experience if you do this type of work only once.

- Keep in mind the elements of art and the principles of art and design. They help to make your work successful and pleasing.

Once you are satisfied with the all-round form (proportion, balance and symmetry) of your artwork, use fine sandpaper to smoothen any rough edges. Because the various materials used for three-dimensional artworks differ in their density, their reaction to sandpaper varies. So before you begin, apply the sandpaper to a scrap of the material you used. Do so along and against the grain of the material. You will soon recognise that each surface and direction of movement produces a different result. Choose one direction in which to apply the sandpaper.

Find out whether painting or decorating is desired. The main objective of this is usually to emphasise the design and the design process, and therefore **embellishing** may not be necessary, or it may hide the natural beauty and texture of the surface and grain of the artwork. If you do emblelish your work, it must be in keeping with the theme and purpose of the design of the artwork, so consider the colour, type of paint and finish you expect to achieve.

7. Present the artwork

Throughout this chapter you have been reminded to see the artwork as a whole. To do this, a three-dimensional artwork is displayed so that the viewer can see it **in-the-round**. This helps to fully understand the artwork and what it represents.

For this reason, depending upon the piece, a three-dimensional artwork may be presented on a pedestal or table, may be suspended, affixed to a wall, may be free-standing from the floor, or may be worn by a model.

The space you use to present your artwork is equally important. A small piece will seem even smaller on a very large table or display area. Ensure that there is sufficient light so that the artwork may be viewed properly. Otherwise, the viewer may not see details or may lose interest in it altogether.

Along with your artwork, you should present your design ideas, the selected design drawings to scale, a list and sample of materials you used, and photographs of your work at the various stages of development. Together these create a complete idea of what you did and indicate where you may need to improve the next time you attempt a three-dimensional artwork.

Key terms
embellishing: decorating an artwork
in-the-round: a three-dimensional form, made to be viewed from all angles

8. My art journal entry

Refer to **Chapter 16** to guide your art journal entry for Stage 8 of your three-dimensional art-making process.

9. Make another three-dimensional artwork

a) Use another design idea, but based on the same theme. You may wish to create a sculpture that captures your subject in a different posture. This adds interest to your work, and is a good way to begin a series of works based on a particular subject or theme.

b) Use other suitable materials with the same technique. For the subtractive method, styrofoam, balsa foam or wood may be interchanged. For the additive method, one papier mâché technique may be replaced with the next or with paper clay, or with styro-beads mixed with plaster. For the construction method, foam core, construction board, plyboard or cardboard may be interchanged.

c) Switch among the subtractive, additive and construction methods. This will give you the widest range of experience, so try them all. As you do so, compare your methods, processes and completed artworks with one another and with those of other students.

d) Consider combining methods. Your experimentation with three-dimensional design may lead you to combine the methods (subtractive, additive, construction) to create a unique artwork or art-making process. But gain sufficient knowledge and experience with all three methods separately before you consider combining them.

e) Experiment with another three-dimensional art technique. One such technique is the use of wire, twine or fibre to create a three-dimensional artwork.

Did you know?

Three-dimensional artworks may be grouped into 'full-round' or 'part- round'. A full-round artwork in made to be seen all around or completely in-the-round. A part-round artwork is usually made to be seen from its front only, or from its front and sides. A relief sculpture or a stella are examples of part-round three-dimensional artwork. Research and compare the views of the Mount Rushmore National Memorial, South Dakota, USA (1927–1941) with the (Statue of) Liberty Enlightening the World, New York, USA (1886).

Wire-bending

Wire-bending is the forming of strands of wire or metal fibre into a desired shape. The technique may be used to:

- create a frame for a three-dimensional artwork
- hold materials together in an artwork
- build a complete artwork.

Creating a frame

An armature is a frame that may be built to create and maintain the shape of an artwork. Wire is popularly used for this purpose. Since wire is available in various thicknesses, called gauges, selecting the proper gauge to use becomes important. A floral arrangement requires a much lighter and thinner wire than the armature for supporting a clay sculpture.

Wire-bending requires a pair of pliers as its basic tool. A combination of simple loops, hooks, twists, plaits and ties of the wire does the trick. Alternatively, ends may be fused using soldering, or other welding or fastening techniques.

Throughout the Caribbean, wire-bending is an extremely popular skill with Carnival artists. Because of wire's light weight, easy bending, quick-cutting and durable character, it has been the preferred material for creating the frames for magical costumes, both small and large. Materials including plastics, textiles and foils may then be spread and stretched over the wire frames.

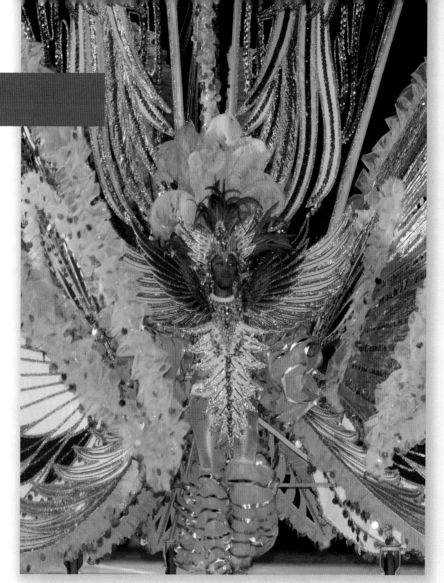

Fig 9.9 Queen of the band. Carnival costume. Trinidad and Tobago Carnival.

Holding other materials together

Many artists create artworks in parts that need to be assembled or linked together. Wire is one way to connect these parts. Depending on the way the wire is used, it may become part of the actual design. For example, leaves may be framed from wire, but may also be connected by branches to stems made from wire. Wire may also be used to link parts, or to puncture and hold soft woods, styrofoam and other foams, and even plastics, glass, rocks and seeds together.

In some cases, the wire reinforces or supports other essential parts or wires. Wire may also be used to suspend or hold an artwork in place, generally for display.

Building a complete artwork

Wire may be used to create an entire artwork. Some artists have chosen to work in metals only: bronze and copper are preferred metals. Their work includes three-dimensional pieces that may be cast as a single mould or cast in separate parts and then combined. Instead of melting metal, wire rods may be shaped into a complete design. The process generally begins with the creation of the 'spine' of the skeletal frame. After this, other wires lifted from the spine or connected to the spine are bent into the desired form, giving the artwork its three-dimensional form.

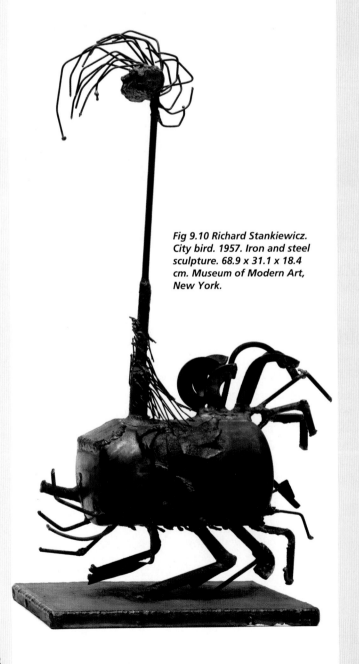

Fig 9.10 Richard Stankiewicz. City bird. 1957. Iron and steel sculpture. 68.9 x 31.1 x 18.4 cm. Museum of Modern Art, New York.

Chapter summary

In this chapter you have learned to:

- trace the history of three-dimensional art
- explain and use terms associated with three-dimensional art
- follow the stages for creating three types of three-dimensional art
- apply ideas that will further develop your skill in creating three-dimensional art
- apply your knowledge and understandings to speak and write effectively about three-dimensional art.

Activities

Individual projects

1. Select a theme from the following: 'My home', 'A mask', 'A piece of furniture', 'Plant life' 'My dream', 'On my desk', or another of your choice.

 Based on your chosen theme:
 carve a model from styrofoam, balsa foam or any other suitable material

 OR

 create a frame from wire mesh and apply a papier mâché technique to complete the design

 OR

 construct a model to a selected scale using cardboard, foam core or any other suitable material.

2. Using any one of the subtractive, additive or construction methods, create a solid shape made of at least ten flat surfaces. The surfaces may be of any shape, but must come together to form a complete and unique whole. Name your design.

3. Using a combination of any two of the subtractive, additive or construction methods, create a three-dimensional artwork based on one of these themes: 'My family', 'Sea life', 'In my room', 'Caribbean people', 'My ambition'. Alternatively, you may use another theme suggested in your class.

Group projects

4. In groups of four or five students, create a three-dimensional design using five different materials. The design must be able to stand freely from the floor and be no less than 100 cm tall, and no less than 60 cm long or wide at its broadest point.

 Suggested themes include: 'Sea creature', 'Our folklore', 'Fireworks', 'Our solar system', 'Waterfall', 'Sadness' or 'Creativity'. Alternatively, you may use another theme suggested in your class.

 Suggested materials include foams, boards, paper, wood, metals, rubber, foils, textiles, plastics, mesh, wire, threads, vines and fishing lines. Materials not listed here may also be used. The materials may be in raw form or may be recycled from other found or discarded objects.

 Write a brief outlining how your ideas came about for the design. At the exhibition for your group's artwork, speak to viewers about the artwork, the materials, tools, techniques and methods you used, and what aspects of the theme the artwork represents.

5. In groups of five to eight students, create a wind chime that combines the use of pieces of hollow cylindrical metal, such as metal tubes for electrical wiring, and other objects. Suspend the pieces from a circular disc with a diameter of 12 to 15 cm. A PVC waterpipe end-cap, available at any hardware store, or a disc cut from Plexiglas is suitable. Include a fastening mechanism and hook to suspend your wind chime.

 In what ways is this activity similar to the creation of an assemblage (see **Chapter 13**)?

Integrated projects

6. Create a mobile to suspend in a baby's room. For your design, you must use two plastic coat hangers to build the frame for your mobile. Some other materials you may consider include: string, crochet thread, boxes, balls and other shapes, adhesives, paints. Add others if you wish.

 Use your design to explain how the following were applied: colour, weight, balance, gravity and use of wind.

Art appreciation

7. Select one two-dimensional artwork such as a painting or drawing. Select one three-dimensional artwork such as a sculpture or decorative artwork.

 a) List as many differences as you can find between the two artworks you selected.

 b) List as many similarities as you can find between them.

 c) Discuss the choices that the artist making each piece would have had to consider while producing their work. Base your discussion on the following: materials, use of space, techniques, skills and abilities, display and storage.

 More activities for this chapter are included on the accompanying CD-ROM.

Chapter 10 Leathercraft

Fig 10.1 Assorted leather items.

Outcomes

After reading this chapter and practising its activities, you will be able to:

- define and explain the term 'leathercraft'

- trace the history and development of leathercraft as an art form

- list, understand and follow the stages for creating your own leathercraft items

- use key terms and understandings to effectively speak and write about leather and designing in leather

- apply theory and skills from other chapters to complement your work in leathercraft

- critique a leathercraft item, using the elements of art and the principles of art and design

- engage ideas and techniques to further develop your skills for designing in leather.

Resources

You will need:

- notebook, art journal, paper, pencils, coloured pencils, markers

- various types of leather

- awl, mallet, revolving punch, stitch spacer, steel square, heavy-duty craft knife or cutter, scissors, shears, leather-stamping tools, heavy-duty hand needles, durable sewing thread

- computer with internet access

- school and public library access.

Introduction to leathercraft

You have already read that early humans hunted animals for their food. After the flesh was eaten, what remained was the bones and skin. Humankind grew to become resourceful enough to use these remains. Bones were used to make vessels, weapons and craft items. The **skins** and **hides** were used to protect them from the elements. It is not difficult to imagine people using these skins to keep warm, to wear on their feet or to sleep on. The hides were better suited to making tents and weapons.

Because animal flesh decays in a short time, the skins and hides had to be replaced frequently. Later, mankind realised that stretched and dried skins would last longer; the moisture in the skin, which contributed to the rotting, was reduced. But the removal of the moisture from the skin also caused the skins to harden and become less flexible. Applying fats or oils to the skin caused them to regain their flexibility. The fats and oils also preserved the animal skin, lengthening the life of the skin, and so leather was first made.

History of leathercraft

The Iceman

When well preserved, leather lasts for a very long time. In 1991, the body of the 'Iceman' was discovered in the Italian Alps. He lived about 7,000 years ago, and was found with clothing made from goatskin, deerskin and tree bark. His shoes and shoe-straps were made of cowhide and his hat of bearskin. His belt pouch was also made of leather and the pieces had probably been fastened together using bone needles. All these items were extremely well preserved and are proof of the durability of leather. From his clothing, weapons and backpack, we are able to tell how well humankind had adapted to their environment, and get a very good idea of their prehistoric artistic ability.

Fig 10.2 Representation of the Iceman with clothing, weapons and tools. Discovered 1991 at Alps Mountains. c. 7000 years old.

Key terms

leathercraft: art of manipulating leather to make artworks or products

skins: pelts or coats of smaller animals or the young of larger animals

hides: skins of larger animals

The early development and use of leather

As methods for preserving improved, the uses for leather widened. Tannic acid, found in the bark of trees, was applied to increase the durability of leather through the process of vegetable tanning. The improvement of the process of **tanning** led to the increased popularity of leather and widened the reasons to use it. This in turn caused a greater demand for leather. Historians believe that this occurred in many ancient civilisations at almost the same time although these civilisations had no contact with one another. China, Egypt and Mesopotamia are three early civilisations that developed leathercrafting independently.

Artefacts and paintings in tombs in ancient Egypt, dating from about 3,500 years ago, tell us that leather was used to make jewellery, furniture, musical instruments, bags, belts and even surfaces for writing. But the military use of leather was also very important. Clothing and shields, used for protection, were made from tough hides, while more flexible leathers were used as straps to hold them in place across the upper body. Quivers for arrows were also made from leather, and so too were parts of chariots. **Observe Figure 10.3, a picture of the pharaoh Ramses II, an ancient king of Egypt, in battle. What objects may have been made from leather?**

Key terms

tanning: process for preserving animal skin to make leather

tannery: factory for processing skins into leather

Fig 10.3 Combat of Ramses-Miamoun against the Khetas on the borders of the Oronte. Coloured engraving.

Greco-Roman leathercraft

About 3,000 years ago, Greek tanneries were already making refined leather products. These skills were passed on and spread throughout the Roman Empire. The Roman army boasted leather clothing, footwear and capes. The production of refined leather products was possible because leathercrafting was organised into a recognised trade with full-time tanners. They used the bark of many indigenous trees and those borrowed from conquests of other civilisations to improve their products. Tanning with alum (a type of salt) and fish oil was also well known. Popular animal skins and hides came from goat, sheep, bear, wolf, lion, leopard and seal.

In 1873, archaeologists unearthed a complete **tannery** at the ruins of the town of Pompeii, in Italy. It contained many rooms for vegetable tanning, alum tanning and the drying of skins; brick basins with water inlets and outlets; vats, jars and tanks; and living quarters. These findings demonstrate how advanced the process of leather-making was 2,000 years ago.

Native North American leather

The indigenous North American peoples made products that proved their knowledge and skill in manipulating leather. Their products included clothing, housing and weapons. Skins and hides were gathered and preserved after their hunts. Buffalo hides were used for almost every aspect of their lives, and became an everyday part of their culture. Other animal skins used included beaver and deer. Observe **Figure 10.4**, a representation of a Moennitarri Indian warrior that was painted around 1834. **What pieces of the warrior's clothing may have been made from leather? How does this compare with Figure 10.2 of the Iceman?**

Eight to twelve hundred years ago, European leatherworkers became highly organised into crafts and trade guilds, following a long tradition introduced by the Greeks, and so the formal organisation of the industry began to take shape. The increased production of leather was matched by its increased use. In Europe, bottles, cases, trunks and bookbinding in leather appeared, and leatherworkers formed themselves into craftsmens' guilds to increase their trade. During the 1800s, Sir Humphry Davy conducted many experiments with leather, discovering other plants and vegetables that could be used in tanning. The invention of the sewing machine in 1790 would refine the finish of leather products. **In your research, try to find out about Sir Humphry Davy's work with leather.**

Fig 10.4 American Moennitarri Indian warrior costume.

In the 19th century, chemicals began to be used for the processing of leather. Industrialisation demanded heavier grades of leather for machine belts, furniture and vehicles. Meanwhile, the fashion industry needed softer, more colourful and finer types of leather. Machines themselves were developed for both leather-making and leathercrafting. Today, synthetic leathers include leatherette, polyesters and plastic leather, which are used for the design of clothing, furnishings and in other industries. But the exquisite quality, refined appearance and feel of natural leathers are still unmatched. **Examine Figure 10.5. Comment on the use of colour and texture in the leather. Can textures reveal the type of animal the leather was made from?**

Fig 10.5 Woman's wallet.

Did you know?
About 1,500 years ago, animal skins began to be used for the production of parchment and vellum. These two materials were made from the skins of animals and were used for writing on. Vellum, which has a grain pattern, was considered of a higher quality and was used to paint and print on. Parchment, however, which has no grain pattern, was used for writing only. Neither was tanned, and therefore they were not considered to be leather.

Preparing leather

To create leather from animal skin, it must first be prepared. The process begins with cleaning. This requires the animal skin to undergo soaking, liming, unhairing, fleshing, deliming, and bating. Fortunately, you won't have to do all of this!

The next step is tanning. Tanning prevents the animal skin from rotting and allows it to remain flexible once it has dried. Today many different materials may be used for tanning, but vegetable and chemical methods are the most popular. The third step is crusting. This step requires re-wetting, splitting, shaving, retanning, dyeing, staking and buffing the leather.

The final step is **finishing**. To finish the skins undergo oiling, polishing and **embossing**.

Basic tools used in crafting leather

Here are some tools that you will require for working with leather. Examine Table 10.1 and discuss with your teacher how each tool is used.

> **Key terms**
> **finishing:** smoothening or application of decorative elements to an artwork
> **embossing:** decorating with parts added to a surface, or parts raised from a surface (the opposite is **deboss**: to decorate with parts removed from, or sunken into a surface)

Table 10.1 Tools and their applications

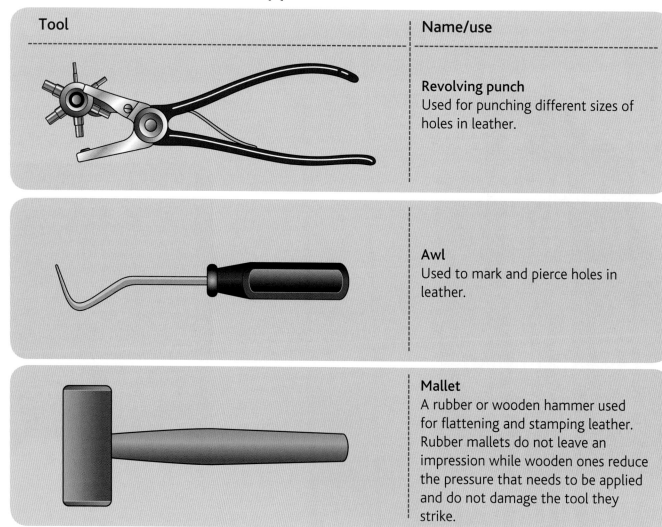

Tool	Name/use
	Revolving punch Used for punching different sizes of holes in leather.
	Awl Used to mark and pierce holes in leather.
	Mallet A rubber or wooden hammer used for flattening and stamping leather. Rubber mallets do not leave an impression while wooden ones reduce the pressure that needs to be applied and do not damage the tool they strike.

Tool	Name/use
	Needles Used to carry thread through pieces of leather for stitching.
	Scissors and shears Used for cutting pieces of leather. The shears are generally for heavier leathers.
	Knife Used for marking and cutting pieces of leather. A wide variety of styles exist for use in leathercraft.
	Embossing wheel Used for creating a variety of patterns on leather. Each pattern exists on a wheel that is attached to a handle. Pressure is applied as the wheel is rolled along the leather.
	Stitch spacer Used for creating marks that are then used to guide a needle.

Tool	Name/use
	Stippling tool or moddler Used to create points or dots similar to the Pointillist technique.
	End punch Used to cut out a shaped end in leather pieces. Suitable for belts in particular. A mallet is used to apply force to the end punch.
	Calliper Used to measure the distance between points. Its two adjustable points accurately transfer or repeat the measurement of a given distance.
	Steel or framing square Used to accurately measure or mark right angles. It also provides a suitable edge along which the leather may be cut.

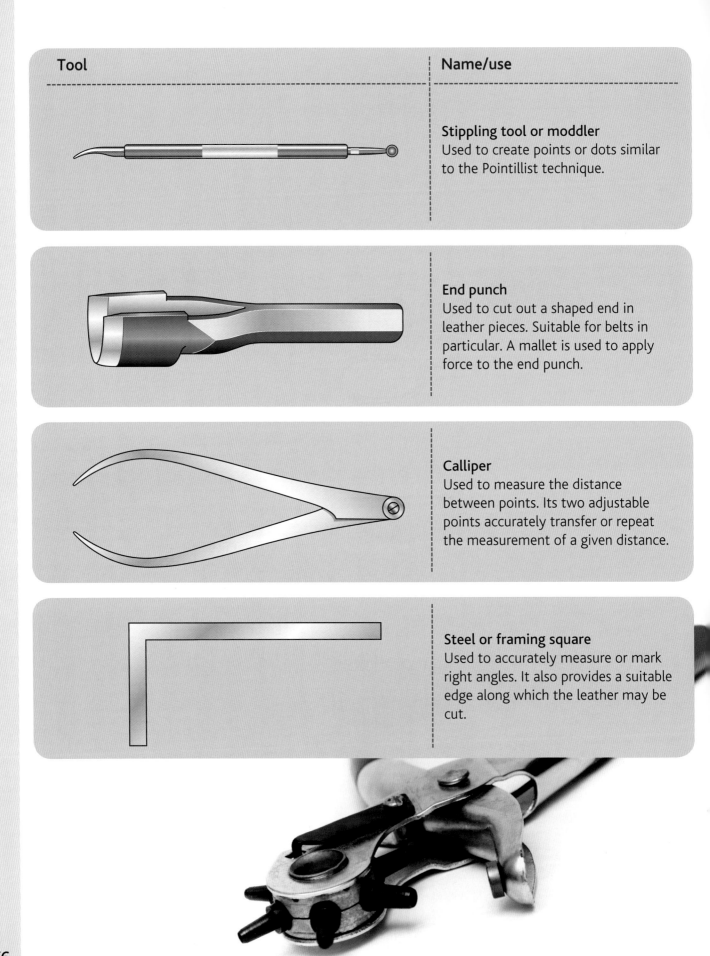

Stages in the leathercrafting process

The leathercrafting process has nine stages that are intended to help you to develop your ability to create artworks from leather. You will begin with what to research, selecting and drawing what to create, transferring the design to the leather, cutting out the parts, assembling the parts, finishing the artwork, presenting your work and making a journal entry along with ideas to include or improve the next time you attempt a work using leather. Along the away, you will use the elements of arts and the principles of art and design.

1. Research leather, and leathercraft techniques and processes

Refer to **Chapter 16** to guide your research for Stage 1 of your leathercrafting process.

Fig 10.6 Various types of belts.

2. Select the topic, theme or brief

Select a simple product to design at first. A belt is a suitable choice. Here are some considerations for you to narrow down what you are about to create. What is the eventual use for the belt? Is it to be worn by a male or a female, or is it for both sexes? Is it maybe a part of a uniform? Do you intend it to be mainly functional – that is, to properly hold up a garment – or is it more of a decorative item, to be worn as an accessory? What length and width is suitable? How thick is the leather to be used? What colour would you prefer? Are you placing designs on your belt? What type and size of buckle is suitable? Or will fasteners do nicely? How will the separate parts be attached to complete the product? Collect actual belts and pictures of belts to help your research, and visit stores that sell belts. Make notes about the things you see and find out.

Draw sketches that show your ideas for the belt. Consider the questions that have been asked previously and improve your design according to the choices you make. Be prepared to say why you made each decision.

3. Draw the design and transfer to the leather

Select the design that you find most appealing or that best fits your brief. Draw the parts of the belts on paper separately and to actual scale (see **Chapters 6** and **7**). Cut out these parts and combine them into a paper pattern of your design. See that the parts work with your model. The best model may be yourself. Check to see how the parts relate to one another: for example, does the length of the belt include an additional 8 to 10 cm of excess length to go around the buckle? Also check to see whether the belt is sufficiently long (after it has been buckled) and wide enough. Make adjustments if you need to.

Select and cut out a sufficiently large piece of the leather you chose and lay it flat. Stretch it out and use pins to keep it in place. Lay the parts of your belt pattern on the leather, then carefully trace out the parts using a soft pencil so that the lines are quite visible. If your design was adjusted or if you are unable to separate the parts of your paper model, redraw the pattern to scale on paper, then transfer to the leather.

4. Cut out the parts

Before you cut from the leather, draw an outline 1 cm larger than the actual outline of each part. These lines are shown in **Figure 10.9**, using broken lines. Use suitable scissors or shears to cut out each part along the broken lines. In this way, you will always have excess leather to work with if needed. If it is not needed, you can always cut it off later. You will also find that making the final cuts to the actual edges of the belt is more manageable if you are cutting from a smaller piece of leather, rather than from the entire sheet that you began to work with.

Read the tips on care, safety and health on the accompanying CD-ROM.

Remember that the tools you are using have sharp edges and blades. With the aid of your teacher, learn how to use each of them, and take care each time you use them.

Trim off the excess leather using a steel square and heavy-duty cutter. Do this by holding the steel square firmly in place while the cutter is pulled along the steel square's edge to mark or **score** the leather. After scoring, repeat the cutting motion across the surface until the leather has been cut through completely.

If your belt has a curved edge, the scissors or shears may be more practical to cut with. Do not forget to cut out the other leather parts for your belt, such as loops or designs to attach.

Fig 10.7 Paper cut-out of a belt.

Fig 10.8 Leather cut-out of a belt lenght with excess marked in broken lines.

Key term

score: when cutting through a surface, the mark that the cutter initially makes to guide the direction of the blade along and into the surface

5. Assemble the parts

A simple belt consists of the strip that coils around your garment, a loop to hold the end of the belt, a buckle, and fasteners to keep the buckle in place. First, work with the strip of leather. Place it around the buckle and fasten it into place. Apply a suitable adhesive and allow it to dry completely, then stitch or rivet the surface to hold them firmly in place.

Next, make the loop. Apply adhesive, allow to dry, then stitch or rivet. Once this is done, fold the strip around the buckle. Ensure that the preferred surface of the leather is visible (on the outside) and that the reverse side will be against the garment. Apply adhesive to the two surfaces of the leather near the buckle to hold it in place. Allow to dry, then stitch or rivet to secure firmly.

Wear your garment and place the belt around it to determine the most suitable point along the strip to use the buckle. Place the strip flat, then mark and puncture the hole or 'eye' at this length, at the middle of the width of the belt. Make two more eyes, each 2 cm on either side of the first. Cut off the excess length of the strip about 15 to 20 cm beyond the eye that is furthest from the buckle. Before you do, consider the shape of the cut you wish to have here. It usually is flat, curved to a C-shape, or tapered to a V-shape. The end punch is the best tool to use for this. Many belts have a protective cap that closes off the end. This cap prevents the leather from fraying and is also decorative. If you choose to use a cap, select one that matches the finish of your buckle. Finally, add the loop for the end of the belt, and try the belt on.

6. Finish the leathercraft

Patterns may now be applied to your belt. Depending upon the type of pattern you wish to add, it could be done before this stage, but it is recommended you do it now so that the patterns are spread uniformly across the length of the assembled belt. In this way, the repeat of the pattern furthest from the buckle end will not be cut off to leave an incomplete final pattern. The pattern you wish to include must demonstrate good understanding and use of the elements of arts and the principles of art and design.

To create a design pattern:
- Measure the length of your material.
- Divide it into the desired number of equal sections, each to contain one of the patterns you wish to repeat.
- Mark the mid-point within each section.
- Apply your pattern using your desired technique from those discussed below.

> ### Did you know?
> Scoring is done to begin cutting. When scoring, make the mark accurately into the surface, guided by a pencil line or the edge of a metal rule or steel square. A score does not go deeply into the surface. Once the score is complete, repeated cuts are made into the score, sinking deeper and deeper until you eventually cut through. Materials that require scoring include paper, boards, plastics, wood, leather and other thick materials.

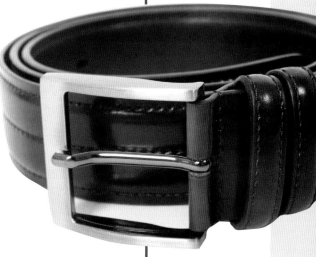

Fig 10.9 An assembled belt.

Techniques for creating a design pattern

Carving

Patterns may be created by carving into the leather. The shape to be carved must be accurately drawn, then carved into the leather to a uniform depth. Skiving knives, tools or machines are available for performing this task accurately.

Cutting

Decorative patterns may be achieved by cutting away selected parts of the leather. For your first effort, try a simple design with as few cuts as possible, such as a diamond shape. Decide where your design goes and how many times it will be repeated. Cutting must be neat, so your cutting tool must be sharp.

Punching

Punches cut various shapes out of leather. The patterns that are formed from punching are similar to those achieved by cutting, but the cut-outs are uniform in size. An alterative may be circular patterns formed by the use of a revolving punch that gives the option of selecting different-sized round holes.

Riveting

Very often, the **rivet** is used for attaching separate pieces of leather, but it can be developed into a decorative pattern with careful design and experience. Decorative items, usually made of metal, may also be riveted into the leather. Depending on the type and thickness of the leather, a pre-drilled hole may be required. Rivets are also quite popular on jeans.

Key term
rivet: *soft metal link for fastening materials*

Stamping

Stamps are a popular method for decorating leather products. Stamps are available in many patterns and require a mallet to create the impression. Choose a stamp that matches the style of your belt. Make sure that a sufficient and uniform amount of pressure is applied in making each impression.

Sticking

Other pieces of leather may be cut and stuck to the belt. If you choose this technique, cut out pieces that are of uniform size or are of different sizes but will create a harmonious pattern. You may wish to stitch your pieces to the belt after sticking, so that the pieces are affixed securely.

Stitching

Stitching by itself can create very interesting patterns. It may be done manually or with the aid of a machine. Machine stitching produces more accurate results, but careful hand-stitching can be just as effective, and works better for producing fine details. Use a stitch spacer to assist you in hand-stitching.

Weaving

Lengths of leather may be woven together (see **Chapter 12**). Separate pieces may be woven then attached to the main leather surface. Or vertical or horizontal cuts may be made through the main leather piece which allows strips of another leather to be woven into them. The ends are then stitched on the reverse side.

After you have completed the application of a pattern, examine the edges of the belt and other areas where you applied your technique for creating the pattern. You may need to remove any unravelled bits of leather, thread or glue. Next, use very fine sandpaper to smoothen the edges of the belt.

7. Present the artwork

Present your belt by hanging it against a contrasting backdrop. If your belt is made from leather with a natural dark stain or dye, use a light-coloured backdrop. If the leather has a lighter appearance, use a dark-colour backdrop. Another interesting way to present your belt may be to create a box for it, into which it is snugly curled. But perhaps the best way of all is to model the belt, so that it is seen as worn.

Photograph your work at the various stages of development to create a photo essay of what is required and how skilful you were at achieving it. Most importantly, these photographs will provide you with an idea of the areas where you may need to improve the next time around.

Be prepared to say what you did to create your leather product, and what decisions you made along the way. Reflect on the decisions you made in Stage 2 to guide your comments.

8. My art journal entry

Refer to **Chapter 16** to guide your art journal entry for Stage 8 of your leathercraft process.

9. Make another leathercraft product

As with all other areas of the visual arts, you will need to practise to improve your skill level and experiences with leather and leathercrafting. Begin another piece of leathercraft. This time, you have the experiences of your first effort to help you. All that you have done will prove invaluable. You will know what to do, what to avoid, how quickly you must work at times, and how careful you must be throughout in order to improve on the quality of what you do and what you produce. Here are some ideas that you may wish to incorporate next time.

a) Change the design of your item

You may wish to make another similar product (for example, a belt), but with a different design. From your research and visits to stores and leathercrafters, you may have been interested in a different style for your product. Consider how the design for this product will be similar to your first, and at the same time how it may differ. The user and the use of the belt make a lot of difference, but the stages in making the product are quite similar.

b) Make another item

There is quite an assortment of other items to choose from for your next design. These include a bill fold, key holder, book jacket or cover, pencil case, wristband, dinner place mat, drinking glass coaster or decorative wall hanging. Select one and begin to improve your craftsmanship.

Preservation and ethical concerns for animals

Almost any type of animal skin may be processed into leather. The high demand for genuine animal skins and hides today has caused worldwide concern for the protection of planet Earth's wildlife. Many unscrupulous hunters kill 'exotic' animals simply for their skins, causing countless creatures to become endangered, and many others to become extinct. An exotic animal is one that is highly prized for its skin, because of its natural texture, skin patterns and colours. Sometimes the animal is considered exotic simply because it is endangered.

Leather items made from exotic skins and hides are very costly, encouraging poachers in spite of laws that protect the animals. At the same time, more popular and readily available animals continue to face the onslaught of hunters, and must also be protected before they too become endangered.

Animals continue to be endangered because their hunting is not illegal in all countries. In some countries the laws and penalties are not as firm as they should be, while in others there are not enough game wardens to monitor the many poachers. The capture of adult animals endangers the lives of their young and creates imbalances within fragile ecosystems.

As in other parts of the world, in the Caribbean some species of animals have become endangered, and not only for skins. For example, sea turtles and conch are sought for their shells.

Perhaps the best way to check this activity is to stop the purchasing of products made from illegally harvested animals.

Do you think earning an income at the expense of extinction of animal species is justifiable? Have a class discussion and share your opinions about this. Consider how educating the hunters about our indigenous wildlife and its preservation can create new and sustainable jobs for them. How can your visual arts promote a campaign to make others aware, and to act to preserve animal life?

Chapter summary

In this chapter you have learned to:

- trace the history of leathercraft
- explain and use terms associated with leather and leathercraft
- follow the stages for creating your own leathercraft
- apply ideas that will further develop your skill for creating leathercrafts
- apply your knowledge and understandings to speak and write effectively about leather and leathercraft.

Activities

Individual projects

1. Design a belt for a student on vacation camp. The belt must be durable enough for use at camp, during hiking and for other related activities. Think about what the student may wish to hang on the belt. Design a case or pocket for one object, for example a knife, that you have identified to hang on the belt. The pocket or case must allow the belt to pass through it as it would through a loop on a garment.

2. Select an item of your choice to be made from leather. Follow the design process to create the product. Be sure to add your innovations and ideas from your research and experience of creating previous leathercraft pieces to improve your selection, design ideas and production of the item.

 Alternatively, produce a design from leather for a wall hanging based on a theme of your choice. Transfer the design to the leather then create the design using techniques you learned about in this chapter or from your research.

 Perhaps you may wish to invite a leather craftsperson as a resource person to facilitate a workshop for your class.

3. Create a sample catalogue of various types of leather and their applications. You may include both natural and artificial types. Categorise them into:
 a) natural and artificial
 b) skins and hides
 c) common and exotic
 d) their use, for example for clothing, household use, industrial purposes.

Group projects

4. In a group of four or five students, gather and use remaining bits and pieces of leather from other projects to create a collage based on a theme. Select a theme from 'Geometric and abstract shapes', 'Elongated forms', or 'National flags of the Caribbean'. Alternatively, your group may wish to work on a theme of your own. Go to **Chapter 13** to find some additional ideas for this question.

5. Gather an assortment of tools that are used in producing leather and in leathercrafting. Brainstorm the various parts of the process that begins with getting the skin; tanning; staining; cutting; designing; decorating; and making the product.

 Include tools that are factory-made and those that were made at home or at school as working substitutes. A good idea is to research the topic to become aware of the variety of tools that are available. If you can, visit a leather craftsperson to get an idea of the tools he or she has and how they are used.

 Create an exhibition of the tools and samples of the work he or she performs on leather. Present the exhibition as part of your class project on leathercraft.

 Perhaps the exhibition can become part of a permanent display for your school library or a community heritage library. Look for a sponsor for the exhibition. Over time, continue to build the collection as more tools are gathered. Add a brochure on the history of leather and leathercraft; photographs of animals that were used for local leathercrafting; a list of tanneries in your territory; samples of leathers and objects made from leather. In this way, many classes can participate in the project over time, and visitors will become aware of the development of the craft in your territory.

Integrated projects

6. As a class, produce a series of different masks on a theme. The theme may be based on a local festival, cultural event or school project. Be sure to use the masks as part of your costume in the presentation of your theme.

Art appreciation

7. As a class, embark on a campaign to create awareness of the endangerment of animal life through one or both of the following:

 a) global climate change

 b) illegal hunting or over-hunting.

 Your campaign should demonstrate the unnecessary use or misuse of animal furs, skins, bones, ivory, shells and other parts. Use photographs from your research to create a powerful visual message of the animal 'before' and its parts 'after'.

 Use any one or more of the following media to promote your campaign:

 • a theatrical presentation

 • an exhibition of visual images

 • a school walkathon.

 Support your campaign with a written explanation, presented as a flyer or fact sheet. Use your chosen medium or flyer to suggest ways in which leather craftsperson can survive without endangering the lives of animals.

 Document your event through still and motion photography, and make this available to your school library, other schools' libraries, national libraries, the Ministry for the Environment in your country, and environmental and animal rights groups.

 More activities for this chapter are included on the accompanying CD-ROM.

Chapter 11 | Pottery and Ceramics

Outcomes

After reading this chapter and practising its activities, you will be able to:

- define, explain and illustrate the terms 'pottery' and 'ceramics'

- trace the history and development of pottery as an art form

- list, understand and follow the stages in the process for creating your own pieces of pottery/ceramics

- use key terms and understandings to effectively speak and write about pottery/ceramics

- apply theory and skills from other chapters to complement your development in pottery design and making

- criticise a pottery design, using the elements of art and the principles of art and design

- engage ideas and techniques to further develop the skills for designing and making pottery/ceramics.

Resources

You will need:

- notebook, art journal, pencils, coloured pencils, paper

- moulding clay, clay, wire, scraper, flat boards or plexiglas pieces, potter's wheel, sponges in various sizes, wooden potter's knife

- leather or cloth towels, bucket, heavy plastic bags, glazes, kiln

- paints, paint brushes

- craft knife, nails or suitable sharpened tool for etching, stencils, masking tape, sandpaper

- computer with internet access

- school and public library access.

Introduction to pottery

Of all the media of the visual arts, clay is perhaps the best material for learning. This is because it requires our senses of sight and touch to produce artwork. The range of movement of the human hands coupled with the feel and ease of working clay makes a perfect combination.

Clay is made up of very tiny soil particles, and is perfect for **pottery** because it becomes plastic when wet, very hard when dry, and is converted to a permanent rock-like state when **fired**. Clay achieves plasticity when all the tiny particles become wet enough to stick and slide over one another. In this state, clay can be shaped. To keep its shape, it is allowed to dry slowly, causing it to harden and reduce its **plasticity**. Once dried, it may be fired.

The best clays are found in rivers and along riverbanks. Because the rocks and soils from which they are derived vary across the world, there are different types of clays. The **ceramics** made from them are classified as earthenware, stoneware or porcelain, as shown in **Table 11.1**. Comment on the shape and proportion of the body parts of **Figure 11.1**.

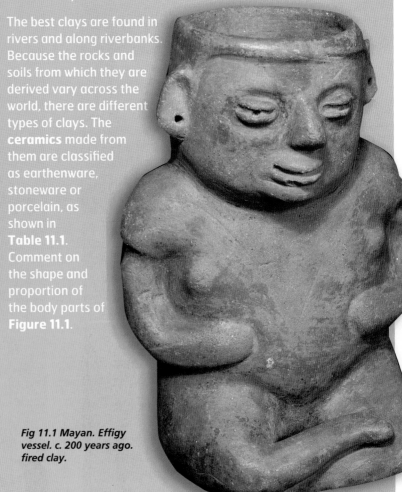

Fig 11.1 Mayan. Effigy vessel. c. 200 years ago. fired clay.

Table 11.1 Fired clay: categories and properties

Fired clay type	Natural availability	Texture	Density after firing	Colour after firing	Use	Cost
Earthenware (fired at low temperatures)	very common	soft, relatively smooth	largest particles, least dense/very porous, not waterproof	reddish-browns, black, opaque	strainers, planters	low
Stoneware (fired at medium temperatures)	relatively common	hard, rough	smaller particles, dense/less porous, waterproof, airtight	browns, light to dark greys, opaque	industrial ceramics, kitchenware	average
Porcelain (fired at highest temperatures)	not as common	very smooth, brittle	smallest particles, most dense/least porous, waterproof, airtight	white to greys, blue to green, translucent	fine ware, decoratives	high
Combination clays	unavailable naturally	variable	variable	almost any possibility	multiple, experimental	variable

History of pottery/ceramics

Early clayworks

The oldest remaining evidence of ancient nomadic peoples comes from their clay objects that have been unearthed. During the Neolithic period, about 12,000 years ago, humankind began to settle from its wandering way of life. Settlements along river valleys grew into early civilisations, and the use of clay developed.

The process of firing may have begun accidentally; perhaps an object tossed into a campfire was transformed. It is commonly said that clay shaped pots, but firing them shaped civilisation. The discovery of this firing process made clay capable of storing food and water, and created time that humankind could use for activities other than seeking out food. **Figure 11.3** shows two bison found at a cave in France, estimated to be 26,000 years old. They are the oldest clay sculptures known, modelled by hand, with the animals' hair etched with a tool. **From the condition of the bison, what can you say about the durability of clay?**

Pottery was first fired in bonfires, which were similar to campsite fires used for light, warmth and cooking. Later, shallow pits were used. These pits were dug into the ground and were able to keep a higher and more constant temperature. This allowed the clay to bake better. Not much later, hillside **kilns** were developed, where pottery was placed into an opening at the top while the fire was set and controlled from another opening below.

In Assyria, an ancient culture, the first bricks used for building were unfired ones strengthened with straw, but their fired bricks transformed architecture, allowing larger and more permanent buildings.

> **Key term**
> **kilns:** ovens for baking clay

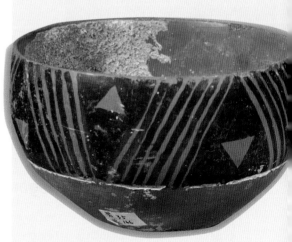

Fig 11.3 Bowl with triangular pattern. Fired clay.

Potter's wheel

It is estimated that the first **potter's wheel** appeared around 10,000 years ago, possibly in Ur, Mesopotamia (now Iraq). This simple turning device aided the potter in making rounded forms out of clay that were more symmetrical. At this time, similar wheels were also used in Egypt and China. The first pieces of pottery completely thrown on a wheel appeared around 5,000 years ago. This technology increased the ease and efficiency of the pottery-making process and influenced trade. The potter's wheel was never developed in southern Africa or the Americas.

Glazes were first introduced on decorative tiles in Egypt about 4,500 years ago. When applied to clay, glaze completely sealed the pieces, making them airtight and watertight, smooth and finished. **Figure 11.3** shows an ancient pot made on the potter's wheel. **Comment on the decorative markings. Suggest at what stage of the making of the vessel these markings were added. How does it compare to Figure 12.2 in Chapter 12?**

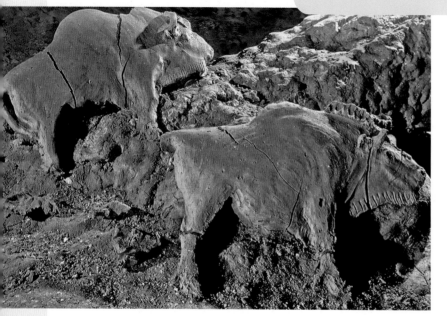

Fig 11.2 Palaeolithic, Magdalenian. Bisons. c. 26,000 years ago. Clay. 60 x 45 x 4 cm. Tuc d'Audoubert, France.

Pre-Columbian South American pottery

During the Neolithic period, Central and South American peoples, too, settled. The style of their artworks found in Mexico, Guatemala and Honduras is unmistakable. Their stone sculptures and clay figurines display rounded forms and charming expression. The Chauvin, a great tribe of South America, developed bottles and jars noted for the hollowed stirrup-spout handle which they invented. It is from these peoples that some of the first inhabitants of the Caribbean islands came, and with them skill in pottery-making. **Use the elements of art to describe the bottle in Figure 11.4.**

Pre-Columbian Caribbean pottery

Pre-Columbian Caribbean peoples used clay to make vessels and flat griddles. The vessels were for household use and religious ceremonies, and had images of their spiritual world, called **zemis**, represented on them. The griddles were used for preparing cassava bread, a staple food of the Caribbean indigenous Americans. Unlike other civilisations, in the Caribbean pottery was not commonly placed in graves. Archaeological findings suggest that the earlier Caribbean pottery was of a finer quality and craftsmanship than that of later years. It seems that although indigenous American societies evolved over time, the level of skill and interest in pottery unfortunately fell away.

When painted, their pottery was covered with natural dyes and stains taken from plants such as the roucou, from rocks and charcoal. **Examine the piece of pottery shown in Figure 11.4. Comment on its design and the artwork. What could the markings represent?**

Key terms

potter's wheel: device used to turn the clay as the hands form the pottery

glaze: coating used to seal or decorate a ceramic piece

zemi: indigenous American spirit, usually represented in their art

Fig 11.4 Ilatilco. Black vessel with markings. Fired clay.

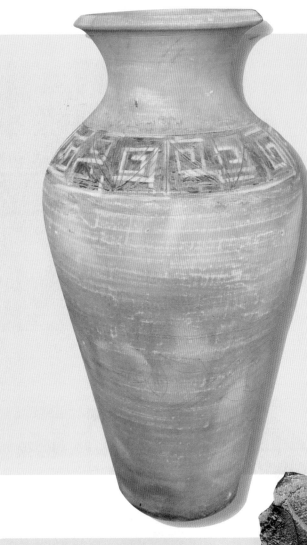

East Indian influences

After slavery was ended, the system of indentureship brought East Indian peoples to the West Indies to work on the estates and plantations. Among the migrants were potters, who began a new chapter in Caribbean claywork design. These potters handed down their craft from generation to generation up to today, serving religious, household and ceremonial purposes. Production continues to follow traditional practice, but also uses many innovations and inventions for clay preparation, wedging and firing.

Today, the market for clay artworks and products includes wider religious, domestic, decorative and tourist sectors in the Caribbean. Niche export markets have opened up among the territories and into North America. **For what purposes could the vessel in Figure 11.5 be used?**

Fig 11.5 Suresh Tiklal. A vessel. 2003. Thrown and fired clay. 64 cm high.

Ceramic art today

Across the world, the 20th century has seen the rapid growth of experimentation and innovation in the design of ceramics. Artists have embraced the use of clay as a fine art form, using the medium to seek out new ways of expression, communication and meaning. Artworks have evolved that display experiences of ceramists, sculptors and painters. Many contemporary pieces are one-of-a-kind works that evoke emotion and encourage debate, among viewers. What are your thoughts on **Figure 11.6**?

Fig 11.6 Paul Soldner. Pedestal Piece. Thrown and altered Raku clay. 15 x 29 x 29 cm. Rodney Mott Collection.

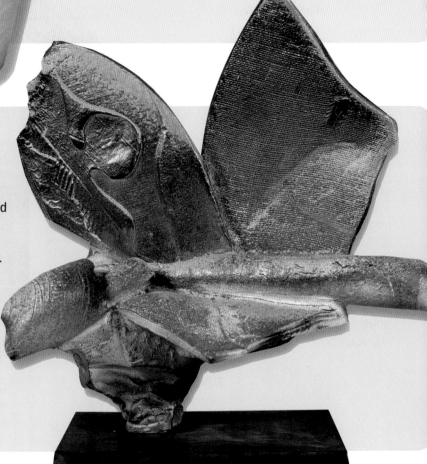

Stages in the pottery-making process

The pottery-making process described here has nine stages that are intended to help you to develop your ability to create artworks from clay. You will begin with what to research, selecting and drawing what to create, sourcing and preparing clay, creating the object, creating a similar set of objects, refining the piece, presenting your work, making a journal entry and considering ideas to include or ways to improve the next time you attempt pottery. Along the away, you will also be reminded about using the elements of arts and the principles of art and design.

1. Research pottery-making techniques and process

Refer to **Chapter 16** to guide your research for Stage 1 of your pottery/ceramic-making process.

2. Select the topic, theme or brief

Perhaps the simplest object to begin claywork with is a small rounded vessel. Use pictures that you have researched to help determine your design. Make sketches for a few different designs, and make changes from one drawing to the next, until you are satisfied with your final design. Because clay peices are usually in three dimensions, you may wish to sketch views from the front, side and top for the final design in orthographic projection. (Also see 'Stages in the three-dimensional art making process' in **Chapter 9**.) Such drawings allow you to see the pot from various points of view. Perhaps you have done such drawings before in a technical drawing class.

Decide on which method you wish to use from the pinch, slab, coil or thrown techniques. A good way to introduce yourself to hand-building techniques is to use moulding clay, also called Plasticine™. This material requires no preparation or water to be fashioned into a form. However, for your first few trials with actual clay, the pinch technique may be best because the piece can be readily cupped and formed in your hands. This helps you to get a good feel for clay, its texture and how it can be worked in your hands. But be sure also to make a pot or object using the other three methods.

Front

End

Plan

Fig 11.7 Orthographic Projection drawings: lamp made from redesigned earthern pot.

Did you know?

Orthographic projection drawings show more than one point of view of a single object. The basic views are the 'front', 'end' and 'plan' or bird's-eye view of the object. The various elevations or views are combined to create an image of the object in your head before you draw it. **Figure 11.7** illustrates three points of view for an earthen pot. Can you draw the pot? Perhaps you can draw the front, end and plan for another simple object. Turn to the table of contents for this book. Which chapters may require such drawings?

3. Source and prepare the clay

You may buy or dig up your clay. Clay that is sold is already processed. But if you must get your own clay, then the best type is found around rivers. Such clays contain impurities and air pockets that must be removed. To do this, the raw clay is placed into a bucket with water and worked by hand. Squeeze the clay so that impurities such as grit and plant matter are separated out. Remove the clay from the bucket and allow it to dry to the required plasticity.

Working the clay also removes the air pockets contained in it. This is known as **wedging**. Wedged clay is easier and safer to use, and the absence of the air pockets prevents objects shattering while they are being fired.

4. Create the pot or object

Select the design that you find most appealing. Decide on the scale to be used. You will remember that you learned about scales in **Chapter 7**. Use your drawings to guide your work.

Get a feel for the clay and learn to manipulate it. At this point, success will come from working and shaping the clay with your hands. Have some water, a bucket, tools and towels nearby and follow the method you have chosen, using the steps outlined below. But most of all, enjoy the clay as it evolves.

> **Key term**
> **wedging:** the removal of impurities and air pockets from clay

Helpful hint

Clay should be sufficiently moist when stored. Use a stiff wire to cut through the clay. Hold the wire tightly and press down to cut your clay into blocks. Place each block in a plastic bag then put them into a plastic bucket that can be sealed. Keep the bucket in a cool dry place. After opening, if the clay has become too dry, simply add water for it to regain its plasticity. The amount of water you need to add depends on how stiff the clay has become.

Table 11.2 Methods for designing in clay

Method	Begins with clay	Suitability	Materials, tools and equipment needed
Pinch	worked into a ball	smaller rounded forms	twine or wire, scraper, slip, cloth, sandpaper
Slab	cut into slabs	rectangular, curvilinear, geometric forms of any size	scraper, cloth, twine or wire, slurry, slip, sandpaper
Coil	rolled into coils	rounded or curvilinear forms of any size	twine or wire, scraper, slurry, slip, cloth, sandpaper
Thrown	in cone shape	rounded or altered forms of any size	potter's wheel, scraper, slip, cloth, twine or wire, sandpaper, potter's knife

Method 1: Pinch

The pinch method is the first and simplest technique for creating pottery. Because of the range of movement of our hands, moulding an object to a rounded form occurs almost naturally. Another advantage for the beginner is that pinching does not require any tools.

The pinch technique begins with a well-rounded workable ball of clay, into which your thumbs begin to make an impression. The ball is continuously turned in your hands, while pressure is evenly applied to deepen the impression, forming a hole.

As the hole deepens, widen the clay form outwards. Use your thumbs on the inside and your remaining fingers on the outside. Keep turning the clay so that the form is created evenly and consistently all round. From time to time, you may wish to place the pot down and press from the inside to make a flat base so that your pot can stand firmly.

Continue to work the sides by turning the pot, and at the same time pulling the clay upwards, making the height. Be careful not to make the side too thin or it will collapse. If the pot becomes too tall, an upper portion or ring may be removed by carefully cutting away to get the desired height.

If the pot becomes too wide, cut out V-shaped darts from the top, then overlap and pinch to close. When cutting out darts, the number depends on how much smaller you require the circumference (or edge) to become. Space the darts at equal distance around the circumference and cut them all to an equal depth from the top.

Complete your shape by smoothening with your index finger and thumb. Any tiny cracks may be filled by pinching, or by adding clay and then working. A soft leather or cotton cloth may also be used for smoothening. Depending upon the plasticity of the clay, the pot may require some drying before you continue the smoothening. When it is completely dry, fine sandpaper is used to finish the piece.

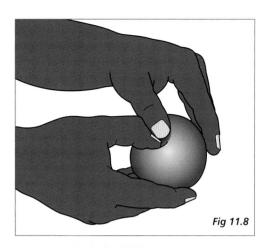

Fig 11.8

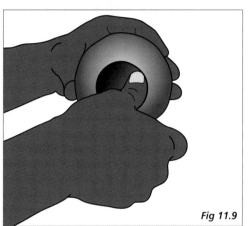

Fig 11.9

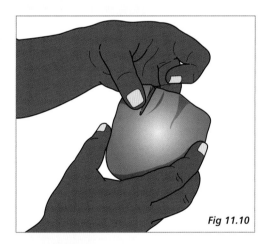

Fig 11.10

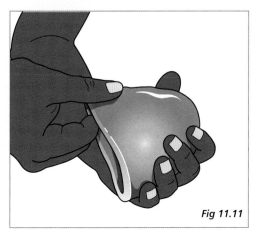

Fig 11.11

Method 2: Slab

The slab method begins with pieces of clay that are flattened. A rolling pin is the best tool for doing this, but any cylinder-shaped solid object of a manageable size will do. Work on a flat board or piece of plexiglas that rests on your work table. Be sure to turn the clay over after every few rolls to achieve a uniform thickness and smoothness on both sides. It is advisable to lift and turn over the entire board or plexiglas and tip the clay onto the next board or plexiglas.

After rolling out, trim off the edges, which tend to be thinner. The slab may now be cut into smaller ones, using your wire. More than one slab may be combined to form a larger one. Square or rectangular shapes seem natural to begin with, but with practice and experimentation, other shapes and forms can emerge from slabs that are curved, folded, punctured or stretched.

The careful designer will determine beforehand the sizes of the slabs that are needed, and so will reduce the number of joints that are made. This increases the strength of your construction, although for larger designs may not always be practical. Cut out all the sides for your pot or object. The first piece to set is the base. Allow space all around for you to work comfortably.

Fig 11.12

Fig 11.13

Score the edges just inside the perimeter of the base upon which the side slabs will rest. Select one side and score the edge that will unite with the base. Use **slurry** as the adhesive on both edges. Apply pressure to make sure that both the slabs are properly joined. Repeat this process for the remaining sides. Do not forget to apply slurry to the vertical seams where two slabs are joined. Use bricks or similar solids to keep the slabbed parts in place as they dry.

Repeat the scoring for the next slab, then continue to combine and build up your pot or object. As the edges where the slurry was applied become dry, a thin coil of clay is added along the inside of the piece to reinforce the joint. When the entire piece has been built, the outside edges are scored and reinforced using coils of clay.

While the completed piece is drying, use your metal scraper or tool to cut away unwanted clay areas and hardened slurry and to smoothen edges. Fill **slip** into fine cracks to refine the surface. Use fine sandpaper to finish the piece when it has completely dried.

Fig 11.14

Fig 11.15

Key terms

slip (or engobe): liquid clay

score: rough marks made to better hold surfaces to be joined together

slurry: thick liquid clay

Method 3: Coil

The coil method requires the clay to be worked into uniform cylindrical rolls. The rolls are then placed one on top of another on a slab base that is cut to the desired shape. The object may be built up with an even cross-section, or may be gradually widened or narrowed above the base to produce a variable cross-section in the form.

Begin by flattening clay into a slab as you did in Method 2. Mark and cut out the desired shape for the base of your pot or object and measure its perimeter.

Next, roll out your clay to the desired diameter. The prepared clay resembles thin long solid cylinders of uniform size. The length of each roll should exceed the perimeter of the base by about 10 cm. Trim off the ends, which tend to be narrower. After trimming, each clay roll must still be able to cover the complete perimeter (or border) of the base. This reduces the number of joints that you make, and thus increases the strength of your pot or object.

Follow the perimeter of your base to apply a thin line of slurry, then begin to place the first coil. The part of the coil that is not as yet set should be held in the air with your other hand. When you have completely coiled the perimeter, cut off any excess length of clay and pinch together the ends of the coil that now meet.

If you wish to widen the body of the form as you build your pot or object, some of the rolls or coils must be longer than the one you will place on the base. If the body has to become narrower as you move up, some of the coils may be a bit shorter than the one used on the base. However, it is best to start by designing and building forms with uniform vertical bodies to gain the basic skills, and then move on to creating other forms.

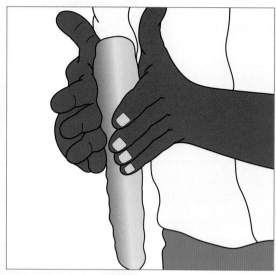

Fig 11.16

Fig 11.17

Fig 11.18

Ensure that the coil is set properly and completely within the perimeter of the base to add strength to your structure. Apply uniform pressure all round to compress the coil to the base, but do not overdo this. Where the ends of the coil meet, pinch them together to join them.

Add the next coil on to the top of the first to continue, but do not begin at the same point where the first coil began. In this way, joints of consecutive coils will not be in line. It is good practice to begin laying each coil a fair distance away from where you started the previous one. Add slurry on the previous coil before placing the next coil.

Continue to build up the coils to the desired height. Pinch the coils together as you add each new layer and pull excess clay down on the outside. This helps you to maintain the same thickness and shapes the pot or object on the outside. Apply slurry to fill the spaces between the coils as you build up.

Complete the shape by smoothening both the inside and outside using your index finger and thumb. Use a flat piece of wood to assist you. Keep one hand inside the pot against the surface to support the structure. Any remaining spaces between the layers of coil as well as any cracks may be filled with slip, then smoothened. You may wish to smoothen the pot or object but still indicate the effect of the coils on the form, or perhaps smoothen to a point of hiding the the coils altogether. Depending upon the plasticity of the clay, the pot may require some drying before you complete the smoothening. There are metal tools designed for this purpose but you may improvise with a piece cut from a sheet of stainless steel.

Fig 11.19

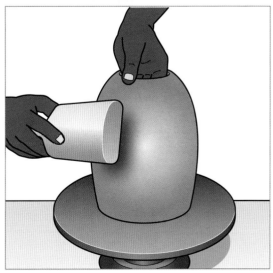

Fig 11.20

Method 4: Thrown

The thrown method uses a potter's wheel, which turns as the potter works the clay into the desired form. The pot is created out of a cylinder-shaped piece of prepared clay. A bat, a circular plate made from board or plexiglas, may be placed on the wheel. This helps you to remove the pottery afterwards. The wheel or bat is wet to hold the clay firmly.

Cut a suitable size piece of clay, using a wire tool. Hold the clay with both hands and set it firmly at the centre of the wheel. As the wheel turns, observe the motion of the clay. If it is very much off-centre then you may notice that the motion will become erratic and unpredictable, and you will need to remove and reset the clay. If it is fairly well centred, place your hands around the clay and begin to get a feel for the turning clay. Begin to compress inward and upward. You are attempting to do two things: perfecting the central location of the clay and transforming the clay into a cone shape. This takes much practice but is well worth your effort.

Once the cone shape has been achieved, take the opportunity to change the shape of the clay as the wheel turns. This is a fun exercise that teaches you how to cup the clay and where to increase or lessen pressure in order to lengthen, shorten, thicken or thin the cone-shaped form. Add water to your hands and to the clay as often as is required. A sponge is suggested for this. At first you will need some assistance. You will quickly realise that your entire arm, the elbows, wrists, palms and fingers, must coordinate themselves if you are to be successful.

Adjust the clay to the desired height (12 to 15 cm is recommended at first), width or diameter. Use your thumbs to press into the clay at the top to create a sink. At the same time, ensure that your fingers work to maintain the rounded form on the outside. Work your thumb into the clay to deepen and widen the sink into a thick ring. Do this down to the base, leaving a thickness of about 1 cm for the base itself.

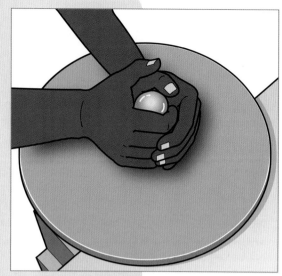

Fig 11.21

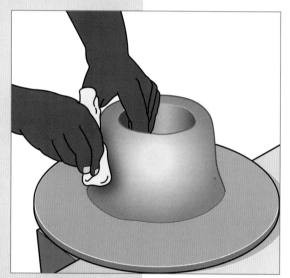

Fig 11.22

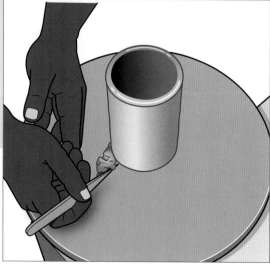

Fig 11.23

Next, the sides must be raised. Place your hands as shown in **Figure 11.22**. Begin by gently pressing into the clay near the bottom of the pot. Keep the fingers of your other hand on the inside and against the point at which you are working. Maintain adequate pressure and slowly lift upwards. As you do this, the pot lengthens and the walls of the pot begin to thin. Do not lengthen or thin the walls too much.

Once the walls are evenly thinned to about 5 to 8 mm, ensure that you are satisfied with the final shape. If not, minor adjustments may be made, always working with one hand on the outside and the other on the inside to provide support. Reduce the speed of the wheel. Shape the base using a wooden potter's knife or another suitable instrument. Do this by placing the instrument at a suitable angle at about 7 mm from the base. Press downwards gradually into the clay until the knife touches the bat. Keep the knife steady as the unwanted clay is shaved off, leaving a bevelled edge.

Use a piece of twine, wire or fishing line to remove your pot from the bat or wheel. Wet the base of the pot, then keeping the wheel at a reduced speed, stretch and place the twine on the wheel, using your thumbs to hold it in place. Gradually pull the twine in one controlled level motion under the pot, using one hand to move the twine. Your other hand stays fixed. Begin at the point furthest from you and pull the twine towards your body. Wash and dry your hands. Use both hands to gently hold your pot at its base, then lift it off. Place your pot on a flat board in a cool place to begin drying.

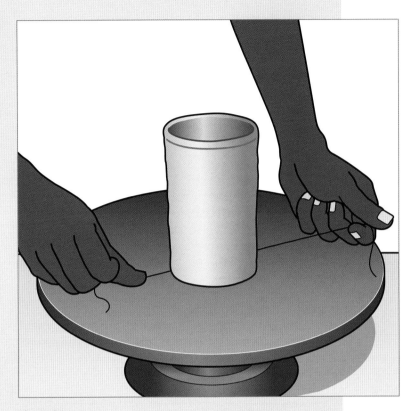

Fig 11.24

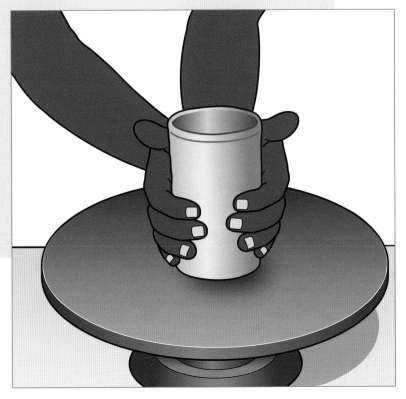

Fig 11.25

5. Create a set of three similar pottery objects

Use your selected technique to create three pots that are as identical as possible. Their size and shape should demonstrate a sense of uniformity and repetition in design. Your success at this will determine your mastery of the technique you chose.

Slip may be added to fill any cracks or joints. Finish your pots using sandpaper to smoothen them. You may choose to end Stage 5 here and go to on to fire your pottery objects.

For ceramic pieces, a glaze may be painted on the claywork before it is placed into the kiln and fired. Follow carefully the instructions for the use of the kiln and the directions of your teacher.

6. Present the set of pottery

You may wish to decorate one of your three pieces for display or present them as they are. Find out from your teacher if the finishing should include decorating. Ideas presented in **Chapter 13** will help with your decorative art techniques.

Photograph your work at the various stages of development. This will create a photo essay of what is required and how skilful you were. The photographs also provide you with an idea of where you may need to improve the next time around.

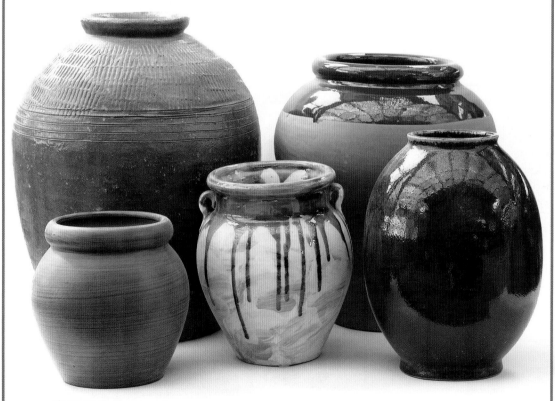

Fig 11.26 Earthenware jars.

7. My art journal entry

Refer to **Chapter 16** to guide your art journal entry for Stage 7 of your pottery/ceramics-making proces

8. Refine the process

As a new **ceramist**, the possibility exists that your product was not what you expected. Do not despair. One or more of the following may help you to improve.

a) Clay preparation: If clay is bought it will have already been prepared and packaged, but it must be wedged in order to remove air spaces and impurities. Clays that are dug up from the earth must be more carefully wedged. The trick is to get fairly sticky clay. Avoid sandy clays altogether.

b) The level of plasticity required for clay is best learned with experience. If it is too wet or too dry, forming the clay becomes a bit more difficult. Our Caribbean climate and the temperature of your work area may speed up drying. This is, however, easily counteracted by adding water – but not too much.

c) The design for your product requires suitable lengths, widths and heights. These dimensions must also be in proportion to the thickness of the sides and base of your products in order for them to be stable. Again, your best teacher is the experience you gain as you work.

d) Select the technique that best suits the object you wish to create. For instance, a slab technique uses flat pieces that will require sizing and joining. The pinch technique teaches you about the feel of clay and the use of your thumbs and fingers to make smaller rounded objects, and is a good place to begin your learning.

e) Designing on your pot may take place while it is still wet, when it begins to dry or after it has dried completely. For the slab technique, some designs may go on before you assemble the pieces. The coil technique creates spiral designs as you build up the pot. You may choose to keep these, shape them into a related design, or cover them up with slip and smoothen off.

> **Key terms**
> **ceramist**: one who makes fired artworks from clay
> **fresco**: painting done on wet plaster

> **Did you know?**
> Marks may be etched on the surface of your pottery using a sharp instrument such as a craft knife. Do this when the clay has almost dried. Have your design drawn up beforehand, rather than doing it without planning. Paints may be added **fresco** style (see **Chapter 13**), while the pots are still wet, but as a beginner, it may be wiser to do this after complete drying.

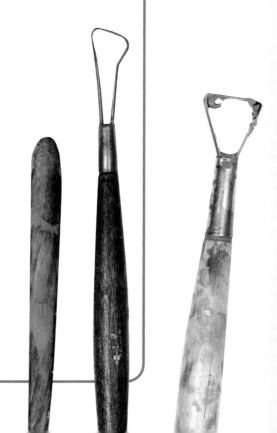

9. Make another set of pottery

After learning from your experience and considering ideas for refining your process, you are now ready to begin another piece of pottery. Here are some points to consider.

a) **Create another design.** Apply the same technique to create a different pot. You may wish to change the dimensions of the pot by increasing or decreasing its size, mouth, body or base. Consider placing a handle or legs on the pot. This teaches you to manipulate the element of shape in design.

b) **Explore the other techniques.** Perhaps you may wish to graduate from one technique to the next. The pinch and slab techniques are a bit simpler and may be a good starting point. Afterwards, you may go on to the coil then the thrown techniques. Consider the order: pinch/slab/coil/thrown.

c) **Create a set of three similarly designed pots** but in three different sizes: small, medium and large. Here you begin to manipulate size, and consider what needs to be done in enlarging or reducing structures in clay.

d) **Finish using a selected technique.** Etching allows you to create a design drawing then transfer the design to the pot while it is still not completely dry. Windows may be cut out from the pot to make it a more decorative object. A good way to build up to this is to design and transfer or cut from a flat clay **tablet** first. The slab technique is suggested for this.

e) **Use paper clay.** Paper clay is a product made from combining clay in a slip-like form with mashed paper. Newsprint is preferred. The mixture is thick and pasty and allows you to 'build-up' your design rather than pressing into a pure clay surface to create form. This is similar to the pulped papier mâché technique discussed in **Chapter 9**.

> **Key term**
> **tablet**: solid flat surface for an artwork

Chapter summary

In this chapter you have learned to:

- trace the history of pottery/ceramics
- explain and use terms used in pottery/ceramics
- follow the stages for producing your own pottery pieces
- introduce ideas that will further develop your skill in making pottery
- apply your knowledge and understandings to speak and write effectively about ceramics and pottery-making.

Activities

Individual projects

1. Create a series of three earthen pots that are as similar as possible. Present your work and talk about what you did and learned.

2. Create a series of three earthen pots, using any three of the coil, slab, pinch or thrown techniques. Present your work and talk about what you did and learned.

3. Roll a piece of clay into a slab, 30 cm x 30 cm in area and 8 to 10 mm in thickness. Place a textured surface such as mesh, fine fishing net or textured fabric on the clay. Perhaps you can think of other unique textured surfaces that mighty also be used.

 Use the rolling pin to transfer the design onto the clay.

 Present your work and explain what you did. Say how you combined ideas for claywork, drawing and printmaking in this activity. Take photographs for your art journal.

Group projects

4. As a class, create and present a display of objects made from clay. Where possible, use a kiln to fire the objects.

 Plan an exhibition for your clay artworks. Perhaps this could coincide with your school's achievement or open day, or an end-of-term activity. Present them at your school activity to commemorate that occasion. Number and name each item in your display.

 Produce an advertisement and a brochure to present to those who attend your exhibition. Use what you have learned in **Chapter 7** on graphic design to develop your ideas.

 Take digital photographs of your planning and exhibition. Print pictures and add them to your class's achievement board.

 Invite the media to have a look.

5. Arrange your class into four groups of students. Each group will create a set of five pottery pieces. The five pieces for each group must show variation in only one of the selected elements of:
 a) size
 b) shape
 c) colour or tone
 d) texture.

 For example the group that manipulates 'size' will produce five related pieces, but each of a different size.

 Create a group portfolio that may include photographs and jottings of ideas for your work.

 Present and discuss your work.

Integrated projects

6. Select a theme from (a) spirals and curved lines; (b) patterns from seashells; (c) edges of a variety of leaves or flowers; (d) dinosaurs.

 Create four design patterns for your theme on 20 cm x 20 cm paper. Add colour using two or three coloured pencils. Examine and select the best design pattern.

 Roll a piece of clay into a slab. A 30 cm x 30 cm area is suitable. Measure and cut off a 20 cm x 20 cm area using your wire. Once it is sufficiently firm, use a craft knife, nails, sharp wooden picks or large needles to transfer your design to the clay. From time to time, dust off particles of clay using one of your soft paintbrushes. Re-examine and make adjustments, then allow the piece to dry completely. Now have even more fun painting your etching.

 Present your work and explain what you did. Say how you combined ideas for claywork, drawing, printmaking and painting in this activity. Take photographs for your art journal.

 You may wish to use your design as a clay block for printing (see **Chapter 6**).

Art appreciation

7. Research and discuss how a simple material such as clay has contributed to:
 a) kitchenware
 b) architecture
 c) early writing
 d) other visual art forms, such as sculpture.

 After your discussion, write a four-paragraph essay about what you shared and learned.

 More activities for this chapter are included on the accompanying CD-ROM.

Chapter 12 | Fibre Arts

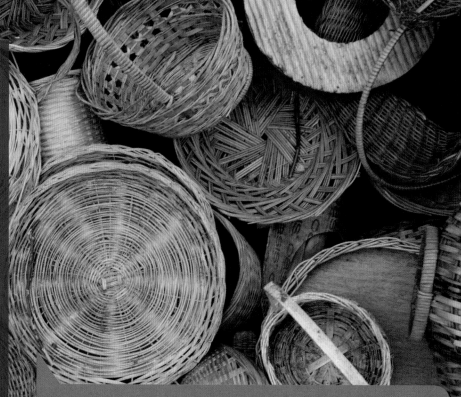

Fig 12.1 A collection of woven baskets.

Outcomes

After reading this chapter and practising its activities, you will be able to:

- define, explain and illustrate the terms 'fibre arts' and 'weaving'

- trace the history and development of fibre arts as an art form

- list, understand and follow the stages in the process for creating your own pieces of fibre art using weaving techniques

- use key terms and understandings to effectively speak and write about the fibre arts and weaving

- apply theory and skills from other chapters to complement your development in the fibre arts

- criticise a fibre art artwork, using the elements of art and the principles of art and design

- engage ideas and techniques for the further development of the skills learned for the making of fibre artworks.

Resources

You will need:

- notebook, art journal, pencils, coloured pencils, paper, card, plastic, fabric, terite, cane, sanguine, coconut

- scissors, ruler, glue, staples, awl, string, craft knife, stencils, masking tape, paints, paint brushes, varnish

- computer with internet access

- school and public library access.

Introduction to the fibre arts

The **fibre arts** use fibres to produce artworks. In the Caribbean, there are many naturally occurring fibres used to create appealing artwork. Palms such as the coconut and grasses are fine examples. A **fibre** is a material that can be produced in lengths or strands. There are natural fibres produced by plants or animals, and synthetic or man-made fibres. Both are used to make fabrics. This is done by **weaving** a mat. A mat is a grid or lattice which, because of its structure, is much stronger than the separate strands used to make it. Mats are preferred for their flexibility and durability. Apart from mats, weaving is used to create ribbon and rope-like lengths.

Weaving is generally done using strands that pass over then under other strands placed at right angles to one another. Once the ends around a weave are well secured, woven materials have the unique ability to stay together without the use of an adhesive. The ends themselves may be glued or stitched.

History of the fibre arts

Early use

The oldest known evidence of the use of fibre by humankind traces back to 12,000-year-old baskets found in Egypt. Weaving has been used since prehistoric times for making materials to keep our bodies warm, for shelter over our heads, and to make vessels for the gathering and storage of food. The 7,000-year-old Neolithic mummy the 'Iceman', discovered in the Alps mountains of Europe, wore an outer coat woven from grass. Examine **Figure 10.2** in **Chapter 10**.

Another interesting piece of evidence is a clay pot found in the river Thames, England. It has the **impression** of a woven pattern on it, which was probably formed when wet clay was placed on the inside of a woven basket to dry. See **Figure 12.2**.

As weaving improved, early craftsmen used it to make both baskets and textiles. Many handy objects were made including nets, hammocks, blankets, mats, bags and tents.

In Mesopotamia, weavers were using natural fibres to make cloth 8,000 years ago. In China, it was discovered nearly 5,000 years ago that natural thread spun by the tiny silkworm had remarkable strength and quality. Since then silk has been used to create some of the finest textiles ever known. In Egypt a model of a weaver's workshop was discovered in an Egyptian tomb that dates back 4,000 years. Closer to our home, in the highlands of South America, early cultures made **tapestries** with **embroidery** from sheep and llama wool, and from cotton. Their tools and textile fragments are nearly 5,000 years old and have been unearthed at burial sites.

> ### Key terms
> **fibre arts:** use of natural or man-made threads to produce artworks
>
> **fibre:** material produced in lengths or strands
>
> **weaving:** interlacing strands of fibre to create a mat

> ### Key terms
> **impression:** the design transferred from one surface to another
>
> **tapestry:** a woven textile artwork designed to hang
>
> **embroidery:** decorative needlework usually done on textiles

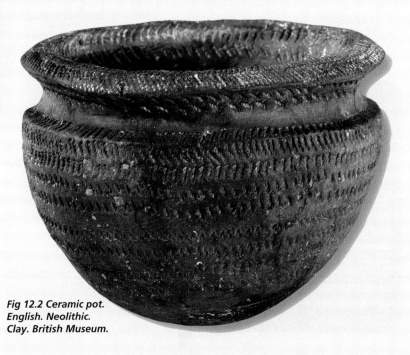

Fig 12.2 Ceramic pot. English. Neolithic. Clay. British Museum.

The loom

The invention of the **loom**, also in Neolithic times, caused greater output in woven materials, especially fabrics. Its invention increased and developed the production of fabrics, including cottons, linens, silks and wools. The process was simple. The weaver would hang and stretch the vertical strands from a tree branch to the ground, then begin the process of passing the horizontal strands over then under the vertical ones. The vertical strands or threads are known as the **warp**, while the horizontal ones are known as the **weft**. The weaver would push and pull the strands into place then adjust them to maintain a uniform appearance and give the fabric its strength.

Key terms

loom: machine for weaving threads into fabric

warp: vertical strands of fibre used in weaving

weft: horizontal strands of fibre used in weaving

basketry: the art of weaving materials into baskets and other containers

Table 12.1 Weaving techniques and materials

Technique	Description	Fibres
Coil	Uses material with a rounded cross-section. Weaves tend to be loose and breathable, often with visible air spaces.	Grasses, shrubs, lianas, vines
Plait	Uses material that are flat and wide. Weaves tend to be tighter and less breathable, with less visible air spaces.	Coconut, other palm branches
Twine	Uses material taken from plant roots or tree bark. Cross-sections vary. Weaves generally tend to have a rougher texture.	Various roots, shredded bark
Wicker	Uses materials such as stems. They may be split along their length into flat, oval or half-round shapes.	Cane, terite, reeds

Did you know?

Many ancient civilisations developed their weaving for two main purposes. They made baskets and other containers for gathering and storing food, and used the technique with finer strands and threads to make textiles which they used for clothing and other household purposes. Over time, many inventions for weaving helped to improve the process and shaped the course of human development. **Chapter 8** teaches you about textiles.

Present-day weaving

Today, there are many different types of looms, including computer-controlled ones, for the manufacture of textiles. However, in **basketry** the basic hand technique of horizontal strands passing over then under vertical strands or threads of fibres has remained unchanged since prehistoric times.

The weaving technique itself has had many innovations, with more than two strands woven at once to add variety, texture and pattern to artworks. There are a few techniques generally categorised by the types of materials that are used for weaving. **Table 12.1** explains these. **Do research to find out about these techniques and materials.**

Weaving techniques

Rand

The rand is perhaps the most common and simplest weaving technique. The finished weave resembles a chequered box pattern, the balance and beauty of which is best highlighted if the warp and weft are of complementary colours.

The rand is achieved by weaving the weft over the first warp, then under the next. These two movements can be repeated through to the end for the first row of the weave. The second row is begun by weaving the weft under the first warp, then over the next. These two movements are then repeated through to the end for the first row of the weave.

All odd-numbered rows then follow the identical pattern of the first row, while all even-numbered rows follow the pattern of the second row.

The rand weave requires a minimum of two rows of weft strips but the pattern is fully appreciated over 12 or more rows. You should have at least 12 warp columns also.

Fig 12.3 Rand weave.

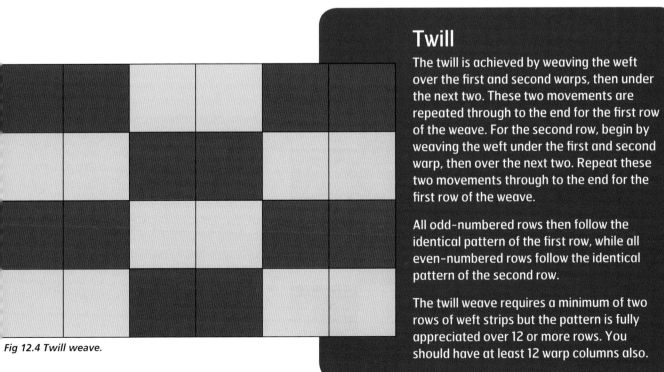

Fig 12.4 Twill weave.

Twill

The twill is achieved by weaving the weft over the first and second warps, then under the next two. These two movements are repeated through to the end for the first row of the weave. For the second row, begin by weaving the weft under the first and second warp, then over the next two. Repeat these two movements through to the end for the first row of the weave.

All odd-numbered rows then follow the identical pattern of the first row, while all even-numbered rows follow the identical pattern of the second row.

The twill weave requires a minimum of two rows of weft strips but the pattern is fully appreciated over 12 or more rows. You should have at least 12 warp columns also.

Cascadura

The cascadura weave has a step-like pattern that resembles the scales of the fresh water fish of the same name. The pattern is achieved over four rows. The second and fourth rows follow the twill pattern. In the first row, the weft passes over the first warp, then under the next two, then over the next two. The over two and under two movements are then repeated to the end of the row. The second row begins over the first two warps, then under the next two. Then repeat these two movements to the end.

The third row begins with the weft passing under the first warp, then over the next two, then under the next two. These two movements are then repeated to the end of the row. The fourth row begins under the first two warps, then over the next two. Complete by repeating these two movements through to the end of the row.

The fourth row begins with the weft passing under the first two warps, then over the next two. Repeat these two movements through to the end of the row.

Continue the pattern with the repetition of the first to fourth rows. The pattern is fully appreciated over 12 or more rows. You should have at least 12 warp columns also.

Fig 12.5 Cascadura weave.

Fig 12.6 Herringbone weave.

Herringbone

This is another fish-like pattern achieved over six rows. The first row is begun with under one warp, over two, under one, over two to the end. The second row goes over one, under one, over two, under one. These movements are then repeated to the end. The third row goes over two, under one, over two, under one repeated to the end. Row four goes under one, over two, under one, over two repeated to the end. Row five goes over two, under one, over two, under one repeated to the end. Row six goes over one, under one, over two, under one repeated to the end. The pattern can continue with the repetition of the first to sixth rows.

The pattern is fully appreciated over 12 or more rows. You should have at least 12 warp columns also.

Activity

Cut strips of equal width to weave each technique above. Use a flat material such as paper, cardboard, coconut or plastic. The strips you cut for the wefts should be longer than the desired dimension of your finished piece. This allows you to hold the strips comfortably as you work, and provides excess for folding over to affix at the back. Any appropriate material may be used, but Bristol board is always a good choice for beginners as it is readily available, made in many colours, and is easy to cut, fold, manipulate and stick.

The warps should be cut to an identical width but may be left attached to one another via a strip across the top. This is done by cutting up to a point near one end, and not completely through the warps. A good idea is to keep the width of the strip across the top equal to the width of the wefts. Weave a sample for each of the four techniques discussed.

As you weave, ensure that the strips are compact. Fold over the excess of your strips and stick with glue at the back. Do so after every two rows. This also prevents the lower end of your weave from widening into an unwanted skirt-like shape. If unnecessary or uneven spaces appear within the weave, it may be that the strips were not cut to the same dimensions or the rows above were not well woven.

Present and compare your weaves with those of your classmates. Comment on the quality and appearance of the weaves. Paste your weaves into your art journal and label them.

Stages in the fibre art-making process

This process has eight stages intended to develop your ability in decorative craft-making. You will do research, select the topic to work with, source and select materials, create the design, refine the process, present your work, make a journal entry and think of ideas to include or improve the next time you attempt a fibre artwork. Along the away, you will also be reminded about using the elements of arts and the principles of art and design.

1. Research fibre art-making techniques and process

Refer to **Chapter 16** to guide your research for Stage 1 of your fibre art-making process.

2. Select the topic, theme or brief

Simple objects to begin weaving with are a kitchen place mat or decorative wall hanging. Use pictures or actual designs you have researched and collected to help determine your design ideas. Make sketches of your own design. Do these for a few different designs, and make changes from one drawing to the next until you are satisfied with your final design. Use actual eating utensils set on paper to determine the size of your place mat. A plate, tea cup, glass, knives, forks and spoons will be useful.

Draw this final design to its actual size (scale 1:1) so that you get a sense of its length and width. The decorative piece may contain an image in it, similar to a picture, for example of a tropical bird or fruit. Vary the size and location of your picture to best use the space in your design.

For woven works in three dimensions, you may wish to sketch views from the front, side and top for the final design. This allows you and everyone else to see the design from various points of view. **Chapter 7** teaches about the use of a scale, and **Chapter 11** about drawing different views of a design.

3. Source and prepare materials

Select the material you wish to use for your artwork. Materials for weaving may have a flat or round cross-section, and therefore create different appearances when woven. Flat materials such as coconut, cane or paper create tighter weaves while rounded reeds such as terite leave some visible spaces.

Cut the materials to a comfortable size to work with. The lengths should be about 10 to 20 cm longer than what is required to complete the weave. Have your design, warps and wefts of your weaving material, shears, scissors or cutter, and adhesive ready.

4. Create the design

As each material is different, it tends to cut, bend, weave and stick differently, so you should make a sample weave with the material you are using before beginning the actual artwork.

Select a weaving technique and begin weaving from a suitable corner, for example the upper left (if you are right-handed) or upper right (if you are left-handed). Leave a bit of excess to complete the border for your design.

Complete the row by weaving towards your preferred hand, one row at a time. Use your other hand to keep the already woven part of the row in place. If necessary, use masking tape to temporarily hold the woven rows in place as you work. As you continue to weave, use your fingers to adjust the warps and wefts to maintain a uniform pattern. See that the width of each warp and weft has been maintained, that the spaces (if you wish to leave any) are uniform and that the pattern is maintained. Check this at regular intervals as it becomes more difficult to adjust the earlier rows when too many have been added.

If you are using natural plant fibres, you must apply a coat of clear varnish. This gives the work a gloss, protects against insects, and also preserves the natural texture of the material. Allow it to dry.

Complete your work by adding a border design if you wish. This design may be created by simply folding the ends, or by using the same or a different material to cover the stitching or staples you used.

For a wall hanging, add a wire or string to the back of the artwork.

Helpful hint

Your weave may be held in place by folding and sticking, stitching or stapling. Ensure that the equipment (glue, sewing machine and thread, or staple machine) are suited to the material you use. Heavier materials may require sturdier equipment and supplies. If applied with care, the stitches or staples you use may become part of the design for the border of your work.

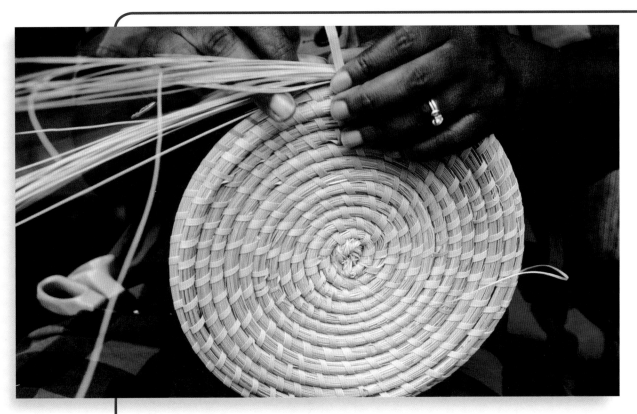

Fig 12.7 Weaving a placemat.

5. Refine the process

The best time to make any adjustments or correct any errors is while you are actually weaving. What to look out for has been discussed in Stage 4 above. However, care must also be taken before you begin to weave to ensure that the materials are cut to a uniform width and are of suitable lengths. If you are weaving in various colours, ensure that all the coloured materials are available in sufficient quantity and that you are clear about where you will use them in the design.

6. Present your piece

You may wish to present your artwork along with other woven pieces done by your classmates. Your teacher will wish to carefully inspect your technique at weaving. Even if the finishing includes decorating, do not overdo this as you may find your woven artwork is elegant and very presentable on its own. Should you choose to decorate you piece, **Chapter 13** gives you some ideas for decorative art techniques.

Be sure to photograph your work at the various stages of development. These photographs create an essay of what you did, which will also provide an idea of what you may need to improve the next time around.

7. My art journal entry

Refer to **Chapter 16** to guide your art journal entry for Stage 7 of your fibre art-making process.

8. Make another fibre art object

a) **Design another artwork using the same weaving technique** or material for weaving. This develops your skill in weaving and is a good way to begin a sequence of works based on a particular weaving method or material. Instead of a kitchen place mat or decorative wall hanging, choose another object to design. A centrepiece for a table, a doormat, or decorations for a festival or cultural event are possibilities.

b) **Use another suitable fibre for weaving.** As each material has its own unique properties, it reacts and appears differently when woven. This exercise gives you the opportunity to use another material and compare the differences between the materials you use. Note the differences in the cross-sections of the fibres, for example flat or round; the effect of bending on the material, for example some twist easily while others may be springy; how they may be best cut, folded and bonded; the colours that are available; and the textures they possess.

c) **Switch among the rand, twill, cascadura and herringbone or another weaving method.** This will help you to gain the widest range of experience and methods for creating designs from the weaving of fibres. As you do so, compare your methods, processes and completed pieces with one another.

d) **Create an artwork that is not flat, but three-dimensional.** Three-dimensional artworks may be woven around a mould which demonstrates a sense of creativity, skill and beautification of an object. Lamp shades, vases, your folder cover, or a simple cardboard box are good objects to begin with.

Another way to begin three-dimensional artworks using weaving techniques is to weave the flat base and attach it to the side of another suitable material. For example, a serving tray or shelves for a space saver may be woven and joined to sides or edges made of a light wood such as cedar.

e) **Consider combining methods.** Your experimentation with the various weaving methods may also encourage you to combine them or invent one of your own. Experiment to develop a unique method.

f) **Experiment with weaving techniques to produce another three-dimensional art technique.** One such technique is the use of wire, line or fibre to create a three-dimensional artwork. Some related ideas are provided in **Chapter 9**.

Chapter summary

In this chapter you have learned to:

- trace the history of weaving
- explain and use terms associated with weaving
- follow the stages for creating your own woven artwork
- introduce ideas that will further develop your skill in weaving and creating woven items
- apply your knowledge and understandings to speak and write effectively about weaving and the fibre arts.

Activities

Individual projects

1. Create a set of four table mats based on a theme.

 As an addition to this activity, you can make coasters for glasses, a napkin holder or serving tray. Another good idea is a matching centrepiece for your table.

2. Make a pencil holder from a jar. Use the jar as a mould, and weave a design around it using a selected natural fibre.

 Apply a coat of clear varnish to the weave. Present the piece and discuss how difficult it was to weave '**in-the-round**' to create the three-dimensional form. Say how you overcame the challenges of turning a direction from the flat base to the vertical sides of the jar.

3. Select an item based on a theme of your choice, for example a hat for an Easter parade or an Amerindian hammock. Use a suitable fibre and a fibre-weaving technique to produce the item. You may choose to work to a scale.

 Present and discuss your piece on the basis of its on its theme, materials, weaving technique and personal value as an artwork.

Group projects

4. As a class, make a list of as many materials as you can that may be used for weaving, including ones not mentioned in this book. Try to select some that are indigenous to your country.

 Gather as many of these as you can. Decide on a size for the samples: 30 cm x 20 cm is suggested. Weave the samples and compile a catalogue.

 Make a folder to store your samples. Perhaps you can weave a design on the covers of the folder as well.

5. Use one or a combination of local fibres to weave one of the following items: a mat, rug, tapestry, decorative wall hanging or another item of your choice that you have discussed in class.

 Your finished product should be no less than 90 cm x 150 cm.

 Present and discuss your work. Compare it with other similar pieces made by other classes or schools. Perhaps you may wish to exhibit the pieces.

Integrated projects

6. Use an indigenous fibre such as coconut, terite or cane to create a unique three-dimensional form. A part of your design must show the weaving of the fibre, but the fibre may be used in other ways also, for instance draping, knotting, splitting, shredding, folding or tearing. The form may be based on an actual object, may be from your own imagination, or may be a combination of reality and imagination. Consult **Chapter 9** to create an armature or frame to support your design.

Art appreciation

7. Discuss the advantages of using indigenous fibres for weaving. Make a list of natural fibres that are found locally and the products and artworks that may be woven from them.

 Consider the following in your discussion:

 a) availability of the resource: location, quantity

 b) cost: for the artist to gather, prepare

 c) durability: how long the material can last in its raw and designed forms

 d) workability: for ease of use, design possibilities

 e) appeal: to whom (market, e.g. local, tourist), benefits, cost to consumer.

> **Key term**
> **in-the-round:** a three-dimensional form, made to be viewed from all angles

 More activities for this chapter are included on the accompanying CD-ROM.

Chapter 13 | Decorative Art and Craft

*Fig 13.1 Display of decrative craft items.
Trafalgar Waterfall Visitor Complex, Dominica.*

Outcomes

After reading this chapter and practising its activities, you will be able to:

• define and explain the terms 'decorative art' and 'decorative craft'

• trace the history and development of decorative craft

• list, understand and follow the stages in the process for creating your own pieces of decorative craft

• use key terms and understandings to effectively speak and write about decorative craft

• apply theory and skills from other chapters to complement your development in the decorative crafts

• critique a decorative item, using the elements of art and the principles of art and design

• engage ideas and techniques for your further development in decorative art craft-making.

Resources

You will need:

• notebook, art journal, pencils, coloured pencils

• paper, card, plastic, glue or cement, staples, string, scissors, craft knife, stencils, fusible web, masking tape

• almost any found or discarded materials or objects – ends of paper, fabric, broken tiles, terrazzo chips, stone, coral, samples of trial artworks, beads, buttons, leaves, seeds, shells, other trinkets

• sand, plastering cement, trowel, sponge, water, tool for etching, cloth or soft leather, tile grout

• paints, paint brushes, varnish

• computer with internet access

• school and public library access.

Introduction to decorative art and craft

Decorative craft is an area of the visual arts that allows you to use almost any material to create artworks. You can make your own object or beautify another object in some way. Since almost any material may be used, try to find **discarded** materials or other **found** items from the environment with which you can work creatively.

There are many advantages when you use discarded or found items. These items and materials:
• incur little or no cost
• are almost always readily available
• encourage reuse or recycling
• are generally environment-friendly, and make you environmentally aware
• give you the opportunity to be creative in finding, exploring and using materials
• evoke Caribbean appeal.

In the Caribbean, **indigenous** found materials include coral, seashells, driftwood, limestone, sandstone, shellfish, coconut, calabash, bamboo, various straws and fibres, assorted leaves, barks, seeds, fruits, roots and vines. Perhaps you can add to this list.

Decorative art

Decorative art techniques are used to finish artworks in other areas of the visual arts, including items of decorative craft. Decorative art techniques include painting, drawing or printing, sticking, carving, cutting, etching, folding, staining, stamping or stitching. Some simple means of decoration include using pencils, glitter, coloured paper, glitter paper, stickers and other adhesive decorative finishes. Decorative art may be applied to walls, furniture, or any other objects.

From your classroom experiences, perhaps you can think of some artworks that you can decorate. Here are just a few suggestions:

- Handpaint or print designs on your pottery.
- Create and colour a pop-up card.
- Cut or carve patterns on leather pieces.
- Weave strips either across or down through a large picture.
- Make a collage with remainders of materials you have used.
- Make patterns from gift wrapping to cover a surface or book.

Select and complete one of these activities, or discuss with your teacher and choose another theme altogether. At another time you many choose to do one of the others.

Key terms

indigenous: *naturally occurring materials available locally*

decorative craft: *the creation or embellishment of an object using materials or other objects*

discarded: *objects disposed of but reused to make art or craft*

found: *naturally occurring objects used to make art or craft*

Discarded materials include paper and card, fabrics, plastics, glass, metals (including wire), natural and synthetic leathers, woods, foams, rubber, thread, string and cord. They may be gathered from packages and cores; old fabric products; used Carnival and other festival costumes; banners and flags; printed materials including brochures, fliers, magazines and newspapers; nets and sieves; rubber and plastic products; bottles, jars, cans and their caps or covers; other vessels and containers; CDs and their cases; machinery and machine parts, among others.

Trinkets include beads, buttons, pins, clips, cards, stickers and shapes cut from glossy paper, plastic or metallic sheets.

Depending on the materials you work with, the pieces are combined using different materials. Suitable types of adhesive, pins, staples, fasteners or thread provide a good variety to choose from.

Key terms

decorative art: *the application of fine art finishes to embellish artworks or other surfaces*

decorative arts: *items beautified to increase their appeal. Function and form are combined*

213

History of decorative art and craft

Decorative masks

Decorative craft were first used in many ancient civilisations. The central American Maya used masks for ritual. The Aztec mask shown in **Figure 13.2** is made of wood, but is decorated with polished pieces of turquoise, a semi-precious material, while the eyes and teeth are made from seashell. Notice the use of the pieces to make the contours of the face. The pieces are stuck to the wooden surface using an adhesive made from vegetable matter. **How effective was this? Can you think of what bits and pieces of materials could be used to create a decorative mask for Carnival or a school drama production?**

Fig 13.2 Aztec. Ceremonial Mask for Quetzalcoatl. c. 500 years ago. Wood covered with turquoise and shell. 30 cm tall.

Mosaic art

The ancient Greeks cut natural stone into geometric shapes for mosaics that were used to decorate floors and pavements. About 2,000 years ago, the Romans used mosaics to create pictures to record their history on the walls of buildings. As the Roman Empire expanded, patterns for mosaics and other decorative arts and craft were influenced by patterns from Middle and Far Eastern countries. One such mosaic, 'The Battle of Issus', is made up of about 1,500,000 tiny coloured tiles that were placed on a floor. **Research to find out about it.**

During the Middle Ages (5th to 16th centuries) mosaics as decorative art began to adorn entire walls and ceilings of buildings. By then the cutting and setting of pieces had improved and mosaics with patterns were made, not only in stone but also in marble, glass and gold. At this time, the Byzantine Empire created the best examples of Christian art. The churches of Hagia Sophia and San Vitale are two fine examples of their style of architecture, and in them are equally rare mosaics. **Try to find out about them.**

Key terms

stained glass art: coloured glass pieces set to make pictures

cassone: a decorative chest

Renaissance decorative art and craft

Stained glass art flourished during the Renaissance. However, long before then glass was coloured by the Egyptians and Romans and used for vases. Stained glass art grew in popularity throughout the Moslem world and in Europe at this time, with fine examples decorating cathedrals in particular. Many churches of the Caribbean are also decorated in this way. Why not visit one? Observe how the glass pieces are set and the effect of light on it, both from outside and inside.

Another interesting piece, the **cassone**, was given to a bride at her wedding. It was hand carved and decorated with paintings and religious writing on its sides. **Apart from their cost, what adds value to such objects of art?**

18th and 19th centuries

During the 18th century Rococo art emphasised the decorative arts, bringing designs with curves to the interior of buildings, furniture, mirrors, fabric furnishings, miniature sculpture and utensils.

During the 19th century more art was made through experimentation, with artists sticking materials to their canvases. These included precious metals and stones. One such application is **gold leaf**. **Figure 13.3** is an example of the use of decorative craft ideas in painting. Mosaic artists have also turned to glass to create unique works. They used the qualities of the glass — transparency, reflection, texture and stained colour — to evoke new appeal. **Comment on the impact of Figure 13.4.**

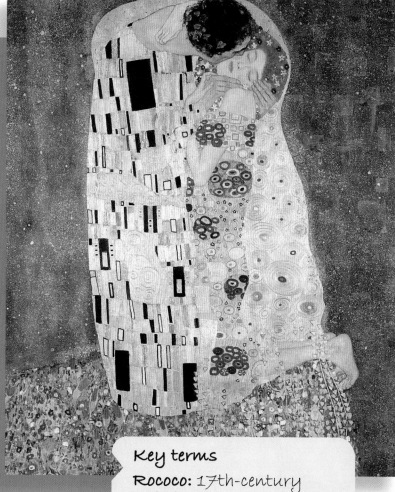

Fig 13.3 Gustav Klimt. The Kiss. 1907–1908. Oil and decoratives fixed on canvas. Osterreichische Galerie, Vienna, Austria.

Key terms

Rococo: 17th-century artistic style, characterised by lighter materials and elements of art used in decoration

gold leaf: gold beaten into thin sheets that fold like paper

The 20th century

During the 20th century, it became common for visual art to be made using mixed media, continuing the tradition of using both common and not-so-common materials, techniques and approaches to make art. This creativity encouraged a cross-over of decorative arts into other visual arts areas. One emerging field is that of stained glass sculpture. Artists work to transform glass into three-dimensional artworks. The colours of the glass and the many angles at which the glass pieces are set enhance the light. **Figure 13.4 is as much an example of decorative craft as it is three-dimensional art. Comment on the features in Figure 13.4.**

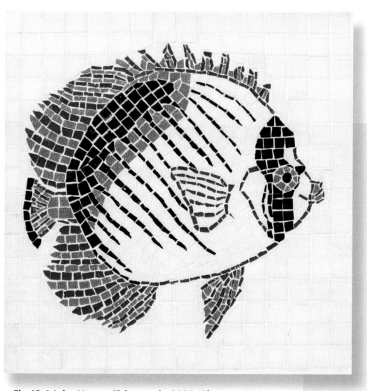

Fig 13.4 John Unger. Fish mosaic. 2006. Glass mosaic. 44 x 44 cm.

Decorative art and craft-making techniques

Decorative craft may be done as an original artwork or on a surface of another artwork such as a jewel box that you may wish to finish in your own unique way. This chapter will teach you about creating artworks using three decorative craft techniques: appliqué, collage and mosaic.

Fig 13.5 Appliqué pocket on blue blanket.

Appliqué

An **appliqué** is a cut-out of pieces of fabric used to decorate a larger piece of fabric. Other appliqué materials include lace, ribbon, edging and leather. The appliqué pieces that you select are generally based on a topic or theme. They are affixed to a larger fabric base using fabric glue. Fabric paints may then be applied to complete the design.

Appliqué techniques include:

Overlapping – the sticking of a second layer of material over a first so that parts of the first layers are exposed while other parts are not.

Interpenetration – the sticking of a layer of material so that it moves above, then under, a previous layer, then above it again, similarly to a simple weave. Learn about weaving in **Chapters 12** and **8**.

Gradation – the subtle shifts in an element of art (see **Chapter 1**) used in design for instance, the use of tones of a colour, or the increase in the size of shapes used in a design.

Collage

The word '**collage**' is French for gluing or pasting. The materials include paper and fabric, but cardboard, plastics and synthetic leathers may also be used. A collage is usually made by sticking together pieces of one material of different sizes, shapes, colours, values and textures. These materials may be folded, torn, cut, twisted or woven.

A preferred medium for collage is kite paper. Kite paper is **translucent**, allowing you to mix colours in a unique way. The colour of the layer below seems to combine with the colour of the layer over it so, for example, a red first layer with a yellow second layer over it produces the effect of orange.

Collage techniques include:

Overlapping – similar to the appliqué technique above.

Interpenetration – similar to the appliqué technique above.

Gradation – similar to the appliqué technique above.

Examine Figure 13.6 to identify any of the characteristics or techniques discussed here.

Fig 13.6 Tonya st Cyr. Tobago wedding. Paper collage.

Mosaic

A **mosaic** is a picture formed by setting small pieces of a material in mortar or a similar base. Common materials used include stone, pottery, ceramic tiles, glass, beads or wood. These materials are not easily bent like paper or fabric. They must be cut or broken to fit the design, or be used in their original shape and size. Different techniques, tools and adhesives are required to separate or unite these materials.

Because the materials are inflexible and have a workable thickness, they may be set. A common base is mortar, made from sand and cement and laid using a trowel. The base is laid, and as it begins to dry the pieces are set into it. A base with an uneven surface, or peice set at varying depths or angles, causes the light to create interesting effects.

Materials that require little or no preparation before creating mosaics include beads, seeds or buttons.

Mosaic techniques include:
Variation – the use of different shapes, sizes, and colours of your pieces adds interest.

Gradation – similar to the appliqué technique above.

Creating shapes, patterns and motifs – the thoughtful use of multiple pieces to create lines and shapes that generates movement within the artwork. The more pieces you use, the more possible it is to have a **motif** in your design.

> **Key term**
> **mosaic:** a picture formed by setting small pieces or fragments of a solid material

> **Key term**
> **motif:** the main element or repeated symbol in an artwork

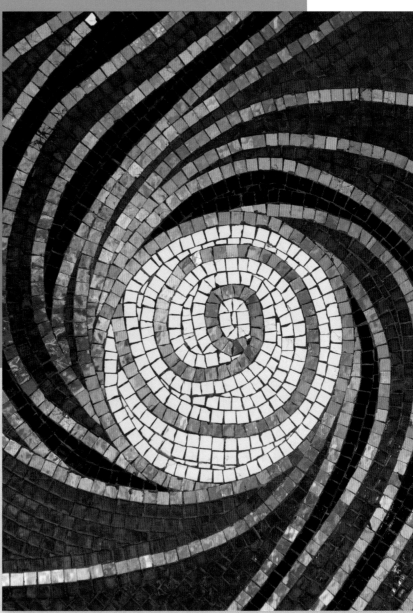

Fig 13.7 Mosaic detail, Buji Al Arab Hotel, Dubai.

Stages in the decorative art and craft-making process

This process has nine stages intended to develop your ability in art and decorative craft-making. You will do research; select what to create; select what technique to use; create your drawing for the artwork; apply ideas for good composition, perspective, and design skills; add details; present your work; make a journal entry; and think of ideas to include or improve the next time you attempt a decorative work. Along the away, you will also be reminded about using the elements of arts and the principles of art and design.

1. Research decorative art and craft-making techniques and processes

Refer to **Chapter 16** to guide your research for Stage 1 of your decorative craft-making process.

2. Select the topic, theme or brief

Because of the wide variety of materials and techniques available, you will need to make many decisions early on. Choose an object, topic or theme that is simple to design, and which uses materials easy to find and manipulate. A suitable theme may be 'tropical birds', but you may choose to use another.

The technique you choose to work with narrows down the type of materials you need. For instance, a collage requires paper or fabric, while a mosaic may require beads, buttons, shells or seeds, and an appliqué requires pieces of fabric. Whichever of these three – appliqué, collage or mosaic – you choose, the process to complete the artwork is similar.

Fig 13.8 Macaws. Can you generate ideas for a decorative piece from this picture?

3. Create the design

From your research, select pictures of the theme or subject you will use. Obtain a few pictures and examine them to select the one that is most interesting and appealing. Perhaps in one picture more colours are revealed, or the subject is captured at an unusual angle.

Once you have selected, decide on the size of the surface or base for your artwork:

- **Appliqué** requires a fabric base, preferably white cotton, and pieces of another fabric with designs related to your subject, or available in as many colours as you wish to use. Cut out the shapes that make up the parts of the design in the colours you want, and then assemble them. Also consider the design you may wish to use for the frame or border of your appliqué design.

- **Collage** requires a paper base, preferably white paper, card or Bristol board. Alternatively, your base and cut-outs may be made of coconut fibre, woven straw, card, Bristol board, foam, plastic or mesh made from plastic or metal.

- **Mosaic** requires discarded ends of solid material, such as ceramic tiles or chips of coloured stone, and a sturdy base made from hardboard or ply-board. Alternatively, it may be created directly on a wall. Terrazzo chips or aquarium stone are quite suitable to provide sufficient variation in colour in your design. Again, consider whether you want a frame or border around your mosaic. If you do, leave space for it.

Draw your design. Use paper and pencil and work with a scale. Refer to **Chapter 7** to create a drawing to scale. If you are using supporting designs to complement your main design, you will need to draw them in also. Supporting designs should not be made too complicated as they are not the **centre of interest** of the design, and also placing them in perspective is not easily achieved.

Also observe your use of space. As a general guide, use about three-fifths of the area for your designs (this is known as **positive space**), and keep about two-fifths of the area for unused space (this is know as **negative space**). Also see pages 98 and 118.

Next, decide what colours will go where on the design. You may wish to use the colours as they appear on the picture you selected for your design, or to creatively add others.

Did you know?
All two-dimensional artworks use the element of space. This space is divided into positive and negative areas. Positive space is occupied by the objects you intend to use in your artwork. Negative space is the space left around the object you used. For your artwork to be appealing and in balance, both spaces must work in harmony with each other. This requires you to pay as much attention to the negative spaces as you do to the positive spaces. Chapter 1 discusses the element of space.

Key terms

centre of interest: main aspect or point of focus in an artwork

positive space: area occupied by a shape set out to be represented

negative space: area occupied by a shape not set out to be represented, or the space around a positive shape

Fig 13.9 Positive and negative spaces.

4. Transfer the design

Reproduce your design drawing on the base. Do this by cutting out the paper drawing, placing it on your base and tracing its outline on the base.

- **Appliqué:** Before you begin, wash your fabric thoroughly to remove any film from the surface. Use pins to stretch and hold the fabric base tightly, then trace the outline of your design. Draw in the supporting designs that complement your main subject, if you choose to use any. Because there is an overlap of appliqué pieces, it may be wise to use different colours of pencil, as a form of colour coding, to indicate the positions of the first, then second layers of appliqué pieces, and so on.

- **Collage:** Use masking tape to firmly hold the base to the table on which you work. Draw out the objects you wish to represent, using your design drawing. Again, use coloured pencils to guide you in the location of your colours.

- **Mosaic:** Apply the mortar to the base, and as it begins to dry, etch the design into the mortar using a sharpened instrument such as a piece of metal rod, a nail or even a pen that no longer works. Unlike with appliqué or collage techniques, you must work quickly so that the mortar does not dry off. Keep your pieces for setting into the mortar, a sponge and some water handy. If you are using pieces of tiles, cut them before you begin the next stage.

5. Create the artwork

Have your design drawings, materials, tools, adhesive and the base available.

- **Appliqué:** Cut out your appliqué pieces. Separate them into the designs for each layer. For example, for each of your designs, you may have the pieces you will stick first, then second, and so on. Set them up as you had designed onto the fabric base, using pins to hold them in place as you work. This allows you the opportunity to move the pieces around to make any adjustments that may be required.

 Begin with the main or central design. Place the first layer of appliqué, then those that overlap. Apply sufficient adhesive evenly, but not too much. Then work towards the designs nearer the margins.

 Fusible web may be used to affix the appliqué pieces to the base. This is done with an iron, which causes the web-like material, placed between the fabrics, to melt and fuse. Trial-test this using ends of your fabric, and never iron directly on the web as it will stick to the iron. Seal the edges of your design with fabric paint. Your fabric paints should complement the colour scheme of your design.

- **Collage:** Cut or tear out your collage pieces. Separate them by layers, then by the designs for each layer. For example, for each of your designs, you may have the pieces you will stick first, then second, and so on. Use masking tape to temporarily hold the pieces as you build up the design.

 Begin by sticking the first layer of pieces into their positions. Paper, especially kite paper, does not require much glue. A clear-drying glue is recommended. As you build up the layers, take care to avoid sticking pieces before techniques of folding, overlapping or interpenetration are applied.

Helpful hint

Always assemble the pieces of your design into a whole before you begin to stick or set them into place. This way, you are able to see the actual design, and to adjust, add or remove pieces to create proper use of space and balance in your artwork. Decide, too, on the order in which you will stick or set the pieces. Where possible, number the pieces or sections of pieces you will work with in the order in which you will stick or set them.

Key term

fusible web: adhesive for textiles, placed between layers then ironed to join

- **Mosaic:** Apply mortar to the back of the pieces and set them into the base. Mortar dries quickly so sprinkle water with a sponge to keep the surface sufficiently moist. You may choose to work from the edges moving towards the centre, or from the centre towards the edges. If you have a border design, it may be wiser to set this first, and then complete the mosaic by fitting the pieces within the border, like a jigsaw puzzle.

 Pay attention to the width of the spaces that are left between and among the pieces of tiles as you set them. If they are set too wide apart, the overall impact of the design may be lost, or you may run out of space to set the remaining pieces. To avoid this, decide on the width of these spaces between pieces at Stage 3. Always set up the complete design next to the actual location to ensure that the spaces are adequate and uniform before beginning to transfer them, piece by piece, to set into the mortar.

It is also possible to create your mosaic by simply sticking the pieces with a strong glue, such as contact cement, to a flat surface. This, however, does not allow for setting the pieces into the base or varying the angles at which they may be set.

<div style="border:1px solid;">

Key term
tile grout: coloured cement mixed with sand

</div>

6. Finish the artwork

Generally, as you work to create the piece, adjustments may need to be made. These may not have been recognised at the drawing stage, and will have to be addressed as you work. Adjustments call for additional cutting, tearing or chipping of material. Other adjustments may require a shift in the position of a part or of the entire design, or it may become necessary to add or remove a part of your original design.

- **Appliqué:** Check that all of the edges of each appliqué piece are well stuck and sealed properly. Work deliberately at this to ensure that neither the fabric glue nor fabric paint are applied to areas where they are not needed. Remove your pins and any unravelled threads. Allow the completed work to dry for a few hours. It is recommended that it be kept flat and in a dry place. You may choose to stitch the appliqué pieces to the base after drying.

- **Collage:** See that all of the edges are well stuck. Again, work carefully to avoid glue or paint where they are not needed. Keep flat and in a dry place, pinned to a flat surface, and allow to dry for a few hours.

- **Mosaic:** Make any adjustments to the pieces while the mortar is workable. See that the pieces are set at a uniform width apart, and tilt some pieces slightly to create variation in the effect of light on particular parts of the mosaic's surface. Wipe off any excess mortar using a sponge or soft leather. Allow the mosaic to dry completely for 24 hours, then use mortar or **tile grout** to fill the spaces between the pieces. Tile grout holds firmly and is available in many colours. Choose a colour that complements the work you have done.

7. Present the artwork

Be sure to autograph your decorative craft piece. This may be done anywhere, but is perhaps best placed at the lower left or right side.

- **Appliqué:** Be creative in your use of fabric paint. You can actually write with it out of the tube. The work may be framed with a border pattern made from the base fabric itself, for example a hem. Planning for this must be done during Stage 3 of the process, because the hem will require a fold of a centimetre or two of the textile all around. Select a thread that complements your colour scheme. If you do not use a stitched border, an edging or a mat may be used. Refer to **Chapter 17** to make a mat.

- **Collage:** Your picture will look complete with a mat or a frame around it. Go to **Chapter 17** to complete this exercise.

- **Mosaic:** A tiled frame serves to highlight the work, and can also highlight the main design of the mosaic. You must therefore carefully plan the size and colour of the pieces you wish to use. Space to create a border may not be available after completion so plan for this during Stage 3. If you worked on a wooden base, such as plywood, a wooden border may be attached to finish your work.

Present a photograph and drawings with your finished work. From them, your teacher will see how you used the elements of art and the principles of art and design, and may point out corrections needed for the arrangement in the composition itself, use of perspective, use of colour, the centre of interest, and the suitability and range of techniques you used for your project.

Another useful idea is to take photographs as you go from stage to stage. These create a photo essay of what you did and where you may need to improve the next time around.

8. My art journal entry

Refer to **Chapter 16** to guide your art journal entry for Stage 8 of your decorative craft process.

Did you know?

One example of dry wall painting is graffiti art, which became popular in New York City in the 1980s, but was first practised in the days of the Roman Empire. It is considered both as a modern art and as a form of vandalism if permission is not sought for the use of the space. Modern graffiti artists use aerosol paints as a popular medium. Skilled works show good composition of image and written message, making graffiti similar to a graphic design. Turn to **Figure 3.17** in **Chapter 3**. Comment on the style of the artwork.

Key term

graffiti art: spray-painted or scrawled images and letters, usually done on the street and in other public spaces

9. Make another decorative craft piece

a) Use another picture as reference for your design. In this way your subject is captured in a different position. This adds interest to your work, and is a good way to begin a series of works based on a particular subject or theme.

b) Use other suitable materials with the same technique. For instance, an appliqué may be created by first creating your designs using a quilting or knitting technique, before fixing these onto the fabric base. A collage may be made using thin, translucent plastic sheets or canvas. A mosaic may be made using only found objects such as seeds, beads, shells or buttons.

c) Switch among appliqué, collage and mosaic. Although they follow a similar process, each technique works with different materials and skills. To gain the widest possible experience, try them all. Compare your processes and completed artworks with one another.

d) Experiment with another decorative craft or art technique. Apart from appliqué, collage and mosaic, there are a variety of other decorative craft and art techniques. These may be used separately or combined with other techniques for unique results. Two are introduced below.

Key term

assemblage: three-dimensional artwork made up of other objects or parts of objects

Other decorative art and craft techniques

Assemblage

An **assemblage** is usually made from discarded or found materials or products. The artist's skill is seen through the selection, combination and assembly of the various parts, which in their original form were not used for art. Almost any material may be used, including materials or objects made from wood, metal, gravel, plastic, styrofoam or cardboard. Perhaps you can think of some other materials.

An assemblage may be considered an extension of a collage, combining pieces, but creating a three-dimensional form. It is therefore a wonderful way to begin your understanding of sculpture. Begin with a simple idea requiring only one type of material to construct, and follow the stages of the design process to make the work. Ideas found in **Chapter 9** on three-dimensional art will provide you with a start.

Figure 13.10 shows an assemblage. What materials have been combined? Examine the title then comment on the use of materials and the use of space.

Fig 13.10 Tizro Martha. Sex, Religion and Politics do not match. Various materials 87 x 128 x 4 cm. 2006.

Mural

A mural is done on a wall or ceiling that has a primary function to support an architectural structure. Traditionally, the artwork itself had a decorative secondary function. This is no longer always so, as many murals have been placed on walls built especially for them. Many have also been adorned with decorative craft pieces. Murals may either be done while the plaster used to finish the wall or ceiling is still wet, or anytime after it has dried. **Comment on the use of the elements of art in Figure 13.11.**

A mural painted on wet plaster is called a **fresco**. The paint itself is absorbed into the plaster as it dries, creating the work. The colour is, however, weakened as it is absorbed into the surface. To counteract this stronger, less diluted colour is suggested.

Begin your own fresco technique on a small area, about 60 cm x 90 cm. Use a ply-board base with a border nailed all round to contain the plaster. Complete a simple design and trace it onto the wet plaster, then paint. Take notice of how the paint gets absorbed and how quickly you must work. Use water to delay the drying as you are working. You will see how strongly colour must be applied. Painting on a second layer of colour strengthens the effect.

Key term
fresco: painting done on wet plaster

Fig 13.11 Hilroy Fingal. Life in Delice. Oil on wall. 2005. Cropped. Delice Primary School, Dominica.

Chapter summary

In this chapter you have learned to:

- trace the history of decorative craft
- explain and use terms associated with decorative art and crafts
- follow the stages for creating three types of decorative crafts
- use techniques to further develop your skill in creating decorative craft and art
- apply your knowledge and understandings to speak and write effectively about decorative art and crafts.

Activities

Individual projects

1. Create a collage based on any theme of your choice. Use printed materials such as newspapers, magazines, brochures, flyers, bills, ticket stubs, calendars or labels.

2. Based on the theme 'Along the shore', design and create a chain, necklace, bracelet or anklet using coral and seashells. You may use a third material of your choice. Be creative in your selection. Consider a pendant made from driftwood that you will carve. Other materials may include seaweed, coconut, water-smoothened glass and shells, seeds, fishing nets, soft rocks, and other found objects.

 At another time, consider designing an artwork using any found or discarded objects. Decorate it with any two or more of the following materials: shells, buttons, rhinestones, metal charms, feathers, or any other suitable decorative craft materials.

 Select a theme from 'Our forests', 'My junk', 'Old clothing', 'Around the neighbourhood' or 'The scrap-yard'.

3. Select an object at home that may require refinishing. A wall, cupboard, cabinet, case or box will do. Brainstorm ways to refinish or decorate it. Seek permission and perhaps a commission from your parents for your artwork.

 Create the design and execute it on the surface. As it may not be practical to move the artwork, take photographs of it before, during each stage, and afterwards. Record how long it took to complete, and what you achieved over each session.

 When you are done, invite your parents (as commissioners), your class (as observer artists) and others (as viewers) to take a look. Provide a **visitors' book** for them to make comments in about your artwork. Keep these safely as in the future they can become a powerful source to inspire your art.

Group projects

4. As a class, collect as many bottle caps as you can. Your school's cafeteria may be a good place to begin, but visit other places to collect different types.

 Use them to create a design based on the theme. The design should not be less than 100 cm x 100 cm, and no larger than 200 cm x 200 cm. Consider the material you intend to create your design on. Use special bottle caps to emphasise or enhance your design and consider wet cement, hammer and nails or contact cement as appropriate means to hold the caps in place.

5. Design and create a mural based on a theme, for instance 'Tribute to a national hero', 'Tribute to my school achievers', 'HIV/Aids awareness or 'Local folklore'.

 Select the space and determine the materials and techniques you will use to complete the artwork. Give it a title and identify your class and the year in which the mural was done.

 At another time you may wish to create a fresco painting on wet clay. This technique will require you to have an understanding of clay and its plasticity (see **Chapter 11**) and how paint gets absorbed into this material.

Integrated projects

6. Create a photograph collage of your class. Each student in your class should submit two or three photographs of himself or herself. Select photographs that show a variety of activities from as many subject areas as possible. Creatively represent the class as one picture, by cutting and sticking the individual photographs together onto a Bristol board or stag blanc base. Frame your photo-collage and hang it in your classroom.

 Another idea is to use photographs of various projects: classroom, laboratory, sporting and physical education activities, cultural events, concerts, field trips, parents' day and open day, over a year to create your Class Yearbook collage. Use large sheets of card or paper, for your pages. Place them into a ring binder so that more pages may be added. Provide spaces for each student, your teachers, resource persons and visitors to comment. Complete the Class Yearbook collage by designing covers with an inset of a class photograph.

 Why not make a class yearbook collage for each year you attend school?

Art appreciation

7. Discuss ways in which the following may be used to create artworks:

 a) found indigenous plant matter

 b) discarded household materials

 c) early writing

 d) garbage found on a beach, to make people more aware of littering.

> **Key term**
> **visitors' book:** book provided for viewers to place comments in about artwork they see

 More activities for this chapter are included on the accompanying CD-ROM.

Chapter 14 | Introduction to Design Arts

Fig 14.1 Sony Playstation Portable. Handheld games computer.

Outcomes

After reading this chapter and practising its activities, you will be able to:

- define and give examples of key terms in design and the design process

- trace the history and development of design and the design process

- apply the design process to the visual arts

- use your understandings to effectively speak and write about the design arts process

- apply theory and skills from other chapters to complement your development in the design arts process.

Resources

You will need:

- notebook, sketch pad, art journal, pencils, coloured pencils

- materials relevant to the design and creation of any artwork based on Part 2 (**Chapters 4 to 14**) of this book

- computer with internet access

- school and public library access.

Introduction to design

What is design?

Design is used to solve a **problem**. We aim to solve problems in order to make our lives easier. For instance, houses are designed so that we solve the problem of accommodating ourselves in the natural environment. In your class, the artworks that you do require design ideas that are inventive and artistic. To make them successfully, you must be able to put together ideas, planning and designing.

The design arts aim to make art students aware of the inputs (resources, technologies, environment, design role and process, communication, and research and development) needed in order to achieve a successful **product**. Sometimes, your solution may become a resource used to solve other problems. To create a design that solves a problem, you use the **design process**. The better you are able to use the design process, the better the solution to the problem. All processes are made up of steps or stages. Each step requires inputs or resources. Because there may be more than one resource available to solve any one part of a problem, you will have to make many choices about which ones are best to use.

History of design

The first designs

Humankind's ability to design began when we first evolved. The first pieces of clothing humans wore used the skins of animals, which provided warmth against the open air. These were designs that solved the problem of being unprotected. When holes were made for arms to fit through, it meant that another design idea was used to improve an existing design solution. The holes allowed the arms to move freely while the body continued to remain protected. When bone and stone were shaped to make spears for hunting, another design idea was used. Design is intended to make our lives easier.

As man settled into the first communities, design was used to create larger and more suitable living areas, weapons, tools and systems for speaking and writing. Over time, the first ideas and inventions became improved, and new inventions were designed.

Early monumental designs

During the Neolithic Era, many early civilisations used improved design ideas such as fired and reinforced clay blocks, carved stone, newer and more durable tools, plaster, and knowledge in art, astronomy and mathematics to build temples cut from rock, giant pyramids, observatories and places of worship. Many of these monuments, some thousands of years old, still stand because of their durable materials and careful craftsmanship. **Turn to Figures 2.1, 2.5 and 2.21 (Chapter 2) and discuss them. Can you name some other examples of early monumental art?**

> **Key terms**
>
> **design**: the ideas used to create a solution to a problem
>
> **problem**: a situation that requires a design solution

> **Key terms**
>
> **product**: a solution to a problem; the output of the design process
>
> **design process**: the stages to follow to solve a problem

Design during the Renaissance

About 500 years ago during the Renaissance, the interest in the revival of ancient Greek culture through the arts and sciences produced a period of development in design unlike anything before. Architecture and sculpture, grand in size and skilfully designed, changed how architects, artists and builders worked. At the same time scientists were making fascinating discoveries and conducting experiments to learn more about the world and the stars. Discoverers travelled far and wide over the oceans in more seaworthy ships armed with the latest instruments for sea travel. **Do some research to find out about some of the amazing inventions and innovations that were designed during the Renaissance.**

Design during the Industrial Revolution

During the Industrial Revolution of the late 1700s, the greatest single leap in humankind's ability to produce goods and services occurred. Manufacturing on a large scale began, and was made possible mainly through the invention and improvements in design of machinery. These designs led to technological advances in agriculture, manufacturing and transportation. Methods for designing were learned and spread, developing creativity and competition among designers and thus causing the design process to evolve. Designers searched for the best resources to build their machines and systems, and to mass-produce goods and services at the lowest cost, making them cheaper and more available to more people. **Find out about and then discuss some of the advantages and disadvantages of mass production for the designer.**

Fig 14.2 Omzad Khan & Nigel Eastman. Dress design. 2008. Fabric. Zadd & Eastman Designs.

Design today

Over time, designers have come to realise that the solutions for problems depend on certain key stages which all designers follow. Today this has led to an evolution in how we go about designing, called the design process.

There is an array of designers working in various areas of human endeavour. In the Caribbean, one area of emerging talent is fashion design. Throughout the islands, many designers showcase through their use of vibrant colour and bold designs, the imagination, vibrancy and rhythm of our people, our culture and our tastes. **Comment on the dress design in Figure 14.2. What about it projects femininity and the Caribbean identity?**

Stages in the design process

The design process is made up of six stages. Each stage depends on the previous one, and relies on conscious choices in finding the best solution to your problem. Each stage also requires certain inputs, which the designer must identify, gather and use. Through each stage of the design process below, factors that concern you as a designer are highlighted. The choices you make for these factors will impact on the final design solution to the problem.

> **Key terms**
> **design brief:** a written statement of the problem and proposal for its design solution
> **specification:** method and resources for creating the design solution
> **brainstorming:** developing possible ideas to solve a problem

1. Planning

a) Brainstorming

The most important tool of the designer is his or her ideas. In order to create a solution, you must identify the problem. Think about the problem to analyse it. This is called **brainstorming** and is done by exploring the many possibilities for solving it, so create as many initial ideas as you can. Allow some time between work sessions to consider your ideas. This will help you to select the best one. Remember, your first idea is usually not your best idea. Consider:

- what inputs are required
- how practical the solution is
- what the costs are
- how long it will take
- what materials are suitable
- what other equipment and resources are required to create the solution.

b) Produce a design brief

A **design brief** is either presented to you or has to be written by you. It is a statement of the situation and the problem that needs to be solved. It is usually agreed to by the client (your teacher) and the designer (you). It contains the assignment, a statement of the problem, the names of the client and designer, a budget, the aims of the design solution, a specification along with its details, and the value of the solution once achieved. A design brief helps everyone to better understand the problem. This leads into the proposed course of action for designing, and the expectations after design. The better you understand the problem, the greater your ability to respond to that problem. Use the design brief to develop your specification and the criteria for evaluating the design during the making and testing stages of the design process.

A **specification** is what is expected of your design: for example, 'this design is expected to ... (write your aims)'. It includes the method (step-by-step) for making the design. It also requires you to list the following categories of resources that you will use in your design: raw materials, tools and equipment. Each resource is presented as an item along with its own details, for example as in **Figure 14.3**.

c) Conduct research

Research is done to find out about the problem and the ways to go about solving that problem. Consider what the problem gets in the way of or prevents us from doing. Why does this happen? Also ask what the solution will help us to do or do better and how will it do so. Research is required to narrow down the type and suitability of materials and other resources from the many that may be available to solve the problem. Guidelines for sources and methods to search for knowledge and information are provided in **Chapter 16**, where you will learn about research and writing for the visual arts.

No.	Name	Quantity	Description	Details
1	framing square	1	aluminium	60 x 35 cm
2	shears	1	metal cutting	24 cm

Fig 14.3 Resource details for tools

All about resources

A **resource** is an input required to achieve an output. The output is your solution to the problem. The output may be a product or service. At each stage of the design process, more than one resource is required to achieve an output. Resources are essential for the successful creation of an artwork, for **invention** or **innovation**. Each resource must be:

- identifiable by name and description
- available in sufficient quantity, so that the artwork can be completed
- suitable, so that the design idea meets its aim
- practical in order to be manipulated
- safe to store and use
- conserved through recovery (found), reusing or recycling if possible
- able to contribute towards creating a successful solution to the problem.

Key terms

resource: an input for the design process, required to achieve an output

invention: the creation of a new idea or product

innovation: the improvement of an existing idea or product

Did you know?

The most successful designers, architects and landscapers are artists who have used their designs to complement the natural environment. They try to make their designs match the natural environment in which they are placed. Frank Lloyd Wright is one architect whose designs harmonised with the environment. In what ways was this achieved in **Figure 14.4**?

Classes of resources

A resource may be placed into classes based on its character. Here are the classes to which resources belong.

Human or non-human

A human resource is any human ability. We depend on the human mind or body to generate it. The human resource is the most important of all because without it we would not be able to plan or use other classes of resources to perform a task. The ability to think of an idea and the skills to paint and carve are human resources.

A non-human resource is one that does not depend on the human being in order to be created. Materials that occur naturally are non-human resources.

Renewable or non-renewable

A renewable resource can be regenerated if depleted or used. Energy from the sun is a renewable resource because the sun's energy is simply available each day. If your solar-powered hand-held game or calculator consumes its energy, it can be recharged.

A non-renewable resource cannot be regenerated. Minerals that we take from the earth are non-renewable. They cannot be replaced.

Consumable or non-consumable

A consumable resource is one that cannot be reused or simply does not exist after it is used. For instance, the paint you use to make a picture is a consumable resource. To make another painting, you need more paint. The paint that was used before cannot be reused.

A non-consumable resource is one that may be used as effectively over and over again. For example, a pair of scissors may be used over and over again for cutting efficiently.

Always remember that each resource belongs to more than one classification. For instance, your ability to do art is a human, renewable, non-consumable resource.

Natural or man-made

Natural resources are found in our natural environment: the land, oceans, air, forests, plants and animals. They occur naturally on our planet. Stone used for sculpture and wood used to make a type of block for printing are examples of natural resources. One day we may even use the natural resources of other planets.

A man-made resource is created by human beings. Man-made resources require natural resources as the raw materials to produce them. A building is a man-made structure constructed from resources such as water, gravel, cement, metal and glass. Some of these materials, like water and gravel, occur naturally, while others such as metal rods and glass require naturally occurring materials in their manufacture before they can be used to make a building. This means that materials such as metal rods, glass windows and concrete are man-made resources. The effort to build it is a human resource. Buildings are one example of design for our built environment. **Can you think of ways in which the visual artist contributes to creating and enhancing our built environments? Consider what is done on or inside buildings.**

Activities

1. Identify the classes in which the following resources belong: paper, air, plastic, animal skins, raw clay, fired clay, sandpaper, electricity, time, an idea for a painting, physical effort to cut out pieces of fabric, a palette.

2. The resources that we use in the visual arts may fall into any of the classes above. For each of the classes of resources discussed above, make a list of five visual arts resources. For any five of the resources you named, describe them by listing all their classes: for example, water is a non-human, renewable, natural, consumable resource.

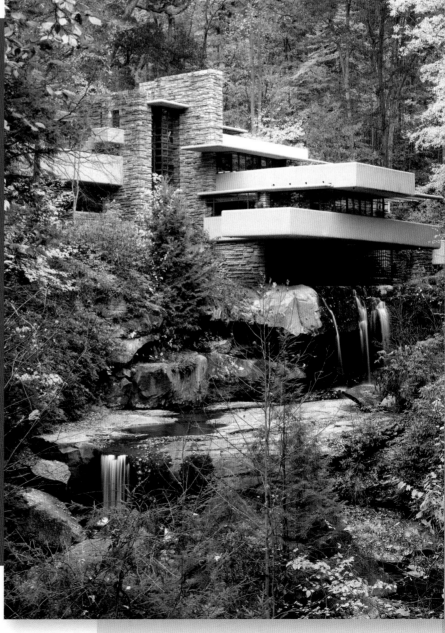

Fig 14.4 Frank Lloyd Wright. Fallingwater. 1935. Pittsburgh, Pennsylvania, USA.

All about technology

Technology does not only include computers and the internet. A pencil, ruler and utility knife make cutting paper to a particular size easier to achieve. Each of these is a technology. If these were not available, would you have been able to perform the task as well?

Because a **technology** is used to achieve an output, it is a resource. As a visual arts student, you will learn of the technologies that are needed, and develop the skills to use them as resources to perform your tasks.

Technology impacts on **human development** because it makes the everyday tasks we perform easier, less time-consuming and perhaps more successful. The technologies we use save us effort and time, and increase the quantity and quality of the product. For example, as an art student you will have to create paintings or frames for your paintings. **What are some technologies that you may require? How do each of them help with the task? Can you name another task and some other everyday technologies you may use to complete this task?**

> **Key term**
> **technology**: any device that makes an output easier to achieve

> **Helpful hint**
> When you think about combining resources and technology, be sure that they are sufficiently available and that you can use them. You may find it helpful to read about each and see them in use. To ensure more **efficient design**, consider what other resources and technologies may be used to achieve the results you want.

Classes of technology

Simple
A simple technology is one that requires little or no specialised training to use. A paintbrush or hammer is a simple technology. Name some other simple technologies.

Advanced
An advanced technology may require instruction for proper operation. The technology itself may depend on other technologies to achieve its purpose: a computer and digital video recorder are good examples. **What other technologies do these depend on?**

Appropriate
A simple or advanced technology becomes an appropriate one if it is used for the right task. An artist's paintbrush is suitable for a painting. A hammer is not, and is considered inappropriate for that task. Sometimes, two or more technologies are able to perform a task, but one is more appropriate. For instance, which are better for sharpening your pencil: sandpaper, a wall, a sharpener, a kitchen knife, a utility knife?

Name some simple and advanced technologies that you may use as an art student. Suggest activities for which each is appropriate.

Combining technologies and resources
Technologies contribute towards human development. Consider how important the simple technologies for painting are to the artist or art student. What else is needed to create the painting? Well, you need the idea and skill and the time to paint to begin with. These are resources that must be combined with the technologies to complete the painting. Resources and technologies work together to solve the task or problem. They combine to impact on our lives each day, at home, at school and in the community. Because resources and technologies are limited, we must be able to conserve them. When they are overused or inappropriately used, the results may be negative, leading to poor design or a waste of resources.

List and discuss a few positive and negative impacts for one selected resource and for one technology. What actions may be taken to avoid negative impacts?

> **Key terms**
> **human development**: ideas, inventions and practices that make living easier and more productive
> **efficient design**: successful design, using less resources

All about communication

Communication is a key part of any visual art-making or design process. Methods for developing good communication include your ability to see and hear, to use what you see and hear to make a sound judgement, and to use this judgement to speak, write, draw and design. We communicate through our voices, hands, bodies, by our actions and through the use of technologies. We do so by speaking and listening, writing and reading, drawing, dancing, acting and singing, then interpreting these. We communicate with other individuals, and small or large groups of people.

When you tell someone about your design ideas, make a drawing to illustrate them, jot down notes to help you record ideas, create a model, record the results of your findings from testing, modifying and retesting, speak and illustrate at the presentation of your product, and present a plan to market your product or service, you are communicating. **What are some technologies used for communicating? How are they helpful to artists and art students?**

Many activities to develop your communication skills are found throughout this book, and the guidelines for how you find, record, understand and use information are presented in **Chapter 16**.

Visual communication occurs when any visual artwork is interpreted. The visual arts and design not only send messages, but are also present all around us. Pictures, signs, logos, symbols, designs, packages, labels, photographs, billboards, newspapers, flyers, posters, machines, vehicles, road signs and building designs all send us information. **Discuss why you may be more attracted to one sign than another, or why you prefer a certain design of car over another. Turn to Chapter 7 to help you along.**

> **Key terms**
> **communication:** the transfer, understanding, response and use of a message
>
> **visual communication:** a message presented through signs, symbols or images; also the message that a visual artwork sends

2. Making

Gather the materials, equipment, tools and your design drawings (physical resources) in your work area. You will need to apply your ideas, skills and techniques (human resources) to develop the solution. A part of your human resource is your ability to use the elements of art and the principles of art and design.

Use the design brief, its specification and the aims of the design solution to establish and write the **criteria for evaluating** the design during the making and testing stages. This ensures that your design remains focused on the problem that you intend to solve.

Now you are ready to combine the physical and human resources to create a solution.

> **Key term**
> **criteria for evaluation:** a standard to judge a design's performance

All about tools and equipment

The use of materials, tools and equipment requires skill and care to ensure that there is no injury to you or others and no misuse or damage to tools.

Before you begin, make a list of all the materials, tools and equipment you require. Once you get them, spend time learning to manipulate or use each of them. Become familiar with safety standards and precautions for your work area, and for the materials, tools and equipment that you use. They require suitable clothing and protective gear, sufficient space for working, and adequate lighting and ventilation. Working in your art and design area also requires your teacher's supervision. Working without your teacher's presence or before instruction may lead to risks of injury and misuse of or damage to resources.

A good idea is to list the materials, tools and equipment you will use. Discuss the procedures for using them and write these down.

Develop your criteria for evaluation of your design. This must be done before you actually design so that all the expectations of your design are planned. A simple way of listing your criteria for design is a checklist for the functions of the product. This checklist is compiled based on the design brief and the problem you wish to solve. A sample for a checklist is provided in Stage 3 of 'Conducting research' found in **Chapter 16**.

> **Key terms**
> **function:** the main purpose of an artwork or design
> **form:** the appearance of your artwork or design

Care, safety and health in the visual arts room is discussed on the accompanying CD-ROM that comes with this book.

3. Testing

Because your design is intended to solve a problem, you must try it out to see whether or not it is suitable. Consider what the problem was, the concerns of the design brief and the criteria for evaluation that you have identified to guide your design. Write down your findings and any newer ideas that may come up as you test your design, **model** or **prototype**. Make a note of them for the modifying stage (Stage 4).

The main question you are seeking to answer is whether the design fulfils the function of solving the problem.

> **Key terms**
> **model:** an object or design smaller in size than the actual product
> **prototype:** an experimental design, usually of a machine

All about form and function

All designs are a mixture of function and form. A common designer's saying, 'form follows function', teaches us that the first consideration is to create a design that suits the purpose it is intended for, and provides the solution to a problem. And only after this requirement is met can the designer focus on the design's appearance.

A ceramic pot serves the function of holding a plant or food, while a table is intended to provide a surface for a meal or for study. But both may also be very stylish and appealing in the way that materials are used and decorated.

In the visual arts, fine artworks tend to present form and aesthetic appeal as their main function. This means that they are made for the sake of art. Their primary purpose is to communicate a message through their appearance and the ability of the artist to apply the elements of art and the principles of art and design to themes and ideas, using materials and techniques. **Examine Figure 14.5. Comment on similarities and differences between the form and functions of the cars.**

Fig 14.5 Designs for two cars.

4. Modifying designs

All designs require **modification**. What you choose to modify will be based on the results of the testing (Stage 3). Identify what is suitable and what is not. Maintain what is suitable and aim to re-design for what is not. Consider the problem and how it relates to the design brief, your ideas and proposed solution, the depth of your research, the specifications you have written, what you designed and the results of your testing. Make your modifications accordingly.

Sometimes the designer will have to completely redesign because there may be a **design flaw**. Identify and record your findings and thoughts about this flaw. Use the ideas that emerged as you worked through the process, especially the testing stage, to find the solution.

Once you have modified or redesigned, you must retest your design. See that what was redesigned has improved your original design. See also that all that was working before you re-designed continues to work as well. Depending on the design you work with, its efficiency will improve considerably as the whole solution comes together.

> **Key terms**
> **modification:** changes made to an original design
> **design flaw:** a problem with a design, model or prototype

All about improving your design

Modifying your product aims to improve the solution to a problem. Most of the problems that designers face are not completely new; solutions to these problems try to improve on previous designs. Improvements may occur at all stages of the design process.

Common ones include:

- coming up with a more innovative idea
- a more careful analysis of the problem, and reflecting this in the design brief
- using newer resources or using existing resources more efficiently
- applying new knowledge or technology to the process
- combining two or more existing solutions
- removing or replacing an idea or part of a design solution
- testing under improved standards for performance, for example more often, under greater stress where practical, using experienced designers in that area of design to test your design
- completing modifications based on results of testing
- re-testing
- getting feedback (see Stage 5) on your design
- making informed marketing decisions (see Stage 6).

Did you know?

Because of the many choices that designers need to make, no two designers will produce the same solution to any particular problem. And more than one design may become a quality solution to a particular problem. Quality is improved by returning to earlier stages to recheck and make adjustments while you work. Quality may also be improved by increasing the design efficiency of your solution (see Combining technologies and resources, on page 232).

Key term
production: *repetition of a design, usually for sale*

5. Presenting

Your presentation should consist of three parts. First is the actual design or prototype. Second is the written report, which includes the design brief, specification for the design, design drawings, results of testing, aims for modifying or redesigning, results of re-testing your modified design, and the expectations of the design to solve the problem. Also include your art journal with all the entries you made as you worked from brainstorming to re-testing. The third part is your oral presentation. Here you will get the opportunity to explain all that you thought and did, including the many decisions you had to make along the way. You will also answer questions about your design put to you by your client or audience. You are always encouraged to use multiple ways of recording and presenting your information. Still and motion photography, audio-taping, drawings, samples of materials used, and earlier models or prototypes that you modified should be presented.

Microsoft PowerPoint is a useful ICT tool for making a presentation. It is available on computers where Microsoft Office software is installed. **Create a PowerPoint presentation of five to ten slides to present an artwork or design arts idea of your own. Use your presentation to aid what you wish to explain as you present your artwork or design solution.**

6. Production and marketing

When your design has won the approval of your client or audience, it may have potential to be marketed. You may also have a part to play in getting other people and sponsors interested in supporting your design and its potential to aid human development. In this way the resources needed for **production** of the design are addressed. Very often, the client may take this responsibility and depend on you as the designer to work up to the design presentation stage of the process. However, an understanding of what goes into production on a larger scale and the marketing of the product you designed is useful for any designer. A good way to begin your understanding of the marketing process is to host an event such as an exhibition of your class work which you put on sale, or your integrated art project for which there is an admission fee. **Chapter 15** provides guidelines for this.

All about promotion and enterprise

As an artist, designer, inventor or innovator, you must expose your ideas, especially if you (and others) believe that your design solution can contribute to society and to human development. When you do so, your design, such as a painting, becomes a product or good. If what you did is a skill, such as your ability to make paintings, then it becomes a service you provide. Very often, other persons rely on the quality of what you produce (such as a painting) to decide whether they require your service (whether they will hire you as an artist).

Here are a few basic skills that you must be aware of to help the promotion of your product and initiate your **enterprise**. This happens after you have a quality product or solution.

a) **Plan the event**
 Determine what and how you wish to showcase your event.

b) **Organise the event**
 Identify and gather all the resources you need for the event. Many ideas are given in **Chapter 15**.

c) **Supervise the activities of the event**
 The project leader is responsible for co-ordinating the activities. Other membersmay be given responsibility for specific parts of the event, for example advertising, preparation of the venue or theprogramme. Each activity has to be implemented properly so that the entire project succeeds.

d) **Evaluate the event**
 This is done as you plan, while the event is in progress and after it has ended. Always record what you observe. Your observations and notes improve your experience as an entrepreneur.

Fig 14.6 The design process.

Chapter 14 | Introduction to Design Arts

All about living by design

Design exists all around us in the natural and the built environment. In the natural environment, landforms on the Earth's surface have been cut, carved, built up and shaped by natural forces. From these natural designs we have learned about our basic elements of art and the principles of art and design. Because of the success of the natural designs of the Earth's atmosphere, sea and land forms as well as plant, animal and the human form, we continue to borrow and apply them to our built or man-made environments.

In the built environment, our clothing, furniture, tools, buildings and vehicles depend on design ideas and raw materials from the natural environment that are combined by the power of the human mind and human potential. One skill of a designer is to make such links. Perhaps you can name a few products and link them to objects from the natural environment. **Comment on the shapes in Figure 14.7.**

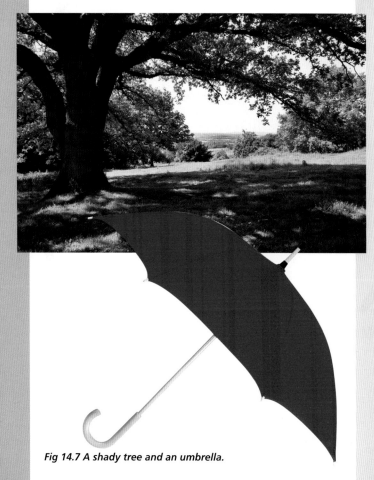

Fig 14.7 A shady tree and an umbrella.

Chapter summary

In this chapter you have learned to:

- trace the history and development of design and the design process
- understand and use resources and other inputs to design in the visual arts
- use key terms and knowledge to speak and write about the design arts process
- apply theory and skills from other chapters to complement your development in the design arts process.

Activities

Individual projects

1. Design a portfolio case to hold the following: ten completed drawings, a large drawing sketchpad, various drawing pencils, an eraser, a roll of masking tape and a hand towel. Your portfolio case should be waterproof, lightweight and flexible and should have a handle or shoulder strap. Present your case and discuss its design, then use it.

2. You have no space to organise and keep your growing amount of visual arts materials. Design a cabinet for the storage of your visual arts materials, supplies and completed two-dimensional artworks. Present the drawings to your teacher for discussion. Build and trial-test the design. Make any changes that are necessary. Install the cabinet in your home.

3. Use any set of found materials to design and create a piece of fashion jewellery based on a theme. Consider materials that are indigenous to your territory or community to make one of the following: a necklace, chain, pair of earrings, wristband or other suitable piece that your teacher approves. Select a model to show your piece and discuss how you applied the design process to create your design.

Group projects

4. Design a space to exhibit ten artworks. Five of the artworks are drawings or paintings that must be hung on walls. The other five are three-dimensional artworks. Three of these are to be placed on pedestals of varying heights and base area, one is free-standing and one must be suspended from the ceiling.

 When they are complete, visitors must be able to walk freely through the space to view the artworks. Carefully consider the sizes, location and stability of the artworks in the space, and visitors' access to them without toppling them. Also consider details of lighting, ventilation and the use of colour.

 The size of the artworks and pedestals are to be decided through your class discussion. You could use actual pieces of your own work.

 Present a written and oral explanation of the design of your exhibition space.

5. Identify a few designers you can visit. As a class, discuss and select one of these designers. Write to him or her requesting a guided tour of the workshop or studio and an informal interview to discuss a design he or she made or is presently working on.

 During your visit, use various means of recording information (refer to Stage 4 of 'Stages in conducting research' in **Chapter 16**) to identify the following:
 - the problem to be solved
 - the stages of the designer's process
 - the classes and types of resources required
 - how the design is tested
 - what results informed modification or redesign
 - the final product
 - your opinion about the designer's process and the final product.

 Discuss your findings in class.

Integrated projects

6. Discuss how the visual arts contribute to invention and innovation of the design process. Use the following topics to guide your discussion: drawing, the manipulation of materials, the use of tools and techniques, the process for design, and communication.

Art appreciation

7. Resources are found in our natural and our built environment. Very often, natural resources are used to create the built environment. Is it right to take natural resources to create our built environment? Discuss the consequences of using natural resources that are:
 a) renewable in the short term, for example water
 b) renewable, but not immediately, for example lumber
 c) non-renewable, for example petroleum or bauxite
 d) recyclable, for example glass.

 More activities for this chapter are included on the accompanying CD-ROM.

Chapter 15 | Visual Arts Integration

Fig 15.1 Trinidad and Tobago Carnival street parade.

Outcomes

After reading this chapter and practising its activities, you will be able to:

- define and explain key terms related to arts integration

- list, define and explain the types of integration applicable to the visual arts

- appreciate the need for integrated approaches to learning within the visual arts, across the visual and performing arts, and across all subject areas

- explore, design and develop ways for expression through visual and performing arts integration from the point of view of a visual arts student

- apply theory and skills from other chapters to complement your understanding of arts integration.

Resources

You will need:

- your notebook or art journal

- pencils, coloured pencils

- materials for your activity of choice

- computer with internet access

- school and public library access.

Introduction to integrated learning

In your school, because many subjects share common learning outcomes, they may be combined through **integration**. Integration enriches your understanding of how subjects relate to one another and to you. In the world outside school, learning and understanding of many subjects are combined to create solutions for the challenges we face each day. For instance, learning about nutrition in biology or physical education, calculating bills in maths, and budgeting in social studies or home economics combine to help you make informed choices about what is healthy and affordable for you to eat. The visual arts share many teaching and learning outcomes that may also be integrated and that prepare you for your future world outside school.

> **Key term**
> **integration:** the combination of various ideas, knowledge or practice to create a new idea or innovation

Levels of visual arts integration

The visual arts may be integrated at three levels. These are intra-disciplinary, cross-disciplinary, and inter-disciplinary integration.

Intra-disciplinary

Areas of the visual arts may be combined with other areas of the visual arts. Some examples of this **intra-disciplinary** learning include using your drawing skills to sketch for a painting, applying techniques in clay to construct three-dimensional art, combining graphic design ideas for printing, and making artworks with mixed media.

Also, skills such as cutting, folding and affixing are used across all areas. But most of all, the process for learning and creating is common, and is key to your success and versatility as a visual arts student.

This may seem obvious, but you must begin to intentionally make the connections among the content for all the chapters of this book. This will help develop good intra-disciplinary visual art-making habits.

You are therefore regularly encouraged to refer to other chapters while you are learning in any particular chapter. This helps you to integrate your learning.

Think of some ways in which you have combined concepts in one chapter of this book with concepts from another. Discuss how it is helpful to combine learning from one area of the visual arts with another. Here are some ideas for you to consider:

- Ideas: for brainstorming, sketching, designing, creating, reviewing and presenting.
- Elements of art: how are these used from chapter to chapter?
- Principles of art and design: how are these used throughout this book?
- Materials: what materials may be used in more than one area of the visual arts?
- Techniques and skills: manipulating, combining, stabilising and framing.

Key term
intra-disciplinary: learning within the areas of the visual arts

Cross-disciplinary

When concepts from the visual arts are used to support learning in other subject disciplines, **cross-disciplinary** integration is achieved. For example, maps help you to learn about your country in geography or social studies classes, while graphs and tables visually present information for all subjects.

At other times drawings and colour are used to effectively illustrate an idea or make quick notes in class, at the library and at home.

Other subject areas also help our understanding of the visual arts, for example the science of colour mixing, the history of painting or the mathematics of using proportion and scale.

Discuss how the visual arts are combined with other subjects to improve understanding in these other subject areas. Also discuss how learning from other subject areas assists your visual art-making.

Key terms

cross-disciplinary: learning across all subject areas

arts integration: the use of two or more of dance, drama, music and the visual arts to achieve shared outcomes in new and creative ways

inter-disciplinary: learning across related subject areas, such as the visual arts and performing arts

Inter-disciplinary

Inter-disciplinary integration, also called **arts integration,** joins learning in all of the arts areas to create exciting ways of learning. Dance, drama, music and the visual arts share common threads of understanding and help one another to achieve their goals. Drama and music may be used to create the mood for the presentation of an art exhibition. A theatrical production may be part of the opening of a visual arts exhibition that features artworks about Caribbean folklore. The characters in the paintings or sculpture may be highlighted through their on-stage presence. Another example is the use of appropriate costumes and stage sets to add to the effect of a music or dance concert or a drama production.

The remainder of this chapter will concentrate on the inter-disciplinary level of arts integration. You will use your knowledge as a visual arts student to integrate with dance, drama and music.

Name some ways in which you have already done this. What are some benefits of integrating learning this way?

Here are some ideas for you to consider:

- **Content:** the topics you do in separate subject areas are connected. This happens especially when you work in different subjects but on a common theme or project.

- **Illustrations:** how are maps, charts, tables, sketches, photographs and video useful for learning in other subjects?

- **Materials:** what materials may be used in other subject areas?

- **Techniques and skills:** in which other subject areas are skills of manipulating, combining and stabilising materials useful?

- **Process:** how does learning by following stages of a process help you to organise yourself to do your schoolwork? For example, brainstorming, creating ideas, selecting an idea, designing, making or using the idea, improving the idea after a trial, using the improved idea now and in the future.

What is visual and performing arts integration?

Arts integration involves the combination of two or more of the visual and performing arts (dance, drama, music, visual arts) to create new, greater or more interesting opportunities for teaching and learning. This is done because these subject areas share common philosophies, objectives, approaches and outcomes. It also happens because everyone learns better through a more varied and creative range of experiences at school.

Humankind has found quite a few ways of communicating. One main way is through the visual arts, as you have come to realise throughout this book. Other unique ways of communicating are through the performing arts of dance and drama. Together these are called the **theatre arts** and they communicate through the movement of the human body. Voice, action and posture send unique messages. **Music** also communicates in its own special way, using the human voice and various instruments to create sounds. Voice and sounds are combined in various ways to produce the melodies that we appreciate and enjoy.

Discuss possible ways in which we can use the visual arts to develop music and the theatre arts. Also discuss possible ways in which we can use music and theatre arts to develop the visual arts. How can activities based on a theme – for example, 'Caribbean people', 'The global environment', 'Climate change', or 'HIV/Aids awareness' – be promoted through the integration of the visual arts with music, dance or drama in your class and at your school?

Fig 15.2 Krosfayah in concert.

When we examine modern shows, exhibitions and performances, we often see a combination of the arts. Artist LeRoi Clarke creates unique visual art (see **Chapter 3**), but is also a remarkable poet. His poetry and storytelling often use ideas from his art. Carnival artist Peter Minshall (see **Chapter 3**) has successfully combined his costumes with dance, music and theatre to expand the boundaries of Carnival performance. Musical artists such as Buju Banton and band Krosfayah spice up their stage performances with visual, dance and dramatic elements. These successful visual artists, dancers, dramatists and musicians use their area of expertise along with elements of the other art forms to create new and appealing performances and presentations. **Name some other artists who combine these subject areas successfully.**

Key terms

theatre arts: human creativity that appeals to the human sense of movement; includes dance and drama

music: human creativity that appeals to the human sense of sound, made by voice, body or instrument

Models for arts integration

The visual arts may be integrated with the performing arts using varying levels of input from each of the areas. Depending on the type of activity and its objectives, the emphasis may be placed on the subject areas for learning, or on a topic, or a project. However, in selecting a model, the main criterion is its suitability to the outcomes of your activity. The models are presented in **Table 15.1**.

Table 15.1 Models to visual arts inter-disciplinary integration

Model	Description	Sample
Core	The visual arts become the central focus to achieve the outcomes of the activity, with the performing arts subjects offering a supporting role. The emphasis is on the visual arts.	Visual arts exhibition; Microsoft PowerPoint presentation; video-**montage**
Integrated core	The visual arts share focus equally with one or more of the performing arts in order to achieve the outcomes of the activity. The emphasis is on two or more of dance, drama, music and visual arts.	Storyboard or film; audio-montage
Thematic	A topic is identified, and the visual and performing arts are tailored to achieve the outcomes, for instance history, practices, awareness, value or impact. The emphasis is on aspects of the topic.	Religious or non-religious festivals; climate change
Project	A project is identified, and the visual and performing arts focus on achieving a major final outcome. The emphasis is on the outcome for the project.	A mural; an exhibition; a concert
Hybrid model	A combination model, using elements of any two or more of the four models above. The emphasis is on the creativity of the process. (This model is suggested only after experience with the others.)	Any activity

Discuss and list some other activities that are suitable to be used with each of the models discussed in Table 15.1.

Key terms

integrated arts activity: experience that uses visual and performing arts subjects for creative learning

montage: segments of recorded data (pictures, film, voice, music) selected and combined differently

Did you know?

An **integrated arts activity** depends on group work. In order for the project to succeed, the group must rely on the combined effort of all its members. This is achieved by building positive relationships among the group's members, who learn to display strong, open, clear and co-operative actions. Group work teaches you how to become a part of a social community, and prepares you for your future as a young adult in school and society.

Stages in the inter-disciplinary arts integration process

The arts integration process has 12 stages designed to help you present an integrated arts activity. You will complete researching, selecting what to create, brainstorming for ideas, selecting a final idea, selecting an approach to use, listing tasks and creating a timeline, completing your tasks, merging the parts of the activity, setting up or rehearsing, delivering the activity, making a journal entry and preparing for your next activity. Along the away, you will be exposed to many life skills that add even greater value to arts integration. These life skills are noted at the end of each stage in the process.

1. Research for arts integration

A good place to begin is to note which knowledge and skills from the subjects of dance, drama and music can be brought together with the visual arts to create an integrated arts activity. This will determine what resources are available and how they may be used. As a visual arts student, consider how you may combine your knowledge and skills from the performing arts with the visual arts.

You may wish to look at various forms of visual and performing arts activities on television, recorded video, in art exhibitions, museums and art galleries, live theatre, and various events in your community and at your school. When you do, focus on the role the visual arts play, and how aspects of the performing arts are used to produce a successful programme. You may need to look at a programme more than once. **Chapter 16** will guide your research further.

2. Select the theme or brief

The theme, project or brief identifying subject areas to use may be given to you or may be discussed and selected. Themes and projects are endless, usually based on cultural, religious, social and environmental issues, national and Caribbean heroes, and other current events.

Your theme or project should be relevant to your education and provide a clear message to your group and its audience. The subjects must be those you are exposed to. Whichever model you choose, it must also allow each member of your group to participate in tasks that work towards achieving and delivering outcomes through a process of participation and learning.

Helpful hint

In order to help your group to succeed and for you to get along positively with others, try to set up some ground rules for all to follow. Promise to allow each person to speak, to give an opinion; to be willing to listen; to be respectful of any opinion; to discuss ideas and opinions openly; to make honest decisions; and to accept the decisions of your group. Follow the rules first yourself as this is the best way to set the right example and learn leadership skills.

Key term

life skills: basic human skills that prepare us for life in a society; examples include listening, tolerance, caring, co-operation and decision-making

Life skill: Better understanding comes from awareness and information gained from finding out.

3. Brainstorm your ideas

You will find that there are many ways to go about getting ideas for your activity. Your group will need to meet to identify and discuss them. Bring along your ideas: jottings of your thoughts, a picture of an artwork, an excerpt from a play, a clip from a movie or a storybook can all spark creativity. As the members of your group come up with ideas, write each of them down. Do so even if an idea sounds quite simple, very challenging, funny or irrelevant. Select a member to take notes for each discussion you have for your activity. A good idea is to rotate this task among the members of your group.

Decide on a time after a meeting when the note taker will present a copy of the decisions that the group made to each member, so that the ideas and thinking continue afterwards. This makes everyone better prepared for your next group meeting.

4. Select your final idea

Reduce the ideas to about two or three. Discuss these so that the best one can be agreed on by your group. During your discussions, share your opinions, listen to the ideas of others and become a part of the decision-making. The final idea may or may not be your own. This should not be as important as negotiating the best possible idea for the **integrated arts activity**.

Identify, write and improve what you wish to achieve and the message you want to send. List the various tasks that are involved, discuss and assign members to perform them. Since your activity may be spread over a term, the quality of what you produce at the end will depend on the quality of what you do during the term, the idea you select and the individual tasks you must complete and combine to make your activity succeed. You will learn skills in decision-making and working towards achieving shared goals.

5. Select the model for arts integration

From the models for arts integration section and **Table 15.1** discussed above, consider which approach is most suitable for your activity. Consider what you wish to achieve, and all the resources you have available. Once again, this takes careful thought over some time to finalise. It is important to note that the goal of sending a meaningful message is much more important than selecting your model. You may actually find that you have combined aspects of more than one model of arts integration. This is indeed quite normal and is encouraged.

Life skill: There are many ways to view and interpret what you experience, see or feel.

Life skill: Listening to the ideas and opinions of others encourages them to listen to yours.

Life skill: Making a firm but fair decision benefits all in the end.

Key term
integrated arts activity: experience that uses visual and performing arts subjects for creative learning

6. List the tasks and create a timeline

Each integrated arts activity is made up of quite a few **tasks** which, when achieved, must be brought together to form the whole. The tasks vary from activity to activity. Begin by listing all the requirements for the activity: for example, the activity group's members, aims and objectives, budget, space, equipment, materials, and advertising strategies.

Write down all the tasks you can think of, then organise them under major headings. List the related tasks for each heading. If two headings share a task, decide where is better to organise for it: for instance, 'space' refers to the venue for delivery of the activity, but may also include an area for meetings, creating or practising for the project, the times the space is available, booking of the space, and lighting and sound for the space.

Note, too, how these tasks inter-relate: for instance, lighting and sound are also part of equipment and materials. Duplicating a task may increase the budget, misuses personnel and creates misunderstandings. Discuss and assign tasks to members of your group. If some tasks were accidentally forgotten at first and are identified at a later stage, try to accommodate them.

Give each person the opportunity to work to their strengths and also to learn new skills. Lead with your strengths and follow the strengths of others. As a visual arts student, try to focus on how your visual arts skills become useful to the activities and tasks for your activity. Always keep in mind the elements of art and the principles of art and design that you will need to employ to add visual creativity to the project.

Fig 15.3 Tasks for an Integrated Arts Project: art exhibition.

Life skill: Knowing what you do is guided by what others have done before, and adds to what will be done in the future.

Did you know?

Depending on the goals of your project, any of the integrated arts models (refer to **Table 15.1**) may be adapted to suit your theme. But give careful consideration to how the visual and performing arts can be best used. Sometimes a combination of the approaches suggested may work best. In reality, there is almost always some overlap of the models.

Key terms

task: single duty that contributes to the overall integrated arts activity

timeline: an illustration of events occurring in order over time

In any project a **timeline** for the tasks is necessary. The timeline ensures that each task is named and placed as part of a chain of events. The time needed to complete it is also determined. Tasks that depend on the completion of a previous task can be identified. Tasks that may be done at the same time as other tasks are also identified. Resources, especially the human resource (see **Chapter 14**) that is available, must be well distributed and managed.

Planning		Main activities	Supporting activities	Final preparations	Activity presentation
Wk. 1	Wk. 2	Wks. 3–6	Wk. 7	Wk. 8	Wk. 9
Brainsrorm ideas for activities	Decide on final activity	**Artworks** • create • select • frame	• mat/frame • number/title	• mount/assemble • adjustments	• art exhibition
		Venue • identify • confirm • use of space	• decor/lighting • sound system • book music/entertainment	• secure • check • confirm • speakers/addresses • rehearsals/meeting	• formal opening • viewing • entertainment/performance
		Funding • raise funds • seek sponsorship	• purchase supplies/resources for artworks • seek sponsorship • downpayments/bookings for lighting/music/sound	• refreshments • confirm	• awards/recognitions
		Promotion • invitees • invitations • catalogue • programme	• select • design/distribute • design	• front desk/information • ushers	• visitors' book • photo sessions • press

Fig 15.4
Timeline for Integrated Arts Project: art exhibition.

7. Complete the tasks

The project leader holds the responsibility for monitoring the achievement of each task in a timely manner so that the entire activity moves along smoothly. Allow time to review and confirm the success of each task.

Tasks may be given to an individual, small groups (four to six students) or larger groups. Sometimes you may be a part of more than one task at a time. Any task's success depends upon:

- ensuring that you are aware of the goal of that particular task
- ensuring that you play your part to achieve the task
- working with your strengths
- learning from the strengths of others
- learning from your mistakes
- doing the task in a timely manner
- the entire group being aware of your individual actions, your achievements and your challenges
- shifting resources to where they are needed
- praising and supporting each member of your group
- providing regular updates on what is done and what still has to be done
- knowing how that task contributes to the overall activity.

Life skill: Time management produces action and results, which build your self-esteem and your group's confidence in you.

Life skill: Whatever you do is always a part of a bigger plan. Learn to see each task as part of a greater whole and to prepare yourself for any unforeseen challenges.

8. Assimilate the completed tasks into the whole

As you work, tasks will be achieved and you will begin to see your activity take shape. Think of these separate parts as pieces of a jigsaw puzzle that have to be put into place. As they go together, everyone begins to get a better picture of what is happening. This happens because you see how all of the parts connect to form the whole. In this way, your focus and emphasis has to be both on the parts and on achieving the whole activity at the same time. The whole activity is always the most important consideration. When you understand this, you learn that limited resources may need to be shifted to ensure the greater good of the entire project. You also become aware that unforeseen circumstances may occur that require you to act differently than you had planned before.

9. Preparation, setting up, rehearsal

Once the parts come together, final preparations are required. Depending on the activity, this may include preparation of space and mounting of a display. For other projects, rehearsal of a live dramatic activity, dance routine or musical performance may be necessary.

Such preparation makes you aware of other concerns that you may not have seen when planning way back at the beginning of the project. It is always very exciting. Here are some concerns that you may need to become aware of: advertisements, storeroom and changing areas, presentation boards and props, lighting, tools and other equipment, accommodation, choreography, ushers, special guests, planned programme of activities, written programme or catalogue or brochure, sound system, refreshments, visitors' remarks book, photography and/or video recording.

Check to ensure that all is in place and working well. This includes:

- ensuring that everyone is involved in the overall activity
- checking that all the tasks are completed for project delivery
- troubleshooting your issues or tasks that are unresolved
- planning for unforeseen/overlooked issues or tasks
- gaining confidence in preparation for delivery of activity.

As you experience your own activity, ideas for improvement will come about. It is a good idea to make a note of these so that the next time around you will be better prepared.

> **Life skill:** Practice makes perfect.

> **Life skill:** Learn to enjoy and benefit from the fruits of your collective effort.

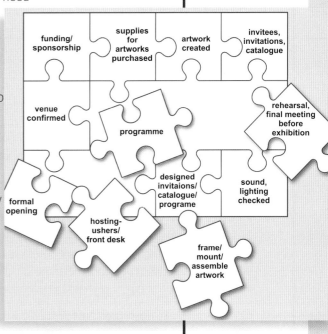

Fig 15.5 Combining the tasks to create the whole activity.

10. Project delivery

The opening day or presentation of your activity is an even more exciting and thrilling one. Everyone wants everything to go perfectly well. Since there will be people attending who were not there throughout your preparation, you may have some nerves of your own to calm. This is quite normal, as any artist will tell you.

Here are some key considerations for the actual activity delivery:

- begin on time
- share and use your own and your group's confidence
- observe and learn from everything around you
- meet people who are interested and supportive of your work
- learn to socialise
- accept compliments and other comments about your activity
- remain a dignified and polite student
- have lots of fun.

11. My art journal entry

Write an art journal entry about what you did and what you learned throughout your activity. This is best done as an ongoing exercise where short entries are made at regular intervals to reflect what you did step by step. Begin with what you researched in Stage 1 and end with your activity delivery. Reflect on the ideas you had and what decisions were made for the tasks you were involved in.

Because your activity was done in a group, each member will also write his or her own journal. From them your teacher will be able to know if ideas and project knowledge were shared and whether you were able to participate and co-operate successfully within your group. **Chapter 16** offers some more ideas for your art journal entry.

> **Life skill:** Thinking and writing about what you did records your experiences, thoughts and ideas for the future.

12. Prepare for your next integrated arts project

The best way to prepare for your next activity is to carefully reflect on the objectives, activities, roles and eventual outcome of this activity. Consider what was done, what the successes and failures were, and to what extent they impacted on its delivery.

As a group, have a **post-mortem** to revisit your plan of activities and re-examine how the resources were used and how this may be improved. Use your art journal entry to help you along.

The aim is never to repeat the process and activity exactly, and amazingly, no matter how many times you repeat the process, the outcome will always be different. This keeps things exciting, and although mistakes will be found and corrected, other new and creative ideas will always evolve. This tells you that you are learning.

> **Life skill:** Reviewing past actions prepares you for future ones.

> **Key term**
> **post-mortem:** meeting to reflect on your project in order to improve the next time around

Chapter summary

In this chapter you have learned to:

- explain and use terms associated with arts integration
- understand the need, ways and means for integrating the visual arts with the performing arts
- follow the stages for creating your own integrated arts activity
- become aware of life skills that may be gained from co-operative experiences
- apply your knowledge and understandings, as a visual arts student, to speak and write effectively about integrated arts.

Activities

Individual projects

1. Brainstorm your experiences throughout your school life. Identify two occasions when each of the following took place:

 a) intra-disciplinary visual arts learning

 b) inter-disciplinary visual and performing arts learning

 c) cross-disciplinary learning when aspects of the visual arts helped with other subjects areas.

 Discuss the benefits of each of (a), (b) and (c) for learning.

2. Make a list of ten possible ideas that you and your class can use for the basis of an integrated arts activity. Compare your list to your classmates' and compile a list of all the different possibilities.

3. Develop and write the details for an integrated arts activity that combines the visual arts with any one of dance, drama or music. Present your idea as a possible integrated arts activity. You may use one of the ideas that you listed in Activity 2 above.

Group projects

4. Record a project, production, festival, show or event that is an example of integrated arts.

 Use any two of the following media to do so: writing, still photography, video photography, audio-recording, drawing or model-building.

 Use your recording to aid your discussion about the contribution of the visual arts and performing arts to the programme you recorded.

 Each time you do an integrated art activity, you will have to go through this process

5. As a group, examine options from your work in Activity 2 above. Select one to produce an integrated arts activity. Follow the 12 steps outlined in the Stages in the integrated arts process to design, develop and present your activity.

 Use video to record as much of the planning, tasks, rehearsal or set-up and activity delivery as possible. Each time you do an integrated arts activity, you will have to go through this process.

6. As a group, view the video and other documented evidence from your previous integrated arts activity. Discuss and make comments about the activity at a post-mortem. Say what was intended and what was achieved. Suggest recommendations for improvement the next time around by responding to the question: If I had to do it all over, what would I (and we) do differently?

Art appreciation

7. The Caribbean is a region that is made up of many independent islands. As a class, discuss ways in which the opportunities provided for learning through the integrated arts may assist in preparing you for improving the integration among the various peoples of the Caribbean, and among the Caribbean territories in the future. Why is this need for integration important to us as Caribbean people?

 More activities for this chapter are included on the accompanying CD-ROM.

Chapter 16 | Research and Writing in the Visual Arts

Fig 16.1 Student conducting research at a public library.

Outcomes

After reading this chapter and practising its activities, you will be able to:

- define and explain the terms 'research' and 'writing' about art

- list, understand and follow the stages to conduct research and do writing about visual arts

- relate research and writing to visual arts as a subject area, artworks or artists

- research and write about ideas, processes and experiences in other chapters of this book

- apply approaches to research and strategies for writing to the visual arts.

Resources

You will need:

- notebook, art journal, notepad or cards for research/writing notes

- highlighters or coloured stickers

- materials suitable for project cover design

- computer with internet access, Microsoft Word software, printer

- school and public library access.

Part 1
Introduction to research

Research requires you to find out about something. When you do research in the visual arts, you try to observe and explore what someone has created or written. This helps you to:

- understand what, why and how that artist created visual art

- create visual art using similar understandings and skills

- improve the visual art you do

- experiment to create new ideas and ways for doing your own visual art.

Research may be conducted in the visual arts to find out about:

- all of the visual arts as a subject area and a contributor to human development

- a particular area of the visual arts, for example painting

- an artwork, collection of artworks or exhibition of artworks

- an artist, art educator, art critic or art curator

- an art gallery, museum or private collection

- how to research and write about the visual arts

- how to combine some or all of the ideas listed above.

252

Research for the visual arts as a subject discipline

In **Chapter 1** you learned that the discipline of the visual arts has contributed to our knowledge of humankind's early history and development. The visual arts promote learning when you observe artworks; use various materials and media; explore methods and approaches; and experiment and innovate.

Because of the wide range of philosophies, techniques, principles, elements, skills, styles and history in the visual arts, there is so much to choose to find out about. There are also many ways to go about doing so. You may find out about the visual arts by:

- creating visual art
- looking at artworks
- reading about the history of humankind and the history of art
- knowing about famous Caribbean and international artists and artworks over various time periods
- appreciating what the visual arts mean to Caribbean peoples and our culture
- responding by speaking and writing about all that you see, read, do and discuss.

> **Key term**
> **research:** to explore to find out about a topic

The questions below will help to guide you to conduct research into the visual arts as a subject discipline.

- What is visual art?
- What are the origins of the visual arts?
- How have the visual arts developed over time?
- How have the visual arts contributed to human development?
- Who are some well-respected international artists?
- How have the visual arts contributed to Caribbean development?
- Who are some well-respected Caribbean artists?
- Why are the visual arts important to the Caribbean?
- What areas make up the discipline of the visual arts?
- How are these areas related?
- What are the elements of art and the principles of art and design?
- How are the elements of art and the principles of art and design used to make visual art?
- What are the stages in the art-making process?
- Why is research important to the visual arts?
- What skills are involved in researching?
- How do I go about trying to improve as an art student?
- How can the visual arts help me to develop in other subjects that I do?

Discuss these in class from time to time with your teacher. The more you do so, the better you will get at it.

Researching Stage 1 of your art-making process

Throughout this book, you have learned to create artworks. **Chapters 4** to **13** encouraged you to learn to create artworks in a particular visual arts area using a process. A process is made up of stages. Each process began with Stage 1, which asked you to do research to find out about that particular area of the visual arts. This helps you to understand what, why and how visual art-making is done, and therefore makes your own art-making better. Because the visual arts communicate messages, knowing why and how these messages are made and how they are presented, seen and understood become important to you as the artist or the viewer.

To create good visual art, you must learn about the area of the visual arts you intend to use, for example drawing. **Can you name the ten areas of the visual arts?**

You learn about each visual arts area by:

- finding and looking at artworks in this book, other art texts, libraries, galleries and on the internet
- reading about artworks, artists, materials, tools and skills for art-making
- understanding the visual arts, the skills you used and developed in this book, your sense of creativity and your art-making
- discussing before, during and after: what you intend to do, what you are doing and what you have done
- creating, using the stages in the process for a particular area, presenting your work and doing another similar artwork
- appreciating what you, other art students or artists have done, and how to improve
- responding by speaking and writing about all that you have seen, read, used, created, discussed and improved.

Researching an artwork

Researching an artwork helps you to analyse the artwork. Try to find out the following:

- name of the artist(s)
- name of the artwork
- photographs of the artworks/artist(s)
- year it was created

- size (length, width, and depth for a three-dimensional work)
- location of the piece, for example the collection, museum or art gallery where it is housed or viewed
- media (materials used to create it)
- techniques and approaches, for instance how the paint was applied
- details about the artist(s)
- aim or intention of the artist and the artwork
- use of the elements of art and the principles of art and design in the artwork.

The following questions will guide you when you conduct research in Stage 1 of **Chapters 4** to **13**.

- What is this particular area of the visual arts about?
- Who are the well-known local, Caribbean and international artists working in this area of the visual arts?
- How do artworks in this area look?
- What do I find interesting about them?
- Are there any parts of these artworks that are confusing?
- What materials are required?
- What tools are needed?
- What skills must I use to create these artworks?
- What are the stages in the process for creating artworks in this area?
- Why is research important to the visual arts?
- What skills are involved in researching?
- How do I use the elements of art to help me create?
- How do I use the principles of art and design to help me create?
- What are common problems art students have in this area?
- How well did I create, and how can I improve the next time?
- What can I say about the entire process?
- What can I write about the entire process?

Now return to the stages for the process in your present chapter. However, you will find that as you continue you will return to this chapter as further research will be needed.

Researching a collection or exhibition of artworks

Collections or exhibitions of artworks provide the researcher with a wider range of artworks to look at. These may be created by the same artist or by various artists working on a similar theme. If the collection is the work of one artist, you get the opportunity to learn more about the development of the artist from one artwork to another, and see similarities and differences.

If the collection is based on a theme and several artists are exhibiting, then you may focus on how each artist interpreted the theme. A wonderful opportunity to compare the various artworks (choose two) should be taken. Include questions about each individual artwork from the list opposite, in addition to researching:

- the theme of the exhibition or collection
- details of the collection: time (permanent, temporary or travelling exhibition), overview of the collection (number of pieces, artists, etc.)
- selected artist(s) or artworks to analyse (name and say why you chose themes)
- photographs of the artist(s) and artworks
- details about the artist(s)
- an analysis of the selected artist(s) and artworks
- a comparison of the selected artist(s) and artworks.

Researching an artist

Research about an **artist** (or **art critic, art curator, art dealer, art educator**) is done to learn about the person and his or her contribution to the visual arts and to society. Here are some guidelines for your research:

- name of the artist
- career as an artist: years of work, when career began (and ended if retired or no longer alive), preferred materials and themes
- influences (from childhood, master artists, other artists, apprenticeships, later influences)
- education (primary, secondary, tertiary post-graduate)
- other art-related knowledge, careers, experiences
- other major accomplishments
- philosophy of art and art-making

- major artworks (and exhibitions, collections, commissions)
- artist's points of view on selected artworks
- photographs of the artist/artworks
- details of the selected artwork(s) (year, size, media, location, techniques and approach, aim or intention of the artwork)
- your analysis of the artist and his or her contribution to the visual arts and to society, relying on data collected above
- future plans/ directions for career and for the visual arts

Key terms

art artist: one who turns ideas into artworks

art critic: one who writes about or reviews artists and artworks

art curator: a manager or researcher at an art gallery or museum

art dealer: a promoter or seller of artworks

art educator: a teacher of art making, criticism, history and appreciation

Fig 16.2 Student interviewing an artist at his studio.

Stages in conducting research

The research process has six stages to help you along. You will learn to identify your topic, learn sources of information, carry out research, record your information, analyse the information, and learn how to use your information.

1. Identify your topic

The topics to research are listed under the heading 'Introduction to research' at the beginning of this chapter. Select one and follow the guidelines in 'Research for visual arts as a subject discipline', 'Researching Stage 1 of your art-making process', 'Researching for an artwork', 'Researching a collection or exhibition of artworks' or 'Researching an artist' to guide you.

2. Identify sources of information

A source is a place where you may find information about your topic. The main places to locate information include:

- artists, art educators, critics, curators and dealers
- exhibitions
- art galleries, museums, and private collections
- computer software and the internet
- libraries at school, in your community, at universities, national libraries and cultural archives
- professional associations: art groups and societies, art educators
- at home: newspapers, magazines, directories, catalogues
- your community: craftsmen, elders, peers
- Ministries of Education, Culture; Chambers of Trade
- businesses: local industries, art and craft shops, advertising agencies, marketing department, trade shows, fairs, expositions, exhibitions, promotions.

These sources can provide information in many media. Here are some media that you can access:

Face to face
A face-to-face interview gathers information directly from the source. You get detailed information from the person who is best able to give it, for example the artist himself or herself. Personal interviews should be supported by written questions or a checklist.

Printed
This includes any source of information that is written or printed, usually on paper. Books, magazines, journals, newspapers, letters, catalogues for art supplies, directories, brochures, flyers, posters, calendars, postcards, stickers, labels and business cards are good examples.

Electronic
This includes computers, the internet, CD-ROMs, VCDs and other disc formats, video and audio tapes, radio and television.

Visual
Visual media refers specifically to artworks that are made for viewing. Paintings, drawings, and sculpture all appeal primarily to our sense of sight in order to appreciate them fully. Line, shape, space, colour, value and texture all appeal to our sense of sight. Exhibitions, photographic collections of artworks, catalogues, journals and scrapbooks are examples of how they are presented.

3. Conduct research

Use the sources mentioned in Stage 2 to gather information for your research. If possible, use them to generate questions for a personal interview with the artist or someone who has expertise about the artist, artwork or topic you have selected.

Here are some instruments for collecting information from people when you meet with them.

Interview schedule

This is a set of questions that you intend to ask at a personal interview. Write your simpler questions first and lead up to others that require detailed explanation or reference to an artwork. For instance:

What is the name of this artwork?

What media did you use?

What is the theme for the artwork?

How do you use your media to express the theme?

Checklist

Items listed that you need information about. When you get the information, check off the item using a tick (√). **Figure 16.3** is an example:

As an art student, I got information about Caribbean art from:

(√) school library
() national library
(√) an artist
() art magazine
(√) my art teacher
(√) a text book

Fig 16.3 Checklist.

Questionnaire

A list of questions that relates to a topic. Provide space for the person to respond in writing. Simple questionnaires give 'yes' or 'no' responses. Others allow for more information. Your choice all depends on how much is necessary for your project. Here are two examples:

Is art important to you? Yes/No

I like art because _____

Likert scale

In the **Likert** scale a statement or question is presented. The person responds by selecting one of a few suggested answers. Usually all the statements or questions follow the same scale. For example:

I have conducted research in the visual arts before.
1 Strongly disagree
2 Disagree
3 Neither agree nor disagree
4 Agree
5 Strongly agree

I have done writing about the visual arts before.
1 Strongly disagree
2 Disagree
3 Neither agree nor disagree
4 Agree
5 Strongly agree

Did you know?

The best source of information is from the artist himself. When you interview or visit an artist, or view an artwork, the information you get comes from a primary source. When you get information from what someone else has written about the artist or artwork, you have used a secondary source. List and discuss some other sources as primary or secondary.

Key term

Likert: *a scale that rates answers*

4. Record your information

Be sure to document the research you do. Here are some suggestions for doing so. The more of these mentioned below that you use together, the better the information you gather.

Note-taking

As you speak to someone or view an artwork, use a notepad to jot down the things you hear or the ideas that come to mind. Maybe something is said that gives you a new idea or reminds you to research something else that relates to what you are doing. Always write the date, time and place where you are in your notepad.

Sketching or drawing

This is very useful if you wish to make reference to a particular detail in an artwork or design. Contour and gesture drawings (see **Chapter 4**) or details of joints or parts can be effectively described using drawing.

Collecting documents

Gather as many documents about the research as you can. These include written sources or excerpts from books, journals, diaries, magazines, brochures, catalogues, flyers or posters.

Audio-recording

A very useful tool is to playback what was said at an interview. This is helpful for writing out what was asked and said. Audio-recordings are also used to record your own thoughts and ideas while you visit an exhibition or view an artwork. Digital recordings may be transferred to a computer for listening, storage or electronic mailing.

Still photography

Useful for capturing multiple fixed shots of an artwork. Photographs give accurate details and angles for three-dimensional artworks in particular.

Motion photography

Video-recordings are capable of tracking the space in which artworks are viewed, for instance seeing all around a sculpture, or establishing the depth of the room in which an exhibit is housed. Motion photography also captures the essence of the encounter, for example the speaker's reaction to questions, the depth of thought and various emotions.

Reference writing

For each source of information you gather, list its reference immediately. These details can be quite easy to overlook. Refer to the heading 'Writing references' in Part 2 of this chapter to help you along.

Helpful hint

When you conduct an interview, you must be prepared. Basic tools include a notebook and pencils, but a digital voice recorder is a handy device to have. It gives you the ability to replay the conversation, and to copy it and share it with your teacher or class group. Always ask for permission from the person you interview before you audiotape or photograph. The main tool, however, is your checklist of questions. A total of 10 to 15 questions should be adequate and, if carefully thought out, can give very valuable information.

5. Analyse the information

Once you have gathered your information, it is time to separate and select what is useful. Remove what was repeated or less useful. Read and highlight information that is similar. Use a special colour highlighter or coloured stickers to identify information that is related. All related information will then appear in one particular colour. Place the information into general categories. For example, suitable categories for research for an artwork may include 'About the artist', 'Description of the artwork', 'Analysis: use of elements and principles' and 'My comments about the artwork'.

Next, compare the information in each category to select what you require. Pay close attention to the purpose of your research as you do this. Place what you select into a sensible sequence as you begin to write.

6. Use the information

Write and present your research. Part 2 of this chapter provides you with a guide to use as you do your writing. You will realise that your writing goes through stages of drafting and re-drafting in order to improve.

One part of your writing will require you to make an analysis of what you have viewed, heard or read. Always rely on the information you find to support what you say. The use of more than one source (from face-to-face, printed, electronic and visual information) helps your **findings, analysis** and **recommendations.**

Fig 16.4 A digital motion-photography camera.

Key terms

findings: necessary information you get from research

analysis: what you understand and can explain from your research

recommendations: reasonable suggestions you make, based on research

Part 2
Introduction to writing

Writing uses images and symbols to communicate a message. When you send a message by speaking or writing, the receiver must be able to understand it. How well it is understood determines the success of your message. As an art student, you will speak and write about the visual arts. The art student's **writing about art** will be of four main kinds: writing about an artwork, about an artist, for a journal entry and for references.

Introduction to writing about the visual arts

Writing about the visual arts is done to communicate our findings, thoughts, feelings, processes and skills about:

- the visual arts as a subject area and contributor to human development
- a particular area of the visual arts you are using to create your artwork, for example painting
- an artwork, collection of artworks, or exhibition of artworks
- an artist, art educator, art critic or art curator
- selected stages of your art-making process (from **Chapters 4** to **13**)
- how to research and write about the visual arts
- how to combine some or all of the ideas listed above.

Key term
writing about art: the expression (usually on paper or computer) of ideas, description, thoughts, feelings and analyses about art

Stages in the writing process

The writing process has ten stages. You will learn to select your topic, plan your writing, conduct your research, compile your research, write a draft, rewrite, finish the writing, proofread, make a journal entry and write again.

1. Select the topic

Choose to write about an artwork, an artist or making your art journal entry, or an area of the visual arts such as leathercraft. This topic may be given to you as an assignment, may be done as part of your student portfolio (**Chapter 17**) or may be carried out independently to record your experiences and improve your knowledge and ability to write.

2. Plan your writing

Planning to write is perhaps the most important step in your writing process. Guidelines are discussed in detail further into this chapter, under the headings:

- Writing about an artwork
- Writing about an artist
- Writing an art journal entry
- Writing references

3. Conduct your research

Guidelines for your research for the visual arts as a subject discipline, an artwork, an artist or for Stage 1 of any art-making process (**Chapters 4** to **13**) are suggested in Part 1 of this chapter. Go back and check to see that you have followed them.

4. Compile your information

Guidelines about where and how to find information, how to select what you want and how to categorise information have also been given in Part 1 of this chapter.

To learn how to write references for your information, refer to the topic 'Writing references' further into this chapter.

5. Write your draft

A draft is your first attempt at writing down your ideas. Make sure that what you say makes sense and that the information is placed in a simple and sensible order. Use headings from the categories you made when you organised your information to help you along.

6. Rewrite

A second draft is done to make corrections and to include useful information that may have been left out. Re-writing improves the quality of what you say and present. Throughout your drafting and re-writing, include and recheck the following:

- the topic you are writing about
- the information you have researched
- the quality, order and clarity of the information you select
- the location of quotations and pictures
- a **list of references** and a **glossary of terms**
- the use of standard English
- the presentation of your writing.

> ### Helpful hint
> Always read your draft while you write and after you write. You may find that errors are found, important information is missing or what you write is not as clear as you thought. As you read, too, look for the best places to insert quotations and pictures that support your writing. Allowing someone else to read your work gives the opportunity to identify things that you may miss and to provide new advice. But this person does not rewrite your work for you.

> ### Key terms
> **list of references:** written details of the sources of information you researched
>
> **glossary of terms:** list of key terms used in writing, with explanations

7. Complete the writing

Complete your writing by including the following:

- cover and cover design (all to be placed before the main content)
- title page with name of student(s)
- assignment detail page: title, date due, teacher's name, name of student(s) again
- table of contents
- list of references
- glossary of terms
- appendices (if any).

8. Proofread your writing

Put the writing together. A computer is the best place to do this because it allows you to see the sections of your writing page by page. You can do this with word-processing software such as Microsoft Word to create and edit your writing. Perform the following tasks:

- Set the language to standard UK English.
- Use the spelling and grammar functions to proof your writing. Make the changes that are required.
- Use the word count tool (if required).
- Insert page numbers.
- Add colour, perhaps one only, to the cover.
- Give your writing a final read and make any changes that are required.
- Name and save your writing as a Word document.
- Print. After printing, it is recommended that you always

 proofread again.

9. My art journal entry

Write your art journal entry. Refer to the heading 'Writing an art journal entry', found further into this chapter, to guide you.

10. Write again

Begin your next piece of writing about the visual arts. Use your experiences from this effort to improve your next one.

Did you know?

An appendix (pl. appendices) is a copy of a document placed after your writing. It is important to the reader because it was referred to in your writing. Some appendices you may choose to include are your interview schedule and questionnaire. Another may be a short document written about the same topic that you are researching. Your list of references and glossary of terms are placed before your appendices in the final paper.

1. Writing about an artwork

An important part of your learning about the visual arts is writing about artworks. When you view art, you arrive at an understanding of what the artist did. As with everything else in teaching and learning, and in life, try to get the complete understanding of what you view.

An artwork is the interpretation of a subject (topic or theme) using representations of persons, animals, objects, scenes, events or ideas.

Writing about an artwork brings together your understanding of the subject (topic or theme), the artist and the artwork itself that you can share with others.

Planning your writing

Your plan for an essay about visual art should follow the general structure outlined below:

1. A description of the artwork:

- an introduction to the artist
- title of the artwork
- when it was created (the year or a range of years)
- the media and materials used
- its size (in either two or three dimensions)
- name of its location (in a collection or a place such as a park)
- the subject of the artwork
- an image of the artwork (with reference).

2. An analysis of the artwork:

- the use of the elements of art (see **Chapter 1**)
- the use of the principles of art and design (see **Chapter 1**)
- the artist's approach to the work (interpretation, style and techniques)
- comparison with another artwork (perhaps by that artist, or another artist who has done work on the same subject).

3. A conclusion to your writing:

- your initial response to the entire artwork (what is most striking, and the emotions you feel – amusement, calm, confusion, disturbance, excitement, warmth, peace, etc.)

- contribution of the artwork to us as a society (what it shares, identifies with, teaches us, becomes a record of, etc.).

As your writing develops from essay to essay, you will be able to more creatively interweave the information you present in your writing about the artwork. This means you will be able to use your information in an order that is not necessarily the same as the order in which the points are made above. You will also be able to choose and add other pieces of information that you find interesting.

Sample essay: Analysis of an artwork

In this chapter , you learned about writing about an artwork. This writing allows you to express what you understand about an artwork you have seen. To do this well, you must bring together your understanding of the subject (topic or theme), the artist, the artwork itself and your understanding as the viewer to share with others who read what you write.

The plan for your writing should include the following three parts: a description, an analysis and a conclusion. Each of these parts contains some key bits of information which you must research to find out about, and which must be expressed in your writing.

> Present a clear picture of the artwork you are writing about before you begin your writing. This may be done on a separate page.

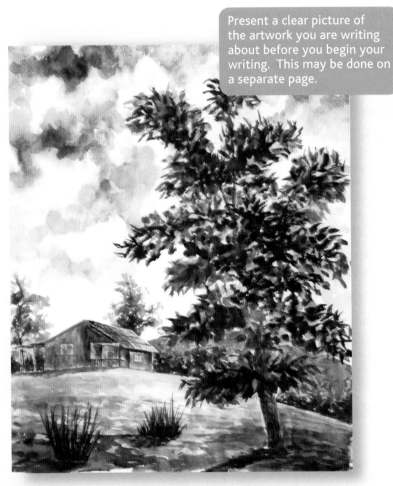

Allan Sieupersad. Evening Time. 1993. Watercolour on paper. 46 x 38 cm. Private Collection.

> Number the artwork, and place full reference for the artwork just below

> Introduction of the artist

Title of artwork

Artwork medium

Artist's name

Year artwork was made

Art key terms

Brief overview or selected facts about the artist

'Evening Time' is a **watercolour** painting done by artist **Allan Sieupersad in 1993**. Sieupersad is a Trinidad and Tobago artist and art teacher who has been painting since the 1980s. His earliest artworks were usually of **landscape themes** done in pencil, charcoal and watercolour. This shows his love for nature, which he often sketches and photographs on hiking and camping trips throughout the country.

> Beginning of the description of the artwork

Subject of the artwork

Art key terms

Physical description of the artwork. What you see

Art vocabulary

This painting shows a landscape scene of a **wooden house set on a gently rolling hill of Trinidad's Central Range**. In the **foreground** are a large tree and two patches of grass. There is an open space between this tree and the house in the **middle-ground**. The house appears old but well kept and comfortable. An open shed extends from the back of the house. Behind the house are two more large trees, low bushes and an outline of another hill in the **distance**.

The artist uses the **elements** of line, shape, space, colour and value in this painting. The lines vary in **curvature** and **direction**, and straighter lines are used to represent the house which is the only man-made object. The lines on the hill and the patches of grass guide the viewer's eyes to the house, the painting's **centre of interest**. The shapes vary in size, with most of the space occupied by the tree in the foreground and the sky behind as the **viewer** looks upward to the hill. Brown is the **dominant** colour but has been mixed with violet and green. The brown appears in a **range** of tones from soft puffs on the clouds to the **intense** darks of leaves in the shadow of the tree in the foreground.

The **principle** of balance is achieved through the division of the space with the tree on the left balanced by the patches of grass, the house and the trees in the background. The large tree also balances the space of the open sky. **Emphasis** is achieved in the large tree in the foreground by contrasting the values of colour that are used, and for the house by placing it all alone in the middle-ground and at the top of the hill. **Variation** is seen through the different shapes, their size and the **contrast** between the man-made house and the natural surroundings. The calmness of this picture adds to the **harmony** created by the scene.

The painting seems to **reflect** the **stillness** of the evening time as the sun sets. It is painted without any person or animal in it. The choice of a **monochromatic** palette of **earthy** browns with just a hint of green adds to this effect. I find that the painting is very calming and has a suitable title. The light seems to be **fading** as the sun sets in the distance. The lack of colour adds to this **effect**. The large space for the sky tells me that the house is on an open hill.

However, if I had to make a change, it would be to add some life, perhaps a farmer returning from the field with his dog. I think this painting is a good record of the way the countryside looks and is therefore a **representational** artwork.

Beginning of the analysis of the artwork (the elements of art)

Art key terms

Continuation of the analysis of the artwork (the principles of art & design)

Art key terms

Beginning of the conclusion of the essay

Mood or feeling created by viewing the artwork

Art vocabulary

Personal statement: a suggestion

Personal statement: an opinion

Benefit of artwork

Art key term

Points to note when writing

- Only the main (not all) elements of art have to be discussed

- Only the main (not all) principles of art and design have to be discussed

- Try to use 'key terms' introduced to you in this book

- A description of the artwork is presented in the first part of your essay

- An analysis of the artwork is presented in the middle of your essay

- Your opinion about the artwork is presented in the last part of your essay only

- There will always be many other things you can probably say about the artwork. Try to choose most important and explain as clearly as you can.

- As your writing develops from essay to essay, you will be able to more creatively interweave the information you present in your writing for the artwork.

- You will also be able to choose and add other pieces of information that you observe from the artwork and find interesting to write about.

Activities

1. Write your own essay about the artwork 'Evening Time'.

2. Select a two-dimensional artwork (such as a drawing, painting, print, textile design or graphic design) that was discussed in class. Write an essay about the artwork.

3. Select a three-dimensional artwork (such as a sculpture, assemblage, peice of pottery or decorative craft) that was discussed in class. Write an essay about the artwork.

4. Research to find an essay written about an artwork. Rewrite the essay adding points you consider important to improve the essay.

2. Writing about an artist

Another way to learn about the visual arts is to write about an artist. Think about how much you have learned about artists in this book. Writing helps you to trace the development of an artist over time and through their visual art. To better understand the artist and his or her art, you will need to find out about the artist's life history as an artist (their bio-data), to examine samples of artworks and to form a conclusion about the artist and his or her contributions.

Planning your writing

Your plan for an essay about a visual artist should follow the general structure outlined below:

a) The **bio-data** of the artist:

- an introduction to the artist
- name
- place of birth (city or town, country)
- details of career
- early influences
- education including art education
- philosophy of art
- years of experience and practice (as an artist and in art-related fields)
- exhibitions of artworks
- commissions
- collections of this artist's works.

Key term

bio-data (i.e. biographical data): personal information that tells us about the life of the artist

3. Writing an art journal entry

b) An art-biography of the artist:

- the career, retraced from the beginning of the artist's career to the present (or until retirement or death)
- the artist's overall approach to art (interpretation, style, techniques)
- periods and stages in the artist's career (changes in philosophy, approach to work, style, techniques, materials, etc. over time)
- samples from each period or stage.

c) An analysis of selected artworks:

- a brief description and brief analysis of selected artworks, perhaps one for each period or stage (or a complete analysis of one artwork).

d) A conclusion to your writing:

- the artist's contribution to society
- the significance of the body of artwork produced (what it shares, identifies with, teaches us, becomes a record of, etc.).

Again, as your writing develops, how you use the information you researched will become more creative.

In each of the **Chapters 4** to **13**, you are asked to write about your art-making process after you created your artwork. Here are some of the questions to consider:

- What were the steps involved?
- What did you research beforehand? Paste cut-outs of some pictures you gathered and write the reference for each.
- What materials, tools and equipment did you need, and how did you use them for your activities?
- What skills did you use? Which ones did you learn for the first time? Which ones did you get better at?
- How do you feel about that particular area of the visual arts and why? What did you enjoy about creating art using the techniques and skills involved in that area of the visual arts? What you did not enjoy?
- Where did the ideas for your art come from? What did you wish the piece of visual art to say to the viewer?
- How did you use the elements of art in your work?
- How did you use the principles of art and design in your work?
- What are some ways you can improve your work next time you make visual art in this area?

4. Writing references

A reference is a way to properly identify the property (words written or spoken, or an artwork) of another person. A reference is used in the visual arts to acknowledge the property of someone else that you have used in your speaking, writing, project or portfolio. You will need to do this when you speak or write about an artwork, artist or art exhibition or about an interview or a written text that you read.

Reference for an artwork

The reference for an artwork should include six pieces of information about the artwork in the following way: artist's name, name of the artwork, year it was created, materials or media used to make the artwork, size of the artwork, and collection and where it is exhibited. Some of these may be presented if others are not available, but you should try to get them all.

Here is an example for the painting used on page 37 of this book:

Allan Sieupersad. The Reader. 2001. Acrylic on paper. 50 cm x 36 cm. Attic Arts Collection, Trinidad & Tobago.

Here is an example for the sculpture used on page 6 of this book:

Palaeolithic. Venus of Willendorf. c. 24,000 years ago. Limestone. 11 cm tall. Naturhistorsches Museum, Austria.

Reference for a quotation

The reference for a statement includes the speaker's name, the interview type and the year the statement was made. This is required when a quotation made by a person is used in your writing. The quotation may be from an interview or from a written source. For example:

'All art is created by making, however the art of making is created through understanding and experimenting. The artist must therefore know first, then do and try in order to succeed.' (Sieupersad, A. Personal interview. 2002.)

Reference for a text

a) Within your writing

Each reference to a text must be accompanied by the author's name, the year of publication of the writing and the page on which the writing is located. Each publication used within your writing must also be placed in the list of references.

Here is an example for a book:
'The art student's writing about art will be of four main kinds: about an artwork, about an artist, for a journal entry and for references' (Sieupersad, 2009. p.260).

b) Writing a list of references

Each entry includes five pieces of information appearing in the following order: author's name, year of publication, title of the text, the place of publication and the publisher. The complete list of references is then placed in alphabetical order. Each text you use for information must appear in the list of references.

Here is an example for a book:
Sieupersad, A. (2009). Longman Visual Arts for Secondary Schools. London. Pearson Education.

Note carefully the use of punctuation marks within and after each of the parts of the references.

Did you know?
Printed books and other documents that are published contain an imprint page near the beginning. This page provides the information you will need for your reference for that book or document. Turn to the imprint page for this book and look for the author, year of publication, title, place of publication and the book's publisher.

Helpful hint
Always write a reference as a sure way of acknowledging the source(s) of information you have found in your research and used in your writing when you make or develop a point. This is important so that the writer of the information is known, and so that you do not claim to say something you did not actually write. If you do, then you are misusing the 'intellectual' property of another person. This is an illegal act called 'plagiarism'.

Key term
plagiarism: unlawful or unreferenced claim or use, or breach of copyright of writing

Chapter summary

In this chapter you have learned to:

- conduct research in the visual arts
- write about the visual arts
- explain and use terms associated with research and writing about the visual arts
- connect research to writing in the visual arts
- use knowledge and understandings from other chapters to aid research and create writing in the visual arts.

Activities

Individual projects

1. Research and select any five
 a) artworks
 b) visual arts books.
 Write the reference for each.

2. Discuss with your teacher and select one world artist (**Chapter 2**) and one Caribbean artist (**Chapter 3**) for each term. Conduct research to identify and find out about one artwork for each artist. Write a short essay discussing each artwork. Also write references for these artworks.

3. Complete a detailed art journal entry for any area of the visual arts you studied this term. Use the guidelines provided in this chapter to help you.

Group projects

4. Divide your class into four groups of students. Find a piece of written report or research about an artwork or an artist. A newspaper or magazine review may be a good source, but as you now know, there are many other sources. Examine the article to see whether it includes sufficient details. At a class discussion, suggest some other information that could be added. Identify any information that was not mentioned in this chapter but was included in the article because it was useful. Present a copy of the article with its reference as an appendix to this activity.

5. Research an artist, such as the author of this book, in your home territory who also writes about art or art education. Visit his or her library to learn about what he or she does and how. Conduct an interview to find out how these practices help the artist to better understand the visual arts, and how the artist uses them in his or her art and to write about or teach art.

Integrated

6. Identify, list and discuss as a class the ways in which research and writing about the visual arts are similar and different to research and writing for:
 a) the performing arts subjects (dance, drama, music) you do at school
 b) other subjects you do at school.

Art appreciation

7. Discuss how research and writing have helped you to learn, understand and improve as a student of the visual arts.

 Write an article (four paragraphs) about this for your school paper.

 More activities for this chapter are included on the accompanying CD-ROM.

Chapter 17 | Portfolio for the Visual Arts

Fig 17.1 Visual arts student portfolio.

Outcomes

After reading this chapter and practising its activities, you will be able to:

- define and explain what a visual arts portfolio is

- use your understandings to select a suitable portfolio

- list, understand and follow the process for creating your own visual arts student portfolio

- include experiences, activities and artworks from other chapters to build your portfolio

- critique a visual arts student portfolio, and its applications.

Resources

You will need:

- portfolio case

- notebook, art journal

- artworks and developmental works (drawings, designs, trials) based on the visual arts areas and topics planned for the duration of the portfolio

- stag blanc or other board, pencils, coloured pencils, ruler, set square or framing square, craft-knife, masking tape, mounting tape

- computer with internet access

- school and public library access.

Introduction to the visual arts student portfolio

A student **portfolio** is a collection of work that shows your performance and learning. It may consist of written or oral assignments for learning experiences in class, at home, on field trips or from research. The portfolio may be a combination of individual, small-group and large-group assignments or projects.

In the visual arts, portfolios are absolutely essential to your development as a student. As the visual arts comprise knowledge, skills and values about art-making, art history, art appreciation and art criticism, various activities and experiences that appeal mainly to the sense of sight are used to judge your work and track its improvement over time.

As you practise drawing, painting, pottery or any other visual arts area, improvement will be measured through your portfolio. This will not only be done for a topic or during a single term, but also for each school year and over all your years as a visual arts student.

> **Key term**
> **portfolio:** a collection of work based on a topic, subject or duration of study

Types of portfolios

Topic portfolio

This portfolio includes all the work you created based on a topic or theme. For instance, if you are doing graphic design, your research; pictures for ideas; idea sketches of your own; final design ideas with their combination of colour schemes, variation of style and size of fonts; and illustration ideas will make up your topic portfolio. The final graphic design artwork you present will be supported by your portfolio. The duration of this portfolio of work may vary from a few weeks to a term.

Special event portfolio

This portfolio may be based on a special occasion, such as your school's annual art exhibition, a cultural event, a national holiday or a special visitor to your school. The portfolio will contain your work from the initial ideas to the final artwork you present. A special event portfolio may also be presented as the work of a group.

Group portfolio

This portfolio is presented by a group of students. There are small groups of two to six students and larger groups of up to your entire class. Usually group portfolios represent the work for a project on a specially selected and planned event. An integrated art project (see **Chapter 15**) is an example of a large group portfolio. It is planned and presented over the course of a term. Each student has both individual and group tasks, and your portfolio must reflect these roles. Other group projects may take a shorter time to complete. The ones in the activity list at the end of each chapter are good examples.

Term portfolio

This portfolio records all the experiences you had and the effort you made during a given term of school. It usually includes a number of topics related to one another that are taught in sequence. In this way, learning in previous topics is applied to later ones. Term portfolios may include topic, special or group portfolios.

Annual portfolio

The annual portfolio is a compilation of three term portfolios. The experiences and efforts of an entire year are recorded. It provides you with a wonderful opportunity to review your achievements, comparing the previous year's portfolio to the current year's portfolio. It also allows you to compare an earlier term's work with that of a later term within one school year. This observation and comparison of how you did will identify what areas of the visual arts you need to place greater emphasis on. As the subject relies on your visual judgement, you will find that you can often see what you need to improve by simply looking over what you have done after some time. The next step is to take action to improve.

Lower secondary portfolio

This portfolio represents the sum of all that you have experienced as a student over the period of three years from Form 1 to Form 3. Through the review of your work over each term and annual portfolio, you will not only begin to see what and how to improve, but will begin to use expertise, creativity and experimentation in your work as you progress from year to year. This portfolio is a building block towards the later years of study in the visual arts.

Upper secondary portfolios

a) Forms 4 and 5

This is a specialist portfolio for the student who selects the visual arts as a Caribbean Examination Council *(CXC)*, Caribbean Secondary Examination *(CSEC®)*, (or equivalent Ordinary Level external examination). It requires the student to have sound ability from the three previous years of lower secondary study in the visual arts, and to be able to work independently.

b) Form 6

This is a specialised portfolio for the student who selects the visual arts as a *CXC* Caribbean Advanced Proficiency Examination *(CAPE)*, (or equivilent Advanced Level external examination). It requires the student to have sound ability from the five previous years of secondary study in the visual arts and to be able to work independently.

Portfolios at (a) and (b) above require evidence of practical work, in-depth studies, finished artworks, research projects, school-based assessments and journal writing over two years.

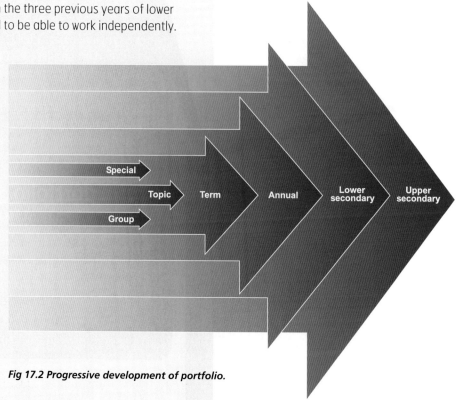

Fig 17.2 Progressive development of portfolio.

Purposes of an art portfolio

Here are some reasons why portfolios in the visual arts are important to you. Your art portfolio:

- records your experiences and effort over a topic, special assignment, a term, a year or a few years
- tracks your progress over time
- includes multiple avenues for effort and feedback
- promotes art appreciation, criticism and history to support your art-making
- allows for oral and written records of knowledge and opinion
- supports what you record in your art journal
- encourages self-assessment
- establishes groundwork for future study in the visual arts
- establishes groundwork for a future career in the visual arts.

Which of these reasons do you consider most valuable? Discuss each reason with your teacher to identify how your portfolio is able to achieve these goals. Perhaps you can add some other benefits of your own to this list.

Did you know?

Portfolios are continuously used in the visual arts. Your portfolio will grow as you develop as an art student. Later on in your school life, an art portfolio will be required to decide if the quality of your work is sufficient for you to move on to other stages in the study of the visual arts. And not too long after, it may be required to determine your place in the world of work. Even if you do not select a career in the visual arts, your portfolio will remain a great way of recalling your school activities.

Key term

entry: a single body of information used in a portfolio

Materials and ideas for the art student portfolio

Here are some possible **entries** from your practice that are used to create a portfolio.

- information and images you have researched
- developmental studies for artworks
- artworks created from activities and exercises
- further work you do on your own
- photographs
- sketches
- jottings for ideas
- art journal
- art notebook
- final artworks
- portfolio statement: thoughts on what you intended to do, what you did and what you learned.

Which of these entries do you consider most valuable? Why is it important to have a wide range of different entries in your portfolio? Discuss each entry with your teacher to identify how your portfolio may benefit from its use. Perhaps you can add some other possible entries to this list.

Stages in the compilation of an art student portfolio

Once you have completed the course of study, it is time to put your work together into a portfolio. To do this you must go through nine stages. You will compile the various pieces of your work, select the pieces to include, arrange your selected pieces, compile a glossary of terms based on the areas and topics you were exposed to, compile your list of references, create a cover design and other supporting designs, write your art student's statement and reflection, present your work and make an art journal entry about what you did.

1. Compile your pieces

Gather all the work you did during the time period of your portfolio. This will include all research notes and images; sketches and early drawings for your ideas; photographs of the work as you progressed; art journal containing entries about what you did and learned; and the final pieces you produced. It is always a good idea to keep these organised as you work, from the beginning.

2. Select your entries

The more work you did, the greater your chance of having a successful portfolio. If you barely completed your research and assignments, then your portfolio will no doubt appear barely complete. If, on the other hand, you have many pieces to choose from, then the quality of what you compile will be far greater and more satisfying.

Very often, your teacher will provide guidelines for what you include in your portfolio. You may have to include some compulsory pieces that all students must have; and there will be some optional pieces that you choose to include on your own. The compulsory pieces allow your teacher to judge your growth as an individual student and as a student in your class group. The optional pieces give the opportunity to judge what else you did, your initiative and further growth. The aim is to present pieces that show a wide range of the skills you learned and practised.

Along with the pieces you select, your art journal and class notebook also become key parts of any portfolio. This gives your teacher a more complete idea of your thoughts, process and the approach you took towards your work. Quite often the art student portfolio supports the final artworks you submit.

3. Arrange your entries

It is always wise to follow the stages in the art-making processes that you were learning about. Therefore the entries you make will include research; the idea development sketches and selection of a final idea; more detailed drawings or drawings to scale; the photographs taken and notes made as you worked; the actual artwork; and the art journal entries that reflect all that you experienced and learned.

4. Compile your glossary of terms

A **glossary of terms** (see **Chapter 16**) is a list of special words related to the visual arts area and body of work you met throughout the duration of the portfolio. The words are listed in alphabetical order and each is accompanied by its definition or supporting explanation.

You should begin compiling your glossary of terms from the beginning of the portfolio period and add new entries as you go along. Compare and review the definitions and explanation for each entry from time to time. In this way, your only remaining work at the end is to place them in alphabetical order. Each of the key terms used in this book is an entry for a glossary of terms.

> **Key term**
> **glossary of terms:** list of key terms used in writing

5. Compile your list of references

Your list of references (see **Chapter 16**) is a complete list of all the sources from which research and information was taken for your portfolio. References are used for books, other written documents, interviews, pictures of artworks you use or discuss, audio recordings, video recordings and internet website data that you use.

You should begin compiling your **list of references** (see **Chapter 16**) when you start your portfolio. As you continue to work, add new entries as you go along. In this way, your only remaining task at the end is to place the references in alphabetical order. A list of references is placed at the end of your portfolio.

6. Write your statement (or reflection)

Each piece of visual art you make is a result of a creative process. Your thoughts, ideas, influences, designs, drawings, materials, methods and techniques, and feelings are all involved in the work you produce. How you used them and the decisions you made along the way help you and others to understand how you create your art.

A **statement** tells the reader about what you set out to do and how throughout the period of learning covered by the portfolio. Your portfolio must therefore present evidence of what you say in your statement. It tells what skills you learned, practiced and developed throughout your experiences. Use your notes from your journal to guide what you write in your statement.

A statement is generally the last thing you write to include in your portfolio. However, it appears at the beginning to introduce your portfolio to the reader.

> **Key terms**
> **list of references:** written details of the sources of information you researched
> **statement (or reflection):** a supporting summary (about 2 paragraphs) of the learning experiences shown in the portfolio

7. Create a cover design (and supporting presentation designs)

Once you have compiled your portfolio, you may wish to design a suitable cover for it. The cover design should reflect the themes, styles, techniques and materials that you used throughout the portfolio. In this way, the cover itself will reveal what to expect inside your portfolio.

If you include supporting designs on pages within the portfolio, these should relate to your cover design. Be careful not to over-emphasise these so that they distract from the portfolio entries themselves. If they do, remove them altogether and use a cover design alone.

8. Present the portfolio

Your final portfolio is presented at the end of the work period, but very often your teacher will look at it as you work to ensure that you are progressing well. Your portfolio may form part of an exhibition of displayed work, or be submitted along with your art journal. Your teacher will use it as a guide to see how you developed your understanding and used your skills as you worked. An art student portfolio is usually made up of the following parts, appearing in sequence:

- cover design
- acknowledgements
- student's statement about contents/reflection
- table of contents
- final artworks (may be exhibited separately)
- sketches, studies and rough works for final artworks
- researches and written assignments
- list of references
- glossary of terms
- appendices.

When you present, your teacher may wish to discuss certain entries with you, or may ask you to explain what you did. Afterwards, be sure to keep your portfolio safe as it becomes a part of a larger on-going portfolio as you continue to do visual art.

9. Making an art journal entry

Make an art journal entry about how you went about compiling your portfolio, and what choices you had to make and why. Discuss whether the portfolio achieved what you intended it to and what you learned from your experiences and the questions asked and suggestions made by your teacher.

Creating a mat

Your completed two-dimensional artworks such as drawings, paintings, prints, graphic design, textiles and some decorative crafts may be finished with a mat.

Here is how to go about making a mat:

Step 1: Measure the width and height of the artwork, then extend both these measurements by 4 cm at each end. This will cause the width to increase by 8 cm and the height to increase by 8 cm.

Step 2: Transfer these measurements to the mat-board you are using. It is best to begin at a corner of the mat-board so that the mat will have one square corner of 90 degrees already made.

 Refer to the accompanying CD-ROM for tips on safety in the classroom.

Step 3: Ensure that the angle formed at each of the remaining three corners is exactly 90 degrees. Use a protractor, set square or framing square to do so.

Step 4: Carefully score and cut out this shape. Remove the excess mat-board.

Step 5: Measure in 5 cm from each edge of the shape you cut out and draw a smaller version of the original rectangular shape.

Step 6: Carefully score and cut out the new inner shape to produce a window in your mat-board. Take care to avoid cutting beyond the corners of your shape.

Step 7: Place your mat over the artwork and adjust the window to centre the artwork. Carefully hold the two upper corners of your mat together with the artwork; lift and turn over to lay flat. Use masking tape to affix the back of the artwork to the back of your mat.

Step 8: Mounting tape, a type of double-sided adhesive tape, may now be used to hold your artwork to the wall. Always place the mounting tape on the back of the mat-board, and not on the artwork itself.

Figure 17.3 shows a painting matted in blue spray painted stag blanc. Suggest a reason why blue colour was selected.

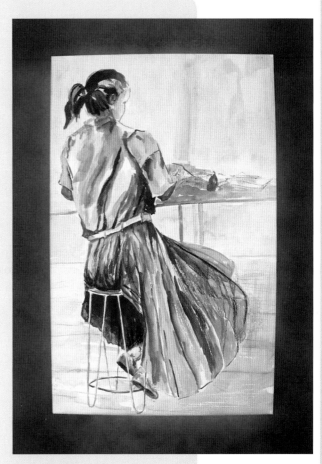

Fig 17.3 The Author. The Art Student. 1997. Watercolour on paper. 45 x 30 cm. Attic Arts.

Helpful hint

You may vary the recommended area of the mat you cut from 4 cm (in Step 1 above) to 7 or 8 cm. This is suggested for larger artworks, to support artworks made from heavier material, or to occupy a larger display space. The width of the border you create (in Step 5) may also be varied from 5 cm to about 8 cm. A wider border is usually used for artworks done on heavier material, while a smaller window focuses attention to a smaller area of the artwork.

Did you know?

A popular material for making your mats is stag blanc. This board is very sturdy. Even when the window is cut out, it does not warp. It is also available in large sheets and various grades of thickness. It is recommended that larger artworks should be matted with heavier grades of stag blanc. Stag blanc is flat white in colour, offering the best window to draw our eyes into the work, but it may be spray-painted in any other colour.

Digital/e-portfolios

A digital portfolio is simply one that contains digitally recorded data. It can be made and stored on a computer. Digital portfolios are becoming popular because they are supported by today's technology: the computer, digital audio-tape, still and motion photography cameras, scanners and storage devices such as CDs (compact discs) and flash drives.

Digital portfolios are also convenient because they can be submitted via e-mail. This saves the time it would take your portfolio to get to its destination. Another advantage is that digital portfolios can be edited, corrected, reduced or extended without you having to redo the entire document. Yet another advantage is that many copies of the portfolio may be made, so you are never without your portfolio even after it has been submitted.

Creating a digital/e-portfolio

The contents of an e-portfolio include artworks you make and supporting writing or references for each artwork. Artworks can be photographed using a digital camera – or, where possible, scanned – and saved. These images can then be copied and pasted into word processing documents containing your writing.

A good practice is to present each artwork on a separate page, checking that the reference is complete and contains the title of each artwork, the year it was created, the medium used to make it, its size and, if needed, its collection.

The artworks may also be presented as a Microsoft PowerPoint slide show which can automatically move from one slide (artwork) to the next.

Developing a digital portfolio

To make your own digital portfolio, you can follow these simple steps:

- photograph your artworks using a digital camera, or scan them using a scanner
- save the images, each as a separate picture document on your computer
- open a new Microsoft Word document
- create the separate headings for your portfolio (see Stage 8 for compiling your portfolio)
- type in your information
- proofread and edit it
- copy and paste your pictures of artworks into your Word document
- type in the artwork names and reference them
- save your portfolio document.

Your portfolio is now ready to be copied to a CD or flash drive or to be attached as a file for export to someone's e-mail address.

Remember to work on parts of this from the time you start your work, so not too much is left to complete at the end.

Fig 17.4 Student preparing her porfolio at home.

Chapter summary

In this chapter you have learned to:

- identify different types of art portfolios
- explain and use terms associated with an art portfolio
- follow the stages for producing your own art portfolio
- make a mat
- apply your knowledge and understandings to speak and write effectively about art portfolios
- use ideas to develop a digital/e-portfolio.

Activities

Individual projects

1. a) Discuss the ways in which your art student portfolio can assist your learning and achievement in the visual arts.

 b) Examine the careers that are related to the visual arts (see Figure 17.5). Select one, and discuss the possible parts of a portfolio you will present as an applicant for this career. Use the headings under Stages in the development of an 'art student portfolio' to guide your choices.

2. Create a topic or term portfolio for the work you have done in your visual arts class for this term.

3. Create an annual portfolio for the work you have done in your visual arts class for this year.

Group projects

4. Produce a portfolio for a small group (two to six students) project that you were a part of.

5. Produce a portfolio for a large group (seven to full class) project that you were a part of.

Integrated

6. Produce a portfolio for an integrated arts project that you did at your school.

Art appreciation

7. Write an essay about how your lower secondary or upper secondary art student portfolio may be of benefit to you as an art student or a visual artist or in a visual arts-related career in the future.

Fig 7.5 Visual art related careers. Adapted from Workshop for Visual Arts teachers for the Ministry of Education, Trinidad & Tobago, presented by the Author.

Visual Arts career mind map with the following branches: Potter, Painter, Sculptor, Still, Motion, VAPA integration, Producer, Fashion designer, Artist, Photographer, Choreographer, Art teacher, Designer, Stage/set, Costume, Fashion, Engraver, Print maker, Leather craftsman, Map maker, Calligrapher, Graphic designer, Architect, Art critic, Sign painter, Graphic artist, Illustrator, Interior designer, Interior designer, Interior decorator, Builder/joiner, Draftsman, Engineer, Art writer.

More activities for this chapter are included on the accompanying CD-ROM.

Glossary

Abstract art: artworks that require interpretation – their meaning is not at once clear as the artworks do not resemble any subject or object and often rely on the expressive use of line, shape, form, space, colour and texture

aerial perspective: the illusion of depth created by manipulating the effect of light

aesthetic function: used with the purpose of beautifying, such as a picture hung on a wall

analysis: what you understand and can explain from your research

anthropomorphic: giving human features or qualities to gods, plants or animals

applicators: any instruments or tools used for placing and spreading pigment on a surface

appliqué: a textile decorated with cut-outs of textile or other material

architecture: the design and use of space for living. It is a form of visual art

armature: skeletal frame created to support the body of the artwork. It is used from within, and it is usually not seen when the artwork is complete

art appreciation: level of understanding of an artwork

art critic: one who writes about or reviews artists and artworks

art criticism: speaks about artworks and how the elements of art and principles of art and design are used to make them

art curator: a manager or researcher at an art gallery or museum

art dealer: a promoter or seller of artworks

art educator: a teacher of art-making, art criticism, art history and art appreciation

art history: record of all that contributes to the making of an artwork

art-making: use of your imagination, techniques and skills, tools and materials to produce artwork

Art Nouveau: late 19th-century art movement featuring flowing lines derived from plant life and female forms in art and architecture

artist: one who turns ideas into artworks

artistic inspiration: reasons and experiences that encourage art-making

artistic style: characteristics that help to identify the art of a civilisation, time period, group of artists or an artist

arts integration: the use of two or more of dance, drama, music and the visual arts to achieve shared outcomes in new and creative ways

assemblage: three-dimensional artwork made up of other objects or parts of objects

awareness in art: message of an artwork

background: in an artwork, the area that appears farthest away from the viewer

basketry: the art of weaving materials into baskets and other containers

bevel: a cut at an angle (usually 45 degrees) to join pieces of materials or to finish an edge

bio-data (i.e. biographical data): personal information that tells us about the life of the artist

bouzaille: technique using soot images for ideas to begin a painting

brainstorming: developing possible ideas to solve a problem

build body: thicken paint to a paste

calligraphy: the art of creative and skilful handwriting

Caribbean art: all visual arts that are created by any artist who has a Caribbean heritage

caricature: a drawing with exaggerated personal features of the subject

cartoon: a drawing, often found in newspapers and magazines, symbolising an action, subject or person

cassone: a decorative chest

cast: to pour liquid material into a mould to solidify into a finished artwork

centre of interest: main aspect or point of focus in an artwork; the most appealing part of an artwork

ceramics: clay artworks that have been fired

ceramist: one who makes fired artworks from clay

charcoal: burnt wooden sticks used for drawing

collage: a picture made by combining and sticking down pieces of materials, usually paper or textile

collection: a group of artworks gathered over time

colour: light reflected from an object

colour wheel: a chart that represents colours and their relationships to one another

comic strip: a series of cartoons with words, used to tell a story

commissioned work: artwork requested of an artist, for which he or she is paid

communication: the transfer, understanding, response and use of a message

composition: arrangement of objects in an artwork

contour line: a line that creates an outline of a person or object

contrast: the degree of variation of pencil tone (or paint colour) on an object (or entire artwork)

creativity: our mental ability to combine, connect or develop new ideas

criteria for evaluation: the extent to which characteristics of the design solve the problem

cross-disciplinary: learning across all subject areas

cross-hatching: the use of two sets of hatching lines, one set drawn across the other, to render darker value

cuneiform: early from of writing in symbols, marked with a stylus

deboss: to decorate with parts removed from or sunken into a surface; see also embossing

decorative art: the application of fine art finishes to embellish artworks or other surfaces

decorative craft: the creation or embellishment of an object using materials or other objects

design: the ideas used to create a solution to a problem design brief: a written statement of the problem and proposal for its design solution

design flaw: a problem with a design, model or prototype

design process: the stages to follow to solve a problem

detail: small but eye-catching part of an artwork. More details may appear at the centre of interest

diluted colour: colour that has a solvent added; thinned paint

discarded objects: previously disposed-of objects reused to make art or craft

drawing: the representation of an object or idea using line

drawing board: flat surface on which paper for drawing (or painting) is fixed

dye bath: vessel for immersing textile for dyeing

dyeing: the process of adding colour to a textile

edition: a series of images printed from the same block

efficient design: one that achieves its purpose with fewer resources

elements of art: basic tools artists use to create an artwork

embellishing: decorating an artwork

embossing: decorating with parts added to a surface, or parts raised from a surface; see also deboss

embroidery: decorative needlework usually done on textiles

emotion: mood or feeling gained from an artwork

engraving: artwork incised or cut into a surface

enlargement: increase in size, using a scale

enterprise: a business that markets you or your product (as a good or service)

entry: a single body of information used in a portfolio

exaggerated form: part of artworks created larger than their true relative size

experimental art: artworks that use ideas and materials in non-traditional combinations. Such art helps to 'invent' new art and new ways of thinking about art

façade: decorated front face of a building

fibre: material produced in lengths or strands; fibres are used for weaving

fibre arts: use of natural or man-made threads to produce artworks

findings: necessary information you get from research

finishing: smoothening or application of decorative elements to an artwork

fire: expose of clay to enough heat to change it to a permanent hardened state

flat shape: two-dimensional shape, without depth or thickness

font: letter type or style

foreground: in an artwork, the area that appears closest to the viewer

form: (1) space occupied by a three-dimensional artwork; (2) the appearance of your artwork or design

found objects: naturally occurring objects reused to make art or craft

frames: skeletal supports for artworks

fresco: painting done on wet plaster

function: the main purpose of an artwork or design

function of art: the reasons for making visual art

functional value: serving some practical purpose

fusible web: adhesive for textiles, placed between layers then ironed to join

geometric form: three-dimensional artwork with mainly flat surfaces and easily identified edges and corners

gesture drawing: a drawing that captures one position from a set of positions

glaze: coating used to seal or decorate a ceramic piece

glossary of terms: list of key terms used in writing, with explanations

gold leaf: gold beaten into thin sheets that fold like paper

graffiti art: spray-painted or scrawled images and letters, usually done on the street and in other public spaces

graphic design: a combination of lettering (words) and images (pictures) to communicate a message (information)

grid: a space, usually sub-divided into squares, used to enlarge or reduce an image

hatching: the use of a series of lines in a near-parallel direction to render value; see also cross-hatching

hides: skins of larger animals

hieroglyphics: picture writing

highlights: unpainted areas of paper, used to indicate strong light

horizon line: where the land or horizontal plane seems to meet the sky or vertical plane in the distance

Hosay: Islamic festival enacting a story from the Holy Koran in artwork

hue: a pure colour

human development: ideas, inventions and practices that make living easier and more productive

illuminated manuscripts: handwritten texts decorated with pictures, borders and fanciful first letters. They are an early form of graphic design

illusion of depth: suggestion of depth or distance on a flat surface

illustration: an artwork inserted in written text to explain or beautify

image: a reproduction made from printing

impression: the design transferred from one surface to another in printing

in-the-round: a three-dimensional form, made to be viewed from all angles

incised block: a design or pattern cut into a surface used for printing

indigenous: naturally occurring materials available locally

innovation: the improvement of an existing idea or product

installation art: an artwork assembled to fill a three-dimensional space; usually a large-scale assemblage occupying a space that allows the viewer to move through it. It may or may not be permanently displayed and, unlike other artworks, it is not collectable

integrated arts activity: experience that uses visual and performing arts subjects for creative learning

integration: the combination of various ideas, knowledge or practice to create a new idea or innovation

intensity: brightness or dullness of a hue

inter-disciplinary: learning across related subject areas, such as the visual and performing arts

intra-disciplinary: learning within the areas of the visual arts

invention: the creation of a new idea or product

kilns: ovens for baking clay

landscape orientation: frame that is wider than it is high

leather: preserved animal skin or hide

leathercraft: art of manipulating leather to make artworks or products.

life skills: basic human skills that prepare us for life in a society; examples include listening, tolerance, caring, co-operation and decision-making

Likert: a scale that rates answers

line: a point in motion

linear: referring to a length, measured with a rule or tape measure

linear perspective: the illusion of depth created by manipulating the size of objects

list of references: written details of the sources of information you researched

lithograph: a printing technique

lithographer: maker of lithograph prints

loom: machine for weaving threads into fabric (textile)

mas (masquerade): Caribbean carnival street parade with costumes

mat: a frame or border for a two-dimensional artwork, usually made from heavy paper or board

middle-ground: in an artwork, the area between the foreground and the background. The middle-ground traditionally carries the main focus of interest for a composition

mixed media: the combination of various materials and media to create an artwork

model: an object or design smaller in size than the actual

modification: changes made to an original design

mono-printing: printing process that can produce only one image

monumental art: large-scale artworks, most often architecture or structures in stone, usually designed and built to last

mood: feeling created from viewing an artwork

mosaic: a picture formed by setting small pieces or fragments of a solid material

motifs: the main elements or repeated symbols in an artwork

mural: large painting done on a wall or ceiling

music: human creativity that appeals to the human sense of sound, made by voice, body or instrument

Naïve art: Haitian art style characterised by its lack of formal western composition and perspective

negative space: area occupied by a shape not set out to be represented, or the space around a positive space

net: arrangement of the flat shapes that make up a solid form

non-representational art: artworks that do not show a distinct likeness to their subject; see also representational art

object: a single item used as the subject for an artwork

off-centre: the position of an object near, but not precisely at, the middle of a surface

orientation: the position of your paper; see also portrait orientation, landscape orientation

orthographic projection: drawings that shows the viewer multiple points of view of a single object, including the 'front', 'end' and 'plan' of the object

painting: the use of colour to express ideas or represent objects

painting technique: a method for applying paint to a surface

palette: surface for mixing paint

panel: flat wood used for oil painting before the use of canvas

papier mâché: material made from paper pulp or paper squares, used in the construction of three-dimensional artworks

perspective: the illusion of depth in a two-dimensional artwork; see also aerial perspective, linear perspective

Phagua (or Holi): Hindu festival welcoming Spring

pictograph: pictures representing ideas

pigment: a substance that transfers its colour to a surface

plagiarism: unlawful or unreferenced claim or use, or breach of copyright of writing

plaster of Paris: material used to make casts and moulds for artworks

plasticity: level of moisture present in clay

plate: printing block made from metal

plein-air: landscape paintings done outdoors and on location rather than in a studio

plexiglas: a plastic-like transparent material, available in sheets

points of view: different positions from which an object or artwork is seen

portfolio: a collection of work based on a topic, subject or duration of study

portrait orientation: frame that is higher than it is wide

positive space: area occupied by a shape set out to be represented; see also negative space

post-mortem: meeting to reflect on your project in order to improve the next time around

potter's wheel: device used to turn the clay as the hands form the pottery

pottery: vessels made from clay; the creation of such vessels

Pre-Columbian art: visual art of the 'New World' made before the arrival of Christopher Columbus

principles of art and design: the organisational tools of an artwork

printing: the transfer of an image from one surface to another

problem: a situation that requires a design solution

process: a sequence of steps or stages for achieving an outcome

product: a solution to a problem; the output of the design process

production: repetition of a design, usually for sale

proportion: measurements relative to other measurements

prototype: an experimental design, usually of a machine

real (tactile) texture: the actual feel of a surface

recommendations: reasonable suggestions you make, based on research

reduction: decrease in size, using a scale

reduction method: the cutting away of parts of the block after the registration of a colour, but before printing the next colour.

references: see list of references

registration: the quality of the impression of the printed image (page 109)

relief: a sculpted form projecting from a surface

relief print: an artwork created from an elevated surface used for printing

religious art: visual artworks based on religion and religious beliefs and practices

representational art: artworks that show a clear likeness to their subject; artworks that are intended to represent reality; see also non-representational art

research: to explore to find out about a topic

resource: an input for the design process, required to achieve an output

retard: slow down the drying of paint

rhythm: repeated movement created within an artwork

ritual: common method or practice developed and used by an artist over time

rivet: soft metal link for fastening materials

Rococo: 17th-century artistic style, characterised by lighter materials and elements of art used in decoration

scale: the relative size used to represent an object (such as a country, person, bottle) on another surface (for example, a map, three-dimensional model, billboard or sketchpad)

score: (1) in pottery and ceramics, rough marks made to better hold surfaces to be joined; (2) when cutting through a surface such as leather, the mark that the cutter initially makes to guide the direction of the blade along and into the surface

sculpture: artworks carved, cast or built up into three dimensions

series: a group of related artworks

shade: a colour formed by adding black to a hue

shape: the outline formed when a line returns to its point of origin without crossing itself

sketch: a drawing that gives limited but important details of a composition, used for a painting or other application

skins: pelts or coats of smaller animals or the young of larger animals

slip: liquid clay; also known as engobe

slurry: thick liquid clay

solid shape: three-dimensional shape, with depth or thickness

specification: expectation of the design solution

spectrum: the range of colours we are able to see

squeegee: tool with a rubber blade that spreads and pushes ink

stained glass art: coloured glass pieces set to make pictures

stela (pl. stelae): a sculpted stone or wooden slab exhibited upright

studies: preliminary drawings or paintings to develop a final artwork

stylus: ancient instrument, pointed for writing on clay

superimpose: to place one drawing or artwork over another so that both are seen

surface design: designs and decorative elements applied to textiles

symbolic: containing meaning apart from what is actually seen

symmetry: arrangement and balance of parts

tablet: solid flattened surface for an artwork

tannery: factory for processing skins into leather

tanning: process for preserving animal skin to make leather

tapestries: woven textile artworks designed to hang

task: single duty that contributes to the overall integrated arts activity

technology: any device that makes an output easier to achieve

tempera: oil paint mixed with egg and water

terracotta: fired clay, usually reddish-brown in colour

tessellation: repeated use of a basic shape to create a pattern or artwork

text: written information (words) in a graphic design

textile: fabric made up of interwoven threads

texture: how a surface feels or appears to feel; see also real (tactile) texture, visual (apparent) texture

theatre arts: human creativity that appeals to the human sense of movement; includes dance and drama.

theme: a general idea used to create an artwork or group of artworks

three-dimensional art: artworks that occupy space, having length, width, and height or depth

tile grout: coloured cement mixed with sand

timeline: an illustration of events occurring in order over time

tint: a colour formed by adding white to a hue

tjanting: tool used to apply wax to a batik design

translucent: a material that allows some light to pass through

utilitarian: used for a practical purpose, such as a clay pot for storing water or food

value: variation of light and dark on an object

Velcro: a fastener with hooks and loops that sticks and unsticks

vertex (pl. vertices): the meeting point of three or more edges of a solid shape

viewfinder: a window cut-out used to select a composition for a drawing or painting

visitors' book: book provided for viewers to place comments in about artwork they see

visual (apparent) texture: the representation of the 'feel' of a surface

visual arts: human creativity that appeals to our sense of sight

visual communication: a message presented through signs, symbols or images; also the message that a visual artwork sends

visual culture: overall presence, impact and dependence on images in our everyday lives

warp: vertical strands of fibre used in weaving; see also weft

wash: a layer of fluid paint

water-based paint: paint that dilutes in water

wax: an oily, plastic-like, waterproof substance produced by bees

weaving: interlacing strands of fibre to create a mat

wedging: the removal of impurities and air pockets from clay

weft: horizontal strands of fibre used in weaving; see also warp

weight: darkness or lightness of the lines of a drawing

whittle: to carve, chip or cut away solid material to create a three-dimensional artwork

woodcut: printing block made from wood.

world art: all visual art that has been created throughout the world from prehistory to the present

writing about art: the expression (usually on paper) of ideas, description, thoughts, feelings and analyses about art

zemi: indigenous Amerindian spirit, often represented in Amerindian art

Index

Picture Credits

The publisher would like to thank the following for their kind permission to reproduce their photographs:

(Key: b-bottom; c-centre; l-left; r-right; t-top)

© **DACS:** © ADAGP, Paris and DACS, London 2009 35bl; © ADAGP, Paris and DACS, London 2009. 26; © Munch Museum/Munch - Ellingsen Group, BONO, 87; © Succession Picasso/DACS 2009 4; © The Estate of Jean-Michel Basquiat / ADAGP, Paris 53bl; **akg-images Ltd:** Electra 29; National Museum of Art, Havanna 47br; Sotheby's / akg-images 46; **Alamy Images:** Andy Levin 49tr; Antiques & Collectibles 8bl; ASP Foods 127; Bill Bachman 141; Blaine Harrington III 167; Dennis Hallinan 61; Dorling Kindersley 217; Eric Gevaert 218; Flab 125; Florian Franke 278; Gary Vogelmann 238b; Glow Images 252; H Mark Weidman Photography 231; Helene Rogers 127cr, 127tr; Hugh Threfall 226; ICP 238t; Interfoto 123; John Helgason 161; Kampfner Photography 240; Kevin Wheal 127t; Kurt Brady 126; Maj-Britt Johansson 216; Marka 171r; Melba Photo Agency 198; Michael Willis 126c; Mouse in the House 173bl; Niall McDiarmid 126b; Nik Wheeler 42; Peter Scholey 126tr; Photo Art Collection (PAC) 173; Rob Walls 202; Simon Reddy 154; The London Art Archive 140tr, 186tr; The Print Collector 59tr; Travel Lib Prime 152; VStock 127b; Zoe Smith 203t; **Allan Sieupresad:** 9, 84t, 111; **Ancient Art & Architecture:** 155r; **Annalee Davis:** 52; **Anniken Amundsen:** University for the Creative Arts/Damien Chapman & Ian Forsyth 157l; **Art Directors and TRIP photo Library:** Helene Rogers 47tl; **Bernadette Persaud:** 49; **Bridgeman Art Library Ltd:** British Library, London, UK / © British Library Board. All Rights Reserved 122, 172; British Museum, London, UK 184; © Central Saint Martins College of Art and Design, London / The Bridgeman Art Library 144; Dora Maar (1907-97) / Private Collection / © DACS / Archives Charmet 34tl; Fogg Art Museum, Harvard University Art Museums, USA / Bequest of Grenville L. Winthrop / The Bridgeman Art Library 34bl; Freud Museum, London, UK 105tc, 105tr; Galleria dell' Accademia, Florence, Italy / Alinari 157tr; Hermitage, St. Petersburg, Russia 82; Ken Welsh 41; Musee d'Orsay,Paris/France/Bridgeman Art Library 32tl; Musee Marmottan, Paris, France / Giraudon / The Bridgeman Art Library 32br; Museo Nacional de Antropologia, Mexico City, Mexico / Bildarchiv Steffens Henri Stierlin 187; Museum of Modern Art, New York, USA / The Bridgeman Art Library 33; Museum of Modern Art, New York, USA / © DACS / Lauros / Giraudon / The Bridgeman Art Library 27; National Gallery, London, UK / The Bridgeman Art Library 8t, 28, 31; Naturhistorisches Museum, Vienna, Austria / Ali Meyer / The Bridgeman Art Library 6; Osterreichische Galerie Belvedere, Vienna, Austria 215tr; Prado, Madrid, Spain / Giraudon / The Bridgeman Art Library 106; Private Collection / © DACS / James Goodman Gallery, New York, USA / The Bridgeman Art Library 53; Private Collection / © DACS / Photo © Christie's Images / The Bridgeman Art Library 35; Saatchi Collection, London, UK 87b; The Iveagh Bequest, Kenwood House, London, UK / The Bridgeman Art Library 30t; Vatican Museums and Galleries, Vatican City, Italy 86; **Chris Henshilwood:** 22; **Corbis:** British Museum, London, UK 214; DACS/Burnstein Collection 87tl; Karen Kasmauski 209; **Cynthia Crawford:** 83; **DK Images:** 213t; **E M Clements Photography:** 57, 61b, 164; **Earl Etienne:** 51tr; **Getty Images:** National Geographic 85; **GNU Free Documentation license:** 24, 26bl, 58bl, 59bl, 104, 121cr, 124, 139br, 140bl, 156; **Heather Doram:** 50; **Hilroy Fingal:** 224; **iStockphoto:** 7b, 7t, 21, 42bl, 57br, 81t, 92, 100, 139c, 139t, 141tr, 155bl, 165b, 166, 171bl, 176, 185, 199, 203bl, 213br, 227t, 241c, 271cl; Adam Mattel 155tl, 165t; Anatoly Vartnaov 258; Andreea Manciu 43; Daniela Andreea Spyropoulos 227cl; Dzianis Mirgniuk 271b; Falk Kienas 171l; Gino Santa Maria 81br, 94; Gunay Mutlu 139b, 150; Jodie Coston 121b; Joshua Blake 259; Lit Lu 253; Marc Dietrich 171cl; Michael Kempf 57b, 78, 241b; Robyn Mackenzie 57cr, 61br; Victor Burnside 38, 57tl, 63r; **James Isaiah Boodoo:** CLICO Art Collection, Trinidad 48t; **John Unger:** 215bl; Judy Thorley 109; **Jupiter Unlimited:** 105bl; Bananastock 121t; Stockexpert 170; Stockxpert 108, 177, 179; **Krosfayah:** 243; **LeRoi Clarke:** 48bl; **NKWO:** Bohemian African Chic 138; **Norris Iton:** 107; **Omzad Khan & Nigel Eastman:** Giovanni Powell 228; **Paul Soldner:** 188b; **POD - Pearson Online Database:** Devon Olugbena Shaw 145t; Jules Selmes 271tl; Malcolm Harris 145br; Peter Evans 23; Photodisc/F Schussler 121c; Photodisc/John Wang 20; **Quarto/Headline:** 95, 96, 96tl, 97tl, 99bl; **Ras Akeym-I Ramsay:** 50bl; **Ras Ishi Butcher:** 51bl; **Rodney Jones/Photographers Direct:** 58t, 186bl; **Ronald Jesty:** 99tr; **Scala London:** Metropolitan Museum of Art/Art Resource/Scala Florence 44; The Museum of Modern Art, New York/Scala, Florence 80, 168; © **The Metropolitan Museum of Art:** Shah Quli 60; © **The Trustees of The British Museum:** 62, 203r; **Tirzo Martha:** 223; **Tonia St Cyr:** 216br

Cover images: Front: **Bridgeman Art Library Ltd:** Oscar Ortiz (b.1964) (contemporary artist) Private Collection / The Bridgeman Art Library Xavier Cortada (contemporary artist) Private Collection / The Bridgeman Art Library

All other images © Pearson Education & Allan Sieupresad

Picture Research by: Alison Prior

Every effort has been made to trace the copyright holders and we apologise in advance for any unintentional omissions. We would be pleased to insert the appropriate acknowledgement in any subsequent edition of this publication.